PRIMITIVISM IN MODERN ART

@ @ @ @ @

# PRIMITIVISM IN MODERN ART

## ENLARGED EDITION

## Robert Goldwater

@ @ @ @ @

THE BELKNAP PRESS OF
HARVARD UNIVERSITY PRESS

CAMBRIDGE, MASSACHUSETTS
AND LONDON, ENGLAND

TO MY FATHER

Copyright 1938 and copyright renewed © 1966 by Robert Gold-
water; Enlarged edition copyright © 1986 by Ambrose Doskow,
Trustee U/W Robert Goldwater
Printed in the United States of America
10 9 8 7 6 5 4 3 2

Original editions published by Random House, Inc.

Library of Congress Cataloging-in-Publication Data

Goldwater, Robert John, 1907–1973.
    Primitivism in modern art.

    Bibliography: p.
    Includes index.
    1. Primitivism in modern art.   2. Art, Modern—19th century.
3. Art, Modern—20th century.   I. Title.
N6465.P74G65   1986      709'.04      86-10304
ISBN 0-674-70490-8

# Contents

# Illustrations

# Publisher's Note
# to the Enlarged Edition

For this new expanded paperback edition of *Primitivism in Modern Art* two important essays by Robert Goldwater have been added: "Art History and Anthropology: Some Comparisons of Methodology" and "Judgments of Primitive Art, 1905–1965," with twelve illustrations. And a bibliography of the author's work is appended. No changes have been made in the text as it appeared in the second, revised edition.

# Preface
# to the Revised Edition

This book was first published in 1938. It was then half a century since Van Gogh and Gauguin had admired examples of the architecture and sculpture of "primitive" peoples at the Paris Exposition of 1889. Subsequent generations of modern artists had been inspired by an ideal image of the primitive largely drawn from their imaginations, and also by many individual works of African, Oceanic, and pre-Columbia sculpture seen from their own highly personal perspectives. Nevertheless, primitive art was still largely ignored by art historians, who could not deal with it in their accustomed terms. And while the technique, the social function, the presumed evolution and (less often) the aesthetics of primitive art had been studied by many anthropologists,

they generally remained unaware of modern art. For the public, primitive art still had attached to it vague associations of crudity and simplicity, and since modern art also often seemed to strive for the simple and the unsophisticated, the two were often confused, both in their intentions and their results. This study set out to establish with some precision the sequence of their historical contacts, the very considerable influence of the primitive upon the modern, and—not less important—to describe the nature of that influence and to show that although modern artists admired primitive art they neither copied it nor, despite what they themselves sometimes thought, ever really had the same ends in view.

Since 1938 the impact of the primitive arts has receded; first because as the history of modern art has lengthened it has established its own non-naturalistic traditions, and also because those arts, now accepted in all their variety, have been absorbed into the history of man's plastic creation and are as familiar as Romanesque sculpture or Chinese bronzes. They no longer appear as "primitive" as they did before 1940, when they could still be thought of as both distant and contemporary—a setting that enhanced their mystery. At the same time, all those qualities which here have been summed up in the term "primitivism" are not as new or as surprising as they once were. They too, like primitive art itself, have become more familiar parts of our aesthetic environment.

The revisions made in the original text have been largely of a documentary sort. Gauguin's sources in the exotic arts, the *fauves'* first contacts with African masks and figures, Picasso's knowledge of Iberian as well as of African sculpture, the visits of the *Brücke* and *Blaue Reiter* artists to ethnological museums, these and other details uncovered by recent scholarship have been added to the factual history. A discussion of Dubuffet has been included in the chapter, "The Child Cult," and the sections on Klee and Miró have been expanded. The most important addition has been a

separate chapter analyzing the extent and nature of the influence that primitive art has had on modern sculpture.

The original Introduction has been left unchanged. Although today some of its formulations now appear obvious and others antiquated, it seemed worth-while to allow it to remain, in order to suggest the context of the taste and the attitudes from which this account was first written three decades ago.

A final word of emphasis is perhaps needed. There has been some misunderstanding—especially among anthropologists—that in this discussion the "primitivism" of modern art has been equated with "primitive" art. It is of course widely accepted today (as it was not in 1938) that the art of the so-called primitive peoples is not itself "primitive," *i.e.,* neither technically crude nor aesthetically unsubtle. Quite apart from this, my purpose has not been to establish a parallel, but rather the opposite: First, to show why and under what circumstances the modern artist went to the primitive for inspiration; and second, to demonstrate in some detail that however much or little primitive art has been a source for modern art, the two in fact have almost nothing in common. The arts of the primitive peoples have widened our concept of what "art" is, has made us realize the many shapes art can assume, the diverse roles it can play, the multiple and ambiguous meanings it can embody. Primitive art has thus had a profound effect. Clearly, however, both the social purposes and the aesthetic achievements of primitive art—its forms and its functions—are widely different from those of modern art. The primitivist impulse in modern art is deep and widespread, and contact with the "ethnological arts" only furnishes one of the occasions for its expression.

*December, 1965*

The subject of this study was suggested by my teacher and friend, the late Professor Richard Offner. A meticulous and

expert connoisseur of the "Italian primitives," he also had a lively, continuing and somewhat ironic interest in the art of the twentieth century.

I wish to thank the museums and private collectors who have either kindly given permission or supplied photographs for reproduction of works in their possession.

Mr. Jean-Louis Bourgeois contributed a very useful critical reading of the text and helped in its editing. Miss Elisabeth Little assisted in the preparation of the manuscript and the gathering of the illustrations. I am grateful to them.

# Introduction

The most contemptuous criticism of recent painting comes from those who say: "Any child of eight could have done that." It is also the most difficult of all judgments to answer, since it involves the recognition, but not the admiration, of an apparent spontaneity of inspiration and simplicity of technique whose excellence we have come to take for granted. But our standard is a recent one, and when its value is questioned we see that it cannot be explained from within the individual canvas.

Whether we understand it or not, and whether we approve it or not, this affinity of large sections of modern painting to children's art is one of the most striking of its characteristics. It is part of a much wider and vaguer affinity

which has been generally recognized, yet never pinned down: It has been felt that modern art is in some way primitive. With rare exceptions in which specific adaptations from Africa and Oceania have been pointed out, the allusions have been as vague as the problem. Has modern art, for lack of a tradition and as a last resort, merely appropriated the technical practices and formal conceptions of aboriginal craftsmen? If so, have the borrowings been indiscriminate or has there been a selection? Has modern art a fundamental emotional and spiritual relationship with the art of the primitives? If so, just what is meant by the primitive; is it Altamira or the Congo; is it a Benin bronze or a New Guinea pointed head? Or is it modern painting itself?

> Children's drawings, folk paintings, Negro art: all bring joy in "primitiveness," for which the overripe culture of the decadence longed. They allowed the hurried inhabitants of large cities to glimpse the recovery of an hour, and so to counterfeit a psychological "gathering together" that in truth is nothing but overstrain. Aids for the weak: Cézanne did not use them.[1]

> No one as much as Cézanne forced French painting toward the primitive, and we can see a dualism in him. . . .[2]

> And just as all new artistic endeavor manifests itself at first with the aid of forms and elements of style taken from strange provinces, modern art also based itself on three spheres in which kindred aims seemed to be realized: on the art of primitive peoples, on prehistoric art, and on the "artistic productions" of the child.[3]

> Are we seeing a vogue for something that is desired and sought after, but that realizes itself only as screaming, invention, violence, self-intoxication, and self-glorification; as flat immediacy and weak-sighted will toward the primitive; indeed as hatred of culture; for something that is truly and deeply to be seen in certain schizophrenics.[4]

These are the problems we will discuss.

Yet clearly, since modern painting is modern, it is not primitive in the same sense as any of the aboriginal or prehistoric arts. If there is any common conception which ties together these very diversified styles, it will not include twentieth-century Europe. Nor are the productions of adults the same as those of children, however imitative their intention may be. In relation to these arts as an ideal, the modern painter must necessarily be *primitivistic*. This is so no matter what his conception of the primitive. Just as in relation to the "classic," whether we conceive it to be the style of the fourth or the fifth century B.C., or like Winckelmann inadvertently confuse it with Rome, any derivative style must be "classicistic." Whether, in any absolute sense, such arts are "truly primitive" we do not propose to decide. Like decisions about the essential and eternal classicism of the painters of the Renaissance, such discussions are probably fruitless.[5] Rather we will try to describe the character of modern primitivism, its variations, its intentions, and some of its causes.

In the light of these considerations the reader will not expect many purely formal comparisons of modern works of art with the aboriginal styles by which they have been inspired. But he may be surprised by the extreme scarcity of the direct influence of primitive art forms. With the exception of a few of Gauguin's woodcuts, of some paintings of the *Blaue Reiter* group in Germany, and of the very limited production of Picasso's Negroid period, there is little that is not allusion and suggestion rather than immediate borrowing. And even in these instances, as throughout modern sculpture, where the opportunities for borrowing are much more numerous, a careful comparison discloses changes and interpretations that are striking.

It is primitivism in which we are interested; but this presupposes the knowledge of some kind of primitive. For this reason we have preceded our examination of modern painting with an outline of the development of museums of ethnology. By tracing the history of their origins, and the

attitude toward their collections reflected in the manner of their installation, we can follow the degree of availability of primitive art objects in Europe. Long before the "discovery" of aboriginal art in 1904, examples from Africa and Oceania could be seen in many museums. A survey of the growth of these museums will show to what extent they were intended to perform an aesthetic function. Further, by an analysis of the opinions of ethnologists toward their artistic subject matter, and of the evaluations latent in their discussions, we can determine the relationship of the slowly expanding scientific interest to the sudden fascination of the purely artistic. We shall see that though in isolated instances the scientists appreciated their objects as "art" long before the artists, the general ethnological revaluation was due to the influence of the painters and sculptors. Nevertheless the gradual awareness resulting from the long presence of primitive art in Europe was a necessary condition of its aesthetic discovery.

Within the history of painting, the primitivism that is associated with a knowledge of aboriginal art also has a considerable background. Throughout the nineteenth century there were recurring tendencies toward the Oriental and the generally exotic, toward the Christian and classical naïve, and toward the provincial. These movements and the primitivizing efforts of *art nouveau* that were contemporary with the work of Gauguin, have been called a preparation: Though still archaizing rather than primitivizing in the manner of the twentieth century, they employed the knowledge of a variety of styles new to their period, in an attempt to recapture a certain kind of simplicity. How their ideal of the primitive, imbued with the old conception of a return to a harmonious golden day—if not of culture at least of a controlled style in the arts—differs from the ferocious primitivizing of the last thirty years we will try to determine in our closing definition.

The terms "romantic," "emotional," "intellectual," and "subconscious" have been used to differentiate four aspects

of the primitivist impulse in the twentieth century. Not intended as rigorous demarcations, they have been employed rather as labels for already existing classifications in order to group together similar tendencies and to establish certain parallels between them. Our analysis will show that with each of these groupings there is a movement from the inspiration of particular primitive forms and styles toward a wider, more general, and more indigenous primitive ideal. Each begins with the impulse of some direct, but external influence. Each passes through a stage in which it finds an affinity with some primitive style closer to its own culture. And each ends by having so expanded its primitivism and so modified and purged its own style of any extraneous elements that the two become synonymous. Thus the artists of the *Brücke* first "discovered" aboriginal art and used the broad medium of the woodcut to simplify their style. While those of the *Blaue Reiter,* who, somewhat later, continued the same approach to the primitive, wished to emulate children's art and the folk art of Bavaria, and finally produced an abstract, pantheistically-oriented style intended to express the emotions of plants, animals, and the universe. Among the "intellectuals," Picasso was influenced by the rhythmic forms of African sculpture; the purists, by a theory embodying the elements of a universal geometry. Moreover, something of the same endemizing process can be observed among the four groups considered as a whole, the latest artists beginning their efforts at a more indigenous level than those whom we have called "romantic." Thus our groupings, originally determined by the general historical development of the various schools, are seen to be justified in terms of the history of primitivism. And it is this parallel process of expansion, repeated in all the four divisions of our study, that ties together the four chapters in which they are examined.

In attempting, finally, to give a definition of primitivism, we do not mean to indicate that we imagine it to be any one specific thing which can be paraphrased in capsule form.

Primitivism is not the name for a particular period or school in the history of painting, and consequently no description of a limited set of objective characteristics which will define it can be given. The various attempts which have been made so to define romanticism—unless this word is used in a narrow historical and geographical sense—should be sufficient evidence of this fact.[6] Since primitivism, as well as romanticism, is an attitude productive of art, its results are bound to vary as the conditions upon which this attitude works also vary, although the variation of the second term need not be proportional to that of the first. But since the conditioning term is in reality a compound, whose different aspects can be picked out and combined in a multitude of ways, it can give rise to many artistic points of view. Therefore it is useless to seek another single attitude which will always accompany the one we are trying to define: Witness the attempts to couple romanticism with individualism, or with *l'art pour l'art*.[7] Not that the primitivism of the twentieth century is a perpetually recurring phenomenon in the arts, like the classic and romantic poles of Grierson.[8] The peculiarities of the time are its peculiarities, and the recent atmosphere has been especially favorable to its growth.

Our definition of primitivism must, in consequence, be discursive: It will summarize and make explicit the implications of the detailed analyses of theories and paintings. Primitivism will be distinguished from other attitudes such as archaism and romantism, from which it partly stems and with which it has partial overlappings. We will point out how its unqualified assumption of the inherent value of the historical, psychological, or formal primitive, and of the pervasiveness and uniformity of the fundamental for which it seeks are new and characteristic features. We will also differentiate it in its points of contact with the true primitive (which again we do not take to be one simple style); and the reasons for the changing attitude of the modern artist toward what he considers as primitive will be indicated. This

will lead to a consideration of the basis of the concentric trend of primitivism which we have touched on above, and how it is born of the constantly renewed endeavor of modern painting to create an art which, by having its roots in fundamental and persuasive factors of experience, will be both emotionally compelling to the individual and comprehensible to the many. And finally, there will be an indication of how the relation of the modern painter (and sculptor) to the history of his own art, to his immediate audience, and to the society in which he tries to assert his existence, all have combined to make for the creation of primitivism.

NOTES

1. Max Deri, *Die Neue Malerei: sechs Vortraege* (Leipzig: Seemann, 1921), p. 139.

2. Carl Einstein, *Die Kunst des 20. Jahrhunderts* (Berlin: Propylaen-Verlag, 1931), p. 19.

3. George Saiko, "Why Modern Art Is Primitive," *The London Studio*, VII (1934), 275.

4. Karl Jaspers, *Strindberg und van Gogh* (Berlin: Springer, 1926), p. 151. Many other examples might be given; e.g.: Otto Grautoff, "Sehnsucht ins Kinderland," *Die Neue Kunst* (Berlin: Karl Siegismund, 1921), pp. 93–103. Konrad Lange, *Das Wesen der Kunst* (Berlin: G. Grote, 1907), pp. 419–20. Francois Lehel, *Notre art dément* (Paris: Jonquières, 1926), *passim*.

5. Roger Hinks, " 'Classical' and 'Classicistic' in the Criticism of Ancient Art," *Kritische Berichte*, VI (1937), pp. 94–108.

6. Léon Rosenthal, *La Peinture romantique* (Paris: Albert Fontemoing, n. d.), Book IV, Chap. I.

7. *Ibid.*, p. 149:
   Le trait dominant de la peinture romantique c'est qu'elle a cherché à s'affranchir de toutes les préoccupations étrangères à la peinture même. . . . La doctrine de l'art pour l'art est la sienne . . .
Paul Colin, *La Peinture européenne au xixe siècle: le romantisme* (Paris: Floury, 1935), p. 9:
   Le romantisme créa donc, ou tout au moins développa la personnalité, l'individualisme.

8. Herbert Grierson, *Classical and Romantic* (Cambridge: University Press, 1923), postulates art's constant fluctuation between the extremes of classicism and romanticism; its position along the scale between can at any time be measured.

PRIMITIVISM IN MODERN ART

# 1 Primitive Art in Europe
## The Accessibility of the Material
## The Development
## of Ethnological Museums

THE DEVELOPMENT OF ETHNOLOGICAL MUSEUMS

The artistic interest of the twentieth century in the productions of primitive peoples was neither as unexpected nor as sudden as is generally supposed. Its preparation goes well back into the nineteenth century, as the history of ethnology and the subsequent outline of the parallel interest within the history of art will show.[1] What follows is not a detailed story of museums of ethnology throughout Europe. Such a project would require a discussion of the development of general ethnological theory in the various home countries and of work in the field in many countries abroad.[2] It would demand as well an investigation of the political and economic conditions that encourage and discourage ethnographical activity. But though we can only sketch in the

results of such a history as it affects the arts, this will at least by implication place the problem of primitivism in its wider setting of the scientific, and more generally extra-artistic conditions of an aesthetic manifestation.

The most superficial account of the history of discovery and exploration makes it clear that Africa and Oceania were explored at an unequal pace.[3] During the eighteenth century, while the various islands of Melanesia and Polynesia were becoming familiar to European navigators, Africa enjoyed an almost complete neglect. Though a trade in slaves, gold, ivory, and other products was carried on with the West Coast tribes, this was done through peripheral trading stations, and there was no attempt at entry into the interior.[4] There were many circumstances—geographical, climatic, religious, and commercial—which produced at the beginning of the nineteenth century a relative ignorance of African tribes and a relative knowledge of the Oceanic islands. Isolated African objects had appeared in Europe much earlier. The Dukes of Burgundy owned a few such works as early as the fifteenth century; the Ulm museum, some time before 1600; the Dukes of Brunswick, during the seventeenth century (they are now in the Hanover museum); and the imperial Austrian collections, somewhat later. Nevertheless, in general—and in any quantity—Oceanic objects preceded those from Africa, in storerooms and exhibits. Thus Vienna began with pieces brought back by Captain Cook; the collection in Hamburg, as a result of South Sea connections with its trading city, was chiefly of Oceanic origin; and in England both the London and Cambridge museums had many Polynesian and Melanesian specimens before Africa was well represented.[5]

These were, however, but slight beginnings. How slight we may judge from a "letter" written in 1843 by P.F. von Siebold in favor of ethnographical museums: Von Siebold urges their importance, and particularly "the importance of their creation in European states possessing colonies," because he sees in them a means of understanding the subject

peoples and of awakening the interest of the public and of merchants in them—all necessary conditions for a lucrative trade.[6] Toward this end the science of ethnology is indispensable. Von Siebold gives us, too, a glimpse of a more curious and less scientific age, the eighteenth century, which picked out of its rarity cabinets, where it "kept cult objects and other savage utensils," the most hideous examples in order to testify to "the strangeness and inhumanity of their customs."

> Some products of the art and the industry of half-civilized peoples were also preserved, but much less in the interests of science than out of regard for the great perfection of the technical arts which had been found among these barbarians.[7]

Though a few years in advance of his contemporaries, Von Siebold was on the right track, and the almost simultaneous founding of ethnographical museums in the decades immediately following was due at least as much to the political and economic competition for world markets as to the Darwinian theory of evolution. This was especially true in Germany, which was further behind, and thus more conscious of the supplementary activity necessary to advance its commercial ambitions.

The chronology of the museums shows that the greater number of the beginnings of the important collections is confined to the third quarter of the nineteenth century.[8] The nuclei of the museums of Berlin, London, Rome, Leipzig, and Dresden go back to this period.[9] The attitude of the founders of these museums is best indicated by the fact that the three museums of Berlin, Paris, and Rome were originally parts of museums of "antiquities" (i.e., prehistoric and unclassifiable objects), and that in each case it took some time to get the ethnological section separated from the remainder of the museum.[10] The Berlin museum had previously been part of the *fuerstliche Kunstkammer* for which Japanese arms and armor were already being bought at the time of the Great Elector.[11] In Paris the proj-

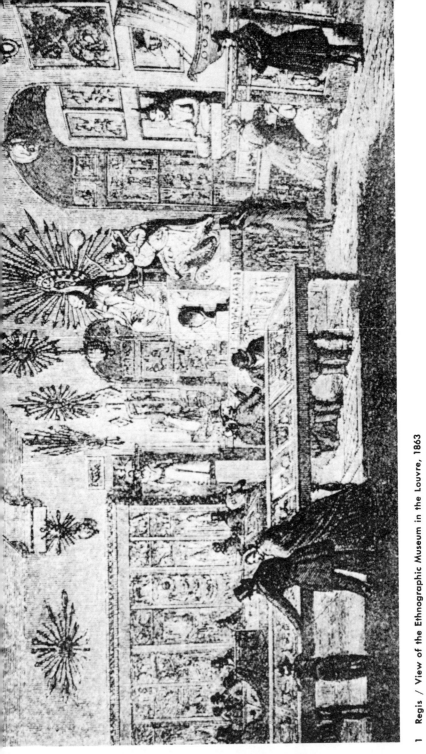

1 Regis / View of the Ethnographic Museum in the Louvre, 1863

ect of an ethnological museum was first conceived during the preparations for the Universal Exposition of 1855, the year after New Caledonia had been annexed, and while Senegal and Gabun were being penetrated by France; it was therefore natural that the museum desired, but never achieved, by E.F. Jomard, whose idea it first was, should have been one of *"géographie et voyages,"* which was to include a "methodical classification of extra-European industry and of objects brought back from distant travels." [12] In the Exposition of 1878, which finally gave the impulse for the foundation of an ethnographical museum—the Trocadéro—separate from the museum at St. Germain-en-Laye, and largely inspired by the Nordiska Museet in Stockholm, by far the largest part of the objects came from America, whence they had been brought from Mexico by Charles Wiener, and from Colombia by Eduard André. [13] (Peruvian pottery and ornaments had been introduced during the previous century into the Cabinet des Médailles by Dombey.) Africa was represented by "antiquities from the Canary Islands . . . and two panoplies from Gabun," and Oceania by "popular objects" from the Celebes, and some "ancient and modern pieces" sent from the Hawaiian Islands, all scant enough. [14]

Nine years after the foundation of the Trocadéro, E.-T. Hamy, its instigator, went to London to report on the Colonial Exposition which was being held there. It is significant that none of the reproductions which illustrate his account are of objects of art, nor are any of the collections which he mentions as being in the Exposition made up of such objects; and he reports that objects were installed helter-skelter, without any regional classification. [15] In the Paris Exposition of 1889, harpoons, arrows, oars, and axes predominated, although a few pieces were shown for their artistic interest: prow ornaments from New Guinea, a "heraldic statue" from New Zealand, a sculptured box from the Ashanti. [16] This evidence of the purely technical and curiosity interest in objects of art, which were exhibited simply as

indications of mechanical development and skill among ex-
otic peoples, is relevant to a contemporary survey of the
ethnological museums of Europe. This survey, written by
Kristian Bahnson in 1888, shows that the principal mu-
seums were by this time well established and had in their
collections objects from most of the South Sea Islands and
from the Gabun, Loango coast, Congo, Senegambia, Guinea,
and Ashanti regions of Africa.[17] Work now highly prized for
its artistic qualities comes from all of these areas, and so it
was not because of lack of opportunity that such work was
either not collected, or not exhibited in a manner calculated
to make for its appreciation. If few art objects were shown
in the museums, it was due to the attitudes of the ethnolo-
gists, influenced, as we will show below through the study of
their writings, by the misapplication to the arts of general
evolutionary theory, which was in its turn influenced by a
naturalistic aesthetic.[18]

From this time on until after the First World War there
was little change. Among museum officials, it was only Felix
von Luschan, at that time in Africa himself, who recognized
the importance of the art of Benin, revealed to the world in
quantity through the British Punitive Expedition of 1897.
The English museums were only tardily stirred into the ac-
quisition of the bronzes and ivories through German activity
in the London market.[19] In 1892 the Leipzig museum held a
special African exhibition, but it was 1921 before there was
an exhibition of Negro sculpture.[20] The Congo was repre-
sented for the first time in the Antwerp international expo-
sition of 1894, and again in 1897 was an important part—in
a special section at Tervuren—of the Exposition Universelle
de Bruxelles. But this was purely in the interests of com-
merce; and the small knowledge of Congo art may be shown
from the surprise of Torday and Joyce—as much as ten years
later—at finding the excellent work of the Bushongo.[21] Yet
the Museum of the Congo, the basis of which was the Ter-
vuren exhibition, was not without influence upon taste; for
the work of the German scholars there during the occupa-

tion of Belgium was of considerable aid to Carl Einstein in his subsequent propaganda for the aesthetic recognition of Negro sculpture.[22]

In 1918, René Verneau—giving an account of the uses of a museum of ethnography—mentions how artists who treat exotic subjects find its documents indispensable, and how exotic fashions have been borrowed from the Trocadéro; but he subordinates these to the knowledge which exporters may gain of the tastes of the peoples with whom they wish to deal.[23] In 1919 the first commercial exhibition of primitive art was held in Paris, though long before this the dealers had been active. And by 1923 an *exposition de l'art indigène des colonies françaises,* having no particular interest for business or commerce, could be held at the Pavillon de Marsan.

The changes which have since taken place, while they are comprehensive neither in the museums they include nor in their action within individual museums, have been in the direction of the enhancement of the aesthetic values of the productions of the primitive peoples. The British Museum and the museum of the Congo long adhered to the "principle of the precedence of collecting over exhibiting," but more recently a modification has occurred. Not only are typical objects less crowded in their cases, so that they may be better seen, but aesthetic standards are invoked by isolating certain works for separate exhibition on the basis of their individual excellence.[24] Other museums have considerably modified their original purely documentary purpose. In Munich, for example, where the installation was carried out on an "art-historical-aesthetic" basis, "the best pieces were so emphasized, through their placing and lighting, that they could be grasped by the hasty visitor who had only an artistic interest." [25] At the Trocadéro, the reorganization instituted by Paul Rivet and Georges-Henri Rivière in 1928 separated public halls from study rooms, and included in the former the "unique objects," shown as such, as well as the "most characteristic objects" of various regions. And al-

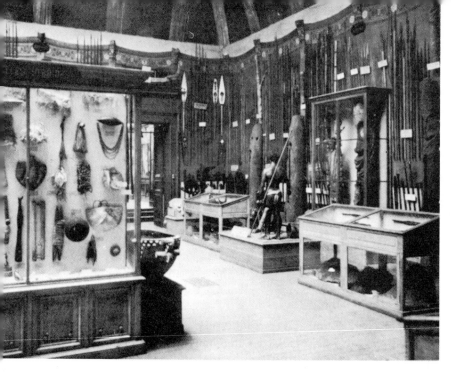

2 Paris / Trocadéro Museum, Oceanic Gallery, 1930

3 Paris / Trocadéro Museum, Installation after Reorganization of 1933–34

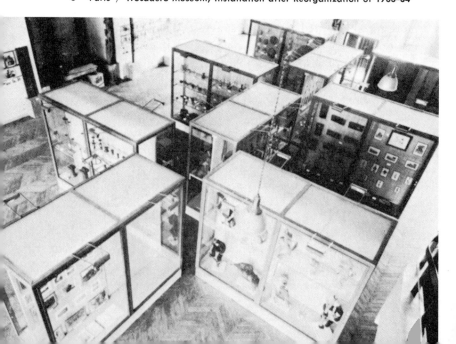

though Rivière protested that the ethnographer must treat all his objects alike, the Trocadéro held numerous exhibitions which in effect were exhibitions of art.[26] (Benin, 1932; Dakar-Djibouti, Marquesas, 1934; Eskimo, 1935.) These divisions were preserved in its reorganization as the Musée de l'Homme in 1937–39 and "excellent" objects continued to be singled out for their aesthetic qualities at the same time as their use and meaning were carefully explained. In Vienna the collecting principle was exchanged for a "cultural-documentary" one, which, while satisfying scientific necessity did not neglect contemporary aesthetic demands.[27] In Cologne during the early thirties the orientation shifted in the same direction, with an emphasis on the individual objects.[28]

What conclusions may be drawn from this brief history? It is clear that the consideration of the aesthetic values of primitive art comes late in the development of museums of ethnology. It comes, indeed, not only considerably after the beginning of such an appreciation on the part of artists and private collectors, but, as a comparison with the second part of this chapter will show, and as is only natural, not until some time after the ethnologists themselves had begun to revise their low opinion of primitive art.

One cannot say, then, that the museums led and guided the taste of artists and private collectors. But the large body of material assembled in the museums and ready for the inspection, even if only with great difficulty, of the aesthetically minded should not be neglected. Not only was it there to be examined when taste became ready for it, as in Dresden and Paris; but it is probable that such a long and unconscious association—it can hardly be called familiarity—with the objects of primitive art was one of the elements in the preparation of this taste.

Interrupted by the war, the trend toward the complete artistic acceptance of primitive artifacts has accelerated in the ensuing two decades. It was undoubtedly hastened by the establishment of the former colonies as independent na-

4    New York / The Museum of Primitive Art, Installation for Senufo
     Sculpture from West Africa exhibition, 1963

tions and the accompanying transformation of their traditional cultures under the impact of modern technology and economy. The result was that with only a few exceptions the primitive arts became arts of the past (in some cases the very recent past), and thus lost part of their previous function as documentation of contemporary primitive cultures. This both freed and emphasized their purely formal values and the expressive power inherent in their formal organization, and permitted a more relaxed and therefore more detailed examination of their social and psychological meanings.

Thus the museums of ethnology, while not neglecting documentation and "functional" considerations, have increasingly presented their objects (or at least some of them) as worthy of purely formal study. They have been willing to take the "ethnocentric" risk of making judgments which separated the finer objects from the more everyday ones in their permanent exhibits, and have also organized exhibitions to call attention to these special products of material culture as works of art.

A parallel development has occurred in the museums of art (especially in the United States) which have begun to widen their aesthetic horizons to include works from primitive cultures around the globe, both through temporary loan shows and in their permanent collections.[29] Moreover, museums concentrating on the primitive arts have been founded in Zurich, New York, and Paris. Thus the artistic creations of the primitive cultures have entered fully into the world history of art, to be, like those of any other culture, understood and appreciated on their own merits.

NOTES

1. See below, Chap. II.

2. For an account of the general theoretical development of ethnology *cf.* Paul Radin, *The Method and Theory of Ethnology* (New York: McGraw-Hill, 1933). Also H.H. Freese, *Anthropology and the Public: The Role of the Museums* (Leiden: Brill, 1960), Chap. I.

3. For good accounts of this process *cf.* Charles P. Lucas, *The Partition*

*and Colonisation of Africa* (Oxford: University Press, 1922); and G.H. Scholefield, *The Pacific: Its Past and Future* (London: John Murray, 1919).

4. Alfred Moulin, *L'Afrique à travers les âges* (Paris: Ollendorf, n. d.)

5. See the chronology given below.

6. Ph. Fr. de Siebold, *Lettre sur l'utilité des Musées Ethnographiques et sur l'importance de leur création dans les états européens qui possèdent des Colonies* (Paris: Librairie de l'Institut, 1843), p. 10.

7. *Loc. cit.*

8. See the Appendix.

9. Kristian Bahnson, "Ueber ethnographischen Museen," *Mittheilungen der Anthropologischen Gesellschaft in Wien,* XVIII (1888), 109–164. K. Weule, "Das Museum fuer Voelkerkunde zu Leipzig," *Jahrbuch des Museums fuer Voelkerkunde zu Leipzig,* VI (1913–14), 23–28. *British Museum, Handbook to the Ethnographical Collections* (London: British Museum, 1925), p. 1.

10. Bahnson, *op. cit.*, p. 116. E.-T. Hamy, *Les Origines du Musée d'Ethnographie. Histoire et Documents,* (Paris: E. Leroux, 1890), p. 53. Note that the foundation of the Trocadéro falls just outside the third quarter of the century (1878).

11. Bahnson, *loc. cit.*

12. Hamy, *op. cit.*, p. 52.

13. The Nordiska Museet was founded by Arthur Hazelius in order to show the popular art tradition of Sweden.

14. *Ibid.*, pp. 55–60.

15. E.-T. Hamy, *Etudes ethnographiques et archéologiques sur l'Exposition Coloniale et Indiènne de Londres* (Paris: E. Leroux, 1887), pp. 13–14, and *passim.*

16. *Exposition Universelle Internationale de 1889,* "Catalogue d'Ethnographie," *Catalogue Générale* (Lille: L. Daniel, 1889), pp. 126–130.

17. Bahnson, *op. cit., passim.*

18. See below, Chap. I, Part 2; especially concerning the Semperians and the Darwinians.

19. Felix von Luschan, *Die Altertuemer von Benin* (3 vols.; Berlin: W. de Gruyter, 1919), Introduction.

20. Fritz Krause, "Das Museum fuer Voelkerkunde zu Leipzig," *Ethnologische Studien* (Leipzig: Verlag der Asia Major, 1929), pp. 106–33.

21. E. Torday and T.A. Joyce, "Les Bushongo," *Annales du Musée du Congo Belge,* Ser. 3 (1910), Vol. 2, No. 1, p. 204.

22. J. Maes, "L'Ethnologie de l'Afrique Centrale et Le Musée du Congo Belge," *Africa,* VII (1934), 174–190.

23. R. Verneau, "Le Musée d'Ethnographie du Trocadéro," *L'Anthropologie,* XXIX (1918–19), 547–60.

24. The Pitt-Rivers Museum in Oxford perhaps preserves most purely the "original" state of an early ethnological collection. It is an unforgettable sight, particularly in contrast with modern installations.

25. Walter Schmidt, "Das Museum fuer Voelkerkunde in Muenchen," *Die Form,* V (1930), 398.

26. Georges-Henri Rivière, "Musée de Beaux-Arts ou Musée d'Ethnographie," Georges Hilaire, ed., *Musées: Enquête internationale sur la réforme des galéries publiques* (Paris: Cahiers de la République, n. d.), p. 67.

27. Kurt Blauensteiner, "Bildwerke aus Benin im wiener Museum fuer Voelkerkunde," *Belvedere,* X (1931), No. 9, p. 36.

28. Julius Lips, verbally, October, 1935.

29. This is also now true of many private collections in both Europe and America, especially among those interested in modern art.

## The Evaluation
## of the Art of Primitive Peoples

The first part of this chapter has outlined the material evidence for the interest in the arts of the primitive peoples: the birth and growth of the museums and the collections devoted to their arts. We have seen what began as a purely scientific interest, if not replaced, at least largely augmented by a lively aesthetic appreciation. Thus the original purely documentary presentation of the objects and their unconsidered mixture with other, purely scientific ethnological evidence, typical of the end of the nineteenth century, was increasingly in the twentieth century no longer considered adequate to their special artistic character. This change in the museum, though partly the result of outside influence, must be the reflection of a similar change in the theoretical point of view of the ethnologists who were responsible for the gathering and arrangement of the showcases in the museums. Striking testimony that this is indeed the fact can be found in the writings of those ethnologists—testimony perhaps less tangible than museum exhibits, but no less weighty for all that. It constitutes, in effect, a complete revaluation of primitive art, gradual in its stages, yet completed in the span of some fifty years. It is a change in taste—from an initial neglect through an interest that presupposed little worth in the objects with which it dealt, to the admiration of the last several decades—which is all the more interesting because it is found in the work of men who are supposed to have the unbiased, objective attitude of the scientist, but who in the course of a century have completely revised their

aesthetic opinions. It is important to recognize, moreover, that the change in point of view was not forced upon anthropologists and ethnologists by the introduction of any new material essential for their consideration. By 1885 all the basic types of primitive art were accessible. Some new styles (e.g., Ife and Dogon, Lake Sentani and Asmat), many thousands of objects and much information about them were still to be discovered, but the whole range of types, from naturalism to extreme stylization, was available for analysis.[1] Explorers and travelers saw many pieces of sculpture and the minor arts, but brought home very few, not because of any physical obstacles to collecting and study, but simply from lack of interest. This initial attitude, though fundamentally aesthetic in character and arising from contemporary aesthetic standards, was conditioned by the generally disdainful opinion of primitive peoples which prevailed throughout the nineteenth century, and which, if it originated in the theory of evolution, was influenced by and useful to colonial programs: the "white man's burden" affected even the arts.[2]

The change in the evaluation of the primitive arts was related to the changing theories of their origins, evolution, function, and meaning. The brief review here will touch on these ethnological problems only to the extent that they are directly related to the questions of shifting taste and appreciation that are our immediate concern.

The best indication of the initial position of the ethnologist is to be found in Edward Tylor's *Primitive Culture,* which was published in two volumes in 1871. That this position, occurring in a work which to this day remains a classic in its field, is given largely by omission is no accident, but merely reflects a typical point of view. In the entire work, Tylor does not have a separate chapter on the arts; and though there is a bare mention of the "really artistic portraits" of the French caves, he deals almost exclusively with ornament and design.[3] Tylor's main concern throughout his work, as he himself states, is "that of determining the rela-

tion of the mental condition of savages to that of civilized man." In this task he finds that the development of the material arts forms an "excellent guide and safeguard to keep before our minds." [4] It is hardly necessary to point out that Tylor considers this development in a purely technical sense, and that it does not redound favorably to the mentality of savages. What is significant is that Tylor did not bother to examine the non-material meanings that might be inherent in the material arts.

The reason for Tylor's point of view becomes clear if we consider the statements of some of his contemporaries about primitive art. Sir John Lubbock, for example, in a chapter dealing with the beginnings of arts and ornaments (1870), is surprised that although the Polynesians are in many ways much more advanced than the Eskimos, and are skillful in ornamentation, they represent plants and animals but poorly.[5] What pleases him in the productions of the African Negroes is that though their idols are not works of art, still "they not only represent men, but give some of the African characteristics with grotesque fidelity"; and for this reason he finds that they do not completely lack the idea of art.[6] In the production of the Eskimos there seems to be a technical anomaly which Lubbock cannot understand; in that of the Africans there is a technical ability which catches his attention. The conception of faithful naturalistic representation as the touchstone of artistic value also dominates William Oldfield's 1865 account of the Australians who are unable to recognize colored engravings of themselves (how far we now consider such engravings from photographic reality!), and can only realize "rude" and "exaggerated" drawings.[7] The same is also true of Sir William Dawkins' judgment, which, as we shall see, was later twice criticized on just the grounds of his realistic assumptions, that neolithic men had fallen far below the paleolithic standard in the arts of design because their engravings are geometric in character, and "they have not left behind any well-defined representations of plants or animals." [8]

Contemporary with this attitude in England, and similar to it in its evaluations of the primitive arts, was the attitude of the Semperians in Germany. Gottfried Semper's *Der Stil in den technischen und tektonischen Kuensten* was published in 1861, and it dominated the consideration of the early arts for the next quarter of a century.[9] Semper's own theory was twofold: he derived the arts from an original purely practical need for shelter and protection from the elements, the productions thus arising being later modified to satisfy artistic as well as practical demands. And secondly, he found in all the arts certain motifs which, though continually modified and varied, persisted in them all; and which had their own origins in a basic motif or "type" whose form was due to the primary technical considerations of the art at its most elementary level.[10] All the decorative elements and the artistic symbols which architecture in its developed forms uses Semper derived originally from the decoration of the body and from connected primitive industry. He opposed the derivation of ornament from natural floral motifs and derived it rather from technical processes which continued to be copied after the processes which conditioned their origin had disappeared.[11] Semper himself never worked out in detail his theories for any of the arts besides architecture, in which his main interest lay; but they were taken up by his followers[12] and applied, or rather distorted for application, to the other arts. Thus, basing themselves in large part on the earliest ornamental motifs they knew, which were geometric, they assumed that the most stylized, non-naturalistic period of any art, its most "geometric" phase, was necessarily the oldest, since it lay nearest to its original determination by the purely technical necessity of a craft. In accordance with his method Von Conze assigns what we now know to be sixth-century Greek work of a developed and refined style (and which, let it be noted, we admire greatly), to a much earlier and more primitive period.[13] Because of this prejudice against the non-naturalistic, the paleolithic paintings which we have seen

that Tylor singled out, were for a long time simply omitted from consideration as a part of early art because they were too naturalistic to fit into the overstylized picture of what such an art should be.[14] We need not, in order to explain the Semperians' point of view, follow Riegl's estimate of them as the victims of a pernicious materialist philosophy, unless by this we simply mean a positivist attitude.[15] Because positivism would give rise both to a naturalistic aesthetic which graded works of art in accordance with what was considered their accurate imitation of nature, and to a theory that artistic development was entirely dependent on the evolution of skills and techniques.

That Semper's theories in themselves did not necessitate a low opinion of primitive nor a high opinion of contemporary art is sufficiently shown in Owen Jones' *Grammar of Ornament* (1868). Jones took over Semper's theory of the technical basis of art, but coupled with it a very high opinion of primitive ornament. With an enthusiasm surprising for his time (though it must be remembered that he is dealing only with ornament), Jones asserts that in savage ornament the "true balance of both form and color" is always maintained; and echoes a much more celebrated primitivist when he says, "if we would return to a more healthy condition, we must even be as little children or as savages," and thus develop a fitting ornament through the unhampered working of our natural instincts.[16]

Schweinfurth (*Artes Africanae,* 1875) too, can be enthusiastic about the African arts, although similarly, while using such a comprehensive title, he confines himself to the study of two-dimensional art, which, like other authors of the time, he refers to as ornament.[17]

The study of this phase of savage art was further carried on in England in the last decades of the nineteenth century. The assumptions which underlay it were very different from those of Jones and radically opposed to the Semperians, since they proceeded on the belief that early art began with a naturalism which it would try to perpetuate. The problem

then was to explain why so much primitive art was not naturalistic; why there was what they called "degeneration." Influenced by Darwinian theory, the English ethnologists turned their attention to the evolution of art, and characteristically, to the evolution of ornament, not because ornament was at the aesthetic base of art, but because it seemed to them to be at the historical beginning. They sought to apply to art the principles of natural selection and thus to discover the laws of its development.

In *Evolution in Art* (1895) Alfred Haddon, trained as a biologist, is content to leave the aesthetic study of art to the professional art critic.[18] What interests him is the "biological treatment of art. Nor [he continues] need surprise be felt if an attempt is made to deal with art as a branch of biology. For is not art necessarily associated with intelligence? Is not intelligence a function of the brain? And is not the brain composed of some form of protoplasm? Art is thus one only of the myriad results of the activity of protoplasm."[19] And Haddon's theory is but one of the results of the very vague applications of Darwin's specific investigation. Haddon and others conducted experiments in the successive copying of a naturalistic representation of an object, which showed that the original was gradually conventionalized and simplified beyond any resemblance to its former self.[20] Though for these experiments he did not use artists, Haddon concluded that all stylization in primitive art was the result of a similar process, and was due to lack of skill on the part of a series of savage artists, who copied, or rather tried to copy, each other because they were not equal to copying from nature. This process, which, significantly, he called "degeneration," was unconscious and not due to any choice on the part of the savage. The possession of such an artistic faculty Haddon could not imagine: "it is inconceivable that a savage should copy or adapt a certain design because it promises to develop into a more pleasing pattern."[21] And he supposed that no one who possessed such a faculty would apply it to any end but copying nature to the best of his ability. Haddon's no-

tions are of course not the result of a well-thought-out theory of aesthetic creation, but simply of those implicit in his transference of a theory of purely physical evolution into the realm of the psychological.

Haddon was not alone in his views. He was enthusiastically supported by Charles Read and Colley March, who were also writing toward the close of the century. March, defending Haddon and also denying "the geometric origin of pattern-making," ridicules those who can imagine that primitive man might have "a desire to decorate a useful surface" with geometric forms, and he quotes Professor W.H. Goodyear and W.H. Holmes as maintaining the same opinions.[22]

The almost exclusive concern of the investigators of this period with two-dimensional art is indicative of the peculiar bias of their aesthetic attitude. They were searching for the origins of art, and thought they had found them in a stylized ornament, which, if they could not appreciate, they could at least explain as the misapplication of a naturalistic art impulse, in spite of the wide divergence of its final result from its intention. They took no notice of sculpture because its forms, which were at such variance with contemporary aesthetic standards, could not be explained by the theories that accounted for the equally strange ornamental forms. March, for example, says of the higher arts only that ". . . they are modelled upon nature and kept in touch with natural phenomena."[23] This is, indeed, a vague enough statement, and one with which varying schools of aesthetics might agree; but that it is to be interpreted in its narrowest sense may be inferred from Henry Balfour's contemporary criticism of "most writers" (and of Boyd Dawkins in particular) who consider the neolithic inferior to the paleolithic period in the arts of design. He holds, on the contrary, that this is true only of the "realistic style," while there was a considerable advance in "fanciful design"; the " 'School' was a very different one, but by no means necessarily inferior."[24] A few years later E.-T. Hamy of Paris, who like Balfour writes in

the tone of one of the minority, also took objection to the denigrating point of view of writers of the school of Boyd Dawkins and Oldfield. Defending the artistic endowment of the savage against Sir John Lubbock, Hamy insists that there is no branch of the human race which is "absolutely without" some works of art, no matter how simple they may be; that all men are capable of reproducing objects which strike their attention; and that neither the Australians, whom Oldfield cites, nor the Bushmen, whom Lubbock had mentioned as not even being able to recognize their own photographs, are without artistic aptitude.[25] After such a long and spirited defense, Hamy's conclusion is more than a little surprising: "From the point of view of the arts of design," he says, "as from so many other points of view, savages are true children; they draw, they mess in paints, they model, like children." [26] And Hamy claims, as others have claimed since, that where we lack the evidence of savage art we can follow the aesthetic evolution of mankind in the development of the abilities of our children.[27]

It is quite in harmony for Maurice Delafosse to find many similarities between Egyptian sculpture and that of the Ivory Coast, considering them both cast in a uniform mold and their works typical and monotonous. He agrees with Gaston Maspero that Egyptian sculpture is a "mixture of naïve science and wishful awkwardness" and finds these same characteristics in the masks and fetishes of the Ivory Coast.[28]

In Germany, too, during the last years of the century, the savages' intelligence and creative capacity were being defended in this somewhat back-hand manner, showing perhaps more clearly than could a downright condemnation of their arts the assumptions of taste and value which lay behind the consideration of primitive art. A.R. Hein has been credited with being the first of the ethnologists to point out the aesthetic worth of non-classic ornament.[29] He laments the fact that the history of art has not considered it worthwhile to treat the primitive arts, and that the aestheti-

cians have not found the subject to their liking.[30] He points out that there is no connection between the quality of the material culture of a civilization and the quality of its art, and that outstanding ability to represent and trenchant observation of nature are to be found even at the comparatively lowest culture levels.[31] The meaning of such general observation seems to be clear to us, but our understanding of Hein's position becomes somewhat obscured by his more particular judgments. Thus in seeking to account for the art of the Dayaks of Borneo, which he treats at some length, he does so by classing them with the Asiatics in general: "The art impulse of the Orientals, who are by their nature little gifted in the higher arts, before all seeks to achieve enjoyment by ennobling the objects of daily use according to the promptings of a subjective aesthetic." [32] A more recent view would surely revise Hein's estimate of Chinese and Japanese art.

The views of Hjalmar Stolpe (who was also a biologist) on the origin of ornament, which he considered at the base of all art, were very similar to those of the English school. Also a realist, he thought that the stylization or conventionalizing of ornament was due primarily to the technical (not the aesthetic) unsuitability as decoration of more realistic designs, and in addition to the desire of savages to repeat as often as possible representations having a symbolic content. Although he agrees with C.H. Read as to the realism of the original art-impulse, he finds other causes for the "degradation" of designs. "The perception of what would be the most suitable decoration for any particular space was no doubt well developed amongst a people so far advanced in technical skill. A desire to display as many images of the god in question is unmistakable. Moreover, an inclination to symbolism always obtains in mystic religions." [33] Elsewhere, Stolpe ridicules the view that ornament could have arisen as the "product of fantasy," or could have arisen from so vain an occupation as a "sport with lines, without other aim than to satisfy a 'sense of beauty.' " [34]

Direct opposition to Stolpe's opinion is voiced by Karl von den Steinen in the course of his study of the art of the Xingu tribe of Brazil. Even those men most bereft of culture, he says, take a simple and direct pleasure in copying; and, likening their art to that of children, he believes that there has been too much attempted interpretation of what is not necessarily picture-writing at all, but is in most cases simply representation done without practical necessity and only for the pleasure in the doing.[35] Von den Steinen studies not ornament alone, but the drawing, sculpture, and masks of the Indians as well, thus showing an interest considerably beyond that of his predecessors. Koch-Gruenberg, whose material also comes from South America, agrees with Von den Steinen that most savage art is not an attempt at picture-writing. He considers that the savage "has a developed sense of beauty and sense for beautifying, and uses every opportunity to busy himself artistically. . . . Wherever he is able he allows his artistic sense to reign."[36] Richard André agrees with these views, and thinks that the artistic ability of savages has been much underrated.[37]

But as late as 1913 Guenter Tessmann, studying the art of the Fang, whose sculpture is now considered among the finest of any African production, concentrates most of his attention upon the derivation and geometrization of ornamental motifs. He mentions the sculpture only in passing because he sees in it no particular characteristics which distinguish it from the work of other African peoples. "The figures . . . with an ever recurring lack of expression, in spite of a superficiality in their rendering of form, seem to me to have a certain lovable naïveté and quiet humor."[38]

More fundamental in their criticism of the previous evaluation of primitive art were Emil Stephan and Max Verworn, both writing at the beginning of the twentieth century. Quoting Riegl, Wölfflin, and Lange, Stephan points out the necessary relativity of such concepts as "true to nature" and "stylized," which have changed even in the course of European art, and the consequent impossibility of judg-

ing primitive art in those terms; it must rather—both for the form and the meaning of that form, which is its content —be understood and evaluated within the framework of its own culture.[39] Verworn, who writes as a psychologist, emphasizes the one-sidedness of previous psychological interpretations of art, and their assumptions of a traditional aesthetic. "The norm of all psychological studies of art has always reflected only the idea of beauty of civilized races. . . . In reality the field is infinitely larger."[40] And Verworn divides art into "physio-plastic" and "ideo-plastic" types, the former resulting from a direct connection between sensation and motor innervation, the latter from the interference of association in the sensory-motor arc.[41] Though he talks of the "dangers" inherent in ideo-plastic forms, he nevertheless considers them to constitute a later and higher form of development.

The Darwinian theories, as we have already seen, had strongly influenced the study of primitive ornament; the development of art was treated as a part of natural evolution, and savage art was considered its lowest form. The Darwinian method, though less uncompromisingly applied, is also evident in the work of Ernst Grosse and Yrjo Hirn, whose books, of a more general character, were influential in England and the United States. Grosse (1894) was well ahead of his time in his examinations of the social aspects of artistic production, in his study of primitive art "as a social phenomenon and a social function," and in his belief that savage productions can only be understood within the context of the "forms of culture in which they arose." It is indeed just for this reason that we must so study them. Grosse also believes that, while a study of the primitives will show us the beginnings of art, a similar aesthetic impulse is common to all mankind: "Strange and inartistic as the primitive forms of art sometimes appear at first sight, as soon as we examine them more closely, we find that they are formed according to the same laws as govern the highest creations of art." [42] Hirn has an even stronger objection to intellectualist

theories of art, and believes that the art impulse is a form of social expression of evolutionary value.[43] He will not commit himself to a belief in the "purely aesthetic and autotelic character of the individual works of art"; he objects to the theories of Schiller and Spencer because art is better able to satisfy the *"greatest* and most *fundamental* instincts of man" than sports or games; and he devotes the greater part of his book to an examination of "the most powerful non-aesthetic factors that have favored the origin and development of the several art forms." [44] Grosse, however, objects to the constant comparison of the drawings of primitive peoples with those of children, finding a lack of perspective their only similarity, and insisting that "not a trace of the sharp observation of the hunting peoples can be discovered in the unaided scrawls of the most earnest children." [45]

Similar in its treatment of art from the point of view of its external motivations and influences to the exclusion of its aesthetic variations, was the French group of sociologists in which the outstanding names are those of Guyau, Durkheim, and Reinach.[46] Their interest was rather in art as a social and more particularly as a religious manifestation. Guyau, for example, conceives of art as an "extraordinarily intense form of sympathy and sociability, which can satisfy itself only by creating a new world." These men thought that the impulse back of the beginnings of art and of its simpler expressions was primarily symbolic; and where they considered at all the individual forms taken by this art, it was to explain the variety of meanings packed into them and not to analyze their peculiar artistic character.

We have already mentioned the opposition of Alois Riegl to the followers of Semper, the technicalists.[47] He exposes to ironic ridicule the philologic-historical method and the purely materialistic philosophy, which, in distortion of Semper's own views, they have applied to the explanation of artistic forms. ". . . One could not be so uncultured and naïve as to believe that, by some chance, one people could have copied a simple meander from another." [48] Riegl

comes to the defense of the "geometric" style and its value as an aesthetic product. He points out that its forms, while they are not copies, are nevertheless not to be placed "outside" of nature since they conform to the same laws of symmetry and rhythm as natural objects and "naturalistic" art forms. Neither is the result of purely technical considerations; both are the results of particular "wills-to-form," which change from place to place and from people to people and dominate and use limitations of material and method. Far from being a degeneration of naturalism, the geometric style has the same relation to it "as the laws of mathematics to the laws of living nature." [49] The whole theory of the technical origin of art simply pushes the premises one step further back. "We would rather say at the start that there is a certain something in people which permits them to find pleasure in beautiful forms, and which the adherents of the technical-material theory of the development of art are as little in a position to define as are we—and that this something has freely and independently created the geometrical line-combination; without first forcing in a material go-between that in the last analysis makes nothing any clearer, and at best can only lead to a wretched seeming success of a materialistic philosophy." [50]

Riegl is, in effect, forcing attention to the forms of art, whether naturalistic or abstract, as they appear as finished products. He is opposing an evolutionary point of view which seeks the explanation of each thing in a forerunner of that thing rather than in itself. His intention is simply to induce consideration of the abstract styles as styles, to place them on the same level as the more naturalistic, not to elevate them to a unique position. But it is precisely to raise them to this position that certain German historians of the early twentieth-century employed Riegl's theories, and he was made—as it was later said he would have meant to be— the prophet of an expressionism whose beginning he just lived to see. [51]

The men who invoked his name were, however, inti-

mately connected with the expressionist movement. Wölfflin (though himself no such advocate) remarks that it is only through "remarkable parallels in certain developments in modern painting" that the qualities of the frozen style of the Bamburg Apocalypse came to be appreciated in a positive fashion.[52] The expressionist connection is obvious in the work of Wilhelm Worringer,[53] at once the champion of the Gothic, the Oriental, and the modern. We do not have to enlarge upon Worringer's general theories. His "rehabilitation of the Gothic," his dichotomy between abstraction and empathy, based upon a misunderstanding of Theodor Lipps' theory of the projection of human feeling into inanimate objects, his Oriental man beyond all knowledge, were for a time very influential. It is through him that Riegl's will-to-form was made a popular phrase. What is important for our study is his idealization of the artistic will-to-form of primitive art, an impulse which he places at the beginning of the line of development which culminates in the Gothic, and in which the Classic period is but a brief (and mistaken) interlude. According to Worringer, primitive man is "confused and alarmed by life," and seeks refuge from its apparent arbitrariness in "the intuitive creation of absolute values. In untramelled spiritual activity primitive man created for himself symbols of the absolute in geometric or stereometric forms." His art may be "an exorcism and a negation of life," but it has, nevertheless, "an inevitable character."

> Thus for primitive man the artistic assimilation of the phenomena of the outer world is bound up with the incorporeal, inexpressive line and . . . with the plane surface. . . . The result of this avoidance of any approximation to life in stylistic purpose was an approximation to abstract cubic elementary forms . . . artistic representation of organic life, even in the case of sculpture, was again removed to the higher domain of an abstract, inanimate orderliness, and became, instead of a reproduction of what is conditioned, the symbol of the unconditioned, of the inevitable.[54]

According to Worringer, primitive art, in its impulse toward abstraction, is the forerunner of Oriental, Egyptian, and modern art.

The later work of Leo Frobenius is a more striking example of the idealization of the art of primitive man. Before the turn of the century he had been among the first to study primitive, particularly African, sculpture. He was especially interested in the way in which, by association, first naturalistic and then more stylized forms were given meaning in their own social context. But his later, wider-ranging theories, which make an explicit connection between primitive and modern art, have an economic and political as well as an aesthetic motivation. Worringer finds German inseparable from Gothic; but Frobenius discovers a direct connection between the Faustian and the African soul: in the *Arabian Nights* everything is foreordained, and there is the Oriental feeling of the inevitable balance of world forces, the idea of a necessary "revanche." [55] Only in *Parsifal* and in the Nigerland epics is there the conception of the fate-conquering individual; only the Occidental has the idea of the character-development of the individual who rises above the material forces around him. [56] Only the West can conceive of an infinite space, in which not only the body, as in the East, but the soul too can live. [57] For centuries the West has been absorbing the opium and morphine of the East along with its porcelain, its silks, and its rugs.

> All [the work of the Orient] was essentially akin to the feminine French, but has been for us Germans, in every period of our expanding strength, the expression of an Oriental lethargy. How different our relation to this giant Africa! Our youth demands nature. The rediscovery of the oldest simple ties with nature, a return to naturalness. Art calls for simplification. [58]

But the true greatness of African art, Frobenius contends, does not lie in its childishness; on the contrary, it lies in a quality which can be traced back to the Stone Age, though it has been discovered and appreciated only lately, namely in

"the unfailing ability to conceive of style." [59] In both Worringer and Frobenius there is a more obvious extra-ethnological bias than in most of the men we have been studying. We cannot be concerned here with the obvious political implications of that bias, tied in Frobenius' case to German expansionism. It is significant, however, that about 1905 and in the following years such an attitude was able to make use of a paean on the primitive arts in order to further its purposes. Ten years before, as our review thus far has shown, this would have been impossible; ten years later it would have been unnecessary.

The first work to review the whole field of primitive art in a comprehensive fashion was Herbert Kuehn's *Die Kunst der Primitiven*, which appeared in 1923. Kuehn's analysis is an aesthetic and stylistic one, and he attempts to establish the underlying basis of the styles he discusses. His conclusions and implied valuations are much the same as Worringer's, though his reasoning is very different. Kuehn discovers in primitive art two fundamentally differing kinds of form: one "sensory" or naturalistic, the other "imaginative" or abstract. Sensory art expresses itself by "imitation" in the Aristotelian meaning; while imaginative art looks in contrast for "the eternal one in things, the essential, the law. It searches for the mysticism of the triangle, the basic symbol of the circle, the quietude of the rectangle." [60] In the one the world overshadows the soul; the other turns to questions of self-inquiry, to absorption in eternity. To uncover the causes of these styles we must look deeper than the simple dying-out or the discovery of a fashion; such theories are based on individual psychology and do not suffice. [61] Looking for causes, Kuehn finds a correlation between types of economic structure and the kinds of art they produce. Thus the sensory styles are the products of parasitic societies—hunting people among the primitive, the Athenian empire in the ancient world, capitalist economy in the modern world; while the imaginative styles are produced by symbiotic or self-subsistent societies: primitive agriculturalists, sixth-cen-

tury Greece, the Middle Ages. Our time is able to appreciate both the abstract and the naturalist kinds of art because we are at a turning point in the history of art, at the end of a long period of sensory production, at the beginning of a period of imaginative forms. Neither the rise of expressionism nor the interest of art historians in abstract styles is accidental: a change in society caused the one and the change in art in its turn caused the other.[62] The validity of Kuehn's correlation is doubtful, its relation to Marx's historical projections quite evident; what is interesting for us is that the high value he accords imaginative forms allows him to appreciate primitive art.

It is clear that the ethnologists whom we have been discussing look with favor upon primitive art just because it is at the opposite pole from the post-Renaissance European tradition. They are not primarily interested in the unique qualities of primitive art, in those qualities which distinguish it from all other art, but in those characteristics which set it off from the art of the nineteenth century in common with other periods and styles such as the Oriental and medieval. There are other modern students of primitive peoples, whom we may class as a group, who carry this point of view still further. They see in early art a manifestation little different from those that have come afterward. As Grosse did earlier, these men consider the impulse to aesthetic expression a primary, or fundamental factor in human nature, one which as such is essentially similar in prehistoric, primitive, and modern civilized man. They postulate what we may call a constant aesthetic urge, and think that the art of primitive people is successful in its full satisfaction of this aesthetic sense. They thus see the origin of art as something free and unconditioned, owing nothing to external catalytics. Discussing the origin of quaternary art, the Abbé Brueil says: "If art for art's sake had not come into being, magical or religious art would never have existed. But if magical or religious ideas had not permeated this 'art for art's sake,' including it in the more serious preoccupations of real life,

art, insufficiently esteemed, would have remained primitive in the extreme." [63] Brueil's pupil, Luquet, takes objection to Reinach's statement that "the impulse behind the art of the Reindeer Age is bound to the development of magic," since sympathetic magic is based on the idea of the power given to the artist by representation, so that this idea had to be preceded by the idea of representation itself:[64] ". . . The sorcerer artists had been inevitably preceded by artists pure and simple, and I consider it impossible for figured art to have been anything but a disinterested activity in its initial phase." [65] Nor, says Luquet (who revives long-abandoned ideas of the similar development of primitive and children's art), is the origin of figured art to be found in decorative patterns, but—as with children—it results from fortuitous lines given a figured interpretation. "Thus one must look for [its] origin in lines traced with no more a decorative than a figured intent, but simply for the sake of executing." [66]

Although drawing his material in the main from entirely different sources (the art of the American Indian), and himself part of a different tradition of ethnology, Franz Boas, in theory, also puts the primitive aesthetic impulse at the same high level. He says in the introduction to *Primitive Art*:

> In one way or another aesthetic pleasure is felt by all members of mankind. No matter how diverse the ideals of beauty may be, the general character of the enjoyment of beauty is of the same order everywhere; the crude song of the Siberians, the dance of the African Negroes, the pantomime of the California Indians, the stone work of the New Zealanders, the carvings of the Melanesians, the sculpture of the Alaskans appeal to them in a manner not different from that felt by us when we hear a song, when we see an artistic dance, or when we admire ornamental work, painting, or sculpture. The very existence of song, dance, painting, and sculpture among all the tribes known to us is proof of the craving to produce things that are felt as satisfying through their form, and of the capability of man to enjoy them.[67]

Boas emphasizes the close connection of the technical tradition which gives a basis for judgment and the correlated standard of beauty, yet he agrees with Riegl that "the will to produce an aesthetic result is the essence of artistic work." He points out the twofold source of artistic effect, form and associated meaning, but believes that art cannot be discussed upon the assumption that the beginning of art is to be found in the latter, "or that, like language, art is a form of expression. . . . Significance of artistic form is neither universal nor can it be shown that it is necessarily older than the form." [68] Boas' approach to primitive art and his consideration of the problems involved in it is thus opposed to the previous ones of Hirn and Grosse, even though he has given us searching analyses of the derivation and evolution of ornamental forms and the social place of the other arts. But Boas makes an important distinction between the aesthetic impulse and art, and he defines art almost entirely in terms of skill which produces accepted form: "When the technical treatment has attained a certain standard of excellence, when the control of the processes involved is such that certain typical forms are produced, we call the process an art." [69] His assumption of the attainment by primitive peoples of a technical standard of perfection shows how far he has moved from those who imagined that the forms of primitive art were due to a manual inability to carry out desired ideas. Nevertheless Boas' conception of the primitive attainment of a certain "fixed form" by which other efforts would be judged tended to downgrade many kinds of primitive art that did not seem to Western (and largely academically conditioned) observers to live up to these standards.

Alfred Vierkandt shares Boas' attitude toward primitive aesthetic impulse. Realizing the implications of his position, however, he does not attempt to justify it on evidential grounds, but considers it merely the most fruitful assumption on which to base a further study of the beginnings of art. He contrasts this attitude with the evolutionary theory,

whose proponents we have already discussed, which recognizes only the biological field of value, and the only motive of art the one of use, and which takes for granted that that use is magic or religious. If we must assume certain things in order to understand savages, says Vierkandt, the easiest and simplest assumption is their similarity to ourselves. Far from postulating only a biologic interest, we are then "authorized and obliged to expect true art and to look for an aesthetic value in the forms" of primitive art.[70] The postulate of an original aesthetic interest also changes the search for the origins of art: since there is no gradual unfolding of the forms of art we know out of previous, embryonic forms, as the evolutionists suppose, but rather the "sudden breaking-out of a new force," there can be no question of a real explanation of the new forms. All we can do is to describe the "prehistory of the arts," to look for "the general atmosphere in which the life of primitive art takes place, out of which it rises and into which it again falls." This can be the only "explanation" of the origins of art.[71]

This point of view is also adhered to by R.H. Lowie, who takes Wundt to task for his constant harping on the religio-magic factors entering into primitive art in spite of his assumption of the similarity of motives of primitive man and of ourselves. Lowie postulates the aesthetic impulse "as one of the irreducible components of the human mind, as a potent agency from the very beginnings of human existence." [72] Moreover, Lowie goes so far as to emphasize the retroactive influence of art on religious and social customs, an influence which Grosse takes the trouble specifically to deny.[73]

There remains only one final point of view upon primitive art to be recorded, one which was, indeed, the only remaining possible opinion. With those who might with justice be called the true champions of the primitives the wheel of taste took its final turn and completed its full revolution. We have seen that others have classed the arts of the savages as among the best, because they found in them certain general qualities which were excellent, but which were also to

be found, perhaps in greater measure, in some period of more "civilized" art. The champions of primitive art saw in it unique characteristics which could be opposed with advantage to any subsequent evolution of style. It was an ideal from which most other art was a falling-away, and to which all other art was to be compared. They did not defend, they eulogized. If there are any difficulties, they are those of explanation to an unenlightened or misguided public; they do not doubt that anyone who has arrived at an understanding of the primitive will see it as they see it, and find in it all the virtues. They approach primitive art directly in isolated examples. They admire its formal organization and what they conceive is its expressive power, and believe these qualities can be grasped by immediate examination alone. Not only have they no desire to approach its meaning through a study of its context in its own society, they often feel that such knowledge will hinder its direct apperception. These men were not ethnologists, but critics and collectors who came to primitive art from the ambience of contemporary art, and who, like the artists, found in it a stimulus to their own search for a new non-naturalistic language of plastic expression. They were thus content to isolate the individual work; but often, not keeping within these limits, they gave it romantic, undocumented interpretations.

The first and most influential of these writers, Carl Einstein (1915), assumes that "the customary lack of understanding of Europeans of African art corresponds to its stylistic strength." [74] Our contempt is merely a reflection of our ignorance. Einstein goes on to explain that Negro sculpture is the only true sculpture, the only sculpture that has dealt with and solved the fundamental problem of the art: that of the representation of cubic mass by direct methods. European sculpture is filled with the use of "painting surrogates," and the moderns seem to attempt the dissolution of the plastic. Even frontality, which has been regarded as a primitive solution of three-dimensional form, is "painterly," since the three dimensions are summed up in a few planes

that suppress the cubic; so that even the beginnings of European sculpture in Greece are ruled out.[75] For Einstein those sculptors too, who, at the other end of the evolution of European art, have taken cognizance of primitive sculpture and have attempted a similar handling of fundamental problems, differ from it in an essential manner: "what appears in the former [European art] as abstraction is in the latter [primitive art] nature rendered directly. Negro sculpture, in the formal sense, proves itself to be the strongest of realisms." [76] Like Boas, Einstein emphasizes the fact that African sculpture is not primitive; "it is anything, but not primitive, and under no circumstances constructive"; but there is this difference: Boas insists that primitive art is adult in relation to its own environment; Einstein that, in comparison to the arts of others, African art alone is fully adult.[77] For Boas, primitive art is comparable to other arts; for Einstein, it is better.

Roger Fry arrived at a similar estimate of African sculpture. A painter and art historian engaged in problems of formal analysis, he was influenced by the same rising artistic tradition as Einstein, and consequently saw the same elements in African sculpture: "I have to admit that some of these things are great sculpture—greater, I think, than anything we produced even in the middle ages. Certainly they have the special qualities of sculpture in a higher degree. . . . These African artists really conceive form in three dimensions." [78]

Though Einstein's work prepared the way for many who came after him, both writers and aesthetes, his own publications were limited. Extremely skeptical of the state of ethnological information, he was content to indicate the essence of primitive art, and did not attempt to write its history or to analyze in detail its various and badly defined provinces. The approach of Von Sydow, although enthusiastic, was vastly different. In numerous lengthy works he brought primitive art into relation with the motivating forces in its own culture, and attempted to characterize it from the

standpoint of the psychoanalytic determination of its forms.[79] Aesthetically, however, Von Sydow, like Einstein, is a champion of the "exotic primitive." He finds in sculpture a clear reflection of the general formal strength of the primitive, so that it gives a true image of the attitude to life of its makers. The three fundamental elements in the primitive world-view are: static unity, system, and aristocracy. "To these correspond in the aesthetic sphere: symmetrical unity of mass and surface, strong stylization, and emphasis on the surfaces."[80] From these comes the impression "that one indicates by the aesthetic category of *monumentality.*"[81] Though one may talk of "sublimity" in connection with certain works, Von Sydow reluctantly denies this appellation to primitive art as a whole. Elsewhere he describes primitive man as "style-possessing," one for whom the aesthetic function is a rooted principle of life. This underlying character the civilized European can understand only as a sort of idyll. For him "style" is comprehensible only as a willed law, and so can be familiar only in a formal way.

> The modern impulses to reflective criticism and creative goals destroy the significant and force each one in an individual direction. The there-existing becomes for us principally a starting-point. But for the primitive the existing is as much goal as beginning. Since the aesthetic function depends on a representable stability of expression, not on the dynamic changes of the impressed form, primitive man is the truly aesthetically educated being of our species.[82]

Under the influence of the psychoanalytic viewpoint, Von Sydow somewhat qualified his opinion, restricting the achievement of primitive art to that of having attained the highest in its own field, "that of organic nature."[83] In his later work Von Sydow—realizing the importance of exact documentation as a tool of objective study—began an ambitious census of African sculpture and its provenances, starting with the museums (1930), and planned to continue it in the field.[84]

In the decade 1915–1925 the popular approval of primitive sculpture reached a high point. This approval had, indeed, in its uncritical appreciation of primitive production, gone beyond the ethnologists' considered appraisal, and really belongs more properly to the history of European taste for the primitive than to the study of indigenous art. An extreme example is to be found in *Primitive Negro Sculpture* (1926) by Guillaume and Munro. Their interest is entirely confined to "the plastic qualities of the figures—their effects of line, plane, mass and color—apart from all associated facts . . . [the ethnological background only] tends to confuse one's appreciation of the plastic qualities in themselves. From the artistic point of view the important question is not what subjects the sculptor chose, but how he executed them, with what distinctive uses of his medium." [85] They value Negro sculpture entirely for those qualities of abstract, geometrical composition they find it has in common with the best modern art.

Opposing the kind of purely formal appreciation that floats free from any foundation in cultural knowledge, the ethnologists warned against a complete abandonment of all critical standards, emphasizing at the same time that they valued the best creations of the native artist very highly. By 1922 even Einstein found dangerous the general romanticizing of primitive life and art.[86] With the same intention Dr. J. Maes, whose writing and activity at the museum of the Congo ranked him among the chief students and advocates of primitive art, objected to the purely aesthetic attitude toward African sculpture.[87] Characteristic of this attitude was the exhibition of Negro art at the Antwerp colonial fair, which in order to establish "the title of absolute equality . . . apart from any racial consideration" of Negro art, found it useful "resolutely to separate art from ethnology, in order to show only those examples with an absolute aesthetic interest." [88] Maes finds that this point of view, perhaps useful in exhibitions, cannot lead to a real understand-

ing of primitive art, and that a systematic study cannot be separated from the idea which guided the artist.

> To wish to separate the object from its social significance, from its ethnic role, to see, admire, and look for the aesthetic side alone, is to remove from these specimens of Negro art their sense, their significance, and the reason for their existence.[89]

Maes does not wish to deny to Negro sculpture its artistic value; rather he thinks that its true beauty will be appreciated only if we understand its psychology. Only with this understanding will we be able to "penetrate all its beauty and all its life."[90]

Ernst Vatter's *Religioese Plastik der Naturvoelker* (1926) likewise examines art within its social settings and adopts the concept of the complete anonymity (or lack of individuality) of the primitive artist. It is a study of the art in terms of its material and psychological background, and it discusses the various types of figures and masks in accordance with their social setting and their uses in religious and magic ceremonies before undertaking a relatively brief stylistic analysis. Vatter is interested in showing "the relations between the sculpture and the religion of primitive peoples in their dependence on the mental and cultural types . . ."[91] His evaluation comes only at the end of an exhaustive study along these lines: after several centuries of denigration and destruction, European civilization is finally coming to an appreciation of non-European cultures. Today, when there is hardly anything left to destroy, we begin to doubt our own soulless civilization, and to realize "that we have lost what the primitive peoples, for so long despised, possessed to the highest degree: a world-view which encloses mankind and the All in a deeply felt unity, which constitutes the essence of their religiousness, and has found form in their religious sculpture."[92] It will be seen that Vatter's opinion coincides with that of Von Sydow which we have given above: a mix-

ture of admiration for the qualities of the work produced by the primitives with a nostalgia for the supposedly simple and comforting psychological character of the savage world, a world in which the conflicts of the individual with nature and with society were not yet realized.

The characterization of primitive art which we have just been considering, that of its champions, is clearly enough at the opposite pole from those descriptions of a half century before which we first took up. In contrast to an original neglect of primitive art—an attitude typified by Tylor's work —and the subsequent treatment of this art from the point of view of purely technical skill or mere externally motivated change—as with the Darwinists—primitive art is now one of the ethnologist's main concerns, and he considers it worthy of aesthetic attention and feels bound to give detailed formal analyses of its peculiar and varying artistic characters. He has, moreover, widened the field of his attention: Where formerly he confined his investigations almost entirely to the limited area of two-dimensional designs, seeking to analyze their various meanings, to find their origins, and to trace their evolution from naturalistic prototypes, as did the English followers of Semper, he has recently given much more of his interest to the dominant art of sculpture, searching for its different types, their interrelations, and their roots within primitive society. As has been remarked above, this change has not been due primarily to any change in the nature of the objects available, but rather to a shift in attention, caused by the gradual penetration of these objects into the visual ken of the ethnologist. It will have been noticed in the course of the account we have given that the field of attention has widened in geographical area as well. In the first studies, examples of the art were drawn from Australia, Oceania, and South America; while from 1920 on, more stress was laid upon African examples. This is partly a result of the relatively late exploration, conquest, and apportionment of the African continent—which delayed scientific work in the interior—but it is due also to the less descriptive

and pictorial nature of African art, the absence of ideo-
graphic surface ornament, and the presence of the three-
dimensional "cubic" character which attracted the modern
artist.[93] It contained the possibilities of a naturalism that it
seemed largely to reflect, and this made it harder for a natu-
ralistic aesthetic to grasp. If in 1910 Torday and Joyce
pointed out the portrait statues of the Bushongo as the
"most beautiful works of African art" because of their real-
istic copying from nature, done with such care that the result
is "greatly superior to what one might expect of a prim-
itive people," it is not surprising that three years later Tess-
mann all but ignored the statuary of the Fang, which is
executed in a style far removed from any attempt to repro-
duce nature.[94] But by 1927 Rattray could realize that even
" 'the uneducated masses' " of Ashanti possess a "love and
appreciation of what is artistic and beautiful," attributes
which are not "the prerogative of all of us"; and point out
that "there is hardly any object capable of artistic treatment
which is not made the medium for some ornamental design
which gives aesthetic delight to the African's mind and
eye." [95] And in 1935 the British were trying to repair the
damage they had done and to revive those arts which their
political and economic penetration had destroyed.[96]

During the last thirty years "ethnological" and "aesthetic"
points of view, mutually influenced, have tended more and
more to converge. The art historian, while insisting upon
making distinctions of quality (which some ethnologists still
consider inadmissible calling them "ethnocentric" or subjec-
tive), has begun to give primitive art the close scrutiny of
his discipline, using all the available evidence, both visual
and factual, at his command, including all that the ethnolo-
gist can tell him. The ethnologist, in turn, has accorded the
arts a larger share of his attention, acknowledging both their
social importance and their aesthetic achievement, and
adapting the methods of art history to his own uses. In the
large body of writing that has appeared during this time—
ranging from broad surveys to detailed studies of tribal

styles based on museum collections and on extended field work—an artistic recognition is everywhere implicit.[97]

The gradual change toward such a high aesthetic evaluation has been evident throughout the history we have been tracing, and we mention it here once more for emphasis. While this change is coincident with a change in ethnology as a whole away from the evolutionary point of view and toward the intensive study of primitive cultures as integral units—and as such is independent of any direct influence from modern art—it is clear that those whom we have called the champions of primitive art were influenced by the movement among the artists which took up and exploited the so-called "pure" and "basic" formal aspects of primitive sculpture. But these champions were for the most part not ethnologists but art critics, or amateurs of art who became interested in the primitive through the modern, and who later influenced the opinions of ethnologists. Our account has shown in addition that this was not a one-sided relationship. Even before the artists "discovered" Oceanic and African art in 1904–5 the way to the appreciation of primitive art had been prepared within ethnology itself by ethnological champions, so that the artists were only adding fuel to a slow-burning fire; and, moreover, the ethnologists had, by the whole activity of their collecting and writing, set the stage for the artists' recogntion of primitive art. This recognition is generally called a discovery, yet we have seen in the work of ethnologists a trend toward this discovery that was part of the same sort of revolt as that of the artists. The romantic opinions of Owen Jones, the rejection of materialism by Riegl, Balfour's defense of "fanciful design," Andrée's protests against the underestimation of the savage's artistic ability, and Hamy's insistence upon the possession of the artistic impulse by all mankind are but undercurrents of a stream of taste which come to the surface at about the same time as the discovery of primitive art by the avant-garde of modern art. In addition a certain number of the creations of primitive artists had been in museums and

curiosity shops for some time, where they were both evidence of a changing taste and one of the conditions of its still further change, on the part of the artists as well as the ethnologists. But to the artists they meant nothing until their "discovery" for the double reason that their own art was not ripe, and that a certain familiarity—doubtless an unconscious familiarity which would later be denied—was necessary before these things could exert an influence. The gathering of the objects of primitive art by the ethnologists was thus one of the necessary grounds without which the artists' enthusiasm and appreciation could not have occurred. They were part of a common, interdependent change in taste.

NOTES

1. The art of Benin was found in quantity in the English raid on the city in 1897; isolated examples had been known since the sixteenth century. *Cf.* Felix von Luschan, *Die Altertuemer von Benin* (Berlin: W. de Gruyter, 1919), Introduction; and Franz Heger, "Benin und seine Altertuemer," *Mittheilungen der Anthropologischen Gesellschaft in Wien*, XXIX (1899), Sitzungsberichte, pp. 2–6. Further particular examples of all types of primitive art have of course been found since 1875.

2. The classic statement of the assumptions which underlie this attitude is to be found in J.A. Gobineau, *Essai sur l'inégalité des races humaines* (Paris: Firmin Didot, 1853–55), Book I, Chap. XIV, Book II, Chap. VI. See also Olivier Leroy, *La raison primitive* (Paris: Alcan, 1927), *passim*.

3. Edward Tylor, *Primitive Culture. Researches into the development of Mythology, Philosophy, Religion, Language, Art and Custom* (London: John Murray, 1871), p. 59.

4. *Ibid.*, p. 68.

5. Sir John Lubbock, *The Origin of Civilization* (London: Longmans, Green & Co., 1870), pp. 37–38.

6. *Ibid.*, pp. 41–42. It is interesting that the basis of this judgment is the art of central and southern Africa, while there is no mention of West Africa, on which any modern opinion would rest. Neither is there any suggestion of the problem of the discrepancy between the realism of the Eskimos' carvings and the abstraction of their masks.

7. W. Oldfield, "On the Aborigines of Australia," *Transactions of the Ethnological Society of London*, III (1865), p. 227. "On being shown a colored engraving of an aboriginal New Hollander, one declared it to be a ship, another a kangaroo, and so on; not one of a dozen identifying the portrait as having any connection with himself. A rude drawing with all the lesser parts exaggerated they can realize."

8. William Boyd Dawkins, *Early Man in Britain* (London: Macmillan, 1880), p. 305. Also p. 224, where the art of the Eskimos, alone among modern primitive art, is admired.

9. Gottfried Semper, *Der Stil in den technischen und tektonischen Kuensten oder Praktische Aesthetik* (Munich: F. Bruckmann, 1861–63). For a brief outline of Semper's theories, see Hans Prinzhorn, *Gottfried Semper's Aesthetische Grundanschauungen* (Munich: Thesis, 1908).

10. Semper, *op. cit.*, I, p. 5.

> Es treten dem aufmerksam Beobachter ueberall, wo er auf monumentale Spuren ersterbener Gellschaftsorganismen trifft, gewisse Grundformen oder Typen der Kunst entgegen, die sich hier klar und unverwischt, dort bereits in sekundaerer oder tertiaerer Umbildung und getruebt zeigen, immer aber als dieselben, die somit aelter sind als alle Gesellschaftsorganismen, von welchen sich Monumentale Spuren erhalten oder von denen wir sonst, in Beziehung auf ihnen eigen angehoerige Kunst, Nachricht haben. Diese typen sind verschiedensten Kuensten entlehnt, wie sie in primitivster Handhabung . . . gedacht wurden.

11. *Ibid.*, II, p. 466.

12. See Alois Riegl, *Stilfragen* (Berlin: George Siemens, 1893), Introduction.

13. A.C.L. von Conze, *Beitraege zur Geschichte der greichischen Plastik* (Halle: Waisenhaus, 1869).

14. Riegl, *op. cit.*, pp. 18–19.

15. *Ibid.*, pp. v–vii, 32. A.A. Gerbrands, *Art as an Element of Culture, Especially in Negro-Africa* (Leiden, E.J. Brill, 1957), p. 30, points out that in placing the psychological "origin of art in the human desire for decoration, first applied to man's own body" Semper gives a "precedence to the creative individual" that is hardly materialist.

16. Owen Jones, *The Grammar of Ornament* (London: Bernard Quaritch, 1868), pp. 15–16. Jones continues:

> The ornament of a savage tribe, being the result of a natural instinct, is necessarily always true to its purpose; whilst in much of the ornament in civilized nations, the first impulse which generated received forms being enfeebled by constant repetition, the ornament is oftentimes misapplied, and instead of first seeking the most convenient form, and adding beauty, all beauty is destroyed, because all fitness, by superadding ornament to ill-contrived form.

17. G.A. Schweinfurth, *Artes Africanae* (Leipzig: F. A. Brockhaus, 1875), Introduction.

18. Alfred Haddon, *Evolution in Art* (London: W. Scott, 1895), p. 306.

19. *Ibid.*, p. 308.

20. Haddon gives the credit of first carrying out such experiments, clearly borrowed from biological technique, to General Pitt-Rivers, founder of the Oxford Ethnological Museum. *Ibid.*, p. 311.

21. *Ibid.*, pp. 317–318. The biological parallel is pushed to the extreme:

> . . . consciousness of purpose has extremely little to do with human evolution, nor has it much more to say in the evolution of patterns among primitive peoples.

22. Charles Read, "On the Origin of Certain Ornaments of the South Eastern Pacific," *Journal of the Anthropological Institute,* XXI (1892), p. 139. Colley March, "Evolution and Psychology in Art," *Mind,* V (1896), p. 441. W.H. Goodyear, "The Origin of the Acanthus Motive," *The Ameri-*

can *Architectural Record,* IV (1894), 88. W.H. Holmes, "The Origin and Development of Form and Ornament in Ceramic Art," *U.S. Ethnology Bureau Annual Report,* VI (1888), pp. 189–252.

23. March, *op. cit.,* p. 461.

24. Henry Balfour, *The Evolution of Decorative Art* (London: Percival & Co., 1893), p. 10. Balfour also differs with Haddon in his emphasis upon conscious, as well as unconscious, variation of design: *Ibid.,* p. 31:

> While the two processes may be associated . . . conscious variation is frequently to all intents and purposes the sole agent . . . there is no idea of slavishly adhering to the original in detail.

25. E.-T. Hamy, "La figure humaine chez le sauvage et chez l'enfant," *L'Anthropologie,* XIX (1908), pp. 385–386.

26. *Ibid.,* p. 396. The general psychological comparison is in itself significant of the point of view.

27. This parallel is more often drawn for the development of prehistoric art. See, Helga Eng, *The Psychology of Children's Drawings* (New York: Harcourt, Brace, 1931), pp. 213–14. For the point of view which holds that there is no parallel, see, Georges Rouma, *Le langage graphique de l'enfant* (Paris: Alcan, 1913).

28. Maurice Delafosse, "Sur les traces probables de civilization egyptienne et d'hommes de race blanche à la Côte d'Ivoire," *L'Anthropologie,* XI (1900), pp. 431–451, 543–68, 677–90.

29. Elizabeth Wilson, *Das Ornament* (Erfurt: J.G. Cramer, 1914), p. 12.

30. A.R. Hein, *Maeander, Kreuze, Hakenkreuze und Urmotivische Wirbelornamente in Amerika* (Vienna: A. Hoelder, 1891), p. 3:

> Fuer Untersuchungen, welche auf solchem Boden haetten gefuehrt werden muessen, fehlte den Ethnologen zunaechst das Auge; den Kuenstlern und Kunstgelehrten aber in gleichen Masse Interesse und Verstaendnis.

31. A.R. Hein, *Die bildenden Kudenste bei den Dayaks auf Borneo* (Vienna: A. Hoelder, 1890), p. 3.

32. *Ibid.,* p. 90. For Hein's theories of ornament, and that of others, see, Martin Heydrich, "Afrikanische Ornamentik. Beitraege zur Erforschung der primitiven Ornamentik und zur Geschichte der Forschung," *Internationales Archiv fuer Ethnographie,* XXII (1914), supplement. Also, Wilson, *op. cit.*

33. Hjalmar Stolpe, "On Evolution in the Ornamental Art of Savage Peoples," *Collected Essays in Ornamental Art.* Trans. by Mrs. C.H. March, (Stockholm: Aftonbladet, 1927), pp. 56–57. (First published in 1890–91.) That stylization is not due to lack of ability may be seen from, *Ibid.,* p. 56:

> Nor were the transformations due to any want of skill on the part of the Herveyan carver, because he often used to place on the very same implements the realistic prototype, as well as a whole series of in-, termediate forms, down to those that are most transfigured.

34. Hjalmar Stolpe, "Studies in American Ornamentation," *Collected Essays in Ornamental Art.* Trans. by Mrs. C.H. March, (Stockholm: Aftonbladet, 1927), p. 69. (First published in 1896.)

35. Karl von den Steinen, *Unter den Naturvoelkern Zentral-Braziliens* (Berlin: Dietrich Reimer, 1894), pp. 243–294.

36. Theodor Koch-Gruenberg, *Anfaenge der Kunst im Urwald* (Berlin: E. Wasmuth, 1906), p. 1. Also by the same author, *Suedamerikanische Felszeichnungen* (Berlin: E. Wasmuth, 1907), Chap. III; in which he takes exception to the current theory that these rock drawings are a kind of picture-writing, done without any aesthetic interest.

37. Richard Andrée, "Das Zeichen bei den Naturvoelkern," *Mittheilungen der Anthropologischen Gesellschaft in Wien*, XVII (1887), p. 98:

> Das Talent, schnell charakteristische Zeichnungen zu entwerfen, ist unter den Naturvoelkern viel weiter verbreitet, als man gewoehnlich annimmt, und bei den Meisten braucht nur eine Gelegenheit gegeben zu werden, um die schlummernde Gabe zu wecken.

38. Guenter Tessmann, *Die Pangwe* (Berlin: E. Wasmuth, 1913), p. 275.

39. Emil Stephan, *Sudseekunst. Beitraege zur Kunst des Bismark-Archipels, und zur Urgeschichte der Kunst ueberhaupt* (Berlin: Dietrich Reimer, 1907), p. 81. Stephan does not agree with the "technical" thories of ornament, nor with its derivation from clanmarks, owner's-marks, or picture-writing. See, *Ibid.*, pp. 63–66.

40. Max Verworn, *Zur Psychologie der primitiven Kunst* (Jena: G. Fischer, 1907), pp. 5–6:

> Die Kunstpsychologie bestand fast ausschliesslich in der traditionellen Aesthetik. Den Mittelpunkt aller psychologischen Kunstbetrachtungen bildete immer und immerwieder allein der Schoenheitsbegriff der Kulturvoelker. . . . In Wirklichkeit ist das Gebiet unendlich viel groesser.

41. *Ibid.*, pp. 16–20. Verworn says that children's art, and that of contemporary primitives, reverses the biogenetic law, found in palaeolithic cave painting; see, Eng, *loc. cit.* He believes that art comes from play by way of technique; see, *Die Anfaenge der Kunst* (Jena: G. Fischer, 1909), pp. 16–19.

42. Ernst Grosse, *The Beginnings of Art* (London: Appleton, 1897), p. 23, and pp. 306–316. Interesting in relation to the thesis of this chapter is a marginal comment on Grosse's assertion that because the designs on Australian weapons are marks of ownership "they have, therefore, not an aesthetic, but a practical significance." The note says, "This has not great significance, even if they be marks of ownership, they are aesthetic expressions." Grosse is careful to distinguish between non-aesthetic decoration, and representative art for which, "with comparatively few exceptions, neither a religious nor any other outside purpose can be proved to be intended. . . ." *Ibid.*, p. 204.

43. Yrjo Hirn, *The Origins of Art* (London: Macmillan, 1900), p. 143.

44. *Ibid.*, pp. 27, 147. Hirn's book is described by Wilson (*op. cit.*, p. 17) as "ein verwaesserter Darwinismus, zur Aufdeckung 'der Ursprunge' angewandt." Hirn's agreement (*op. cit.*, p. 34) with Marshall's definition of pleasure and pain seems to justify the epithet.

45. Grosse, *op. cit.*, pp. 193, 24, 165, where he takes exception with Oldfield.

46. Emile Durkheim, *Les formes élémentaires de la vie religieuse* (Paris: Alcan, 1912); Salomon Reinach, *Cultes, mythes, et religions* (5 vols.; Paris: E. Leroux, 1905–23); J.M. Guyau, *L'Art au point de vue sociologique* (Paris: Alcan, 1887).

47. See above.

48. Riegl, *op. cit.*, p. vi:

Die Eile, mit der man jeweilig sofort versicherte, dass man ja nicht so ungebildet und naiv waere zu glauben, dass etwa ein Volk dem anderen ein 'einfaches' Maeanderband abgeguckt haben koennte, und die Entschuldigung, um die man vielmals bat, wenn man sich herausnahm, etwa ein planimetrisch stilisiertes Pflanzenmotiv mit einem aehnlichen aus fremden Kunstbesitz in enfernte Verbindung zu bringen, lehren deutlich genug, welch' siegreichen Terrorismus jene Extremen auch auf die 'Historiker' unter den mit der Ornamentforschung Beflissenen ausuebten.

49. *Ibid.*, p. 3:

Die geometrischen Kunstformen verhalten sich eben zu den uebrigen Kunstformen genau so wie die Gesetze der Mathematik zu den lebendigen Naturgesetzen.

Compare this with the primitivism of certain abstractionist theories, considered below, Chap. V.

50. *Ibid.*, p. 32:

Die ganze Theorie erscheint hiernach bloss als Glied der materialistischen Weltanschauung, bestimmt die Ableitung einer geistigen Lebensaeusserungen des Menschen aus stofflichmateriellen Praemissen, um einen Schritt weiter hinauf zu ruecken. Wir wollen diesen Schritt gar nicht thun, um schliesslich eingestehen zu muessen, das wir des Pudels Kern doch nicht zu erkennen vermoegen.

51. Julius von Schlosser, "Alois Riegl," *Corona*, IV (1933), p. 214. ". . . etwas von einem "rueckwaertsgewandten Propheten' . . ."

52. Heinrich Wölfflin, *Die Bamberger Apokalypse* (Munich: Koeniglich Bayerischen Akademie, 1918), p. 2.

53. Wilhelm Worringer, *Abstraktion und Einfuehlung* (Munich: R. Piper, 1907); *Formprobleme der Gotik* (Munich: R. Piper, 1912) Translated as, *Form in Gothic* (London: Putnam, 1927); *Griechentum und Gotik* (Munich: R. Piper, 1928).

54. Worringer, *Form in Gothic,* Chap. IV.

55. *Ibid.*, pp. 180–81. "For the Germans in the 'widest sense,' as we have seen, are the *conditio sine qua non* of Gothic." The correlation of race and primitive art (other than simple endowment, or lack of it) goes back to ca. 1890, a connection being made between certain fundamental forms (e.g. the swastika) and the Indo-germanic stem. See, Wilson, *op. cit.,* p. 11. For ideas similar to Worringer, also see, Adama Van Scheltema, *Die Altnordische Kunst* (Berlin: Mauritius, 1923), p. 248.

56. Leo Frobenius, *Paideuma* (Munich: C.H. Beck, 1921), pp. 94–96. Frobenius was an agitator for the return of the German colonies.

57. *Ibid.*, p. 92:

Der Morgenlaender lebt in einer Welthoehle. Ein Aussen kennt er nicht. . . . Der Abendlaender dagegen lebt in einem Haus. Dem entspricht ein Innengefuehl und erst hieraus konnte sich ein Aussengefuehl entwickeln. Dieses Aussen ist ein Undendlichkeitsraum.

58. Leo Frobenius, *Das Unbekannte Afrika* (Munich: C.H. Beck, 1923), p. 4:

Als das Merkwuerdigste an diesen Afrika erscheint mir immer wieder, dass sein Inneres uns so verwandt ist. . . . In dem durch Eklektismus

ausgezeichneten Kulturstadium, in dem wir uns befinden, nimmt Afrika eine ganz eigenartige Stellung ein.

59. *Ibid.*, p. 140. The reference here seems to be to modern African primitive art. But see also his, *Madsimu-Dsangara* (Berlin: Atlantis, 1931), Vol. I, *passim;* where the same critique is given of the Rhodesian "prehistoric" or "Bushman" painting. These tendencies do not appear in Frobenius' early work such as, "Die Masken und Geheimbuender Afrikas," *Abhandlungen der Kaiserlichen Leopoldin-Carolinische Deutscher Akademie,* LXXIV (1899), p. 1 ff.; or, *"Die Bildende Kunst der Afrikaner," Mittheilungen der Anthropologischen Gesellschaft in Wien,* XXVII (1897), 1 ff. But see his, *Kulturgeschichte Afrikas* (Zurich: Phaidon, 1933), for a further exaggeration.

60. Herbert Kuehn, *Die Kunst der Primitiven* (Munich: Delphin Verlag, 1923), pp. 11–12.

61. Herbert Kuehn, "Praehistorische und Ethnographische Kunst," *Ipek,* I (1925), 3, 11.

62. Kuehn, *Die Kunst . . . ,* p. 22.

63. Abbé Breuil, "Les origines de l'art décoratif," *Journal de Psychologie,* XXIII (1926), p. 366.

64. G.H. Luquet, *The Art and Religion of Fossil Man.* Trans. by G.T. Russell (New Haven: Yale University Press, 1930), p. 111. (First appeared in 1926.)

65. *Loc. cit.*

66. *Loc. cit.* See also by Luquet, "Les origines de l'art figuré," *Ipek,* II (1926), pp. 1–28.

67. Franz Boas, *Primitive Art* (Oslo: Aschehoug, 1927), p. 9. Boas' opinions, based upon field work carried out and published before 1900, were formed very much earlier.

68. *Ibid.*, p. 11.

69. *Ibid.*, p. 10. There is some confusion between the priority (or the collaboration) of "idea" and "technique."

70. Alfred Vierkandt, "Prinzipienfragen der ethnologischen Kunstforschung," *Zeitschrift fuer Aesthetik und allgemeine Kunstwissenschaft,* XIX (1925), 342.

71. *Ibid.*, p. 344.

72. R.H. Lowie, "Religion and Art," *Primitive Religion* (London: George Routledge, 1925), p. 260.

73. Grosse, *op. cit.*, pp. 205–206.

74. Carl Einstein, *Negerplastik* (2nd ed.; Munich: Kurt Wolff, 1920), p. ix.

75. *Ibid.*, pp. ix–xii.

76. *Ibid.*, p. xi:

> Ueblicher Weise bezeichnet man die Bemuehungen dieser Maler als Abstraktion, wiewohl sich nicht leugnen laesst, dass nur mit einer ungeheueren Kritik der verirrten Umschreibungen man sich einer unmittelbaren Raumauffassung naehern konnte. Dies jedoch ist wesentlich und scheidet die Negerplastik kraeftig von solcher Kunst, die an ihr sich orientierte und ihr Bewusstsein gewann; was hier als Abstraktion erscheint ist dort unmittelbar gegebene Natur.

77. Carl Einstein, *Afrikanische Plastik* (Berlin: E. Wasmuth, 1922), p. 6.

78. Roger Fry, "Negro Scultpure," *Vision and Design* (London: Chatto & Windus, 1928), p. 100. (First published, 1920.)

79. Eckart von Sydow, *Primitive Kunst und Psychoanalyse* (Vienna: Psychoanalytische-Verlag, 1927).

80. Eckart von Sydow, *Kunst und Religion der Naturvoelker* (Oldenburg i. O.: G. Stalling, 1926), p. 21:

> Die Grundsaetze der Primitiven Kunstuebung praegen sich am reinsten in der Skulptur aus. Sie geben ein deutliches Spiegelbild der allgemeinen Formkraefte der Primitivitaet, so dass sie ein getreues Abbild der Lebenshaltung ihrer Traeger sind. Drei Elemente hatten wir als grundlegend gefunden: statische Einheitlichkeit—Systematik —Aristokratismus.

81. *Ibid.*, p. 25.

82. Eckart von Sydow, *Ahnenkult und Ahnenbild der Naturvoelker* (Berlin: Furche, 1924), p. 9.

83. Sydow, *Primitive Kunst . . .* , p. 169.

84. Sydow, *Handbuch der Westafrikanischen Plastik* (Berlin, 1930); *Afrikanische Plastik* (Berlin, 1954), posthumous publication.

85. P. Guillaume and T. Munro, *Primitive Negro Sculpture* (New York: Harcourt, Brace, 1926), p. 7. This book expresses the point of view of the Barnes Foundation toward the study of all art.

86. Einstein, *op. cit.*, p. 5:

> Mit Vorsicht moege man afrikanische Historie rekonstruieren; denn leicht geraet man ins Idealisieren und laesst sich von den modischen Vorstellungen einer romantischen Primitiven betaeuben.

87. For Maes' numerous articles see, *Bibliographie Ethnographique du Congo Belge et des Régions avoisinantes* (Brussels: Musée du Congo Belge, 1932–33).

88. Quoted by Maes in, "La psychologie de l'art nègre," *Ipek*, II (1926), p. 275.

89. *Ibid.*, p. 283.

90. *Loc. cit.*:

> Efforcons nous au contraire de comprendre la psychologie de l'art Nègre et nous finirons par en pénétrer toute la beauté et toute la vie! N'oublions point, l'art nègre ne peut avoir toute sa signification pour celui qui ignore la pensée et l'âme de son auteur.

91. Ernst Vatter, *Religioese Plastik der Naturvoelker* (Frankfurt am Main: Franfurter-verlag, 1926), p. 5.

92. *Ibid.*, p. 172.

93. For the main dates of discovery and settlement, see above, Chap. I, Part 1.

94. F. Torday, and T.A. Joyce, "Les Bushongo," *Annales du Musée du Congo Belge*, Ser. 3 (1910), Vol. 2, No. I, p. 204. Tessmann, *loc. cit.*

95. R.S. Rattray, *Religion and Art in Ashanti* (Oxford: University Press, 1927), p. 269. The more recent favor accorded the even more highly stylized art of the Sudan (Bambara, Dogon), may also be correlated with a further change in the problems of modern art.

96. M.E. Sadler, ed., *Arts of West Africa* (Oxford: University Press, 1935), *passim*. This is of course not a unique attempt to undo the effects of civilization upon primitive culture. *Cf.* the surprisingly successful effort of the United States Government in the thirties (through the India Arts and Crafts Board), to revive the arts of the American Indian.

97. A notable instance is the influential work of F.M. Olbrechts, *Plastiek van Congo* (Antwerp, 1946), trans. as *Les Arts plastique du Congo Belge* (Brussels: Editions Erasme, 1959). Olbrechts applies Morellian methods of stylistic analysis and attribution through comparison of details. Other examples of implicitly high value judgments are: Raymond Firth, *Art and Life in New Guinea* (London and New York: The Studio, 1936); P.J. Vandenhoute, *Classification stylistique du masque Dan et Guéré de la Côte d'Ivoire Occidentale (A.O.F.)* (Leiden: Rijksmuseum voor Volkenkunde, 1948); Marian W. Smith, ed., *The Artist in Tribal Society* (London: Routledge & Kegan Paul, 1961); as well as many general introductory books to the whole field. *Cf.* also, Grebrands, *op. cit.*, and *Wow-ipits: Eight Woodcarvers from Amanamkaj* (The Hague: Mouton and Co., 1966); Margaret Mead, "Bark Paintings of the Mountain Arapesh & New Guinea," in *Technique and Personality*, New York: The Museum of Primitive Art, 1963).

# II  The Preparation

Primitivism presupposes the primitive, and an artistic primitivism assumes the knowledge of and an interest in arts that are in some sense considered primitive. But such an interest —in so far as it takes for granted a curiosity about styles other than one's own and an ability to appreciate and make use of their particular aesthetic contribution—is in itself the issue of a more general orientation which the artist shares with others, that of a historical consciousness which finds stimulating the cultural manifestations of the past. The account of the first chapter has shown that the scientific interest in the exotic arts, which began as an interest in origins and demonstrable evolution, transformed a historical orientation into a geographical extension. By replacing the tem-

porally distant with the spatially removed, and by assuming a lack of change among the "retarded" peoples, it was possible to identify what was still preserved among them with what had been lost in a more rapid evolution elsewhere. Likewise within the field of art itself the primitivism of the twentieth century—however far it may later outrun its start —develops from the artistic historicism of the preceding century. Looked at from one point of view, the interest in primitive art is only the latest of a series of such interests in the distant arts which goes back to the *Chinoiserie* of the eighteenth century, and includes Persia, Egypt, and Japan, besides various periods of the art of Greece and Rome.[1] Some of the high points of these preliminary contacts can be briefly sketched here.

The exoticism of the first half of the nineteenth century is concentrated upon Mohammedan civilization in both the Near East and North Africa. At first such exotic elements, which derive from the immediate environment rather than from the arts, are used as a kind of *décor,* a setting within which a scene may be put in order to lend it episodic or dramatic value; in a general fashion to go to the Islamic East was to return to the classical or the Biblical past.[2] Different as they are formally, and in spite of an avowed opposition of aesthetic and even moral intention, the treatments of "Oriental" subjects by Ingres and Delacroix have in common a disregard for exactitude, a primary interest in the exotic as exotic rather than as documentation, as something worthy of attention because of its difference from the ordinary. They share a conception of an "arbitrary picturesque" which enables Delacroix to vary with impunity the Algerian scenes he paints several years after he gets home from Africa, and which dominates the lesser work of Alexandre Decamps and Charles Champmartin in spite of their journeys to the Near East.[3] But about 1830 a new, more documentary and exacting historical interest begins to come into play, a curiosity which desires to reproduce in correct detail all the aspects of Oriental costume and architecture. Baron Gros

had already displayed a somewhat similar attitude in his studies from books for his Jaffa hospital and in his copies from Persian miniatures; the work of Victor Orsel among the Egyptian antiquities of the Louvre, and the journeys of Charles Gleyre to Egypt in the thirties and of Prosper Marilhat to Greece and Eugène Fromentin to Africa in the forties give it a new archaeological impetus.[4]

The intention of these journeys, as they are carried on by Horace Vernet and Holman Hunt also includes a primitivist element. Both Hunt's voyage to the Dead Sea and Vernet's trips to North Africa with the French army have the purpose of a correct religious documentation; and though they are perhaps not equally serious in the manner in which they employ their finds, both artists wish to render accurately an earlier and more authentic religious atmosphere through the use of existing details which they conceive as still properly preserving it.[5] For this reason Hunt gives us an exact transcription of the shore of the Dead Sea in his *Scapegoat* (1856), and Vernet, in such pictures as *Rebecca at the Fountain* (1835) and *Abraham and Agar* (1837) replaces the conventional Biblical costumes with contemporary Arabic clothes, using them as Orsel had previously used his Egyptian documents. The practice in each case aroused excitement and indignation, but neither in England nor in France did it have much following.

Scandalous as these attempts seemed at the time, they were but new manifestations of a combined historical and religious spirit which had existed for some time and which was certainly no less open to criticism in its use of other historical styles as means to the same end and in the supposition that through them an originally "true" and purer spirit had been caught. Historicism, and particularly the painting of medieval subjects, goes well back toward the middle of the eighteenth century in the work of West, Copley, and Menageot, but these painters are still classicist in style, using subjects deriving from a national tradition and only occasionally attempting any contemporaneity of representa-

tion.[6] The most primitivist manifestation of historicism occurs among that sect known as the *Barbus* which arose in the atelier of Jacques-Louis David about 1800, and of which we have extensive accounts but apparently only one preserved picture.[7] These young men, of whom the leader was a certain Maurice Quaï, wished to go back beyond the supposedly classical Greek sources of their teacher (for whom in turn the Roman style of his master J.M. Vien and his own early works had become not "original" enough), to something that was "simpler, grander, more primitive."[8] They dressed in what they imagined to be pre-Periclean Greek costumes, admired "Ossian" even more than Homer, and derived their style from the newly discovered "Etruscan" vase paintings, trying to emulate, as we can tell from Ingres' *Wounded Venus* (1802), their linear design and flat relief stylization of form. They had an admiration of the primitive just because it was the primitive that cannot be matched again before the twentieth century, even though their art, in the clarity and grace which are its obvious ideals, is essentially archaist, rather than primitivist in its feeling.[9]

Somewhat later Ingres shifted his admiration to "primitives" of an entirely different sort, those of the fifteenth, and on occasion the fourteenth century in Italy, and the phrase "Italian primitives," common in the nineteenth century, still persists today even though the concept of style behind it has entirely changed.[10] The other, more religious movements which derived their inspiration from the *Quattrocento*, were also, in so far as they sought to refine and purify their own style through an imitation of an earlier style, rather archaist in intention. They abandoned later technical inventions and formal complications in order to return to what they considered a severe and noble style. But this severity and nobility lay also in the power of this style, which these later artists thought inherent in it, to express a simpler, earlier, and therefore truer religious sentiment. It was this latter emphasis that made it possible for the pre-Raph-

aelites to combine their admiration of the early Italians
with a professed wish to paint realistically, and to claim that
in so doing they were following the precedent of their fore-
runners. We shall see that the belief of Nazarenes and
pre-Raphaelites that in going back toward the *origins* of reli-
gious and artistic developments they were proceeding to-
ward a more essential core, is analogous to later primitivist
beliefs, particularly those of Gauguin and of Emil Nolde.
But the earlier sentiments were sweet, charming, and rea-
sonable, and their formal expressions contained slight shad-
ings and delicate nuances, all very different from these later
attitudes.[11] The pre-Raphaelites appreciate the *Quattro-
cento,* not as a really *prime* epoch, but simply as one preced-
ing a period of overdevelopment, and their artistic inten-
tion includes neither the extreme formal simplicity nor the
immediate emotional intensity of a later primitivism.

The style of the turn of the century which in Germany
was given the accidentally appropriate name of *Jugendstil*
and whose parallel French manifestations were known as *art
nouveau* marks a new stage in the preparation for later
primitivism.[12] Lacking any influence from aboriginal art,
this style nevertheless foreshadows certain later primitivist
tendencies of abstract art in its attitude toward decorative
motives, and in its use of subject matter exerts an influence
on those German artists of "expressionism" who had in the
meantime come to know the styles of Africa and Oceania. In
his book of 1907, which may be considered as embodying the
principles of *art nouveau,* Henry van de Velde, its chief ar-
chitectural exponent, tries to find an abstract aesthetic basis
upon which all of the new art may be built, thus freeing it
from the purely constructive origin it hitherto had had and
which demeaned it, and also establishing a further bond for
the axiomatic unification of all the arts.[18] This basis Van de
Velde discovers in the form of the screw, from which he
thinks all ornament can be elaborated, since he cannot con-
ceive of any particular ornamental motif "whose life and
logic one cannot derive from the screw." Such a search for

one simple underlying form upon which an art can be based is itself indicative of a fundamentalist tendency which we will meet again; but the derivation of the decorative designs of *art nouveau* from simple kinds of animal and plant life is further evidence of this special orientation. The plant forms in which Van de Velde found comfort are well exhibited in the details of his Folkwang museum; while the stylizations of simple animals, particularly polyps and jellyfish which most often furnish the motifs for their decorations, have perhaps their best-known example in the façade of August Endell's House Elvira in Munich, whose ornament might be one gigantic sea animal.[14] Apparently the discovery of Mycenean art with its polyp and snakelike decoration of vases, which had been published by Adolf Furtwaengler in 1886, had a direct influence on the formation of this style; but more than this the use of such forms had, as has been remarked, a deliberate primitivistic intent:[15] It was a method of conscious reaction against the overrefinement of impressionism, a search "in these primitive forms, for the 'ornamental fearfulness' of nature. One wanted to seize life at its lowest levels, at its origins." [16] As such it is comparable to later similar attempts inspired by the art of aboriginal peoples.

We cannot here go into the more architectural instances of this desire, whether they remain rather abstract in character as in the work of Van de Velde himself and the Paris *Métropolitain* stations with their ironwork tracery of Hector Guimard, or whether they take on a more symbolic character as in Antonio Gaudi's Casa Mila in Barcelona; nor can we detail its many expressions in the applied and minor arts. But it will be well to mention some paintings which belong to the *Jugendstil* in its larger sense and in which the primitivist use of ornamental forms is obvious. Perhaps most evident is Edvard Munch's *Madonna* (1895) surrounded by an ornamental-symbolic border made up of an embryo and of swimming spermatozoa, but it is also proper to include the *Cry* (1893) in which a swirling arabesque of

line is meant to be not only the carrier of the sound but the embodiment of the essence of the cry itself. The symbolic dream-forms of Odilon Redon, his combinations of flowers and faces in his water colors, and his use of both flower and animal forms in his lithographs, particularly the series with the significant name of *Les Origines* (1883) which particularly reveals his interest in evolutionary beginnings, have much the same intent.[17] Even Van Gogh's desire to "express the love of two lovers by a marriage of two complementary colors"—if we view it in the light of his approval of Gauguin's wish to paint "like children" and his advice to the impressionists "to learn a little to be primitives as *men* before pronouncing the word primitive as a title," his despair at civilization's spoiling of the simple and lovable nature of savages, and his admiration of the simplicity of ancient Mexican and Egyptian houses—is a part of this same primitivist tendency.[18]

These descriptions have already indicated the other aspect of this trend, the desire to present as subject matter the basic emotional situations of life, visualizing them as violent and irrepressible, and depicting each one as a symbol representing the "realities" of life. Munch's subjects of the nineties—*The Dead Mother, Jealousy, The Dance of Life, The Vampire, Urns*—which are paralleled by those of Gustav Klimt and Redon, and the satirical mask scenes of Ensor (*e.g. Death and the Masks, The Assassination*) have this end in view. It has been said of Munch's art of this period of the nineties that "its content is life itself," and it is this wishful immediacy, the conscious sense that it is fundamentals which are being conveyed that constitutes the primitivistic element of these pictures. Mixed with a sentimentalism that is also evident in Van Gogh, and that is much stronger in Klimt and Aubrey Beardsley, is the feeling that these are lower, underlying realities which the painter, by casting off the surface is showing bravely and directly. In line with this attitude and with the opposition to impressionism that it implies, the compositions are presented in a broad fashion,

5  Munch / *Dance of Life*, 1894

there is little bother with delicacy of line or close harmony of color; rather simple linear complements are used and the colors are in evident and striking contrast to each other. The compositions are not meant to bear detailed analysis, but an immediate and startling effect of the whole as a unit is intended in order that the "fearfulness" may be conveyed the better. In Munch's work the symbolic atmosphere given partly by the ornamental signs that have been mentioned, is increased by the exaggeration of perspective as in *The Cry,* or by the repression of the enclosing space as in the *Dance of Life,* the purpose in either case being to create the feeling of a tremendous pressure of outside forces at the particular spot shown in the picture, forces which are ominous but cannot be withstood.[19] Thus by showing only the head of the man in *Jealousy* the space is continued beyond the frame of the canvas, and by his direct look is borne immediately in upon the spectator. In the 1892 version of *The Kiss* this fearful intensity crowds the couple into one corner of the

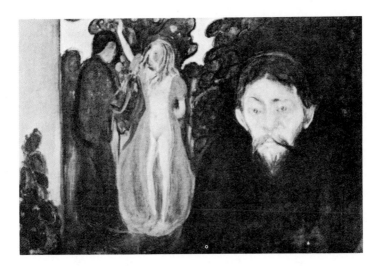

6  Munch / *Jealousy,* 1895

canvas, while the child in *The Dead Mother* as in *The Cry* stares straight out with round, frightened eyes. Something of the same spirit, though more lightly expressed, is to be found in the work of Klimt; and the symbolism of Ensor's masks as a half-humorous way of showing the really terrible state of the underlying strata of the mind need not be labored. Redon's dream subjects (later made use of by the surrealists) tend in the same direction, although theirs is much more the effect of simple wonder at a mystery.

Ferdinand Hodler's primitivism is of more varied and complicated character. Even before he was influenced by P.O. Runge and Runge's interest in communion with nature and the innocent child as the symbol of its achievement (*Boy with Flower* [1893], *The Chosen One* [1893/4]), and by the religious group of the *Rose-Croix,* whom he knew in Paris, Hodler had found an archaizing if not a primitivizing retreat into nature (*Intimate Dialogue with Nature* [1884]) which in its tenderness is at the opposite pole from other aspects of his art.[20] At the same time he shows his affinity with the ornamental side of *art nouveau,* and particularly that of the synthetists, who were also influenced by the *Rose-Croix,* in his symbolic use of flat decorative surface and simplified, rhythmic arabesque (*The Night* [1890], *The Disillusioned* [1891/2], *The Day* [1900]). Throughout his work there is at times a curious combination of this decorative style with a eulogy of brute force as it is embodied in the peasant (*The Courageous Woman* [1886], *The Woodsman* [1910]), which in his later paintings is cast in the form of an historical romanticism (*William Tell* [1903], *Marignan* [1912]).

Something of the same liking for the simplicity of the peasant as such, but with a Rousseauesque leaning, is characteristic of Van Gogh. He admires Jean-François Millet for his creation of the "type," and wishes his own art to contain "something more concise, more simple, more serious," which would have "more soul, more love, and more heart," and would be "true" like the work of Millet and of Josef Is-

raels. [21] This latter sort of primitivism is also characteristic of Gauguin, part of whose style, in its "deformations" and its decorative character, is properly *art nouveau* (as witness its transformation into the related style of Symbolism); while both the psychological and technical qualities of Munch's work (perhaps best expressed in his use of the lithograph) contribute to the influences making for the primitivism of the *Brücke*.[22] These styles will be examined presently; here we may once again remark that the primitivist tendencies thus far very briefly described antedate any knowledge of aboriginal art. Because of this, and because of their mystical orientation, they have a bearing upon our interpretation of the later stages of primitivism, which again breaks away from the direct influence of the primitive and tries to attribute to itself an absolute character.

NOTES

1. The influence of Japanese prints specifically should be mentioned, and the fact that only a late, somewhat broad and coarse style was known at first. Perhaps their influence would have been less had the contact come through the earlier style.

2. Léon Rosenthal, *Du Romantisme au réalisme* (Paris: Laurens, 1914), p. 82. The change is accompanied by numerous archaeological publications.

3. Champmartin had been to Constantinople; Decamps to Asia Minor. *Cf.* also the *Orientales* of Victor Hugo. Rosenthal, *op. cit.*, p. 91.

4. Rosenthal, *op. cit.*, p. 294. The tendency was continued by such minor artists as Adrien Dauzats and Eugène Flandin. The Egyptian work of Charles Gleyre has been destroyed.

5. Hunt's first voyage to the east was in 1854. But in the seventies he made two different trips to Jerusalem and established a studio there.

6. Jean Locquin, *La Peinture d'histoire en France de 1747 à 1785* (Paris: Laurens, 1912), *passim*. Medievalism later becomes part of the romantic repertory, using it in much the same way as it uses the Orient, the variations depending upon the painter.

7. Walter Friedlaender, "Eine Sekte der 'Primitiven' um 1800 in Frankreich und die Wandlung des Klassizmus bei Ingres," *Kunst und Kuenstler*, XXIX (1930), 320.

8. E.J. Delécluze, *Louis David, son école et son temps* (Paris: Didier, 1865), p. 428.

9. But note the comparison drawn by Delécluze, *op. cit.*, p. 434, between the situation in 1799 and that in 1832 when the older admirations have been replaced by Dante, the primitives by the naïve, Paestum by Cologne, vase paintings by the "première école allemande," "Ossian" by the English and Scotch ballads.

10. For a discussion of this change see Friedlaender, *op. cit., passim.*

11. The attitude of the German Romantics should also be included in this conception, although their work has in it more of a naïve mysticism.

12. The whole analysis of this section is obviously indebted to the article of Ernst Michalski, "Die Entwicklungsgeschichtliche Bedeutung des Jugendstils," *Repertorium fuer Kunstwissenschaft,* XLVI (1925), 133–49; the inclusion of Redon and Ensor, not to be found there, is justified by the particular slant of this analysis.

13. Henry van de Velde, *Vom neuen Stil;* quoted by Michalski, *op. cit.,* p. 139; the further quotation also from here.

14. Note particularly the details of the large skylight, of the stair railing, and the door lintels. In the applied arts the clearest example is that of Tiffany glass.

15. Michalski, *op. cit.,* p. 143.

16. *Ibid.,* p. 142.

17. It is interesting to note the titles of some of this series: "Le polype difforme flottait sur les rivages," "Il y a peut-être une vision première essayée dans la fleur." The frontispiece shows a marked similarity to the work of Ensor, while the handling of parts of the "Temptation of St. Anthony" (1888) is like that of Munch or Gauguin in the way in which forms trail off into abstract, symbolic line.

18. *The Letters of Vincent van Gogh to His Brother 1872–1886* (3 vols.; London: Constable, 1927, 1929), III, 139, 166, 353. Note also (III, 201 and elsewhere) Van Gogh's admiration for Japanese prints. Also *Lettres de Vincent van Gogh à Emile Bernard* (Paris: Ambroise Vollard, 1911), pp. 83, 142: "Et ces sauvages étaient si doux et si amoureux!" Related to this is the admiration for English illustrated children's books (Greenaway, Crane, Caldecott) because of their *"naïveté consciente."*

19. Munch derives his use of perspective from the practice of the early impressionists, as his work in Paris shows; but in the work of this period he changes their diagonal into an almost direct recession from the picture plane, since his work becomes frontal. The parallel between the atmosphere of Munch's work and that of his contemporary Ibsen can of course not be missed.

20. The Salon de la Rose-Croix was held in 1892 at Durand-Ruel.

21. Van Gogh, *op. cit.,* II, 3, 50, 62, 92.

22. It is significant for this influence and its evolution that with the *Brücke* the lithograph should have been replaced by the much broader medium of the woodcut and the linoleum cut. See below, Chap. IV.

# III  Romantic Primitivism

## Gauguin and the School of Pont-Aven

In any study of the influences of the primitive in modern painting, Paul Gauguin obviously occupies an important place. His name, which has become synonymous with a geographical romanticism that has not yet lost its flavor, has been made a symbol for the throwing off of the stifling superfluities of the hothouse culture of Europe in favor of return to that more natural way of life of which Rousseau is the generally accepted advocate. In the first years of the twentieth century Gauguin was considered the typical bohemian-artist rejecter of bourgeois living and morality, with its stupid, encumbering artificialities; the typical simplifying artist, cutting both his life and his art to the bone in order that he might find and express reality. Not only did

he become the symbol and the type but, by a shift familiar in the history of art, he came to be considered the originator of the movement he summarized: He became the "discoverer" of a primitivism which was simply the crutch of an ailing art; he was said to have begun a trend that achieved its final culmination in the "Negro review"; he was the "calm madman" embodying sanity.[1] We have seen that such praise or such reproach cannot be laid at Gauguin's door. He was not the first to feel the attraction of the provinces, either at home or overseas, and except for definite imitators, artists' voyages after his time lessened rather than increased in extent. And the simplifications practiced by the artistic movements that succeeded him, whether the *fauves* in France or the expressionists in Germany, though they received an impetus from his life and from his painting, were hardly due to his influence alone. There is, however, no doubt that this influence was great, and for this reason, as well as for his later position as a symbol, it is important to determine the exact nature of Gauguin's primitivism, and to analyze his art so that we may fix his position in the history of primitivist evolution.

Because of the identification of Gauguin's life and his art, it is not merely permissible, but compulsory, to try to discover from his own writings his attitude toward the primitive. That Gauguin felt it was necessary to write about himself, to express himself through "private journals" written with an eye to the public as well as through his painting, indicates in itself that his relation to the primitive world in which he had chosen to live was not simple and direct. The whole tone of *Noa Noa* and *Avant et Après* is one of self-conscious revolt against a watching world.[2] It is not simply that the comparisons between the barbarian life of his choice and civilization are always in favor of the former, nor that his complaints are those of the misunderstood artist. It would not be natural that he should write otherwise; Tahiti, in spite of all its difficulties, gave him a better reception than Paris. But each incident that he relates, whether it is

about the South Seas or not, each point that he makes, is a kind of parable that contains in itself and explains all the wrongs of the insincere and complicated society that he had left, contrasting them with the simplicity and naturalness of the people of the South Seas. Thus his hatred of the church and its hypocrisies is concentrated in the story of the bishop and Thérèse, and his dislike of the provincial government with which he had such difficulty in the account of the administrator Ed. Petit.[3] Each such story that he tells, whether it be of his exhibition in Copenhagen, closed on the morning of the first day, or of the Cabanels in the museum at Montpellier, is proof of his own rightness and the infamy of an overcomplicated culture.[4] It is nevertheless this civilization which sets his standard of judgment and to which all other modes of existence must be referred, so that it is impossible for him to describe his own life in Tahiti or that of the natives in the Marquesas without thinking of their tremendous distance from the European life that he has left. Such continual comparison means that Gauguin was dependent upon Paris for more than simply his livelihood, and that try as he might to assimilate himself to the native way of life, the center of his attention was still the artistic world of Paris. Yet Gauguin did not leave Paris merely to find a cheaper mode of living (although this was an important consideration), or he would not have gone to Tahiti after having been to Martinique, nor have gone back to Tahiti in 1895, leaving it in 1901 to spend the two last years of his life in the Marquesas.[5] His was an exoticism which thought that happiness was elsewhere but which at the same time—and this is what is characteristic of his part in a new tendency—sought not the luxurious and the intricately exotic of the earlier nineteenth century, but the native and the simple.[6]

Because it judges on the basis of contrast rather than directly, such an attitude identifies as primitive any things sufficiently far removed from the kind or the style of object which it seeks to avoid, even though they may differ greatly

among themselves. This opposition point of view makes it possible, and in a sense even reasonable, for Gauguin to say,

> Have before you always the Persians, the Cambodians, and a little of the Egyptian. The great error is the Greek, however beautiful it may be,

since these arts, however they may differ, all express themselves, as he says (using the vocabulary of the symbolist poets and critics), "parabolically" and "mysteriously," deforming nature in order to achieve a symbolic, and consequently a meaningful, beauty.[7] It did not clash with these opinions that he should counsel his daughter:

> You will always find nourishing milk in the primitive arts, but I doubt if you will find it in the arts of ripe civilizations,[8]

because for him the Persians and the Egyptians, not being in the classic tradition which had degenerated into a naturalistic art, were "primitive." Nor was Gauguin's occasional use of antique motifs (drawn from the extensive stock of photographs to which he so often referred) more than a superficial contradiction. He saw in the Parthenon frieze and the reliefs of the column of Trajan, from which he borrowed figure poses, a flat and stylized art opposed to the three-dimensional and naturalistic. He therefore could consider it "primitive" and symbolic, just as the critic Albert Aurier, in finding parallels to Gauguin's work, could put Egyptian, Greek, and primitive art together on the grounds that they were all equally "decorative."[8] Similarly Gauguin acquired a piece of Javanese carving and photographs of Cambodian sculpture, copied Aztec sculpture at the Exposition of 1889, praised the absence of values and perspective in Japanese art because this eliminates the possibility of taking refuge in the "illegibility" of "effects," and wrote what are probably the first lines in appreciation of Marquesan art, describing the "unparalleled sense of decoration" and the "very advanced decorative art" of the people he was

pleased to call "Maori."[9] It is characteristic of Gauguin that
his consideration of the excellence of this art should imme-
diately lead him to a violent denunciation of the petty offi-
cials who could not appreciate it, and that his thought
should then lead back, by way of the impudence of the
officials' judgment in view of their dowdiness, to the "real
elegance" of the Maori race, and particularly of Maori
women.[10]

Gauguin's identification of the barbarian in art and the
barbarian in living is important for our understanding of
the development of primitivism, since in its subsequent evo-
lution these two factors are separated.[11] Their union in
Gauguin's mind and the symbolic value of the former for
the latter, may be inferred from Gauguin's reply to Strind-
berg's letter declining to write a preface for the exhibition
of February, 1895.[12] In his refusal, which he said was forced
upon him because he did not understand Gauguin's art,
Strindberg characterizes Gauguin as "the savage, who hates a
whimpering civilization, a sort of Titan, who, jealous of the
Creator, in his leisure hours makes his own little creation,
the child who takes his toys to pieces so as to make others
from them. . . ."[13] Gauguin answers that what he had
wished to realize was a revolt,

> a shock between your civilization and my barbarianism.
> Civilization from which you suffer, barbarianism which has
> been a rejuvenation for me. Before the Eve of my choice
> whom I have painted in the forms and the harmonies of an-
> other world, your memories have evoked a painful past. The
> Eve of your civilized conception nearly always makes you,
> and makes us, misogynist; the ancient Eve, who frightens
> you in my studio, might some day smile at you less bitterly.
> This world, which could perhaps not rediscover a Cuvier,
> nor a botanist, would be a Paradise that I would have
> merely sketched. And from the sketch to the completion of
> the dream it is far. What matter! Is not a glimpse of happi-
> ness a foretaste of nirvana.[14]

It is true that Gauguin is talking here in a metaphor, but
it accurately describes his attitude toward the "barbarian"

(a word which he preferred to "primitive," perhaps because it renders more precisely his active opposition to the "civilized"), and suggests the atmosphere which pervades his pictures, because in them he uses the same metaphor recurrently.[15] Gauguin approved Achille Delaroche's description of him as a painter of primitive natures, one who "loves them and possesses their simplicity, their suggestions of the hieratic, their somewhat awkward and angular naïveté." [16] Nevertheless his primitives still have something of *luxe barbare* about them, a heritage of the entire exoticism of the nineteenth century, not quite so easily or wholeheartedly forgotten or suppressed.[17] He said of himself that he had two natures, the Indian and the sensitive; and he whistled to keep up his courage: "The sensitive has disappeared, which allows the Indian to proceed straight and firmly." [18] With these considerations in mind we may finally turn to the sentence which is often taken to sum up Gauguin's whole aesthetic:

> I have gone far back, farther back than the horses of the Parthenon . . . as far back as the Dada of my babyhood, the good rocking-horse.[19]

A whole aesthetic may indeed be there, but it is not the aesthetic of Gauguin.

The most direct and obvious influence of primitive art upon the work of Gauguin is to be found in a certain number of his sculptures and woodcuts, in which he makes use of decorative motifs common in the wood and bone carving of the Marquesas. Marquesan decoration is found chiefly on ornamental club heads and stilt foot rests and, on a smaller scale, on fan handles, ear plugs and diadems. It is almost wholly made up of the squat, semi-seated figure (the ancestral "tiki" which may be sacred or secular), and of stylizations of the face or separate features of the face—derived originally from "tiki" representations—the pattern most often used being the outline of the two eyes, with the lines of the nose and prominent nostrils between. Such motifs are

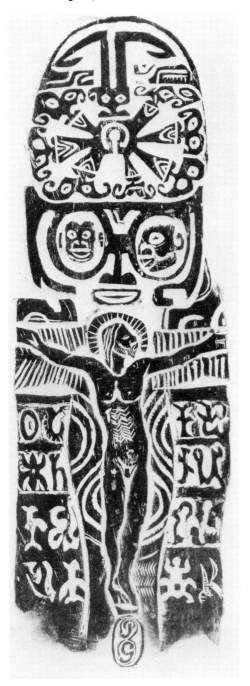

8   Marquesas Islands / *Decorated Staffs*

to be found in ten of the sculptures published by Gray and half a dozen of the woodcuts catalogued by Guérin.[20] In Number 28, *Nave Nave Fenua*, for example, the band which borders the picture at the left consists of such Marquesan stylizations of the face, and these are used again in Number 44, identified as the figure of a Tahitian idol. In Number 50, a lithograph of the painting *Manao Tupapu*, Gauguin uses the Marquesan form of nostrils and mouth below his initials in the upper left corner.

The restricted number of these direct copyings from the art of the South Seas almost certainly cannot be explained by the fact that Gauguin did not go to the Marquesas until 1901, only two years before his death.[21] It is true that Tahiti, the island of his earlier residence, is comparatively poor in indigenous art and produces almost no wood or stone sculpture and little decorative carving. The influence from this source was obviously negligible, and *Avant et Après,* which we have quoted above in praise of the Marquesan sense of decoration, was written after 1901. But, as Gray remarks, Marquesan objects were as accessible in Tahiti as in the Marquesas themselves, and Gauguin showed that he was familiar with Easter Island script as early as 1893. Therefore it is not surprising that the work that employs the most extensive repertory of Polynesian motifs was probably done about 1895. It is a carved cylinder showing a Crucifixion: a Christ of Marquesan features, with bodily proportions and rendering derived from Easter Island statuettes and set against Easter Island ideograms. Above the figure of Christ are designs adapted from one form of Marquesan war-club decoration, but with one of the tiny heads set into the tiki eyes turned in profile.[22]

It is characteristic that Gauguin was sympathetic to the surface, or at most the relief aspects of Marquesan art. He must have encountered its massive stone sculpture but it apparently held little attraction for him.[23] Thus it was only the flat and decorative aspects of the "primitive" (whether Mediterranean, Asian, or Oceanic) that were accessible to

Gauguin and whose individual motifs he assimilated. We shall see from an analysis of his paintings that this restriction to the decorative is not accidental, and we can conclude that even had he had a greater opportunity to study the art of Polynesia, the grace and pre-Raphaelite simplicity which were an integral part of Gauguin's conception of the primitive would not have permitted the assimilation of any of its intense and angular forms.

It is also typical of Gauguin that having traveled half across the world he should still have been more generally influenced, though in a less precise and accurate way, by an art that was even then removed from him and that had nothing to do with the simple life he had sought out. The Indonesian deities sitting crossed-legged on their stelae (which he must have seen in Paris museums, and which he had known since at least 1889 in photographs of Borobudur which he took with him to Tahiti) seem to have made a real impression on him. The sitting posture of the Indonesian deities is of course also that of Polynesians and thus it correctly appears in Gauguin's paintings in which natives are portrayed. That memories of Indian figures were also still at work in Gauguin's mind is seen most clearly in several of the sculptured pieces, where motifs of definite Indian iconography are repeated. The figure in *Idole à la Perle,* for example, touches her right hand to the ground and lays the other palm up in her lap, in typical Buddhist gestures. The votary figure on the two cylinders of *Hina* comes from the Borobudur photographs and sways in Eastern fashion, while the Tahitian goddess herself—one of Gauguin's favorites—also derives from Indonesian art, modified by a certain stiffness, rather than from the hard angular bodies of Polynesian sculpture.[24]

Though our chief concern is with his painting, we have purposely approached Gauguin's art through his wood blocks and his wood sculpture. The use of these media is in itself significant, permitting as they do the production of direct and immediate effects by simple means. The woodcut

particularly—working through extreme contrasts of large areas of light and dark, and necessarily doing away with any delicacy of line or refinement of modeling—is especially suited to the simplifying artist (or more exactly, one kind of simplifying artist), and we shall find it coming into prominence again among the German expressionists, who had much in common with Gauguin in their attitude toward the primitive. In the woodcuts, those characteristics that appear in Gauguin's painting in diluted form and mixed with the other ingredients of a more complicated method, are present in an obvious concentration.

In the paintings, his major form of his expression, his attitude toward the primitive is basically no different, although the elements derived from South Sea art count less and there is almost no direct transcription of Polynesian motifs. The various figures which are meant to portray Polynesian gods represent not only the gods themselves, but Gauguin's idea of the manner in which the natives wished to render them. The deity in *The Day of the God* (1894), for example, has that mixture of Polynesian and Indian traits which we have already noted in the cylinder with Hina, and which Gauguin will use once again in the background figure of *Whence Do We Come . . .* (1897–98). The posture and headdress of the god are anything but native. The goddess Hina appears again in the background of *The Parrots* (1902), with the same gestures, and a similar figure appears in the self-portrait of 1898 in the upper right corner.[25] But the figure which occurs the most frequently, and which was apparently of most importance to Gauguin, is one seated in profile on a low stool, with its hands in its lap. The features of the face, with its flat nose and continuous line of forehead, nose, and lips, square chin and large long ear, are Gauguin's way of typifying and generalizing the Polynesian facial characteristics, and he often gives them a more naturalistic rendering, as in the attendant figure in *The Nativity* (1896). While the result bears some relation to the Marquesan stylization, it is apparent that Gauguin

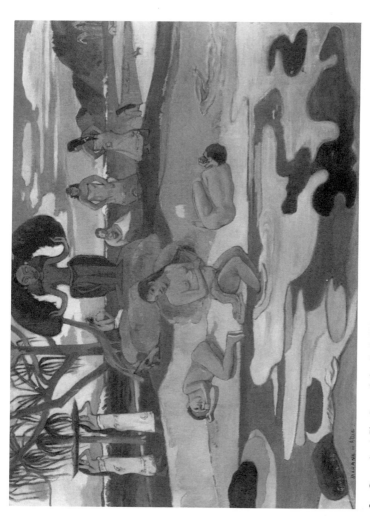

9   Gauguin / The Day of the God, 1894

evolved the type himself. In Marquesan sculpture the gener-
alization is achieved through geometrizing and angularizing
the original contours so that the form is never that of an
individual, much less a copy of a living person.[26] With Gau-
guin, however, while there has been a smoothing and reduc-
tion of the contours in order to bring them within the oval
of the head, an intensity of individual character remains,
borne out by the curved forms of the rest of the body. He
has nevertheless given his idols a symbolic distance and thus
produced the brooding, terrifying quality by which he
meant to convey the atmosphere of primitive religion. Good
examples of this magical figure are to be found in *Sacred
Mountain* (1892), *Arearea* (1892) and *Hina Maruru*
(1893), where the mystery is emphasized by the profile posi-
tion of the figure staring into space. It reappears in the
ancestral presence in the *Spirit of the Dead Watching*
(1892)—however calculated or (as Gauguin would have us
believe) spontaneous its introduction was. The same effect
of hovering, unplaceable, awful spirits, which was one ele-
ment in Gauguin's notion of the primitive, is also present in
*The Moon and the Earth* (1893), in the much more tangi-
bly rendered, enormous, dark half-figure rising from no-
where in the background; and in the *Poèmes Barbares*
(1896), where it is conveyed by the little crouching figure
with bright staring eyes seated on a table in the left fore-
ground.[27] To be sure, this conception of primitive religion
has little to do with the rather cheerful mythology of the
Society Islands, but this only emphasizes the eclectic nature
of Gauguin's ideas and the degree to which he came to Oce-
ania with established preconceptions of the primitive.[28]

There is another side to Gauguin's rendering of the prim-
itive, perhaps as far removed from the truth as his "bar-
baric" interpretation, yet directly opposed to it. On the one
hand he wished to bring out the exotic and the mysterious,
and so expatiated upon the personal freedom that was pos-
sible among the children of nature in contrast to the "civi-
lized" restrictions of society, the family, and the church, in-

stitutionalized and hypocritical. This is one of the constant themes of his writings. On the other hand he interprets many Polynesian scenes in Christian terms, transforming the natives into historic figures of the church. The best-known example of this tendency is the *Ia Orana Maria* painted at the beginning of Gauguin's first stay at Tahiti (1891), a picture which is a transplantation of the Adoration to the South Seas, now done with native scenery and native actors. As with so many of his pictures, his sources are composite, and only very partially based on direct observation. The poses of the two adoring figures come from his photographs of the Borobudur reliefs—and it is unlikely he ever saw a Tahitian infant carried on its mother's shoulder—while the haloes and the angel are clear references to the supernatural. Yet by making it a scene from primitive life, the poses apparently unstudied and the composition unsymmetrical, he has sought to take the hierarchical quality from it and thus to show again its original "simple" human meaning. Nevertheless he is thinking in Christian terms, even if in idyllic, Virgilian, Early Christian terms, and imposing a European tradition and European morality, which he himself had professedly gone so far to avoid, upon a people whose unspoiled naturalness he claimed to enjoy and to have come to seek. The same almost missionary spirit is shown again in the drawing called *Adam and Eve,* in which Adam has become a Polynesian fisherman, dressed in a loincloth and with his rod over his shoulder, while Eve wears a shift of European manufacture, and the two are accompanied by the scrawny South Sea mongrel that Gauguin depicts so often. In *The Idol* (1897), he has combined the barbaric and the Christian, placing behind the dark stone figure which overshadows the native group in the foreground in a typically mysterious way (the base contains barely distinguishable Marquesan motifs) the scene of the Last Supper, with the tiny lighted form of Christ coming directly behind the native idol. In this manner Gauguin portrayed the unity of Christian and Polynesian beliefs; the latter might be mys-

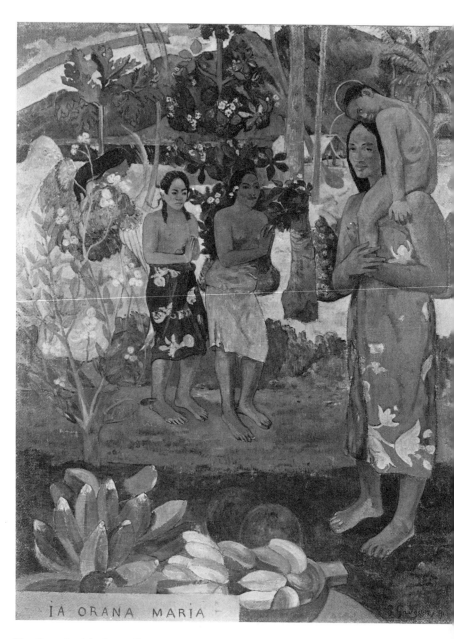

IA ORANA MARIA

10   Gauguin / *Ia Orana Maria*, 1891

terious, but behind them lay the same truth. It is obvious that the feeling for the necessity of this demonstration was at variance with a simple acceptance of native life and customs.

The pictures which lack this specifically religious content —such as *Nave Nave Mahana* (1896), the two versions of *Maternity* (1896 and 1899), *Woman and Children* (1901), and finally the allegory of life, *D'où venons-nous? Que sommes-nous? Où allons-nous?* (1897–98), and what is perhaps its pendant, the quiet, friezelike *Faa Iheihe* (1898)— while they show the "state of nature," the desire for which we ordinarily connect with primitivism, nevertheless conceive this state of nature as having all those moral elements that Gauguin claimed to despise: work, family life, and calm human contacts. His search for the primitive and his belief in its powers of creative renewal, and his pridefully recurring description of himself as a "savage," must be interpreted in the light of the quiet, almost contemplative ideal projected in his paintings—whatever the sources of their formal or symbolic detail may be. Of course this idyllic conception of the primitive fits in with the general European tradition of the original golden day, and particularly with that of Rousseau, whose "state of nature" refers not to a primeval condition, but to one in which a definite cultural level had been reached; yet it was against this tradition, and especially against the sense of "duty" of this tradition, that Gauguin was rebelling.[29]

The infusion of religious motifs in Gauguin's work, and their interpretation in simple terms, leads naturally to a consideration of the painting of Gauguin's stay in Brittany. These pictures, painted in the years 1889 and 1890, already demonstrate many of the attitudes toward the primitive which we have discussed. They were influenced, as Maurice Denis mentioned and as is clear from the pictures themselves, by the local religious art, by Japanese prints, and by the *images d'Epinal*.[30] The last two influences show themselves in the bright colors applied in broad flat areas with

clearly marked lines of separation; the first, in the actual themes of the pictures. As Charles Chassé discovered, the *Calvary* (1889) is directly inspired by the stone Calvary of Brasparts, and the figure on the cross of *The Yellow Christ* (1889) derives from the Crucifixion sculpture of the Trémalo Chapel. Again we see contact with a variety of arts related merely by comparison with the art Gauguin was trying to avoid, and though they have in common a simplification of technique and an intensity of subject matter, their spirit is very different. And further it is obvious that Gauguin was attracted by the "simplicity" of the Breton peasants, and by their "simple"—that is, their wholehearted—faith. He renders them not as individuals who happen to be peasants, but as examples of the typical peasant. Their expressions, as in the group around the Christ, are without variation, and their gestures, as in *Jacob Wrestling with the Angel* (1888) or *Breton Girl in Prayer* (1894), remain, in the symmetry and angularity of their motions, symbols rather than portrayals of religious reverence. In the same way the popular religious monuments are rendered in even further reduction and simplification than the originals, so that they become symbols of religious symbols, and lose the expressive quality of the popular originals. Yet if these pictures are closer to the spirit of the scenes they portray (and by this we do not mean closer to the exact rendering of a particular scene) than are the similar subjects of Tahiti, it is because Gauguin was approaching the latter through these Brittany pictures, and because the French provincial scenes themselves were closer to that idea of the primitive Gauguin had in his mind.

We have thus far not treated the purely formal elements of Gauguin's art directly, because the influence—even if not the assimilation—of the primitive and his attitude toward it are more obvious in the subject matter of his pictures. Nor need we discuss here the thorny question of the creation of the synthetist style in the years 1888–89. Gauguin's method of painting was more primitivizing than primitive, both in

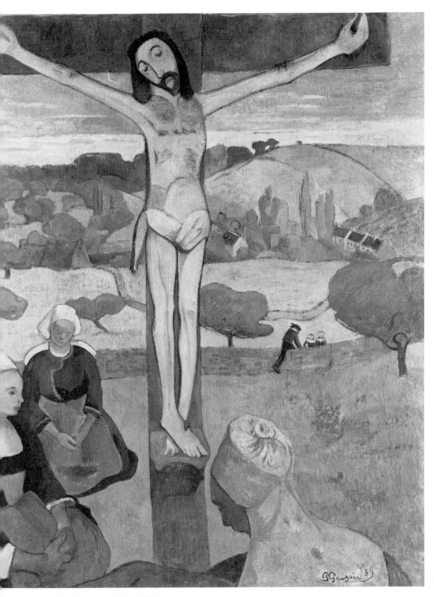

Gauguin / *The Yellow Christ,* 1889

the form that he attempted to achieve and in the interpretation of this form. In his use of broad areas of color applied flatly and in strong contrast with one another, he was influenced, as we have mentioned, by Japanese prints and by the *images d'Epinal;* they lead in the direction of simplification and a return to the fundamental elements of painting.[31] These influences are of course more evident during the Brittany period, when synthetist methods of flat planes and strong contours are boldly employed, and light tones predominate, than in the later work, where there is less obvious stylization. Even here, however, Gauguin did not really assimilate the "primitive" factors, but substituted a smooth line and rhythmic undulating composition for the angularities and jagged sequences of these arts and close color harmonies for their strong contrasts. Already in this early work, where he was not really dealing with the primitive at all, he insisted, as Maurice Denis said, "on putting grace into everything."[32] The same may be said of the lack of perspective and the reduction of the picture to a single plane, of which theoreticians have made so much; Gauguin achieves rather a succession of planes set up parallel to the picture surface and with spaces in between, much as a stage set might be arranged and without the construction of any real spatial volume.[33] There is a more generally significant connection with the work of Puvis de Chavannes than the occasional borrowing of single figures.[34] The similarities, both of pictorial arrangement and iconographical ideals, with a painter whose most obvious quality is an idyllic sweetness are important to note, similarities which become strikingly apparent in the romantic transformation of Gauguin's effort at pictorial simplificaion by the members of the "School" of Pont-Aven, particularly in the art of Maurice Denis and Emile Bernard.

It cannot be our purpose here to discuss how far Gauguin approved the theoretical doctrines of the symbolist school, or to what extent he was their originator. They found their justification in his painting if not in his words. The theories

themselves, as developed by Aurier, Serusier, and Maurice Denis, differ among themselves, those of Aurier and Serusier tending toward the metaphysical and mystical, while those of Denis are more purely formal in character.[35] They have in common, however, that they seek to return to the essential elements of art, to rid art of its anecdotal, documentary character and to make it a reflection of the important truths of the universe. Even Gauguin, though he is said not to have liked the theorizing tendencies of his disciples, wished to cease working through the eye, and instead to "seek at the mysterious center of the universe." [36] Aurier, in more high-flown language, desired to "reclaim the right to dream, the right to the pasturages of the sky, the right to take flight toward the denied stars of absolute truth." [37] The "subjective deformation" of which Denis speaks, is an attempt to rid art of the personal character of "nature seen through a temperament," by means of "the theory of equivalence of the symbol" thus making a picture the plastic reproduction of the emotion caused by a particular scene in nature, so that by the common symbol the same emotion might be produced in the spectator.[38] Such ideas, they held, only seemed new because art had been lead astray by an unimaginative naturalism; in fact they "are at the bottom of the doctrines of art of all ages, and there is no true art which is not symbolist." For this reason "the innovators of 1890 wished to ignore all the learned epochs, and to prefer the naïve truths of the savage to the 'acquired ones' of the civilized." [39]

Maurice Denis has pointed out that synthetism, which only became symbolism in contact with poetry, was not at first a mystic movement although it implied a correspondence "between exterior forms and subjective states." [40] If however, to synthetize meant "to simplify in the sense of rendering intelligible," it is strange that the painters should have had any contact at all with poets who were following the opposite course. Neither the ideal of Verlaine *"pas la couleur, rien que la nuance,"* nor Mallarmé's preference for

white and his wish finally to get rid of limiting words entirely had anything formally in common with the broad, flat, undifferentiated colors separated by a sharp dividing line and the bright hues that were the goal of the painters. The two groups were, nevertheless, allied in this: both attempted to enter directly into the essence of things and to express them with as little intervening formal material as possible. Charles Chassé has indicated the emphasis of painters and poets on intuition, and has shown the parallel of Gauguin's eulogy of the savage and Veilé-Griffin's exaltation of the intuitive responses of illiterate conscripts.[41] Mallarmé went even further than Gauguin, since, not content with interpretation through a symbol, he wished to do away with this also, leaving nothing but the white page, evocative of all because it contained nothing. If artists formally so far apart could recognize this affinity to the point of friendship and discussion, we are not mistaken in recognizing in the desire to return to the ultimate bases of experience one of the main elements of the art of the "School of Pont-Aven." We have already discussed the largely romantic form—a romanticism partly historic and partly geographic—that the expression of this desire takes in the painting of Gauguin. There is no need to consider in detail the work of the other members of the group, except to point out that aspects of Gauguin's art become clearer in their work. Thus Serusier continued the "early Christian" elements of Gauguin, adding, however, a romantic medievalism of the kind that used early French spelling; and Bernard carried on the master's provincialism in subject matter and the colors of the Brittany period.

The subsequent work of these men adds nothing to the development of primitivism in any of its aspects, and they are without influence on other painters. The next section therefore, will deal with those artists who not only continued Gauguin's formal and iconographic ideas, under the influence of his art, but who changed these ideas, intensified them, made them more immediate, brought them nearer

home, and at the same time made their application more general.

NOTES

1. *Cf.* Max Deri, *Die neue Malerei: sechs Vortraege* (Leipzig: Seemann, 1921), pp. 138–139. "So entdeckte er die 'Exotik.' Und in der Gefolge zog nun alles herauf, was Gegenpart gegen das differenzierte Erleben des fin de siècle bieten konnte."

2. Paul Gauguin, *Avant et Après* (Paris: Crès, 1923); and *Noa Noa* (Paris: Crès, 1929).

3. Paul Gauguin, *The Intimate Journals of Paul Gauguin*. Translated by Van Wyck Brooks (London: Heinemann, 1931), pp. 11, 63.

4. *Ibid.*, pp. 180, 191.

5. *Cf.* a letter to Willemsen: "Je vais aller dans quelque temps à Tahiti, une petite île de l'Océanie où la vie matérielle peut se passer d'argent." Quoted in Charles Chassé, *Gauguin et le groupe de Pont-Aven* (Paris: Floury, 1921), p. 11. Also the letter to his wife of February, 1891: "Puisse venir le jour (et peut-être bientôt) où j'irai m'en-fuir dans les bois sur une île de l'Océanie, vivre là d'extase, de calme et de l'art. Entouré d'une nouvelle famille, loin de cette lutte européenne après l'argent." M. Malingue, ed., *Lettres de Gauguin à sa femme et à ses amis* (Paris: Grasset, 1946), No. 100.

6. *Cf.* Gaspard Tschann, "Paul Gauguin et l'Exotisme," *L'Amour* de l'art, IX (1928), pp. 460–464. Tschann places Gauguin in the direct line coming from the eighteenth century. Contrast the *splendeur orientale* of Baudelaire's *L'Invitation au Voyage* with the simplicity of Gauguin's ideal.

7. *Lettres de Paul Gauguin à Georges-Daniel de Monfried* (Paris: Crès, 1920), p. 187. (Letter of October, 1897.)

8. From the manuscript of Gauguin's *Notes éparses* in the *Bibliothèque d'Art et d'Archéologie*, quoted in M. Guérin, *L'Oeuvre gravé de Gauguin* (Paris: H. Floury, 1927), p. xx; and from his letter of 1889 to Emile Bernard. *Cf. Lettres de Gauguin à sa femme . . .* , LXXXI, p. 157. Also Bernard Dorival, "The Sources of the Art of Gauguin from Java, Egypt and Ancient Greece," *The Burlington Magazine*, XCIII, No. 577 (April, 1951), pp. 118–122.

9. Gauguin, *Intimate Journals*, p. 75. "And I shall maintain that for me the Maoris are not Malaysians, Papuans, or Negroes." Gauguin's contention that the Marquesans and the Maoris are of the same race has been supported by recent ethnology. See Ralph Linton, *Ethnology of Polynesia and Micronesia* (Chicago: Field Museum, 1926), pp. 12, 16.

10. Gauguin, *ibid.*, p. 69.

11. See below, Chaps. V and VI.

12. The letter and reply were, together, used as a preface to the exhibition, held at the Hotel Drouot, February 18, 1895. They are quoted by Jean de Rotonchamp, *Paul Gauguin* (Paris: Druet, 1906), pp. 131–134.

13. Gauguin, *Intimate Journals*, p. 29.

14. Rotonchamp, *loc. cit.*

15. See also Gauguin's dedication of the *Intimate Journals*. "Moved by an unconscious sentiment born of solitude and savagery—idle tales of a

naughty child . . ." The union of savagery and childhood is characteristic.

16. *Ibid.*, p. 31.

17. Tschann, *op. cit.*, *passim*.

18. From a letter of February, 1888, to his wife. *Cf. Lettres de Gauguin* . . . , LXI, p. 126.

19. Gauguin, *Intimate Journals*, p. 22. We must here emphasize the distinction, which we will attempt to make throughout, between the artist's expressed attitude to the primitive and that actually to be found in his painting.

20. Christopher Gray, *Sculpture and Ceramics of Paul Gauguin* (Baltimore: The Johns Hopkins Press, 1963), Catalogue Nos. 96, 99, 102, 104, 105, 117, 122, 125, 140, 145. Guérin, *op. cit.* In addition to those mentioned in the text, there are the following: No. 18, showing a Marquesan stylized face on a log (?) in the upper left corner; No. 30, showing, to the right, a figure like that in the Alden Brooks collection, and, to the left, seated figures like those on the cylinder in the Monfried collection; No. 84, with three heads showing Marquesan influence but less stylized than these. No. 63 shows a Buddha with one hand in the gesture of meditation, the other that of calling the earth to witness.

21. April, 1901. He went to the island of Dominique. The change was occasioned by an influenza epidemic, and by the fact that life was said to be much cheaper in the Marquesas than it had become in Tahiti. Charles Kunstler, *Gauguin* (Paris: H. Floury, 1934), p. 126.

22. In the collection of Daniel de Monfried. The reverse also contains a copy of an Easter Island statuette. This combination fits in with the interpretation we have given of the paintings. Robert Rey, "Les Bois Sculptés de Paul Gauguin," *Art et Décoration*, LIII (1928), pp. 57–64. Gray, *op. cit.*, p. 69, Catalogue No. 125. The print made from the Crucifixion is not published by Guérin. The distinction between sculpture made as such, and that done as a block from which to print is not always clear.

23. *Cf.* Merete Bodelsen, "Gauguin and the Marquesan God," *Gazette des Beaux-Arts*, 6th per. Vol. LVII (1961), pp. 167–181. The drawing of the large stone god, Takaii, of Hiva Oa was taken from a photograph rather than *in situ*.

24. Gray, *op. cit.*, Catalogue Nos. 94, 95, 96; and Dorival, *op. cit.*, fig. 20.

25. Apparently Gauguin used the figure he had made as a model, rather than inserting it from memory.

26. That this stylization is not due to any lack of ability to create naturalistically may be seen from the statue in red tuff now in the Trocadéro Museum.

27. Figures such as these occur nowhere in Polynesian art. Gauguin's explanation of the *Spirit of the Dead Watching* (in his *Notes éparses*), was probably suggested by Poe's analysis of *The Raven*.

28. Gauguin apparently became interested in Maori mythology early in 1892. *Cf.* letter to Serusier of March, 1892 in Paul Serusier, *ABC de la Peinture* (Paris: Floury, 1950), p. 60. Gauguin's debt for his ideas to Moerenhout's *Voyages aux iles du Grand Océan* (Paris: Bertrand, 1837), has been fully explored by René Huyghe in his introduction to the facsimile edition of *Ancien Culte Mahorie* (Paris: Beres), 1951.

29. For an analysis of Rousseau's conception of the "state of nature" see A.O. Lovejoy, "The Supposed Primitivism of Rousseau's Discourse on Inequality," *Modern Philology*, XXI (1923), pp. 165–186. Lovejoy shows

that Rousseau advocated what was to him a third, rather than a primeval stage of development.

30. Maurice Denis, "De Gauguin et de Van Gogh au classicisme," *théories: 1890–1910* (Paris: Rouart & Watelin, 1930), p. 263. Yvonne Thirion, "L'Influence de l'estampe japonaise dans l'oeuvre de Gauguin," in *Gauguin, sa vie, son oeuvre* (Paris: Gazette des Beaux-Arts, 1958), pp. 95–114. Charles Chassé, *Gauguin et son temps* (Paris: La Bibliothèque des Arts, 1955).

31. Gauguin, *Intimate Journals,* p. 162:

> When I am in doubt about my spelling my handwriting becomes illegible. How many people use this stratagem in painting—when the drawing and color embarrass them. In Japanese art there are no values. Well, all the better!

32. Denis, *op. cit.,* p. 270. "Malgré sa volonté de faire *rustique* en Bretagne et *sauvage* à Tahiti, il met de la grâce en tout." However, it is not "in spite of," as we have seen; grace is an integral part of Gauguin's conception of the primitive. Chassé, *op. cit.,* p. 88.

33. See for example *The Day of the God,* where there are three such planes; and *Breton Girl* and *Breton Children* where there is a lack of middle ground such as is found in *quattrocento* portraits.

34. *Cf. The Sunflowers,* in which there is a copy of Puvis' *Hope.* The sideways sitting posture, with, however, the full width of the shoulders shown, that Puvis uses in his *Normandy* (1893) and his *Magdelene* (1897) is used by Gauguin in *The Queen of the Aréois* and *Te Matete;* the latter has an Egyptian origin. *Cf.* Dorival, *op. cit.*

35. Denis, *op. cit., passim.* Paul Serusier, *ABC de la peinture* (Paris: Floury, 1950), Albert Aurier, "Les Peintres symbolistes," *Revue Encyclopédique* (1892). Denis' painting, however, is as mystical-medieval as that of Serusier; *cf.* his *Annunciation* in the Luxembourg. On the origins of synthetism and symbolism, *cf.* H.R. Rookmaaker, *Synthetist Art Theories* (Amsterdam: Swets and Zeitlinger, 1959); and Sven Lovgren, *The Genesis of Modernism* (Stockholm: Almquist and Wiksell, 1959).

36. Quoted in Denis, *op. cit.,* p. 268.

37. Aurier, *loc. cit.*

38. Denis, *op. cit.,* p. 267. The phrase to which Denis objects was first used by Zola in an article on Courbet and Proudhon: "Une oeuvre d'art est un coin de la création vu à travers un tempérament." Emile Zola, *Mes Haines* (Paris: Charpentier, 1913), p. 24.

39. Denis, *op. cit.,* p. 271. *Cf.* Matisse's desire to do away with the "acquired means."

40. Maurice Denis, "L'Influence de Paul Gauguin," *Théories: 1890–1910* (Paris: Rouart & Watelin, 1930), p. 168.

41. Charles Chassé, "Gauguin et Mallarmé," *L'Amour de l'art,* III (1922), pp. 246–256.

## The Primitivism of the Fauves

In their knowledge of primitive art, the painters who consti-
tuted the group known as the *fauves* differed in one impor-
tant respect from Gauguin. He was familiar with some Aztec
sculpture and with the work in stone and wood of the South
Seas, but, if we except India and Egypt from the list of the
primitive, he knew of no other indigenous non-European
artistic tradition. The *fauves* added African sculpture, and,
unaware of the parallel findings of the *Brücke* in Dresden,
prided themselves upon being the first to discover and ap-
preciate its aesthetic values.

The exact date and circumstances of this discovery are
still somewhat in doubt, there being numerous claimants for
the honor.[1] The most convincing account, and the one tra-
ditionally best established, is that by Vlaminck who, in his
autobiography, *Tournant Dangereux,* published in 1929,
tells of seeing two Negro statues behind the counter of a
*bistro,* among the bottles of picon and vermouth, and of
buying them for two litres of aramon with which he treated
the customers present.[2] He bought them because he experi-
enced "the same astonishment, the same profound sensation
of humanity" that he had had from the puppets of a street
fair, which, however, he had not been able to purchase.[3] In
this first recollection Vlaminck does not give the date of his
discovery and acquisition, but judging from its context, we
may place it in the year 1904, and certainly not before 1903.
Recalling this same incident in a book that appeared in
1943, however, Vlaminck places it in 1905, and describes
three statuettes: two from Dahomey, painted red, yellow,
and white; and one, all black, from the Ivory Coast. Al-
though he had often visited the Trocadéro with Derain, he

had until then thought of African art as "barbaric fetishes." Now he was "profoundly moved . . . sensing the power possessed . . . by these three sculptures." Then a friend of his father gave him two more Ivory Coast figures and a large white Congo mask.[4] Derain, who at this time was in close association with Vlaminck, soon saw the statues and admired them. Derain was particularly struck by the mask, which he bought and hung in his studio in the rue Tourlaque.[5] It was there, recounts Vlaminck, that both Matisse and Picasso first saw and were impressed by African art, although their own recollections are somewhat different. Vlaminck never collected extensively; Derain did, adding folk art and the archaic arts of both East and West. Matisse's very considerable collection was perhaps begun as early as 1904, and certainly before 1906. Apollinaire, writing in 1909, said of him: "He likes to surround himself with objects of old and modern art, precious materials, and those sculptures in which the Negroes of Guinea, Senegal or Gabun have demonstrated with unique purity their frightened emotions."[6]

The admiration for this new primitive tradition differed in some respects from any previous appreciation of exotic art. For the first time the products of a native culture were being considered as isolated objects, entirely apart from the context of their creation. Gauguin had had to go to the Marquesas to come upon Polynesian art, and its exotic content and association interested him as much as its form; even his copying of Aztec sculpture took place in the proper setting of a colonial exposition where its foreign origin could not easily be forgotten. Even if the popular origin of Japanese prints was ignored, and they were admired as individual objects of art, they never lost their connection with a definite foreign culture. The admiration called forth by these individual pieces of African sculpture, however, returns in a double sense to an earlier stage in the history of the taste for the primitive: We have mentioned that the first objects of native art were collected as curios, objects which

were evidence of the diversity of the human imagination and of the ingenuity of the primitive craftsman.[7] In Vlaminck's appreciation of African sculpture there is still something of this attitude, so that in part he is drawn to these statues by their strangeness and their curiosity, rather than by their qualities as works of art. For this reason he "cannot keep himself from smiling" at the later developments in the history of African art, the determination of its origins, its arrangements and its classification, all of which is taken so seriously.[8] The other side of this attitude (likewise a throwback in taste) is the consideration of these objects as symbols, one might almost say mystical symbols, of the primitive, as is still suggested in Apollinaire's curiously admiring description of them. Thus Vlaminck and the other artists who early collected African sculpture preferred objects which our present knowledge shows are poor examples of their respective styles, either because they are by inferior craftsmen or because they are representative of a late stage of evolution.[9] We may indeed call them "poor" in the purely technical sense of mastery over the material, without introducing any aesthetic qualifications at all. Objects of this kind corresponded better to the idea of the primitive work of art which they were considered as embodying, so that more could be read into them than into highly finished examples. There is here still something of the notion of the compulsory childishness of African technique and its inability to produce accomplished work; it is part of the same preconception which had made it impossible to accept the bronzes of Benin as really African because their technical mastery resembled too closely the work of more developed cultures.[10] Only after 1933 did Derain, then striving to revive the classic tradition, concentrate on Benin sculpture, just because it was the most "evolved" and technically refined of African arts. Thus ignorance concerning primitive culture, once simply a fact, is consciously preserved as a positive value, and the combined (if opposed) attributes of childishness and mystery can still be attached to the primitive

object. Even the surrealist enjoyment of native art contains much of this double exoticism.

In spite of the separation of the statues from their context, therefore, the *fauves'* appreciation of African sculpture was not the isolated admiration for the solution of a purely formal problem. In London, in 1910, Derain found African sculpture "amazingly, frighteningly expressive," both because of its symbolic meaning and because its forms were designed to function in a full outdoor light.[11] Such admiration for primitive works of art did not come about before the time of the cubists, and even then, such a pure-form point of view was more an ideal than a fact. The aesthetic attitude of the *fauves,* while it goes further than that of Gauguin, is still mixed with much of his romanticism. This can be seen in their continuing admiration for anything that is primitive, or that they consider primitive, regardless of whether its formal qualities resemble those of other primitive works which they also admire. Thus Vlaminck and Derain collected not only Negro sculpture, but provincial and popular art as well—the *images d'Epinal* of Gauguin, and the labels on packages of chicory.[12] But the Egyptian and the Asiatic were neither provincial nor bizarre enough for inclusion in this modern curio collection. That such was really their attitude is further borne out by the absence of any direct influence of primitive art upon the painting of the *fauves;* there is hardly any trace of either African or Oceanic production in the form or subject matter of their pictures, and while knowledge of Japanese prints makes itself felt, their style was largely absorbed through the medium of Van Gogh's art.[13] The art of the Douanier Rousseau also was known to the group and interested its members, but as Marquet has mentioned, it "remained entirely outside of our work."[14]

Lacking any direct borrowing of subject matter or copying of form from the primitive, in what does the primitivism of the *fauves* consist? It is evident in the first place in their choice of subjects to paint, and their relation to these

subjects. One of the most common themes is that of nudes bathing in a landscape, a scene neither new nor original, yet given a treatment, quite apart from the method of drawing and the handling of color, which sets it off from anything that has gone before. The figures are not simply placed in a landscape setting which serves them as a scene of action while they yet preserve their human characters distinct from it; they are mixed up with the landscape in such a manner that they become part of it. In the Derain *Bathers* of 1907, for example, the legs of the figure on the left are covered by the water, while the branches of a tree hide the arms of the figure on the right. The same mixing up and cutting off is found in the Derain *Bathers* of 1908 and in the treatment of the same theme by Vlaminck. Coupled with this is the cutting of figures by the frame of picture, which by an amputation similarly carried out in the fragmentary character of the landscape, also indicates that they are not considered as set within the natural scene, but as being co-extensive with it.

Another aspect of the artists' attitude toward the human beings of their pictures is embodied in the lack of mutual psychological relation or of any active demonstration of emotion in general which these display. The scene portrayed is just a group of figures which stand or sit or lie about, looking into or out of the picture, but almost never at each other. There is no unified action which brings them into mutual play, as in the bathing scenes of Renoir, nor are there various stages of action leading toward the same goal, as in the *Bathers* of Daumier. The poses and gestures of the figures have no exterior determinant which can be grasped by the spectator, but are seemingly compelled solely by the interior mood of each figure. On the other hand the implications of this mood, in its still preserved "synthetist" qualities, differentiates these bathers from the likewise depersonalized constructions of Cézanne. They are, so to speak, not constructions, but reductions. The feeling of mood thus created, of the rendering of a symbolic scene which is to affect

2   Derain / *Bathers,* 1908

the beholder by its symbolic qualities, by the suggestion of things outside itself, rather than a scene complete in itself and external to the spectator, is forcibly heightened by the filling of the frame by the figures. They reach from the top to the bottom of the picture, and are often incomplete at both extremes. Not being set back into the picture by any strip of foreground, lacking perspective depth and psychological distance, they impose upon the spectator immediately without any intervention of artificial setting; not bearing any relation to each other, but still partaking of a pervasive mood, they have an undetermined, but apparently important, relation to the spectator. We may note this effect in Matisse's *Bathers* of 1907, and his *Women by the Sea* of 1908, as well as in Vlaminck's *Bathers* and Derain's *Composition* of the same year.

The combination of immediacy and remoteness, of direct, intense appeal and unlimited implication, is not a paradox. The symbolists (Gauguin, Munch, Hodler) had had similar intentions. We shall find it again in different forms in the later developments from cubism and in the painting which derives its inspiration from the art of children.[15] Among the *fauves* it varies in its application. The shore scenes of Matisse use the broad expanse of sand and water which is cut off at random and against which the figures are placed in emptiness, while the forest scenes of Derain and Vlaminck achieve the same unlocalized effect by the crowding together of figures and foliage in a uniform pattern so that the scene is indeterminate. This random cutting differs from that of the early impressionist work of the seventies in which, though objects are cut by the frame of the picture, they nevertheless retain their identity as complete and discrete objects that happen to finish outside of the frame, that indeed must be completed in the mind of the spectator if the much desired "slice of life effect" is to be achieved. This *fauve* handling also differs from that of the late impressionist landscapes in which, though the natural objects—trees, fields, water, and so on—may continue indefinitely, the com-

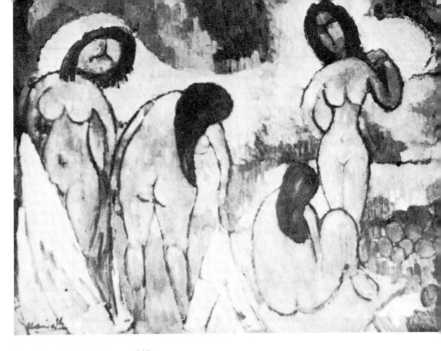

13 Vlaminck / *Bathers, 1908*

14 Matisse / *Three Bathers, Collioure, 1907*

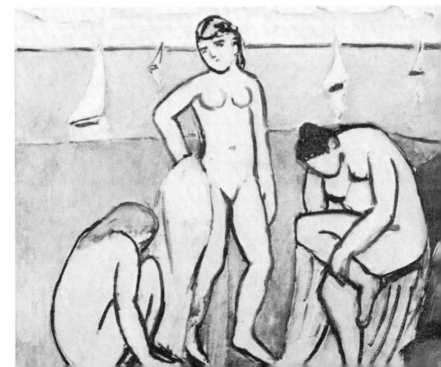

position of light upon surface, the true subject of these pictures is self-contained within them.

It is true that in certain of the *fauve* paintings there are figures which, in their bent forms and closed contours, recall certain primitive and prehistoric work. (*E.g.,* Matisse, *Bathers,* 1907, and *Women by the Sea,* 1908; Vlaminck, *Bathers,* 1908 and 1909.) Such similarity is hardly due to direct copying.[16] We may perhaps explain it by this very effort to give the figures meaning beyond themselves, replacing by an isolated emotional symbolism the natural and direct symbolism of the primitive peoples. In that earlier religious context the single figure is quite naturally a self-sufficient magically efficacious image of a kind that the allusive ramifications of later mythological and hierarchical developments prevent. We will return in a later chapter to this same theme.

These attitudes and effects may be pointed up by a comparison with two other bathing scenes of an earlier period. They are not the only pictures which could be chosen, but they will serve to bring out, by contrast, the *fauve* attitude. In the Daumier *Bathers* the movement of the figures is motivated by an obvious action, that of undressing in preparation for the bath. All the figures have this common purpose, and they are shown in different stages of preparation for a common action, beginning on the right and culminating in the nude figure on the left. This figure is presented as unusual in its setting and is contrasted with the landscape in which it is put, both by its differentiation from the other dressed or half-undressed figures and by the way in which it is silhouetted against the background. It is daring both in action and in presentation. In the *fauve* pictures not only is the nudity accepted (there being nothing to contrast it with), but by lack of concerted action and by similarity of modeling the figures are made to count in the same way—though not always to the same extent—as the surrounding landscape. A like contrast may be pointed out between these canvases, traditionally labeled *Bathers,* although they are

devoid of all that this implies of action and interaction, and the correctly named *Bathers* of Renoir. Here the figures are made to constitute a whole separated from an artificial setting by means of an active relation with one another, either actually physical or established through gestures and glances. The nakedness of the figures is brought out by hats and ribbons which lie about, adding piquancy to the scene, while the method of modeling the trees and grass is different from the treatment of the bodies. The *fauves* treat their subjects with a combined directness and abstraction which is at the opposite pole from this half-aesthetic, half-sensual conscious appreciation.

If we have discussed the iconography of the painting of the *fauves* before dealing with their methods, it is because the latter have usually been given much more consideration. The simplification of means; the use of a broad, unfinished line; the application of large areas of undifferentiated color; the use of pure color; the lack of perspective, both in the individual figures and in the composition as a whole—these are the most obvious characteristics of *fauve* painting. Stemming from Gauguin, from Van Gogh, and from Seurat, they mark a further simplification of the methods of these painters, a simplification which is in two respects primitivizing, but which also had consequences pointing directly away from primitivism.

In the purely technical sense, the broadening of line, the direct application of color from tube to canvas, the lack of concern about nuances within the color surface, the neglect of the general finish of the picture are in accordance with the appreciation of children's art and the kind of expressively simple primitive art which the *fauves* admired. Like these, the appeal of *fauve* painting does not depend upon the mastery of a sophisticated craftsman's skills but upon the immediate effect of the canvas as a whole. The *fauves* are not concerned with subtleties of drawing or nuances of color, nor do they worry about carefully balanced masses and harmonious composition. If the *fauve* pictures repro-

duce so badly in black and white it is because they depend upon the violent effect of broad areas of color which are nearly of the same tonality, colors which impress themselves on the beholder by a common brilliance which disappears in reproduction. The desire is to interpose as little of the consciousness of the technical method as possible while imposing the immediacy of hue and pigment. Even where the actual application of the paint is divisionist in method, it is not really so, since there is no longer any concern about complementary colors or the fusion of these colors into a different whole. Toward the same end the palette is also reduced, only "pure" colors being used—that is, no colors were mixed before being applied; but because no active fusion is required of the spectator there are even fewer obstacles between him and the painter than in the method of Seurat. In this the *fauves* are closer to the manner of Gauguin and his wish to produce flat decorative harmonies than to either of the other principal influences working on them, even though their bright palette and pure colors stem directly from Van Gogh and to a lesser extent from Seurat.

The *fauves'* reduction of the means employed to flat color areas and a limited selection of colors gives their work directness and immediacy. These are not paintings to be studied and analyzed at length, compositions in which intricate relations can be grasped only after prolonged contemplation. This is not to say that these were inexperienced, unsubtle artists, unaware of tradition and technique. They employed their knowledge to eliminate from their work all that they felt was unnecessary to a single essential effect. The subtlety resides in an analysis which permits simplification, and which since it precedes all actual painting is never present and can only be inferred. The result is simple and striking and the appeal of these pictures, both iconographic and formal, is immediate and direct. Their aim is to produce a visual and emotional response which, without reflection, will "engage the whole personality," whether by means that shock, as Derain implies in "reinforcing the ex-

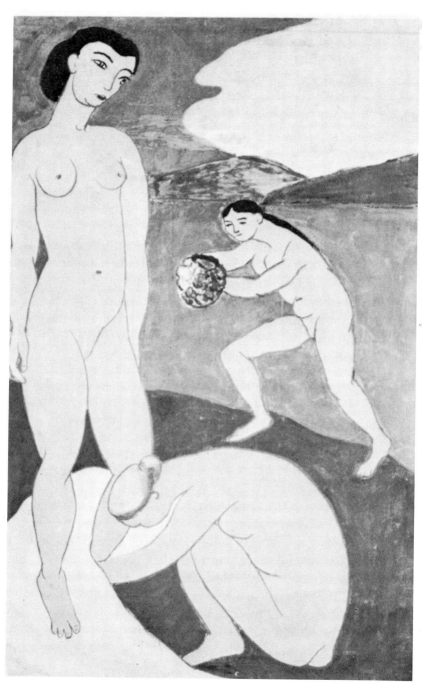

15 Matisse / *Le Luxe II*, 1908

pression" of the Ghirlandaio that he copied in the Louvre;[17] or by means that comfort, as in Matisse's wish to make his art "something like a good armchair in which to rest from physical fatigue."[18] Color is to be used "to render emotion without admixture, and without means of construction," to portray the actual "vibration of the individual . . . rather than the object which has produced this emotion."[19] Communication between artist and spectator no longer is through the indirect means of rendering matter in such a way that it will produce in the latter the emotion that it aroused in the former, but emotion is to be rendered directly. "One does not depict matter, but human emotion, a certain elevation of spirit which might come from no matter what spectacle."[20] Such emotion, simple and wholehearted in itself, can only result from simple means.

On the other hand, the replacing of the world of objects by simple human emotion has in it, as we have already noted in our analysis of the composition of certain *fauve* pictures, implications far beyond the canvas itself:[21]

> The painter remains in intimate contact not alone with a motif, but also with the infinite nebulousness . . . [He] refuses nothing . . . of omnipresent space, let us rather say of extension.[22]

Emotionally as well as in its formal structure, the picture becomes a symbol whose very generality increases its possible meaning. This grasping of reality through emotion has been compared with the philosophy which Bergson was contemporaneously expounding at the Collège de France.[23] Without going into the resemblances in detail, we may note the anti-intellectual, anti-analytical aspect of the two phenomena, and their similar attempt to grasp reality by means of a return to something fundamental in the human being, to do away with a developed superstructure, with, as Matisse has said, "the acquired means," in favor of something native and simple. In so far we may speak of both movements as primitivizing.[24]

Their effort to "return to naked simplicity" had induced the *fauves* to reduce their methods of communication to one, namely that of color, and to employ this as directly as possible. This very reduction, however, necessitated in the end an amplification and refinement of expression through color which is far removed from the simplicity that was at first envisaged. Lacking an interior elaboration of the canvas, only one thing can be said with one means, and it was just the elaboration of this means that those who remained closest to the *fauve* method undertook. This is first evident in the work of Matisse, whose exclusion of line was never as drastic as was that of some of the later adherents, and is dramatically illustrated in his later career. Already in the *Joie de Vivre* (1906–7), "the climax of the *fauve* period," which, iconographically, has much of the idealization of simplicity and union with nature which we have noted above, there is "a flowing arabesque of line" and the indication of a succession of planes which are anything but simple.[25] In a composition of this kind the eye must follow the separate parts and move rhythmically about the picture, rather than grasp it as a whole, and it is this which distinguishes *Women by the Sea* (1908) from the static *Music* (1910) as well as the moving *Dance* (1909), close as it is in other respects.[26] In Matisse's painting from 1910 on, the use of color is continually refined, both in the tones used and in their combination in unexpected form, and in their employment to establish (often by extremely knowing allusions to previous styles), the structural composition of the pictures. This is also true of the work of Dufy, in which an apparently childish linear technique has been adapted with the utmost sophistication. His "bad" drawing is elliptical to such an extent—suggesting everything which it pretends it cannot represent—that it is really the exact negation of the child's attempt to set down in accurate detail all that he can recall about an object or a scene. And Dufy adds to this method color harmonies and juxtapositions of line and color which have become ever subtler since his *fauve* days.

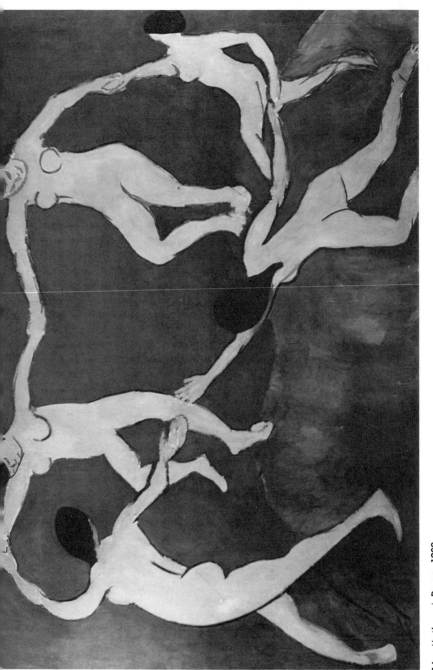

16　Matisse / *Dance*, 1909

The other *fauve* painters also recognized, although in a different way, the difficulty of expressing themselves in colors "whose choice is determined solely by the exigencies of a tonal register." [27] Thus Vlaminck explains that because color led away from the comprehension of the universe, the original reason for its use, he was led to renounce it:

> It was necessary therefore to return to the feeling for things, abandoning the acquired style. Captured by light, I neglect the object. Either one thinks nature, or one thinks light. . . . I had to look for the interior character of things, save the feeling for the object. . . . Thus a more profound comprehension of the universe led me to modify my palette.[28]

Othon Friesz, also seeking "the maximum of expression," was led to renounce "the technique of colored orchestration" in favor of a "return to construction" which would render more adequately the emotions experienced before nature.[29]

These changes were designed to enrich the work. They now seem inevitable, since it appears that this road to simplification had reached its end. But as events were to show, they hardly ensured that the new, more complicated paintings would improve upon the older, "simpler" ones.

With this renunciation we too may halt our study of the search for the primitive and the essential among the *fauves*, to begin it again among the works of other painters. In comparison with the conception of Gauguin, that of the *fauves* is at once less localized and closer to home. In spite of the tropicalizing of much of their work, the scenes of the *fauves* do not have the definite locale nor the precise exotic associations of Gauguin's subjects, whether provincial or Polynesian. In their technique, too, the *fauves* were more radical than the school of Pont-Aven, abandoning the conscious grace of "objective deformation" in favor of subjective composition. No longer seeking interior equivalents of an exterior world, no longer, that is, symbolists, they attempt to short-circuit the connection and establish direct

communication between individual and universal essentials. In the next chapter we will continue the study of this kind of emotional primitivism, noting how it once more became localized, partly by a return to exoticism, and partly by its application to the personal and contemporary environment of the painter.

NOTES

1. It has been maintained by William Fagg in *Nigerian Images* (New York: Praeger, 1963), pp. 19–20, that the arrival in Europe in 1897 of the many Benin bronzes paved the way for the later enthusiasm of French and German artists for very different styles of primitive art from Africa and Oceania. The historical evidence hardly supports this contention. Although Benin art was readily accessible in the museums of Berlin, Dresden, and Munich it was ignored by the *Brücke* and *Blaue Reiter* artists alike, just as Jacob Epstein ignored it in the British Museum. Among the *fauves* only Derain came to it years later when his own style had shifted toward naturalism. The naturalism of Benin removed it from consideration by artists whose aesthetic goals were radically expressive and anti-naturalistic.

2. Maurice de Vlaminck, *Tournant dangereux. Souvenirs de ma vie* (Paris: Stock, 1929), p. 88, trans. by Michael Ross as *Dangerous Corner* (London: Elek, 1955), p. 71.

3. *Ibid.*

4. *Cf.* Vlaminck, *Portraits avant décès* (Paris, Flammarion, 1943), pp. 105–106. André Level (verbally, June 4, 1934) mentioned that he began collecting in 1904. D.H. Kahnweiler (verbally, June 6, 1934) also placed the discovery of Negro sculpture in 1904, and attributed it to Vlaminck.

5. There was a shop in the rue de Rennes run by Heman (or Sauvage), where the artists bought. *Cf.* Vlaminck, *Portraits*, p. 107.

6. It is interesting to note that Matisse did not collect Persian miniatures, even though they influenced his work. From 1933 on Derain concentrated on Benin bronzes. *Cf.* Alfred H. Barr, Jr., *Matisse, his Art and his Public* (New York, The Museum of Modern Art, 1955), p. 553.

7. See above, Chap. I, Part 1.

8. Vlaminck, *Tournant dangereux*, p. 89.

9. Charles Ratton (verbally, May 27, 1936) was kind enough to show me photographs of objects coming from various collections to substantiate this point.

10. See above, Chap. I, Part 2.

11. André Derain, *Lettres à Vlaminck* (Paris, Flammarion, 1955), p. 197.

12. René Huyghe, ed., *Histoire de l'art contemporain. La peinture.* (Paris, F. Alcan, 1935), p. 105.

13. Quotation from Albert Marquet in Georges Duthuit, "Le Fauvisme, II," *Cahiers d'art*, IV (1929), pp. 260–261. Barr, *op. cit.*, p. 139, notes that Matisse's *Two Negresses* (1908) "may well be influenced by African Negro sculpture . . . particularly the rigid, thickset figures of the Ivory Coast." The influence on Derain did not come until after 1909, when he had given up the *fauve* style.

14. Duthuit, *loc. cit.*

15. See below, Chaps. V and VI.

16. Many of the *fauve* stylizations of the contours of limbs, heads, and hair are close to Gauguin and his followers. Vlaminck's *Bathers* is a good example.

17. Quotation from Derain in Duthuit, *op. cit.*, p. 268:

> J'ai copié au Louvre un Ghirlandaio, jugeant nécéssaire, non seulement de remettre de la couleur, mais de renforcer l'expression. On a voulu me mettre à la porte du Louvre pour attentât à la beauté.

The picture is not a Ghirlandaio, but by Giovanni Utili; *cf.* R. Van Marle, *The Italian School of Painting* (The Hague: M. Nijhoff), XIII, p. 177.

18. Henri Matisse, "Notes of a Painter," trans. by Alfred H. Barr, Jr., *Henri Matisse* (New York, The Museum of Modern Art, 1931), p. 35. The following may also be added:

> It is through it [the human figure] that I best succeed in expressing the nearly religious feeling that I have towards life. . . . The simplest means are those which enable an artist to express himself best.

19. Duthuit, *op. cit.*, p. 132.

20. *Loc. cit.* These statements seem to anticipate intentions attributed to the abstract expressionists of the "New York School" in the forties and fifties.

21. Georges Duthuit, "Le Fauvisme, V," *Cahiers d'art*, VI (1931), p. 80. Duthuit's analysis becomes itself somewhat mystical:

> [La toile] possède une vitalité élémentaire; elle représente la cellule, choisie dans un organisme sans limite, par où la vie supérieure de l'esprit doit s'infuser au corps tout entier.

22. Georges Duthuit, "Le Fauvisme, IV," *Cahiers d'art*, V (1930), p. 130. *Cf.* Bergson.

23. *Ibid.*, p. 132. Bergson's philosophy, in so far as it is primitivizing, is not to be compared particularly with the primitivism of the *fauves;* the parallel is rather between this (and other anti-intellectual theories, *e.g.*, Croce's aesthetic) and the general primitivizing tendency of the time.

24. Marquet and Matisse seem to have been the first to employ the *fauve* method, in the sense of using pure, flat color; Marquet puts the date as early as 1898, and considers 1905, usually given as the beginning of *fauvisme*, as the beginning of the last stage. Duthuit, "Le Fauvisme, II," pp. 260–261.

25. Barr, *op. cit.*, p. 14.

26. *Cf.* also *Le Luxe* (1906), which has the same quality as *Women by the Sea*, and many of the characteristics analyzed above.

27. Duthuit, "Le Fauvisme, II," p. 262.

28. *Ibid.*

29. *Ibid.*, pp. 259–260.

❦ ❦ ❦ ❦

# IV  Emotional Primitivism

## The Brücke

The last chapter dealt with the primitivism of French artists who were among the first to come into direct contact with primitive works of art. Though influenced by these works, and though Gauguin included some of their motifs in his own paintings, neither he nor the *fauves* assimilated their form or their spirit in any serious manner, but were content to let them be external factors that determined style only through the general formation of their taste. This exterior quality may be felt in the extreme generality of the primitiveness of both Gauguin and the *fauves;* their striving for the primitive expresses itself in terms apart from the artist, creating a somewhat symbolic effect even in the most direct

productions of the *fauves*. For this reason their primitivism has been described as still romantic in spirit.

The artists who constituted the *Brücke* group also knew of primitive painting and sculpture. The creations of the native artists of Africa and Oceania were "discovered" by Ernst Ludwig Kirchner in the cases of the Dresden ethnological museum in 1904, as he recounts in his history of the group, the *Chronik der Brücke*.[1] Whereas Gauguin had known the sculpture of the Marquesas and Easter Island, and perhaps of New Zealand, and the *fauves* figures and masks from Africa, the Germans, with proper thoroughness, found both Africa and Oceania at once and in a museum; and as befitted the more advanced state of ethnological collecting in their country, they immediately became acquainted with a range and variety of style which the French took some years to discover.[2] Owing perhaps partly to this circumstance but also to their artistic intentions, they never regarded primitive art simply as a curiosity, as Vlaminck did in large measure. As Emil Nolde wrote, it was at once "raised up to the level of art . . . pleasing, ripe, original-art."[3] It is true that other primitive and exotic arts were being discovered at the same time—Chinese, Indian, Persian, and above all German woodcuts of the fifteenth and sixteenth centuries; nevertheless, since the members of the *Brücke* did little direct copying and were little interested in purely formal exercises, there is never any question of a borrowing eclecticism in their work. What fascinated them was the power and immediacy of primitive art or, as Nolde said, "its absolute primitiveness, its intense, often grotesque expression of strength and life in the very simplest form."

An element of exoticism nevertheless remains. This is evident not only in their admiration for Gauguin, whose art they came to know either in Germany or, like Nolde, on trips to Paris; or in the clear imitation of Gauguin's voyages and paintings in the work of Max Pechstein, the least original member and one of the later adherents of the group.[4] It

can be seen also in the subjects chosen for their pictures, and particularly in those of Nolde. The ironically entitled *Missionary* (1912) and *Man, Woman and Cat* (1912)—although directly inspired by Dahomey sculpture—are interpretations of native life in terms of Dahomey art and show no attempt to copy its formal characteristics. Alongside such pictures as the several paintings of *Masks* (whether of 1911 or 1920)—composed of isolated objects hung close together as one would find them in the documentary cases of a museum—and the *Still life with Dancer* and the *Still life* (1915) —which contain a New Guinea shield placed with other non-primitive objects—appear such subjects as *Evening Glow, South Pacific* (1915), *New Guinea Natives* (1915), and *Indian Dancers* (1915).[5] These testify to Nolde's voyage to Russia, Japan, the Palau and Admiralty Islands, New Guinea and New Ireland in 1913–14, made perhaps under the inspiration of Gauguin, but after a long familiarity with Oceanic art. This voyage produced no such derivations as Pechstein's.[6] The dates of the pictures are significant because although some, like *Men from Manu* (1914) and *Papuan Family* (1914), were painted during his six-month sojourn, others, done later, show that Nolde had no need to make native portraits or to copy the decorative details of native art—as Gauguin had done: he could transcribe his impressions and his feelings after he got back home. In the pictures of the *Masks* it is difficult to recognize the exact provenance of each object, even at times to tell whether it is African or Oceanic. These pictures are not ethnological documents. They are not even the idealized documents that Gauguin painted, in which correct details are merged into a whole that is meant to be the unspoiled essence of the primitive world, a world which, because it is both symbolic and ideal, remains outside and apart from both the artist and the native life it is meant to interpret. Rather, the *Masks* are the primitive in terms of the artist's own emotions, taken out of its context and put into the artist's head, and are therefore both unlocalized and immediate, qualities

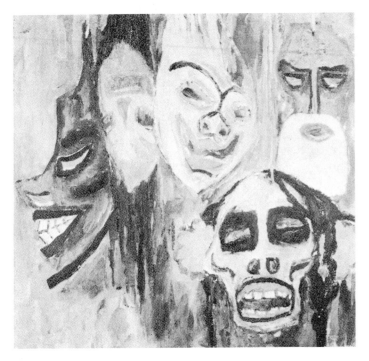

17   Nolde / *Masks*, 1911

18   Nolde / *Dancer*, 1913

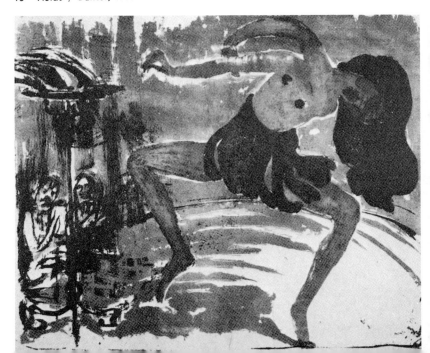

which are most striking in the close-ups of masks and heads.[7] The change from Gauguin's point of view is toward an interiorization of the conception of the primitive, a change whose start we have noted in the work of the *fauves,* and which we will have occasion to point out again.[8]

It is characteristic of the non-formal quality of the *Brücke's* appreciation of primitive art that in the painting of Kirchner, its discoverer, there should be little direct evidence that he knew of its existence. On occasion, he liked to create an environment of "primitive" sculptures for his figure pictures; but, like the "Oceanic" works in *Bacchanal* (1908), he carved such objects himself. It is perhaps possible to see in his sculpture the influence of Cameroon figures and house decoration, the more so since Cameroon was a German colony and its art was well represented in the museums.[9] In *Alp Procession* (1918), a relief in wood, the animal muzzles recall Cameroon work, and the method of cutting back from the original surface of the block in order to indicate modeling, creating a zigzag profile outline, is similar to that used by Cameroon sculptors in the carving of their door posts and lintels.[10] In *Woman's Head* (1912) the modeling of the lozenge eyes, the connection of the brows and the nose, and the projecting mouth and chin likewise recall the Cameroon technique. In Kirchner's other carved figures, however, there is a much more general primitivizing effect. *Bather Drying Herself* (1905) and *Adam* (1920), for example, simply make use of a crude wood technique which recalls popular art wherever it is found, whether in primitive or advanced cultures, rather than the most characteristic work of the primitive peoples.[11] The use of contrasting color, which is found in the above-mentioned figures and again in *Women and Girl,* shows an approach to the primitive that is closer than that of most modern sculptors who have been drawn under this influence. Still affected by the idea of the beginnings of art as it was formed from an incomplete understanding of the archaic Greek, they carefully avoid the application of color and keep the surface of their

work as uniform and unaccented as possible.[12] The primitive is conceived as reached by stripping off later layers of unessential accretion in order to reveal a pure homogeneous core. The primitive is equated with simple uniformity. In reality, of course, the African and the Oceanic artist employs color whenever it will heighten the intensity of his work (as did also the Greek), and does not hesitate to have recourse to a diversity of material if it will serve his purpose, combining wood with metal, shells, feathers, or cloth as he wishes.[13] The color increases the realism of the subject, and while it intensifies, it limits the effect of the artistic conception, giving it a precision of reference which avoids the vague and undetermined symbolism which is usually connected with the primitivism of modern sculpture, but which plays no part, either in form or religious meaning, in the art of the truly primitive.[14] In this sense, if not always in his formal rhythms, Kirchner comes close to the African and the Oceanic spirit.

In our discussion of the attitude of the *fauves* toward the primitive, we have remarked upon their use of the nude human figure in a wild landscape setting.[15] We noted especially the union of the figure with nature, and the contrast of its lack of action with an apparent emotional savagery, combining to give the picture a symbolic quality. Both these aspects of the *fauve* attitude, and consequently the resulting symbolism, are intensified in the work of the *Brücke* artists. The settings chosen, as with the *fauves,* are either the beach or the forest, and the figures are again given in close-up, covering nearly the entire height of the picture when they are not themselves cut by the frame. Such scenes occur very frequently in the work of Kirchner, who, through a high horizon and a lack of depth in the landscape, makes almost no compositional distinction between the two geographical classifications, just as he employs the same intense palette. This was already apparent in the *fauves'* treatment, but in their work broad areas of flatly applied color and straight lines of sea and sky emphasized the extensiveness of the

sand and water, while here the more broken color areas and the interrupted contours of the objects minimize the distinction, and tend, in either case, to make the setting grip the figures. There is, for example, no difference of immediacy and expanse between *Nude Girls at the Beach* (1912), where there is almost no sky and the red-hued figures are buried in the foliage, and *Four Nudes under Trees* (1913), where the identical high format is used. This conception is of course not confined to Kirchner, and we may mention as other examples *Red Dunes* (1915) of Schmidt-Rottluff, Otto Mueller's *Girls Bathing* (1921), and Heckel's *Glasslike Day* (1913).

It is characteristic of the manner of conception of these subjects that even where the views are typically northern ones, as in the scenes of beaches or sand dunes—not to mention those of woods and forests which are perhaps of a more southern nature—the effect achieved should nevertheless be that of a tropical landscape. We have already mentioned this tropicalizing in the work of the *fauves,* and here, as in their painting, it results from the effect of the proximity of the spectator to the scene rendered, his feeling that he is in immediate contact with it, rather than viewing it from a distance. This feeling, in its turn, comes from the close-up aspect of the objects depicted, the apparently unfinished, random quality of their choice, and the even distribution of the composition over the canvas. These elements, present in the *fauves'* painting, are here depicted with an even greater intensity, an intensity further heightened by a darker, more saturated color scheme and a closer juxtaposition of opposing hues. As with the *fauves* again, the violence of these pictures is due to the manner of composition of the subject, rather than to any violence inherent in the subject itself. The figures are without an individual psychological character, and have no binding relationship or common point of interest. This isolation is even indicated in the titles: The participants are no longer "bathers" whose action issues from an interior volition, they are "nudes under trees"

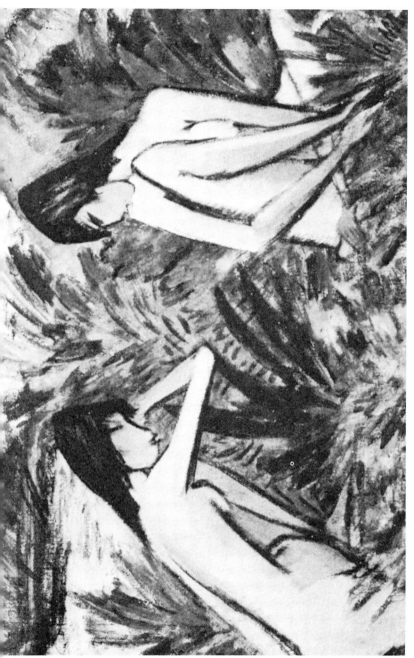

19  Mueller / *Girls Bathing,* 1921

whose meaning and whose significance lie just in the fact of their being under the trees, on the beach, or in the forest. They are to be treated as one with their setting in nature, and it is this assimilation which gives them their meaning. Even the graceful attitudes of the *fauves'* figures, indicated by flowing curves and closed contours, have disappeared, and in their place there are flipper-like hands and feet which seem to terminate in and become part of the surrounding foliage.[16]

The paintings of the *Brücke* which we have discussed so far are in line with the romantic-symbolic attitude toward nature and toward the primitive in its union with nature that we have seen in Gauguin and in the *fauves*. In Gauguin the type of scene we have been considering was definitely exotic; with the *fauves* it was unlocalized; but the painters of the *Brücke* attempt, unsuccessfully perhaps, to bring to their northern home these equatorially conceived landscapes. They are reinforced in this tendency by the other aspect of their primitivism, an aspect which is more particularly northern in character and which stems from northern prototypes. This side of the primitivism of the *Brücke* is directly emotional, attempting the portrayal of emotions and passions in as outspoken a manner as possible. The scenes rendered are not simply pleasant views painted with purely pictorial concerns in mind; they are thought of as having some connection with the fundamentals of human life and destiny. They may vary in type and character but there is always an attempt to bring into conscious prominence the essential emotion behind the accidental physical setting. One must not, however, read too much into their rather uniform stylistic intensity. Kirchner was searching for "the natural in man and nature" and in the relationship between man and woman.[17] It is this quest which explains the subjects of these pictures, just as it is connected with the simple bohemianism of the *Brücke* style of living.

Apart from the landscapes we have discussed and the portraits to which we will come, the two most frequent kinds of

subjects painted by the *Brücke* artists are cabaret and music-hall scenes and scenes from the Bible. Superficially these have nothing in common; nevertheless both furnish an opportunity to depict emotion at a level of intensity which is rarely reached in the ordinary routine of daily events. (The depiction—often sentimental—of both clown and prostitute as essentially unsullied vessels of goodness and tragedy, which has a long history in modern art, is related to this desire to find concentrated symbols.) In such a picture as Heckel's *Clown and Doll* (1912) the individuality of the figures, the existence of the actors as separate human beings, has almost disappeared in favor of the purely typical roles which they are playing. Their relation is made symbolic of a type relation, of a basic human situation. The figures are of course themselves types; the lack of modeling, the stiffness of gesture, and the compulsory absence of facial expression emphasize still further their lack of individuality. Elsewhere, when such a clear symbol cannot be chosen, the particular, separate character of the subject is done away with by similar means. Above all, the faces are never individualized, the features being given as large unmodeled spots of color within the area of the head. Often, as in Nolde's *Comedy* (1920), or *Be Ye as Little Children* (1929), it is impossible to tell whether or not certain of the figures are wearing masks, and the undetermined quality of the picture and its power to evoke meanings beyond itself are thereby greatly enhanced.[18]

Such a picture as *Comedy* recalls—in the caricatures of the faces, the vertical alignment of the figures, and the indefinite haze from which the figures emerge with a certain ghostlike quality—the work of James Ensor, whom Nolde visited in 1911.[19] There is, however, this difference—that Ensor's atmosphere is wholeheartedly of another world, whether of the spirit or of the dream, whereas here this world has not been completely exorcised. The result is that while one is at times uncertain whether or not caricature is intended, the terrible quality of these pictures, their hinting

at some underlying, basic reality which would be awful if it could but break through in its full power, is much greater than in the work of Ensor. On the other hand, some of the subjects painted by these artists, particularly Kirchner's scenes of *cocottes*, of brothels, and of the *variétés*, recall Toulouse-Lautrec's treatment of the same type of life.[20] With the French artist, however, the tragedy, whenever it is portrayed, is a personal one; and it is the ironic contrast of the individual and the role that counts, so that the superficially amusing elements must always be kept in mind. Kirchner, not bothering with the reality of tinsel charm, immediately does away with the surface qualities and brings into play (in a manner that foreshadows the later work of George Grosz) the underlying forces of human nature that determine the particular situation which he is rendering. In other words, he is plumbing deeper, more primitive depths than either of his predecessors.

It is in this sense also that the religious scenes must be interpreted. They are attempts to bring out the essential, the inner quality of the story, getting rid of everything but the concentrated expression of violent emotion. The dogmatic, the churchly surface is stripped off, and a return is made to a primitive Christianity. For we must recognize here, in spite of the tremendous formal and emotional distance which separates them, an attitude toward religion akin to that of the Nazarenes.[21] The idyllic, pastoral-classicizing quality of these reasonable romantics--their archaizing simplification which preponderates over all realism of detail—is here replaced by a simplification of technique and an omission of all detail, a deliberate suppression of nuance and overtone in favor of a single, undifferentiated, overwhelming emotional effect. Nolde's *Entombment* (1915), through the crowding of its composition, the concentration of its modeling on the closely juxtaposed heads with their large features, and the reduction of these heads to the expression of a single, dominating emotion, becomes a thing of immediate terror. In *The Last Supper* (1909) individual reac-

20  Nolde / *Entombment*, 1915

tions and *affetti* are neglected, and a single group emotion, terrible and wonderful, unites all the figures in one sweeping whole. A similar concentration ties together the series of the life of *Mary of Egypt* (1912), in which, as in *Dance Around the Golden Calf* (1910), Nolde recognizes a relation between sexual drives and religious passion. Where the nineteenth century strives to reach religious truth by ridding itself of historical and geographical accretions, the twentieth century attempts to find it by stripping the emotional overlay of the individual. And where the nineteenth century thought of the primitive, thus revealed, as calm and reasonable, the twentieth sees it as violent and overwhelming.[22] These are some of the differences between the primitivism we are studying and the romanticism out of which it grew; we will return to them in our last chapter.

To a critic who told Emil Nolde that he must make his pictures much milder if he wished to sell them, the artist replied, "It is exactly the opposite that I am striving for, strength and inwardness."[23] The desire which Nolde expresses in this manner comes out very clearly in the portraits and in the figure groups which are combinations of portraits, painted by all the members of the *Brücke* group. Their interest does not lie in anatomical structure or in the formal relations of cubical mass and surface light and color, but rather in the strong expression of a single dominating character. Toward this end the features, particularly the eyes and mouth, are exaggerated and contrasted with the rest of the head, while the whole figure emerges from a background which is neither clearly indicated nor entirely abstract in character, and which seems pregnant with possible forms. The faces are either devoid of ordinary expression, and with fixed eyes seemingly intent upon something within, as in Nolde's *Woman and Child* (1914) or Schmidt-Rottluff's *Portrait of S.G.* (1911); or they convey a violent, uncontrolled emotion which is again the product of an interior force rather than related to the outside world, as in Heckel's *Roquairol* (1917) and his *Portrait Study* (1918) or Nolde's

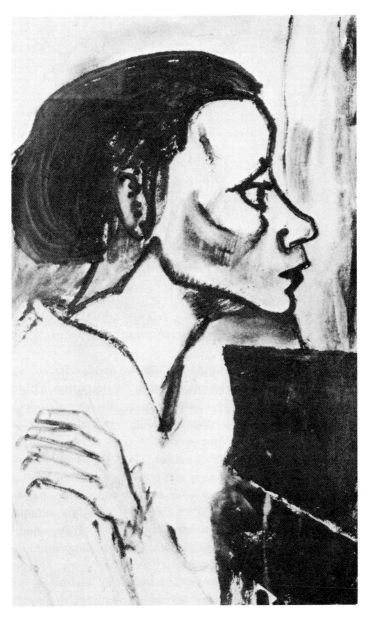

21   Heckel / *Portrait Study, 1918*

*Excited People* (1913).[24] In these pictures the feeling of a basic controlling force against which there is no rational struggle remains human in its application; in others, where there is some indication of the background, it extends from the outside world so that the figures become the focus of surrounding forces. In such a picture as *Making-up* (1912), by Heckel, the silhouetting of the figures against the background, the dark forms of the figures themselves, and the bare landscape seen through the window, indicate the influence of Munch's art. Munch himself, as we have seen, was interested, in the same symbolic way as the other artists of the *Jugendstil,* in depicting the basic forces of the universe, and he added a violence of emotion that was lacking in the more decorative work of other men.[25] However, he connects emotional violence and the imminent forces of the surrounding atmosphere only with the recognized basic and crucial situations of human life. His people are momentarily "possessed" and seem to await release, while the persons shown by the *Brücke* are themselves composed of such forces and such emotions.

In analyzing the pictures to which we have referred, we have noted the simplification of form, its definition within simple contours, and the elimination of nuances of modeling and variegations of surface which might detract from the single immediate impression that the artist wishes to convey. To a certain extent such a formal reduction must be accompanied by a similar technical simplification, and at the start of any such process it may be impossible analytically to separate the two. Where finesse of line, for example, is used to depict simple, or simplified forms—as in some of the drawings of Picasso—the result, far from being simple, is one of extreme sophistication. In the work of the *Brücke,* however, there is a deliberate coarsening of technique, the beginnings of which we have already seen among the *fauves,* and an emphasis upon this coarsening which goes far beyond any such technical necessity. The *fauves* made use of thick, unfinished line, but Kirchner reworks his outlines in

different colors, leaving the various lines all of an equal strength and not picking out the final contour. In *Portrait of Dr. Döblin* the linear contour has been blurred with pencil and crayon zigzags normal to the curve of the form, and the same conscious coarsening, whose occasional absence in other works proves it not to be a necessary part of the artists' vision, is again present in the pen drawing, *Pair in Conversation*.[26] Such a deliberate confusion of the outline, which also occurs in some of Schmidt-Rottluff's work, is due to the influence of children's drawings, where, however, the reworking is a sincere effort to pick out the true contour.[27] Here the desired effect is of something unstudied, less artistically artificial and consequently truer to the inner qualities of the subject. To the same influences and to the wish for the same effect may be ascribed the filling in of the background of so many of these graphic portraits with an unregulated scribble that again resembles the work of children and that indicates clearly the value given to the immediate and the unfinished.[28]

It is natural that an attitude such as this should create an interest in modes of artistic production which not only permit but force a crudity of finish and technique. Nolde praised primitive pottery and sculpture because it was executed directly in the material which it expressed, without the distortion introduced by preparatory drawings. The great popularity of the woodcut and the linoleum cut among the members of the *Brücke* group is due to the opportunity that these media give for bold, uncomplicated effects of the sharp contrast of large and undifferentiated areas of light and shade. Gauguin, as we have seen, was fond of the woodcut for the same reasons, and even chose to simplify the primitive motifs from which he largely borrowed. The woodcuts of Kirchner and Schmidt-Rottluff are influenced rather from the "primitive" German woodcuts of the fifteenth and sixteenth centuries, as is evident not only in the technique but also in the prevalence of religious subjects.[29] It is significant that the refinement, or rather the lack

of refinement, of technique which is used corresponds to a rather early stage in the development of the woodcut, and that the modern artists prefer to reduce the possibilities of even so limited a medium.[30] The tortured aspect of both styles is due more to a correspondence in artistic situation—a correspondence which made the technical borrowing possible— than to a direct copying of the earlier style by the modern artists. The linoleum block is of course the child's medium *par excellence,* and the interest in the child's artistic education which grew so rapidly in Germany in the first decade of this century had given rise to its wide use in schools and art classes.[31] Its use by the *Brücke* group is further proof not only of the kind of aesthetic primitivism which we have shown to be one of the chief aims of their painting, but of a direct influence from the art of children.

What, then, are the distinguishing marks of the primitivism of the *Brücke* group? There is in the first place an influence from three kinds of art which were considered primitive: African and Oceanic Sculpture, German woodcuts, and children's drawing. The discovery and the interest in Oceanic sculpture marks an extension in the appreciation of the arts of primitive cultures, and also a change toward a more emotional consideration. Secondly, there is an influence from three artists whom we have seen to be, each in his different fashion, primitivizing themselves: Gauguin, Ensor, and Munch. But the chief characteristic of the primitivism of these artists is a tendency to call all the refined and complicated aspects of the world about them superficial and unimportant, and to attempt to get behind these to something basic and important. Their main interest lies in the bases of human character and conduct, and these they conceive as violent and somewhat unpleasant, attempting to express them by simplifications of form and contrasts of color. The "expressionist" character of their art (a term thus far purposely avoided) lies in the thoroughness and the narrowness of this interest, rather than in any purely optical difference from "impressionism." [32] There has been some discussion as

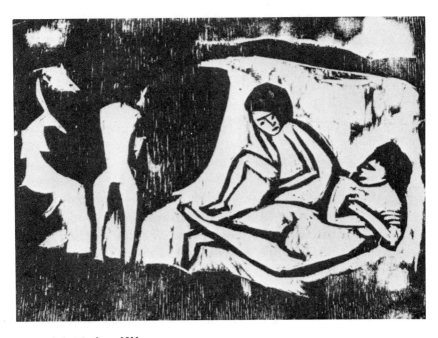

22   Heckel  /  *Bathers,* 1911

23   Heckel  /  *Self-Portrait,* 1914

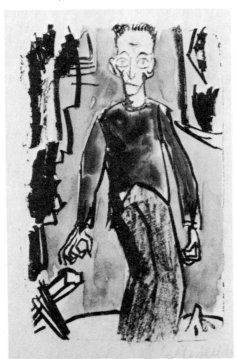

to whether primitivism is an essential component of this art, or whether it is the result of the desire for a maximum of emotion and the wish to penetrate to the essence of things.[33] On this point there can hardly be any question. The maximum of emotion has not always been conceived in terms that necessitated formal simplification or the reduction of technical means, as witness the baroque. Nor has the essence of things been thought of as being reached by penetrating, as it were, downward and into the depths, as witness the rational refinements of the neo-classic. It is just because the search for these qualities takes the form that we have examined that we may characterize the art of the *Brücke* as primitivizing. The study of Gauguin and of the *fauves* has shown that this is not the only manner in which primitivism can manifest itself. In spite of certain exotic tendencies, the *Brücke* artists are influenced by arts which are less outside their tradition and create symbols from elements—personal and social—which are closer to their own lives than any of their predecessors. The symbols thus become of greater force and of wider application, but, just because they are less objective, they may also become more vague; and into such vagueness, mistaken for generality, any meanings can be read. We will see, in the work of the artists of the *Blaue Reiter,* how such a desire for universal meaning can transform the nature of their art.

NOTES

1. The *Chronik* was written in 1913. It is reprinted in Lothar-Günther Buchheim, *Die Künstlergemeinschaft Brücke* (Feldafing: Buchheim-verlag, 1956), pp. 102–104. In a sense the *Brücke* discovery of the primitive was antedated by Kokoschka's enthusiasm for Oceanic art, which he found in Vienna's ethnological collections about 1902. But Kokoschka was still in secondary school and not yet an artist. *Cf.* Edith Hoffmann, *Kokoschka: Life and Work* (London: Faber and Faber, 1947), p. 26.

2. *Cf.* Chap. I, Part 1, p. 3. The quality of objects in the German museums was well above that of the pieces in French commerce until after the War.

3. Emil Nolde, *Das Eigene Leben* (Berlin: Julius Bard, 1931), p. 158. Nolde's opinion of primitive arts in general is worth recording:

Als etwas Besonderes, wie eine Mystik, stand vor mir die Kunst der Aegypter und Assyrer. Ich konnte sie nicht, wie damals fast allgemein, als "geschichtliche Objekte" nur werten, ich liebte diese grossen Werke, wenn auch es war, als ob ich nicht duerfe. . . . Das folgende Jahrzehnt brachte Einsicht und Befreiung; ich lernte die indische, chinesische, die persische Kunst kennen, die primitiven seltsamen Erzeugnisse der Mexicaner und die der Ur und Naturvoelker. Diese waren mir nicht mehr nur "Kuriositaeten," wie die Zuenftigen sie benannten, nein, wir erhoben sie zu der Kunst, die sie ist, beglueckende herbe Urkunst, und das war herrlich. Der Wissenschaft der Voelkerkunde aber sind wir heute noch wie laestige Eindringlinge, weil wir sinnliches Sehen mehr lieben als nur das Wissen. Auch Bode war noch grosser Gegner kuenstlerischer Geltung des Urprimitiven.

*Cf.* also Nolde's *Jahre der Kaempfe* (Berlin: Rembrandt-verlag, 1934), pp. 172–173, where he quotes from his 1912 notes for an introduction to an (unpublished) book on primitive art.

4. Pechstein was the only one of the group to collect African art extensively, beginning almost immediately after his introduction to it. Karl Schmidt-Rottluff did not appreciate it until later. Pechstein's attitude always remained external and aesthetic; in contrast to Gauguin's symbolic projections his paintings of the Palau Islands (1913–14) are "folkloristic reportage with ethnographic indications." Pechstein's work also has in it many other influences: Matisse, Van Gogh, and the cubists. Directly influenced by Gauguin was Paula Modersohn, in Paris in 1903; she follows both his formal simplifications and his romantic-symbolic painting of peasant types. The Worpswede community of which she was a part had many primitivising elements. Its desire to draw strength from a return to native soil was carried over further in the Bavarian group of *Die Scholle*.

5. Nolde's preferences—Courbet, Millet, Manet—and his dislikes—the eighteenth century, the impressionists—are characteristic. *Cf.* Nolde, *Das Eigene Leben*, pp. 143–145.

6. See also *Still-life (Mask, Head, and Green Animal)* (1913), in which the mask and animal are perhaps African; and *Strangeness* (1923), in which there is a New Guinea influence in the birdlike features of the faces.

7. These qualities also occur in the portraits, such as *Artists* (1919) and *Young Couple* (1920).

8. See below, section on the *Blaue Reiter*.

9. The kind of sculpture and masks appearing in Nolde's work is that of German (now Australian) New Guinea (*Strangeness*, 1923). Two of the pieces in *Masks* (1920) are from the Cameroon. Two pieces of sculpture, Schmidt-Rottluff's *Head* and Pechstein's *Squatting Figure*, show a knowledge of the forms of Baluba (Congo) heads and masks.

10. *Cf.* the carved posts and lintel now in the Berlin Museum, reproduced in Eckhart von Sydow, *Die Kunst der Naturvoelker und der Vorzeit* (Berlin: Propylaen-verlag, 1923), Plate 116.

11. The best work of the primitive peoples is, on the contrary, characterized by a careful attention to surface and a high state of finish, since the details have precise iconographic significance.

12. Note the work of Brancusi, of Derain, of Maillol, of Modigliani. Epstein's variations are purely of texture.

13. On the Ivory Coast and in the Cameroon metal and wood are combined; in the Cameroon beads and wood; elsewhere in Africa shells and

wood. The most diverse combinations of Oceania are those of New Britain and New Ireland.

14. This precision of reference is not often realized by the modern connoisseur; the art of the Bakuba and of Easter Island are examples. Here, as elsewhere, full knowledge might detract much from our present appreciation.

15. See above, Chap. III, The Fauves.

16. *Cf.* Schmidt-Rottluff's *Moonlight* (1919), *Women in Greenery* (1919), etc.

17. W. Grohmann, *E.L. Kirchner* (New York: Arts, 1961), pp. 30–32.

18. The same vague mysterious quality is present in such pictures as Nolde's *Child and Large Bird* (1912) and *Strange Conversation* (1916).

19. See above, Chap. II. One of the 1911 *Mask* paintings is perhaps influenced by Ensor.

20. Compare Heckel's *Dying Pierrot* (1912), with its squeezed mannerist composition and its relation to a *Descent from the Cross,* with any French work.

21. At its inception, the *Brücke* also attempted a similar association of its artists as had the Nazarenes and the pre-Raphaelites. The Worpswede group also tried to set up a community.

22. Both, nevertheless, go back to what they consider the human qualities at the base of their religions.

23. Emil Nolde, *Jahre der Kaempfe*, p. 44.

24. It is interesting to compare these portraits with Gericault's studies of mad people where the interest is in the objective rendering of an external countenance. The interest has been reversed.

25. Munch's first success came with the *Sezession* of 1902. In 1906 he did the decorations for Ibsen's *Ghosts,* produced in Berlin by Reinhardt. *Cf.* Curt Glaser, *Munch* (Berlin: B. Cassirer, 1917), pp. 36, 67.

26. *Cf. Potsdamer Platz* (1913), *Fuenf Frauen in der Strasse* (1913) and *Lungernde Maedchen* (1911) where this technique has been used, and contrast these with the drawings: *Zwei Maedchen im Hause* (1906), *Trauriger Kopf* (1906), where the contours have been picked out with a single line.

27. *Cf. Moonlight* (1919). The influence of children's methods of composition also appears: *Fishermen with a Boat* (1919). Kirchner liked to emphasize the relationship of his mature work to his childhood drawings by showing them together.

28. *Cf.* the preface to the *Berliner Sezession Schwarz-Weiss Ausstellung:* November, 1911:

> Wir wollen im Gegenteil (to position that only recognizes the 'deutlich zu Ende gefuehrte') auch all das Kuenstlerische und Interessante, was in den ersten Entwurfen und Studien . . . liegt, an die Oeffentlichkeit bringen. So haben wir das Publikum gelehrt, der Kunst in ihren ersten Stadien der Entwicklung . . . nachzugehen und sie zu beobachten.

29. *Cf.* Kirchner, *Chronik der Brücke,* in which he mentions German fifteenth- and sixteenth-century woodcuts as having been part of his artistic education. Buchheim, p. 102.

30. The idea that simple effects which do not approach those of other media are "proper" to the woodcut is in itself a modern idea; older artists developed all the possibilities of detail. The whole attitude of simplicity

due to "truth to the material" (to be found also in modern architecture and sculpture) has certain primitivist implications.

31. C. Ricci, *L'Arte dei Bambini* (Bologna: 1887), was translated into German in 1906: *Die Kinderkunst* (Leipzig: 1906), and this was the beginning of much interest in the artistic education of children; notable experiments were in Munich. *Cf.* Helga Eng, *The Psychology of Children's Drawings* (New York: Harcourt, Brace, 1931).

32. Georg Marzynski, *Die Methode des Expressionismus: Studien zu seiner Psychologie* (Leipzig: Klinkhardt & Biermann, 1921), pp. 39–41. Marzynski divides all art, from that of children on, into the "copying" and the "symbolic."

33. G. Johannes von Allesch, "Die Grunkraefte des Expressionismus," *Zeitschrift fuer Aesthetik und Allgemeine Kunstwissenschaft*, XIX (1925), pp. 112–120. And Max Dessoir, *Appendix* to the above, pp. 118–119.

> Zunaechst scheint mir, dass der Herr Vortragende nicht genuegend die dem Expressionismus eigne Rueckkehr zur Primitivitaet betont hat. Diese Rueckkehr ist ja nicht dadurch bedingt, dass die Formen- und Farbengebung der Primitiven besonders ausdruckskraeftig ist, sondern sie Entspricht dem Drange, der sich auf vielen Gebieten unseres gegenwaertigen Lebens bemerkbar macht: Wurzelhaftigkeit, Urspruenglichkeit, unverstuemmelte Erlebnisfaehigkeit zurveckzuerobern. Dieses Streben nach Urspruenglichkeit liegt den von Herrn v. Allesch hervorgehobenen zwei Hauptsabsichten der expressionistischen Kunst zugrunde . . .

*Cf.* also Wilhelm Waetzoldt, *Appendix* to the same:

> Der Expressionismus kennzeichnet sich als eine romantische Bewegung durch seinen Drang zur Elementaritaet. Wieder ist das Elementare, Primitive, das Zeitlichferne und Raeumlichweite, weil es den unverstellten, reinen und starken Ausdruck zu tragen scheint, das Ziel der Kuenstlerischen Sehnsucht. Was fuer die Romantik des anhebenden 19. Jahrhunderts das Mittelalter war, ist heute Orient, Eiszeit, Bauren-, Kinder- und Negerkunst.

We will return to both the relation of primitivistic art to the primitive, and of primitivism to romanticism in the last chapter. Intensity and simplicity of emotion have no necessary connection; romanticism looks to the sublime rather than to the elemental.

# The Primitivism of the Blaue Reiter

In continuing the discussion of emotional primitivism we do more than move from the north of Germany to the south, and from a group which took form in 1906 to one which had

its official beginnings in 1911. The painters of the *Blaue Reiter* knew a wider selection of aboriginal styles, were more conscious of their kinship with a variety of primitive and exotic arts and more articulate about that kinship than were the artists of the *Brücke*. How closely the relation which they expressed at length in their writings was adhered to in their pictures we shall have to examine. In many respects, however, their primitivism, though it does not stem from it, continues the primitivism of the Dresden group. We have seen that in relation to the attitude of Gauguin and to a lesser extent to that of the *fauves,* who had already expanded Gauguin's position, the elements from which the *Brücke* was influenced and the means through which it expressed its primitivism were both closer to the artist and of a wider, more general application. This double process of interiorization and expansion is further carried on by the painters of the *Blaue Reiter,* is carried (at least in this particular line of development) as far as it is possible for any modern artist to go.

The best indication of the acquaintance of the Munich group with primitive art and of their appreciation of its various manifestations is to be found in its elaborate manifesto, (edited by Kandinsky and Marc in 1911 and published in 1912), from which the group derives its name.[1] There, in addition to examples of their own work and that of their French contemporaries whom they admired, we find illustrations of figures from New Caledonia, the Malay Peninsula, Easter Island, and the Cameroons; a Brazilian mask, and a stone sculpture from Mexico; a Russian folk statuette and Russian folk prints; Egyptian puppets and an archaic Greek relief; Japanese woodcuts, Bavarian glass painting of the fifteenth and sixteenth centuries, and German nineteenth century folk pictures; a thirteenth century head of a stone cutter, fourteenth century tapestries, and a Baldung-Grien woodcut. In addition there are European and Arabian children's drawings and water colors, and many popular votive pictures. Such a diverse array of arts that are con-

sidered primitive or are for some reason, as we shall see, thought of as allied to the primitive, demonstrates an acquaintance and an interest in the history of art far beyond that of the members of the *Brücke*. It indicates further some principle of appreciation which—while it may in part contain elements of the curio-collecting of Vlaminck, the violent emotional interest of the *Brücke,* or the formal apprehension of primitive style peculiar to nascent cubism—must go beyond any of these in order to unite such a diversity of artistic expression. That the selection is not simply a haphazard one is shown by the absence of any examples of arts that might be considered developed or sophisticated. We wish to discover what brings all these objects together as "primitive."

The relation which the artists of the group felt toward these examples of "primitive" art, and the manner in which they themselves judged their appreciation, may best be gathered from extracts from their own writings. A trip to Vologda province, while he was still a student at Moscow University, had first suggested to Kandinsky that "ethnography is as much art as science." But the decisive experience was the "great impression" made upon him by the African art which he saw, in 1907, at the Berlin ethnographic museum.[2] In January, 1911, shaken by his study of African and Peruvian sculpture in the same museum, Franz Marc wrote to Auguste Macke: "We must be brave and turn our backs upon almost everything that until now good Europeans like ourselves thought precious and indispensable. Our ideas and our ideals must be clad in hair shirts, they must be fed on locusts and a wild honey, not on history, if we are ever to escape from the exhaustion of our European bad taste."[3]

In 1910, also before the formation of the Munich group, Kandinsky expresses himself thus, in the book later published as *The Art of Spiritual Harmony:*

> When there is a similarity of inner tendency in the whole moral and spiritual atmosphere, a similarity of ideals, at first closely pursued but later lost to sight, a similarity in

the inner feeling of any one period to that of another, the logical result will be a revival of the external forms which served to express those inner feelings in an earlier age. An example of this today is our sympathy, our spiritual relationship with the Primitives. Like ourselves, these artists sought to express in their work only internal truths, renouncing in consequence all consideration of external forms.[4]

We have already seen the essentials of this attitude in Nolde's estimate of his own aims, but this is the first time that it has been directly applied in the judgment of primitive art.[5] It will have been noticed that in the illustrations of the *Blaue Reiter* children's art appears for the first time on exactly the same basis as the primitive. For though the *Brücke* was influenced by the technique of children's art, this is the first time that we find an express appreciation of its qualities and of the reasons for their importance to the modern artist. These Kandinsky explains in an article in the *Blaue Reiter:*

> In addition to his ability to portray externals, the talented child has the power to clothe the abiding inner truth in the form in which this inner truth appears as the most effective. . . . There is an enormous, unconscious strength in children, which here expresses itself, and which places the work of children on as high (and often on a higher) a level as that of adults. . . . The artist, who throughout his life is similar to children in many things, can attain the inner harmony of things more easily than others. Christ said: "Suffer the little children to come unto me, for theirs is the kingdom of heaven."[6]

Kandinsky points out that it is here that the roots of the "new realism" lie, because the simple and naïve rendering of the shell of an object brings out its inner values.[7] Henri Rousseau, who "with a simple and convincing gesture has shown the way . . . and revealed the new possibilities of simplicity," is the father of this new realism. In *The Masks,* another article in the same manifesto, August Macke ex-

presses a similar appreciation of these arts, and the same neglect of external form:

> To hear the thunder is to feel its secret. To understand the speech of forms is to be nearer the secret, to live. To create forms is to live. Are not children creators who build directly from the secret of their perceptions, rather than the imitators of Greek form? Are not the aborigines artists who have their own form, strong as the form of the thunder? [8]

For this reason "the art forms of the peasants, of the primitive Italians, of the Japanese, and of the Tahitians" have the same exciting effect upon the artist as if they were forms of nature, perhaps an even greater effect, because of their lively expression. [9]

To carry out in one's own work the attitudes toward art of those whom we may perhaps group together under the name of "simple" people, as it is defined in the quotations we have given, requires no superficial copying of their form or subject matter. Rather it should find its expression in a relation of the artist to contemporary life similar to that of these other artists to their own environment. And in fact in the work of the members of the *Blaue Reiter* we find no secondary formal derivation from primitive, exotic, or archaic styles. The direct influences which are present are those of medieval religious art and folk art. This is most evident in the work of Heinrich Campendonk, who, himself a painter on glass, developed under the influence of votive pictures painted under glass, and of more recent peasant art. [10] This derivation of Campendonk's painting is shown not only in the subjects which he chooses, scenes of the farm, uniting in their iconography the most important elements of country life—cattle, fowl, farmhouse, and church all brought into the same canvas, as in *The White Tree* (1925)—or of idyllic landscapes which bring together people and animals, as in the *Bavarian Landscape* (1925). The composition of these pictures, the disproportion of the figures and their arrangement according to importance, the

placing of the figures in their broadest aspect, the perspec-
tive which puts objects above rather than behind, all indi-
cate their relation to folk art. And the "realistic" aspect of
the modeling—the careful indication of details such as the
veins of the leaves and the hooves of the animals—is proof
of the same influence.[11]

All this means that in these pictures Kandinsky's theory
of the parallel roles of the primitive and the modern artist
has been considerably overreached. In effect, the artist has
attempted to lose his own personality as part of a compli-
cated culture, and, by sinking it in his conception of those
folk craftsmen whose products he admires, to reproduce
(rather than to imitate) not only their techniques but also
their subject matter and the spirit of its interpretation. We
have come a long way from Gauguin's interpretation of
Breton peasant life in terms which lay outside of that life,
and from his desire to render the "simple" qualities which
he found in it. The artificiality of this aim lies not in a
misinterpretation of those qualities, natural to any sophisti-
cated observer, but in the very idea that the artist can be-
come other than an exterior observer of things of which he
is not really a part. Yet it is the direction taken, rather than
the desire itself, which constitutes the *Brücke's* primitivism.
It lies in the fact that, seeking the mystical essence of the
universe, these artists, instead of becoming one with the in-
finite, found that essence in the simple minds of peasant
folk or at least in those whom they considered as such, and
tried to interpret the world as such people interpret it.[12]

Kandinsky shied away from this sort of folkloristic identifi-
cation, although he was familiar with the folk art of Russia.
He believed that his 1889 Vologda expedition, plus his pre-
dilection for the "hidden and the mysterious," saved him
from the "bad influence" of folk art. For whatever reasons,
he was only momentarily attracted by such a style.

In the paintings of Campendonk there also appear wild
animals, animals shown idyllically at home in nature, at
peace with one another and with man. This is evidence of the

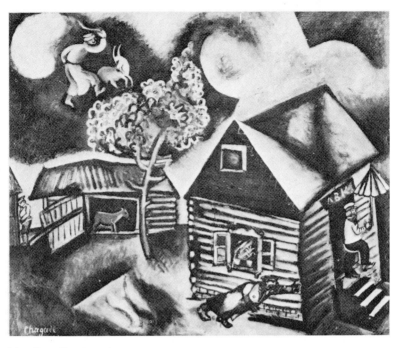

24   Chagall / *Farm Reminiscence*, 1911

25   Kandinsky / *The Cow*, 1910

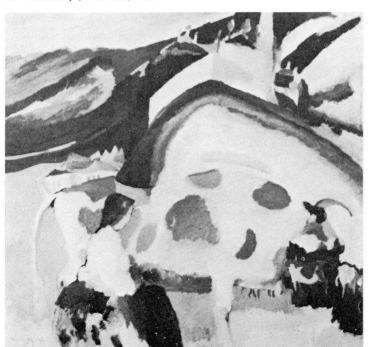

third important influence which helped to form Campendonk's art, that of his older contemporary, Franz Marc. In Franz Marc's letters, written during his years in the German army, there are indications of the desire to paint the world as it is felt by creatures other than himself. In this case, significantly, he attempts to identify his way of thinking, not merely with simple human beings, but with the manner in which animals perceive and interpret the world.

> Is there a more mysterious idea for an artist, than the conception of how nature is mirrored in the eyes of an animal? How does a horse see the world, or an eagle, or a doe, or a dog? How wretched, how soulless, our convention of placing animals in a landscape which belongs to our eyes, instead of sinking ourselves in the soul of the animal in order to imagine his perception . . .[13]

No exception can be taken, says Marc, to the artistic logic of a Picasso or a Robert Delaunay; each renders his own interior world, and does not bother really to "see" the object he paints. It is not, however, the exterior of the object that counts, this is given by science.

> The most important part of a thought is the predicate. The subject is its premise. The object is an unimportant afterthought making the idea special and banal. I can paint a picture; the roe; Pisanello has painted such. I can however also wish to paint a picture: "The roe feels." How infinitely sharper an intellect must a painter have, in order to paint this. The Egyptians have done it. The "rose." Manet has painted that. The rose "flowers." Who has painted the "flowering" of the rose? The Indians.[14]

It is among the Egyptians and the Indians that Marc finds affinities with what he wishes to do.

The measure of execution of such an intention is naturally difficult to judge, particularly by one who is neither beast nor artist. Purely technically, there is little which can be called its expression, nor are there any features traceable to the direct influence of the primitive as opposed to the folk arts. In Campendonk's pictures there are occasional at-

titudes of animals which recall palaeolithic wall paintings, as in the repetition of the bent legs, the line of the back and neck, and the general silhouette character of the doe in the *Bavarian Landscape;* but in Marc's renderings there is no echo of this early art.[15] Some influence of folk art is present, however, as witness for example the joyous cow given in broad-side in the foreground of *The Cows* (1911). The chief manner in which Marc's conviction is expressed, aside from the simple fact of the concentration of most of his work on the portrayal of animals, is in the linear and formal rhythm of his pictures. The animal bodies themselves have rhythms, sometimes staccato—as in the *Frieze of Apes* (1911)—but, more usually, smooth unbroken curves from one end of the body to the other, through which Marc tries to express the energy and vitality, the harmony and whole ness that he admires in the animal world and that for him set it apart from the psychological conflicts and social struggles of humanity. In the *Blue Horses* (ca. 1911) and the *Gold Horses* (1912) this expressive curve, which extends from muzzle to hindquarters, is repeated in each animal, so that there is an impression of unity of purpose and mood uniting the members of the group. The same continuity of spirit, expressed through continuity of design, determines the more angular forms of the *Frieze of Apes,* in which the movement proceeds from one beast to the other in an unbroken pattern.[16]

But the method through which Marc's intention is most clearly expressed is by the repetitions of contour in the shapes of the animals and the shapes of the landscape. In the famous *Red Horses* (1911) the contour of the hills in the background repeats, in its rise and fall, the undulations of the backs of the horses so that, with the heads of the horses excluded, the two are practically identical. One might say, in this picture alone, with its open spaces and its clear separation of the animals from the landscape, that this is simply a method of composition such as other painters have used, and carries with it no further intention.[17] From

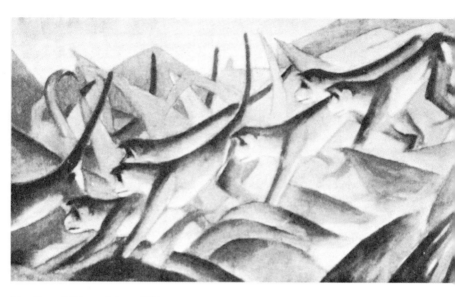

26   Marc / *Frieze of Apes,* 1911

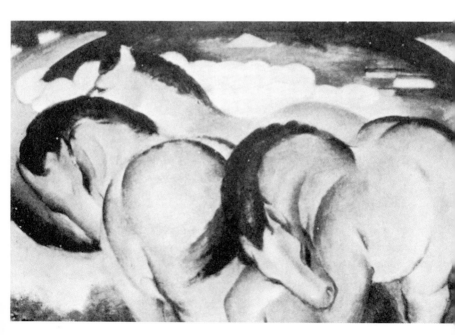

27   Marc / *Gold Horses,* 1912

an examination of other pictures, however, in which the set-
ting is crowded in upon the forms of the beasts so that the
two merge into a single rhythmical whole or into a single
movement which is the chief if not the sole formal impres-
sion of the canvas, it becomes evident that Marc wishes to
convey the unity of beast and nature, for in his vision "the
entire life and being of animals seemed to be part of an
existing natural order." In both the *Blue Horses* and the
*Apes* this is so much the case that the separation of the
animals from the natural forms—when it is accomplished by
the observer—does not change the total formal effect of the
picture, though it is indispensable for the grasping of Marc's
intention. The unity is further conveyed by the identity of
coloring throughout the picture, while at the same time the
abstract quality and its symbolic intention are heightened
by the arbitrary coloring and its freedom from nature.
Marc's purpose here is to express a pantheistic conviction,
to convey the underlying harmony on the universe, lost by
modern man, in symbolic canvases "that belong on the altars
of the coming spiritual religion." [18]

The general trend of Franz Marc's painting in the re-
maining five years of his life is toward an abstract art. In
view of his desire for a direct expression of inner truths and
his judgment of man as ugly, this would not be surprising,
even without the influence which we know came from his
fellow artists.[19] It is characteristic, however, and demon-
strates the connection of what Marc himself recognized as
an inner constraint to the abstract with the primitivistic de-
velopment we have been outlining, that he should at the
same time have wished to have a close relation with the folk
and with folk art. "Artists are only the interpreters and ful-
fillers of the will of the people," he says; and deploring that
at present the people do not want anything, he combats the
naturalistic art of the nineteenth century in order that "folk
art, that is the feeling of the people for artistic form" may
once again arise.[20]

In contradistinction to Campendonk, the wish for a fu-

ture folk art rarely expresses itself in Marc's work by the copying of folk arts of the past. In the *Yellow Cow* (1911) and in the *Poor Land of Tyrol* (1913), with its childlike horses and abbreviated landscape symbols, something of the folk influence does come through, but these are isolated instances. Though influenced by the work and theories of his friend Kandinsky, and even more by those of Delaunay— whose paintings had been included in the 1911 exhibition as an example of the "great abstract" tendency, and whose writings Paul Klee translated—Marc's pictures do not lose their connection with his previous artistic intentions, but rather, in the formalistic straightening of their lines and the simultaneous breaking up of animal and landscape forms into an almost indistinguishable planar pattern, carry further the merging of the organic unit with the essential rhythms of the world as a whole.[21] This is in itself a mystical rather than a primitivistic aim, a desire to give symbolic form to the "underlying mystic design" usually hidden by surface appearance; but Marc's preoccupation with animals, and his concentration upon their mystical union with the universe to the exclusion of any human subject matter, justifies an emphasis upon the primitivist aspects of his mysticism.[22] In his last work, however, these aspects are increasingly confined to the meaning and intent of the pictures, which, formally, become more variegated and elaborated. Thus the most important painting of the period, *Animal Destiny* (1913), goes far beyond any of the more naturalistic works of 1911 in the complication of its linear pattern; yet the indistinguishable intermingling of stylized animal and natural forms is meant to express the same pathetic union with the animal soul as did those pictures. That such is indeed Marc's purpose can be seen from the very titles of the *Dog Before the World* (1912), *The Fear of the Hare* (1912), and the *World-cow* (1913) in which, as in *Animal Destiny*, human longings and imaginings and the desire for mystical oneness with the universe have been read into the animal bodies.

In patterns of color, as well as in abstract design, Marc's art at the time of his death was moving closer to the "object-less" painting of Kandinsky, with whom he had been in contact since 1911.[23] In asking to what extent these first abstract "compositions" and "improvisations" of the older artist are primitivist, we must make a double distinction.[24] In the first place, they are not primitivist in the sense of having a simple, undivided form without interior complication and differentiation. The color harmonies are subtle, many colors are used, and the balance of lines and forms has in it several elements; lines are clean and careful and the whole is highly finished. Nor is the search for the fundamental bases of art which Kandinsky has expressed in his two books, *Ueber das Geistige in der Kunst* and *Punkt und Linie zu Flaeche,* in itself necessarily primitivist.[25] Others before have searched for the fundamentals of art without thereby being primitivist. Line is one of the elements of art, and the circle and the square are pervasive forms in the geometrical analysis of nature as well as of painting.[26] In the importance he gave to these forms—both as direct abstract experiences and as symbolic equivalents of the creative forces and the structure of the universe—Kandinsky was greatly influenced by Oriental, especially Indian philosophy, ideas (whether learned at first or second hand) which were very much in the air in both Russia and Germany.

It is rather the emotional tenor of the analysis that Kandinsky gives, his attribution of stresses and strains to lines themselves instead of to their effect upon the beholder, the inner kinship which he established between certain lines and colors, the "spiritual" affinity between colors, temperatures, and certain states of mind, his "silent" colors and his lines which have no desire to leave their surface, which are primitivist in their tendency.[27] For all the intellectuality of his analysis, with its careful building up from smaller elements to a diversified superstructure and its distinctions and parallels, Kandinsky's final purpose is not only anti-intellectual, but more than that, it is opposed to the separation of

emotional variations and nuances. It is not a series of ro-
mantic emotional experiences resulting from the interplay
of the most elaborated and finest-spun faculties of imagina-
tion and intellect for which Kandinsky is striving, but rather
the sinking and losing of the whole personality in a single
emotion. The analogy of Bergsonian philosophy, to which
we have referred in our discussion of the painting of the
fauves, does not come to mind by chance in connection with
an art outwardly so different:

> Reason was discovered to be incapable of grasping true real-
> ity, which one tried to penetrate with the aid of intuition.
> . . . Intuition permits one to see everything at once, instead
> of by a summation of parts. . . . Thus, in a manner analo-
> gous to that of philosophy, art hopes . . . to give absolute
> views, to seize the eternal.[28]

The analogy is à propos here, as it was with the fauves,
because here too the intention is to do away with "the ac-
quired means" in favor of an appeal to fundamental ele-
ments in human nature, and to appeal to them in their
undeveloped, undifferentiated form.[29] The quotations which
we have given at the beginning of this section show that
Kandinsky was not unaware of this primitivizing tendency,
though he states it in the rather misleading form of an affin-
ity with true "primitive" art. We may give one further pas-
sage:

> Just as art is looking for help from the primitives, so these
> men (who renounce materialistic science) are turning to
> half-forgotten times in order to get help from their half-
> forgotten methods. . . . Frau Blavatzky was the first person
> . . . to see a connection between these "savages" (the In-
> dians) and our "civilization." [30]

Much the same attribution of pathetic qualities to line
and color symbols characterizes the explanations of Paul
Klee's Paedagogisches Skizzenbuch.[31] In accordance with the
greater influence on Klee of children's art, to which we will
return in a later section, Klee's symbols remain more intellec-

tual in that they must be grasped as individual wholes before they can be understood. Thus the arrow, important in Klee's theories and in his art, made up of a combination of lines and colors, must be seen as a unit before it can carry its message to the beholder, even though its "father is the thought." [32] Similarly the other symbols of air, water, and earth, simplified as they are in their rendering, correspond more closely to the child's "intellectual" grasp of them as unit meanings than do elements such as Kandinsky's which have a more direct and immediate access to the emotions of the spectator. Klee's art has also its purely mystical side, as his liking for the writing of the German romantics confirms, and as the undetermined way in which he uses his childish symbols so that they may give rise to uncontrolled revery indicates; but the very use of these symbols, as Marc's use of animals, demonstrates a valuing of the simple as such and for itself.[33]

With this symbolic animism, whose relation—true or false —to that of more primitive peoples was quite consciously realized by the painters of the *Blaue Reiter,* the process of interiorization and expansion of primitivizing elements is carried as far as may be along emotional lines.[34] Beginning with a wider and more sophisticated acquaintance with exotic and primitive arts than had the members of the *Brücke* group, the artists of the Munich association try to unite the search for human fundamentals with a search for corresponding fundamentals in the universe outside. The primitive arts from which they draw a stimulus includes fields which are as far removed as are certain of those of the *Brücke* group, yet they also include folk arts which are closer to home than any naïve art which had thus far provided inspiration. At the same time, while their animal and folk subject matter is more specifically primitive in its limited reference, their painting is technically subtler and more complicated than either that of the *fauves* or of the *Brücke;* while the fundamental emotions to which they appeal are both vaguer and more general. The general emotional basis

of human nature has replaced the specific, violent primitivizing emotions of the *Brücke,* finally resulting in a fusion of an emotional primitivizing and an emotional pantheism. Further than this, as we have seen with the *fauves,* who arrived at much the same position by a different road, the broadening of the primitivizing base cannot go. We must therefore continue our study of primitivism among those artists who hoped to find the common denominator by intellectual means.

NOTES

1. Franz Marc, and Wassily Kandinsky, eds., *Der Blaue Reiter* (Munich: R. Piper, 1912). Already prepared in November, 1911; *cf.* Alois J. Schardt, *Franz Marc* (Berlin: Rembrandt-verlag, 1936), p. 103. Its writing thus precedes the first *Blaue Reiter* exhibition of December, 1911. At about this same time, the Viennese Egon Schiele, visiting Klimt in his house in Hietzing (to which Klimt moved in 1911), noted his large collection of exotic art: "Around the room were hung in close proximity Japanese woodcuts and two large Chinese paintings. On the floor lay Negro sculptures, in the corner by the window stood a red and black Japanese armor." Quoted in Arthur Roessler, *Errinerungen an Egon Schiele* (Vienna, 1922), pp. 50–51.

2. Kandinsky, in a 1930 letter to Paul Westheim, reprinted in Max Bill, ed., *Essays über Kunst und Künstler* (Stuttgart: 1955), pp. 123–128.

3. Quoted in Werner Haftmann, *The Mind and Work of Paul Klee* (London: Faber, 1954), p. 53.

4. W. Kandinsky, *The Art of Spiritual Harmony.* Trans. by M.T.H. Sadler (London: Constable, 1914), p. 6. Written in 1910; published in German in 1912. It must be noted that Kandinsky holds that "the Primitive phase . . . with its temporary similarity of form, can only be of short duration."

5. It should be remarked that for certain types of primitive art at least —*e.g.* the Bakuba of the Congo, and the Maori of New Zealand—"consideration of external form" that is, the exact rendering of realistic detail, is of the utmost importance.

6. W. Kandinsky, "Ueber die Formfrage," *Der Blaue Reiter,* pp. 92–93.

7. *Ibid.,* p. 94. "Henri Rousseau, der als Vater dieser Realistik zu bezeichnen ist, hat mit einer einfachen und ueberzeugenden Geste den Weg gezeigt."

8. A. Macke, "Die Masken," *Der Blaue Reiter,* pp. 21–22. See also G. Biermann, *Heinrich Campendonk* (Leipzig: Klinkhardt & Biermann, 1921), pp. 6–7.

9. Macke, *op. cit.,* p. 23. *Cf.* also, in answer to a questionnaire, Macke, "Das neue Programm," *Kunst und Kuenstler,* XII (1914).

10. Biermann, *op. cit.,* p. 5.

11. In his attempt to assimilate the folk spirit, Campendonk went to live among the Bavarian peasants, and lead a peasant life.

12. The art of Marc Chagall, admired by the followers of the *Blaue Reiter* (*cf.* Herwarth Walden, *Einblick in Kunst* (Berlin: Der Sturm, 1924), *passim*, has no basis in a plastic folk tradition, though much of it is inspired by the legends of Chagall's native Witebsk, particularly those pictures painted after his return to Russia in 1917. Its individual elements are allied rather to children's art (*e.g. The Enclosure*, 1926), combined on a personal dream basis, except where the iconography is directly given by the inspiring legend.

13. Franz Marc, *Briefe* (2 vols.; Berlin: Cassirer, 1920), I, p. 121.

14. *Ibid.*, I, p. 122.

15. The parallels drawn between Marc's animals and those of Altamira (W. Paulcke, *Steinzeitkunst und Moderne Kunst* (Stuttgart: Schweizerbart, 1923), p. 40, do not seem to me to be accurate. In *The Bull* (1911) there is only the most superficial resemblance of posture. The same is true of some of Kandinsky's shorthand methods, as in *Lyrisches* (1911).

16. Other examples are *The Small Blue Horses* (1911), *The Small Yellow Horses* (1912), *The Tower of Blue Horses* (1913).

17. Nicholas Poussin is perhaps the outstanding example of the use of this method of composition; even he employed it to express a unity of "mode." Marc's nudes of this time confirm the influence from Cézanne suggested by this landscape, and the "classic" Cézanne was of course related to Poussin.

18. The theories of color attributed to Marc by Schardt (*op. cit.*, pp. 74–77), in so far as any conscious use was made of them by Marc, derive from Kandinsky; later there was the influence of Delaunay.

19. *Cf.* Marc's letter of April 12, 1915; quoted by Schardt, p. 140:

> Ich empfand schon sehr frueh den Menschen als haesslich, das Tier schien mir schoener, reiner, aber auch an ihm entdeckte ich soviel Gefuehlswidriges und Haessliches, so dass meine Darstellung instinktiv, aus einem inneren Zwang, immer schematischer, immer abstrakter wurde.

20. Aphorism No. 31, quoted by Schardt, *loc. cit.* Article in *Pan*, March 21, 1912, quoted by Schardt, p. 104. *Cf.* also letter of September 8, 1911, to Auguste Macke, in which folk art is discussed as showing the artist how to unite again with the people.

21. Some examples are: *Tiger* (1912); *Doe in a Monastery Garden* (1912); *Leaping Horse* (1912); *Interior of Wood with Birds* (1913). *The Wolves [Balkanwar]* (1913), seems to be influenced by Kandinsky's *Lyrisches* (1911).

22. *Cf.* letter of April 12, 1915, to his wife:

> Der unfromme Mensch, der mich umgab (vor allem der maennliche), erregte meine wahren Gefuehle nicht, waehrend das unberuehrte Lebensgefuehl des Tieres alles Gute in mir erklingen liess.

For a study of similar "animalitarianism" see George Boas, *The Happy Beast in French Thought of the Seventeenth Century* (Baltimore: Johns Hopkins Press, 1933).

23. For example: *Sunrise* (1914); *Cheerful Forms* (1914).

24. Kandinsky's first purely abstract compositions probably date from 1911, although the date is sometimes given as 1910. *Cf.* A. H. Barr, Jr., *Cubism and Abstract Art* (New York: Museum of Modern Art, 1936), p. 64.

25. W. Kandinsky, *Ueber das Geistige in der Kunst* (Munich: Piper, 1912); *Punkt und Linie zu Flaeche* (Munich: Langen, 1926).

26. For an intellectually primitivist employment of the same kind of analysis, see the following chapter.

27. Kandinsky, *Punkt und Linie* . . . , Chap. I, *passim.*

28. Will Grohmann, *Kandinsky* (Paris: Cahiers d'art, 1930), p. xvi. For a mystical feeling about raw material, see the Kandinsky, *Selbstbiographie* (Berlin: Der Sturm, 1913), *passim.*

29. In *Punkt und Linie* . . . , p. 7; Kandinsky explains that if art is to be rescued it will not be by going to the past, as the French have done, but by the ability of the Germans and Russians "in die tiefen Tiefen absteigen."

30. Kandinsky, *The Art of Spiritual Harmony,* pp. 27–28.

31. Paul Klee, *Paedagogisches Skizzenbuch* (Munich: Langen, 1925), *passim.*

32. *Ibid.,* III, p. 26.

33. Note the influence on Klee of the German romantic Christian Morgenstern, beginning in 1911. Klee's liking for the Byzantine (trip to Italy, 1901, Ravenna) can hardly be held to be primitivistic.

34. For confirmation of this, *cf.* Johannes Molzahn, "Das Manifest des absoluten Expressionismus," *Sturm,* X (1919), No. 6, p. 98.

@ @ @ @ @

# V  Intellectual Primitivism

## The Direct Influence
## of Primitive Sculpture

The influences of primitive art upon modern painting so far
examined have not been direct formal borrowings. Gauguin
employed subject matter from the South Seas, and adapted
individual figures from Indian art; and in Germany artists
drew inspiration from the primitive, and painted "primi-
tive" or naïve scenes. With the exception of a very few of
Gauguin's sculptures there was no study of the form and
composition of aboriginal sculpture, and none of the artists
we have discussed tried to reproduce its aesthetic effects.
The closest approach to such an attitude was the relation of
the *Blaue Reiter* group—notably Marc and Campendonk—
to the folk art of their native Bavaria, although even here
their apprecation was largely determined by a romantic no-

tion of the value of popular art, unaffected by the particular form the art might take. The approach of the artists whom we have thus far considered has, in other words, been dictated by a bias toward the idea of the primitive as such which predisposed them to value primitive works of art as the symbolic products of primitive peoples. The strength of this indirect approach and the extent of its domination are well indicated by the fact that it has been possible to begin our discussion of each group with quotations from the artists themselves concerning the appreciation and value of the primitive and their ideas about it.

With the artists whom we will consider in this section such an analysis is not possible, because there is no writing with which to deal.[1] This lack reflects attitudes different from those of the men already discussed. It means that the contact with primitive art is now directly through the objects themselves, whose individual effects of form and expression are studied apart from any general ideas about the primitive outside of its manifestations in art. Their intention, indeed, was to limit themselves even within this field, and to consider only the formal aspects of primitive work, disregarding not only its particular iconographical significance, of which they were entirely ignorant, but also the more general emotional expression and the effect induced by the form and composition of the objects that they knew. This intention was not, as we shall see, completely carried out, and there was a more definite emotional connection with African art than the generalized "poetic suggestion" which was all that Guillaume Apollinaire (thinking in the same sort of terms as had Vlaminck), as much as ten years later, could discover in the "fetishist sculpture of the Negroes."[2]

There have been conflicting accounts of when and where Picasso first encountered African sculpture. He himself, after an ironic affirmation of total ignorance, said that he first came across it in 1907 on a chance visit to the Trocadéro, and only after he had finished the *Demoiselles d'Avignon*. Vlaminck wrote that both Matisse and Picasso

first saw African art in Derain's studio. However, Matisse told André Warnod that he was in the habit of buying African sculpture in a shop in the rue de Rennes, and that shortly after they met in the fall of 1906 he showed Picasso a just-acquired piece, the first Picasso had ever seen. Since Gertrude Stein, at whose apartment this occurred, confirms the account, it can be accepted as accurate. It is possible that the Trocadéro visit did take place in the spring of 1907 while Picasso was working on the *Demoiselles,* and that only then did Picasso feel the impact of African art.[3]

The range of Picasso's acquaintance with the various African styles is still a moot question.[4] His paintings are evidence that he knew the wooden sculpture and masks of the Ivory Coast and the metal-covered grave figures of the Gabun. His few sculptures in wood of 1907, although clearly under some primitivizing inspiration, give no evidence of specific stylistic sources. Though there are references in later writings by his close associate Apollinaire, none too accurate in their geographic allusions, to the sculpture of the Congo, the discernible reminiscence in Picasso's art is much less conclusive evidence.[5] It is unlikely that he knew the work of the Cameroon grasslands, the sculptural tradition which in certain respects was the closest of any in Africa to the formal effects that Picasso was striving for.[6] Picasso early began a collection of African art—with the exception of Matisse the only artist of this time to do so on any considerable scale. Gómez de la Serna notes that there were African and Oceanic "idols" in Picasso's atelier in the Bateau Lavoir. Fernande Olivier recalls that his studio in the Boulevard de Clichy (where he lived from 1909 to 1912) was filled with *bois nègres* which he had begun to collect several years before: "Picasso was mad about them, and statues, masks, fetishes of all the African regions piled up in his studio. The hunt for African works became a real pleasure for him." There are photographs of his studio, and also of Braque's atelier, showing African masks hanging on the walls.[7] It is not without significance that at the same time he was hang-

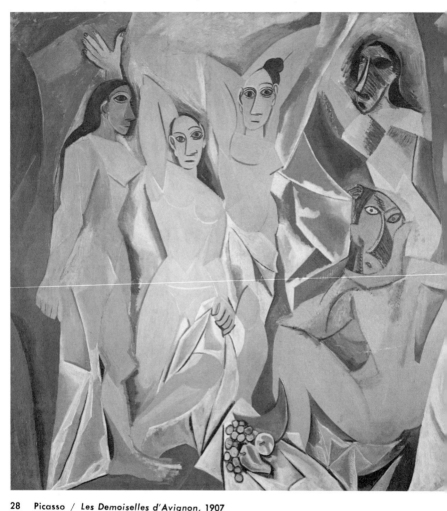

28    Picasso / *Les Demoiselles d'Avignon,* 1907

ing the paintings of the Douanier Rousseau, paintings which certainly have no formal relationship to African art and whose emotional relationship, which we will presently examine, it is now difficult for us, with a greater knowledge of primitive sculpture, to see.[8]

It is clear that some time during the spring of 1907, at the latest, Picasso became aware of African sculpture. The pictures of the period bear this out. The *Demoiselles d'Avignon,* or at least its two right-hand figures, even more so the studies connected with it and a group of related paintings of 1907, all attest to his familiarity with at least two African styles: Ivory Coast (especially Dan) masks, and copper-covered guardian figures of the Bakota tribe of the Gabun.[9]

In a way, however, Picasso had already been prepared for the shock of African sculpture and its stylizations. In the spring of 1906 the Louvre put on exhibition a group of late Iberian reliefs from Osuna; and, as James Johnson Sweeney has pointed out, it is from at least one of them that the facial features of the three left-hand figures in the *Demoiselles* are adapted.[10] The lozenge-shaped eye, with its heavily circumscribed lids and large dark pupil is especially characteristic, as well as the emphasis on the flat plane of the long straight nose. This "Iberian" influence appears first in the *Portrait of Gertrude Stein,* which Picasso partially repainted in the autumn of 1906 after returning from Gosul. It is the source of the simplified eyes—curiously blank in their expression—and it explains, in the 1906 *Self-Portrait* with a palette the similar modeling and effect of the eyes, which at the same time seem perfectly appropriate to the rendering of Picasso's own large round eyes. The left-hand figure of the *Two Nudes* (1906) also has these same features, as well as an arrangement of the hair which repeats the ovoid forms; and the *Woman in Yellow,* painted in 1907 when Picasso already knew African sculpture, continues the "Iberian" style, though now perhaps fused (as Alfred Barr has noted) with the stylizations inspired by Africa. Thus the short-lived "Iberian" style leads into the "Negro" paintings,

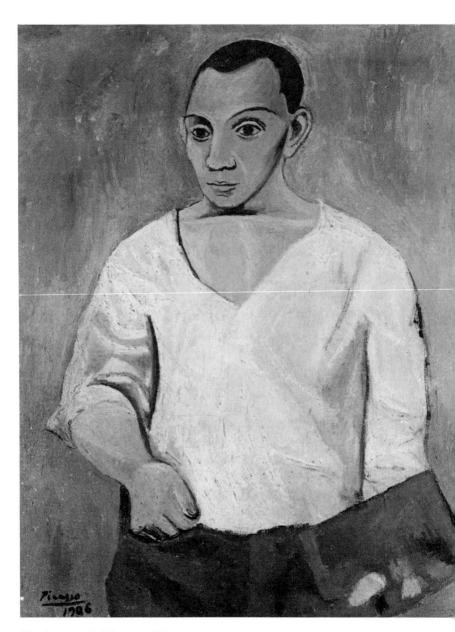

29   Picasso / *Self-Portrait*, 1906

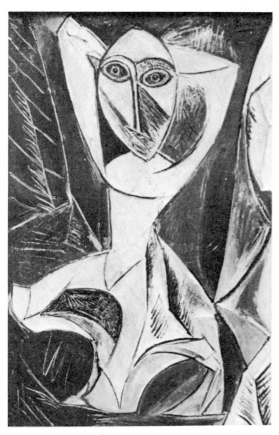

30 Picasso / *Dancer,* 1907–08

31 Gabun, Bakota / *Guardian Figure*

both because its general archaic character and hard, clearly defined forms opened the way to the primitive, and because it employed ovoid shapes akin to the African.

A comparison of the *Dancer* (1907), the painting most similar to its primitive prototype, points up Picasso's complicated and subtle relationship to African art. The parallels are evident: the arms of the figure have been brought up behind the head to surround the face in the manner of the schematic headdress of the Bakota image; the bent right leg, with foot pushing against the left calf, approximates the angularly formed extremities (which may not stand for legs); and the roughened surface of the metal is paralleled by the deliberately coarse and uneven modeling of eye and nose.[11] But the differences are at least as significant. The Bakota sculpture, despite its strong curves and indented silhouette, or perhaps because of its symmetry and frontality, is static, hieratic, impersonal. Picasso's figure is all movement and violence. Its intensity is of an entirely different order, because instead of being self-contained, it immediately and directly engages the spectator. The pose itself, with its lifted arm and bent leg, is not new nor is it invented to match the African rhythms. Parts of it go back to 1905; it was used, complete, but in a much more naturalistic and quiet way in the *Nude Boy* of 1907; it is found in the two center figures of the *Demoiselles* and it will be employed again. It is significant that under the impulse of primitive sculpture it here becomes angular and linear, the modeling reduced to flat planes, and the whole agitated and brutal.

The striated surface of the metal-covered Bakota image similarly influences two portrait heads painted about the same time, although probably before the *Dancer*. These two paintings are also built out of its same ovoid forms, repeated in the silhouette of the face, the eyes, the forehead and the simplified ear—all of which suggest Ivory Coast influence.[12] But they also have the strong *quart de Brie* nose whose origins go back to the "Iberian" faces. This nose is

32    Picasso / *Head*, 1907

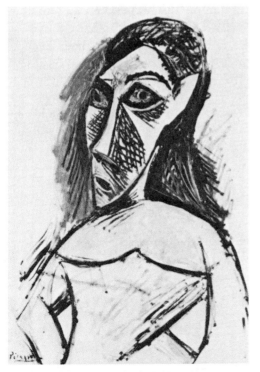

33    Picasso / *Study for Les Demoiselles d'Avignon*, 1907

not to be found in either the Dan, the Baulé, or the Bakota style, and though a concave nose silhouette is characteristic of Fang heads (also from Gabun), it is flat and small. Its jutting prominence seems to be entirely a function of Picasso's concern with new methods of transcribing the three-dimensional relation of parts that leads toward cubism, and which was also partially responsible for his interest in the primitive.

All these characteristics of style are present in a study for the upper right figure of the *Demoiselles d'Avignon,* a study whose bold rendering of eyes and nose-shadow are again an adaptation from the African. In the painting itself the direct connection is less evident. It is, nevertheless, clear that both the seated and the standing nudes on the right are of a different style from the three figures on the left, and that the difference is due to the intervention of African art. Picasso has acknowledged that they were painted later in 1907 than the others, though he would not say just when. Although there is no precedent for the twisted features of the seated figure, the stylizations are those that appear in the other early works of this period.[13] It is also possible that the eyes of the other figures were reworked at the same time, since the way they have been filled seems closer to the "Negro" than to the "Iberian" stylizations.

Quite apart from the question of sources, the distinction between the two sides of this important painting is above all in their different intensities. The later figures have an angularity, an absence of even those remnants of grace that still linger in the earlier ones, and a heavy, darker modeling. They thus embody a new emphasis on the barbaric, which becomes even more pronounced in the slightly later *Dancer,* with its still darker earth colors.[14] It is important to recognize this new emotional tone, because it suggests that although Picasso's intention was toward the recognition and utilization of the formal solutions he perceived in African art, a romantic feeling for the savagery of the primitive also played an important role in the attraction it had for him. To

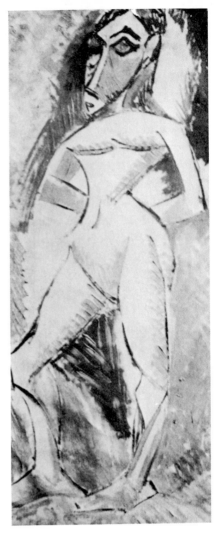

34   Picasso / *Nude*, 1907

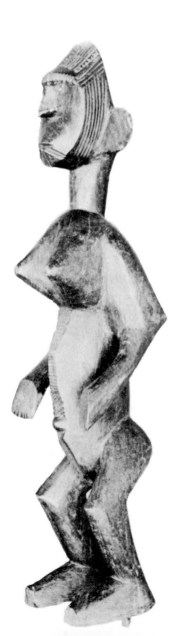

35   Ivory Coast, Senufo / *Figure*

be sure, that feeling was in part conveyed through the forms. Picasso said later that he liked African art because it was *raisonnable,* and he certainly found in it a parallel to his tendency at this time to summarize and epitomize the essential characteristics of form from memory, to work more with the "idea" than with detailed observation.[15] Nevertheless, it was hardly pure form alone that inspired him, but also his own concept of the primitive, which read into its simplified and geometric, rhythmically static composition, an inner nervousness and violence.

Perhaps another way of recognizing this is to note that Picasso's Negro paintings have a self-consciousness entirely foreign to almost all primitive art. A comparison between Picasso's *Nude* (1907) and a Senufo wooden figure brings this out. The sculpture is a relatively unsubtle and angular figure, without either the more modulated carving usual in the refined Baulé style, of which Picasso must also have seen a good many examples, or the smoother, sensitive curves of the Fang heads. There are certain similarities of rhythm in the two works. Yet the deliberate expressiveness of the painting, its assertion of posture and individuality, a tenseness in the figure, and a vibration in the background, give it a personally insistent impact that would be an incongruity in the sculpture. The conceptual basis of African sculpture (as opposed to its basis in observation) has often been exaggerated; its simplifications, where they exist, may have other causes, and its unselfconsciousness may be due to aesthetic premises inseparable from its functional role.[16] But whatever "reasonableness" Picasso saw in its compositions, in his own work he obviously employed it to very different ends. These works, however rational they set out to be, are imbued with the strong emotionalism that characterizes Picasso's art generally. This is certainly true of the *Nude with Drapery* (1907), which is probably the last of the series of works of this year related to the surface markings of the metal-covered Bakota guardian images; it is as agitated as

the *Dancer,* but its unit of design is smaller, and its pose, again with raised arm and bent leg, more sentimental than fierce.[17]

A more generalized African inspiration is present in a series of related works that begin late in 1907 and continue in 1908. Both the *Woman with a White Towel* (1907) and *Friendship* (1908) employ a shape of head, ovoid but broad, and a hollowing out of cheeks on either side of the nose and set back from the mouth that are related to the Dan masks of the Ivory Coast and Liberia.[18] Not only the contours, but the schematization of the face into a few related areas and the strong emphasis on the concavity of the profile all relate to the way these masks interpret the salient features of African physiognomy. The limbs in *Friendship* (1908) are reduced to a few simple, flattened planes, the sections of arms in *The Farm Woman* (1908) are indented at the joints, and the hands and feet in these paintings are both large and merely blocked out so that they play a role as contrapuntal plastic elements. All these characteristics, which may be found again in the *Nude in the Forest* (1908), had their source in similar features of African art. But increasingly in these pictures Picasso seems to be summarizing his analysis of Negro sculpture, and employing his conclusions in a more and more personalized fashion. The blank eyes do away with the sense of the individual figure which, however stylized, had previously obtained, and abstract geometrical principles now also seem to come into play. Indeed the head and bust of the half-length *Farm Woman* (1908) almost seem conceived as a demonstration of Cézanne's famous sentence, written to Emile Bernard in 1904 and published by him late in 1907: "You must see in nature the cylinder, the sphere, the cone." [19] Only in its special application to the human face, the particular province in which it had been the least applied by Cézanne (and by Braque)— and which must have been suggested by Picasso's study of African heads—is the influence of primitive art still in evi-

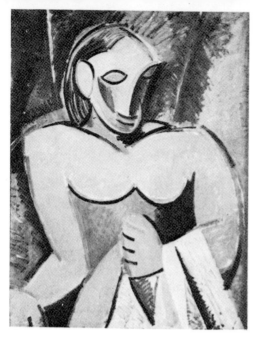

36    Picasso / *Woman with a White Towel, 1907*

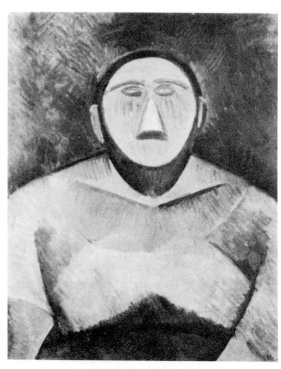

37    Picasso / *The Farm Woman, 1908*

dence. In other respects it, and a number of other heads of 1908, show the growing tendencies which are to lead toward analytic cubism.[20]

Since these relatively few paintings of 1906 to 1908 most nearly approximate direct, formal borrowings from primitive art, it is of some importance to analyze their relation to the primitive, and so to understand the reasons for the admiration given to it. How can we account for Picasso's simultaneous appreciation of African sculpture and of the painting of Henri Rousseau? In its striving for academic realism and its actual result of flat patterns of color Rousseau's art is at the opposite pole from a sculpture which, if not always more basically conceived in three dimensions than any that Europe had produced, certainly has had that character attributed to it. Since this contrast in formal qualities is obvious, we must look for the connecting link rather in the psychological attitude of the two arts, or more accurately, in these attitudes as they were conceived by Picasso. In comparison with the works of Picasso up to 1906, we are struck by the psychological directness of the paintings of the following three years. With certain exceptions (such as the two figures of *Friendship*), which, precisely, are revivals of an earlier tone, the romantic sentimentality of that previous period is gone. The bent heads, the contemplative or idyllic atmosphere of the Blue and Rose periods, are replaced by vertical heads in three-quarter view and eyes that, even when they are empty of pupil, assert an existence to the world in general rather than to the particular spectator. Even in the *Demoiselles d'Avignon* (closest to the work of that time) the figures have no relation to each other.

One of the characteristics of African sculpture, which is coupled with its formally static qualities, whose partially technical origin we need not analyze here, is the relative permanence of the states of feeling which it renders. This is true, for obvious reasons, above all of those statues which are intended as dwelling places for the souls of the dead and which, because of the required resemblance to the owner,

are a kind of living death-mask; but even the dance masks, though in use only for short periods of time, are the objectivizing of a state of feeling which is conceived as having an independent, enduring existence.[21] This relative permanence is also true, in spite of formal differences which do not need to be emphasized, of the work of Rousseau and the other "Sunday painters." In their case, it is due partly to a lack of technical ability which, in the exaggeration of realistic detail and in its making rigid all the forms that it renders, gives its scenes to the sophisticated eye a symbolic permanence that is not the conscious intention of the painter. This effect would not, however, be possible without an intensity of feeling about the object or the emotion to be portrayed and without a belief in the psychological importance and aesthetic efficacy of his art that makes careful and minute delineation worth while and that is akin to the feeling of the primitive artist. The projection of Rousseau's dreams upon canvas (and his belief in the reality of their independent existence) is similar to the objectivizing of certain spirits in primitive masks. In both, moreover, there is the unself-conscious acceptance of an artistic tradition (directly opposed to an academic acceptance), which permits concentration on the desired expression. It is true in this sense alone to say, as Guillaume Apollinaire did of Rousseau, that "One finds no mannerism, no calculated procedure, no system"; and in this sense, in spite of the contrast of its technical achievement with Rousseau's, it is also true of African sculpture.[22]

Picasso's appreciation of this supposed "naïveté" is precisely what makes possible his juxtaposition of these two arts, and the directness and assertive qualities that we have noticed in the work of this period are due to its emulation. But the overdramatic qualities of Picasso's rendering, which we have also remarked, are due to his conscious attempt to assimilate what was thought to be an altogether unself-conscious attitude on the part of the primitive artist who simply follows tradition, but is really a preoccupation with other

things which does away with a subjective artistic personality. Because this cannot be achieved by the modern artist, Picasso's figures, like Picasso himself, must continue to assert themselves to the world. In view of this attitude it is not surprising that the "Negroizing" of these paintings should take the form of emulating and exaggerating such features as blunt fingers, conical noses, blank or staring eyes, and open mouths—simplifications which serve the double purpose of strengthening the plastic design and of generalizing and typifying the psychological presence of the figures. These features undoubtedly embody a tendency toward a certain conception of the primitive, and even a deliberate overprimitivizing to achieve the desired result; but neither separately nor together do they constitute any comprehensive assimilation of the style of African sculpture, nor were they so intended. It is in the stimulation of an attributed concept, not in pure form, that the relation of primitive art to cubism is to be found.

A more purely formal influence from African sculpture may well have played an important role a few years later—at the height of the cubist period. But if it did, the process, though less emotional and more intellectual, was just as subjective and teleological, with the artists once more finding only what they were looking for. Kahnweiler has made a strong point of a connection between the work of Picasso and Braque in 1912 and 1913 (paintings and constructions), and a type of Wobé (N'gere) mask from the Ivory Coast, an example of which Picasso owned at this time.[23] In these masks (which vary greatly in their degrees of naturalism), there is a stylization of the features; they are made to stand out horizontally from a single vertical background plane which represents the face without suggesting any receding modeling of the skull. The forehead, whether bulging or horizontal, is given a prominent shelflike overhang, and in extreme instances the other features are indicated by more or less abstract geometrical shapes, so that the eyes may be cubic, cylindrical, or clam-shaped, and the nose and mouth

simple, separate rectangles, one vertical, the other horizontal. On occasion additional cylinders are placed in the cheeks below the eyes. All these features are given extreme prominence, being made to project as rigid, discrete forms from the recessed plane of the face. If one is accustomed to the traditional European emphasis on the space-filling convexities of the whole head, pierced by the concavities of eyes and mouth, it seems that the African artist has made concave what in reality is convex, thus reversing natural appearance. If this is so, we are being asked to fill in what is not there and—by imagining the connecting surface at the upper level of the projecting forehead, nose, eyes, and mouth—to supply that rounded, volumetric mass that the sculptor has deliberately omitted. Kahnweiler, who was an intimate of the artists at the time, proposes that this is indeed the way in which Picasso and Braque saw the Wobé mask, and that it was this vision of "transparency" which lead to the transparent planes of cubism.[24] He suggests that the proof may be found in the reliefs of the time, where, for example, the sunken hole of a guitar (a negative shape) is expressed by a projecting cylinder (a positive shape), just as in the Wobé mask the eye, in fact a recessed form, is expressed by a cylinder or cube in very high relief. This discovery freed painting from naturalism, allowing it to create "invented signs, freed sculpture from the mass, and led it to transparency."

If Picasso did, indeed, look at his Wobé mask in this way, he was viewing it in the light of his own aesthetic problems. Wobé masks are certainly highly stylized representations, more concerned with effective dramatic expression than with naturalism. But in their emphasis upon large features, projecting from a background plane, they are only extreme instances of a manner of representation widespread in African masks and figures, which, however stylized, does not reverse mass and void. Overhanging forehead, large and sometimes bulging eyes, conical nose, advancing mouth, do stand out from the flat or even concave plane of the cheeks—in essen-

tially the way they do in Mediterranean archaic sculpture; but these are all expressive exaggerations of the observed forms of Negroid physiognomy. If the lips project, so do they in the archaic smile; if the eye projects as sphere or cylinder, it is because—in addition to the carving necessity of giving it its shape—it expresses the magical penetrating glance of the spirit symbolized by the mask or temporarily housed in it. The idea of transparency, then, is not a fundamental quality of African art (if it is in fact a characteristic at all), taken over and incorporated into cubism by Braque and Picasso. It is rather a subjective interpretation, read into Wobé masks as they were analyzed by artists engaged in the creation of an evolving series of works of art and seen through the selective lense of their own necessities. This is everywhere the relation of the modern "primitivizing" artist to primitive art.[25]

NOTES

1. During those years both Picasso and Braque were averse to saying anything about their art. Picasso's first statements were not made until after 1930. Cf. *Cahiers d'art*, VII, X; and "Letter on Art." *The Arts*, Feb., 1930, No. 2, pp. 3–5.

2. Guillaume Apollinaire, *Catalogue: Première Exposition de l'art nègre et d'art Océanien* (Paris: Galérie Devambez, 1919), p. 7. Reprinted from *Premier Album de sculptures nègres* (Paris, Paul Guillaume, April, 1917). Apollinaire almost takes pleasure in the fact that "rien ne vient éclairer le mystère de leur anonymat . . ."

3. Cf. *Action*, No. 3, April, 1920, where Picasso replied simply *"L'Art nègre? Connais pas."* C. Zervos, *Pablo Picasso* (Paris, Cahiers d'Art, 1942), Vol. 2, Part 1, p. 10. André Warnod, "Matisse est de retour," *Arts*, No. 26 (July 27, 1945), p. 1; Gertrude Stein, *The Autobiography of Alice B. Toklas* (New York: Harcourt, Brace, 1933), p. 68; and Gertrude Stein, *Picasso* (Paris: Floury, 1938), p. 22.

4. Picasso himself (July, 1936) furnished only the most vague indications on the subject. André Salmon (*Burlington Magazine*, CCII, April 1920), pp. 164–171, says Picasso collected Negro masks as early as 1906.

5. In an article in *Le Temps*, Oct. 14, 1913, quoted by Guillaume Janneau, *L'Art cubiste: théories et réalisations* (Paris: Charles Moreau, 1929), p. 12; Apollinaire refers to "les imagiers de la Guinée et du Congo," apparently using Guinea to refer to the whole West Coast region. Janneau remarks on the "amused condescension" with which he still treats primitive sculpture. Both Daniel Kahnweiler and Charles Ratton assured me that it was the sculpture of the Ivory Coast with which Picasso was famil-

iar. Braque did own a "Congolese" mask as early as 1905. *Cf.* Paris, Galerie Knoedler, *Les Soirées de Paris*, 1958.

6. This was due to the fact that Cameroon was a German colony; see above, Chap. I, Part 1. For similarities *cf. Seated Figure* in the Chadourne Coll.; *Mask*, Tzara Coll.; *Mask*, Leipzig Museum (Museum of Modern Art), *Corpus of African Sculpture*, Nos. 257, 273, 275); others might be adduced.

7. Quoted in John Golding, *Cubism* (New York, 1959), p. 58. Also Fernande Olivier, *Picasso et ses amis* (Paris, 1933), p. 169. For the photos *cf.* Roland Penrose, *Portrait of Picasso* (New York, 1957), Illustrations 76, 84. The "first Negro mask bought by Picasso" seems to be an Ogowe River mask with crest. Picasso still has an extensive collection.

8. Maurice Raynal, *Picasso* (German ed.; Munich: Delphin-Verlag, 1921), p. 53; he mentions, in his description of Picasso's atelier, Rousseau's *Portrait of Yadwrigha*.

9. For general discussions of this period *cf.* Alfred H. Barr, Jr., *Picasso: Fifty Years of His Art* (New York: The Museum of Modern Art, 1946), pp. 53–65; and Golding, *op. cit.*, pp. 47–62.

10. J.J. Sweeney, "Picasso and Iberian Sculpture," *The Art Bulletin*, XXIII (1941), no. 3, pp. 191–198.

11. Alfred H. Barr, Jr., *Cubism and Abstract Art* (New York: The Museum of Modern Art, 1936), p. 30 makes the comparison.

12. The male head is certainly a self-portrait; Picasso wore his hair brushed in this way.

13. Janneau's reference (*op. cit.*, pp. 12, 13) to "Melanesian fetishes is borne out by a photograph of Picasso in his studio, taken 1908 or 1909 that shows two New Caledonian figures on the wall behind him. *Cf.* Gelett Burgess, "The Wild Men of Paris," *Architectural Record*, XXVII (May, 1910), pp. 401–414.

14. Barr, *Picasso: Fifty Years of His Art*, p. 60, refers to this as the "barbaric phase."

15. *Cf.* Golding, *op. cit.*, p. 59.

16. This emphasis is probably still the lingering influence of the point of view of the cubist period.

17. Golding, *op. cit.*, p. 61. Braque's *Grand Nu* (1908), with a similar pose and summary treatment of hands and feet reflects African influence through Picasso's adaptations.

18. But similar stylizations also appear in the more refined Baulé style.

19. *Mercure de France*, Oct. 16, 1907. As Golding points out (*op. cit.*, p. 139–140), a similar convergence was attained for a moment by Derain as early as 1906, in his *Bathers* and perhaps in his *Last Supper*, where some of the heads have the same simplified blocklike geometric character. However the *Head*, then in the collection of Derain's friend Frank Haviland (and now in the collection of Jay Leff, Uniontown, Pa.), is not—as Golding assumes—at all typical of French Congo sculpture. *Cf. African Sculpture from the Collection of Jay C. Leff* (New York, The Museum of Primitive Art, 1964), pl. 1. Its blank, hollowed-out features, which are really absences, are entirely exceptional. It follows that Derain's blocked-out heads stem more from the idea of the simplicity of African art than from any of its actual formal characteristics.

20. Barr, *Picasso*, p. 62 ff.

21. The spirits which take up residence in the masks at least for the time of their use represent for the most part single states of feeling. *Cf.*

Maes, *Aniota-Kifwebe* (Antwerp: Editions De Sikkel, 1924), *passim;* R.H. Lowie, *Primitive Religion* (London: Routledge, 1925), *passim*.

22. Guillaume Apollinaire, *Méditations esthétiques* (Paris: Figuière, 1913), p. 56. The "charming child" attitude taken toward Rousseau is shown by the often-mentioned dinner given for him in 1908 by the members of this group.

23. Daniel Kahnweiler, *The Sculptures of Picasso* (London: Rodney Phillips, 1949), Preface.

24. Daniel Kahnweiler, "Negro Art and Cubism," *Horizon*, December, 1948, pp. 412–420. Kahnweiler denies any earlier influence of African art on Picasso, while claiming for cubism all the subsequent evolution of transparent sculpture.

25. In the same number of *Action* (No. 3, April, 1920, p. 24) in which Picasso denied acquaintance with Negro art, Juan Gris replied: "Negro sculptures provide a striking proof of the possibilities of an *anti-idealistic* art. Inspired by a religious spirit, they offer a varied and precise representation of great principles and universal ideas. How can one deny the name of art to a creative process which produces individualistic representations of universal ideas, each time in a different way. It is the reverse of Greek art, which started from the individual and *attempted to suggest an ideal type*." The deductive method, which Gris here attributes to African sculpture, is precisely that upon which his own later work was based—in theory, if not always in practice. He started with geometrical principles; from their precise concatenation the concrete forms and the composition of a given picture took shape. *Cf.* Daniel Kahnweiler, *Juan Gris. His Life and Work.* Trans. by Douglas Cooper (New York: Curt Valentin, 1947).

# Primitive Tendencies in Abstract Painting

In the last section we quoted Guillaume Apollinaire's purely aesthetic evaluation of Negro sculpture, and his not unconnected realization—which was far from minimizing his pleasure—that for a long time to come it would not be possible to place these objects in their iconographic or chronological context.[1] The appreciations of primitive art cited in the first chapter were the result of a similar point of view, affecting ethnologists as well as critics. The praise of both Roger Fry and Carl Einstein, formed in the atmosphere of the cubist tradition, of African sculpture as being more truly "sculpturesque," that is, more essentially conceived in

three dimensions—than anything Europe had produced, is likewise on a purely formal basis, a basis which extracts each object from its context and views it as an aesthetically isolated absolute. Even such writers as Boas and Lowie, who insist upon the technical and sociological origins of primitive art, base their comparisons with the art of civilized man upon the similarity of a purely aesthetic impulse which they find common to all men; and the claim of the field worker R.S. Rattray is that primitive art is as aesthetically "pure" as any other.

Although these estimates were made under the influence of an "abstract" or purist point of view, we have seen how impure such tendencies toward the pure appreciation of the primitive can be. Yet this attitude toward the formal simplification (or supposed simplicities) of primitive art is related to another kind of simplification of form, and an accompanying expansion of emotional meaning, that has its own primitivist connotations without benefit of any exotic association. Different, though related, programs of abstract art—following after cubism as the "Negro" period preceded it—and the paintings created in consonance with them, contain a strong emphasis on the "simple," a quality they seek out since they place a high value on it for its own sake. Unconnected with primitive art, their common desire to create an art of simple fundamentals, and an art uncomplicated because it reflects such fundamentals, is in itself a particular kind of primitivism. While doing no more than touching on the art, or the complete theoretical position of three important schools of abstraction—the purists, the neo-plasticists, and the suprematists—we can point out their common emphasis on simplicities of this kind.

Thus Ozenfant and Jeanneret, in their explanation of the purposes of Purism, demand that the painter

> create images, organizations of forms and of colors which may be the carriers of fundamental and invariable characters of object-themes.[2]

The painter, they say, must base himself on "primary sensations" produced by "unvarying elements" in order that he may arrange sensations which will be "transmissible and universal."

> Primary forms and colors have standard properties, universal properties which permit the creation of a transmissible plastic language. . . . The purist element, issue of the purification of standard forms, is not a copy but a creation whose goal is to materialize the object in all its generality and invariability.[3]

Therefore the "secondary elements" of association with known forms are concessions, to be used only to put the spectator into the proper mood to appreciate the more difficult primary ones:

> Purism is an art of plastic constants, avoiding conventions, and addressing itself before all to the universal properties of the senses and of the spirit.[4]

These themes—the themes of simplicity, fundamentality, and universality—also run through the theories of the other abstract schools, schools which are opposed to purism or which see in it an unfortunately mistaken method. Van Doesburg (founder with Mondrian of *de Stijl* in Holland, later called neo-plasticism), explains that in the art which he has discovered, modern painting has reached its goal:

> Modern painting approaches its end. . . . Painting, that is to say the occupation of making visible by the means of painting an equilibrium of relationships, a harmony. Modern, the search to create this harmony by the methods which are the most pure, the most true, and the most simple. These means alone are the most universal.[5]

Composition by personal taste is an illusion and has no reason for existence. The goal of all the arts, working together, must be the creation of a plastic unity. Elsewhere Doesburg describes the evolution of modern art as

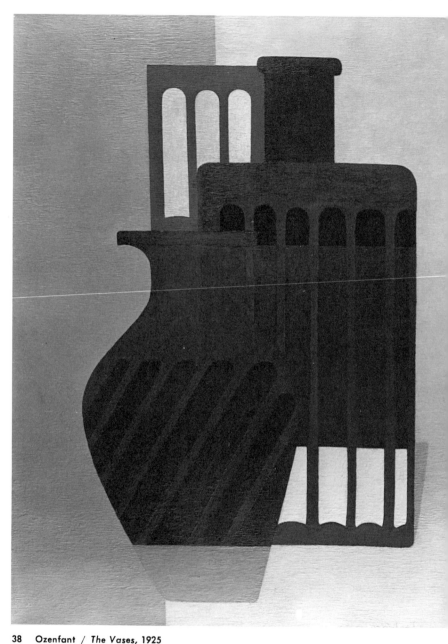

38   Ozenfant / *The Vases, 1925*

> . . . toward the abstract and the universal . . . which has
> made possible the realisation, by a common effort and a
> common conception, of a collective style.[6]

Similarly Mondrian talks of the "employment of a rectangu-
lar plan, universal synthesis of constructive elements," and
of the merging of painting with architecture.[7]

The desire of both purism and neo-plasticism is to do
away with the individual, the personal, the subjective ele-
ments of art. Both condemn cubism—though they consider it
on the right road in its battle against the extreme subjectiv-
ity of the impressionists—as still too dependent upon the
temperament and the individual sensibility of the artist.
The transmission of his effects occurs only with the chance
discovery of a similarly attuned observer, and so he can find
only a limited audience.[8] Other modern artists have longed
for a wide audience. It is significant that the program here
calls for the objectivity of the painter, and the consequent
automatic understanding of a collective body of spectators
for which he is striving, to be obtained almost solely by
means of reduction and exclusion. Plastic and associative
elements heretofore used by painters are to be simplified,
purified, or eliminated altogether; and the admittedly desir-
able synthesis of these analytic parts is to be obtained only
from a combination of the rediscovered fundamentals. Con-
sciously at least, plastic forms derived from a technical and
mechanical environment unknown to older artists are to be
omitted even though such forms, stemming from objects of
common experience, would be comprehensible to everyone.
Therefore, in so far as the appeal made is to elements of
sensation, to factors of the external world, and above all to
the principles of a reality ordinarily hidden by the appear-
ance of the external world, all of which are assumed to be
simple because they are eternal, basic, and common (a mo-
ment's reflection upon the surrealists will show that sup-
posed simplicity is by no means a necessary concomitant of
supposed universality), and in so far as the combination of
such elements is deliberately limited in richness and compli-

cation, we may correctly speak of the "primitivizing" tendency of such theories.

The purists rely on the geometrical forms of the external world to attain a generally meaningful artistic product because, in so doing, they reduce the subjective element in any work to a minimum. The "creation of a work of art must make use of methods producing sure results," writes Ozenfant, and such methods are to be found in the geometry of purified forms.[9] Thus, in effect, by the elimination of the particular variations of the individual object, of those characteristics which, though they give it its identity, are (in terms of essentials) accidental, one arrives at a representation which is at once truer and simpler. Here is the belief, typical of so much of twentieth-century art and of so little of the art of the past, that reduction, elimination, simplification are valuable for what they reveal and for themselves.

While Malevich does not deny that art is affected by its time and by the artist, which together give rise to a conditioned character he calls the "additional element," his main concern is the discovery of those truer, more revealing elements through which the supremacy of pure impression and pure feeling will be made possible in the plastic arts. It turns out that these "suprematist elements" are also very simple: the square, the circle, the cross, etc.

> The suprematist square and the forms proceeding out of it can be likened to the primitive marks (symbols) of aboriginal man which represented, in their combinations, *not ornament but a feeling of rhythm.*[10]

> The Suprematists have . . . abandoned the representation of the human face (and of natural objects in general), and have found new symbols with which to render direct feelings (rather than externalized reflections of feelings), for *the Suprematist does not observe and does not touch—he feels.*[11]

At the same time suprematism, because it is nonobjective, expresses its own time, its own "inspiring environment":

> I call the additional element of Suprematism "the suprematist straight line" (dynamic in character). The environment

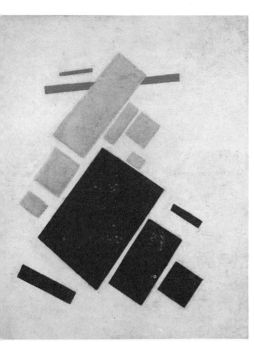

Malevich / *Suprematist Composition,* 1914

Mondrian / *Composition with Red,* 1936

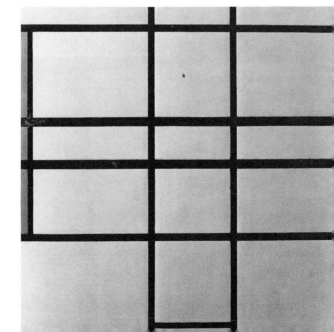

corresponding to this new culture has been produced by the latest achievements of technology, and especially of aviation, so that one could also refer to Suprematism as "aeronautical." [12]

How suprematism's absolute character as "pure sensation" is to be reconciled with its conditioned character as the expression of a particular culture Malevich does not explain. It is clear however that in striving for such sensations, which will be common to and also alike in everyone, and in assuming that these sensations will be well and truly rendered through the most elementary geometric forms, Malevich is expressing his belief in the virtues of a reductive principle. This is a belief he shares with the purists and the neo-plasticists.

A distinction must, however, be made between the purists on the one hand and neo-plasticists and suprematists on the other. The purists, though they wish to deal only with the typical, derive their types from the visible, external world, and it is this world whose structure they propose to codify and make intelligible. Although they reduce and simplify, it is still the world of physical objects which they wish to grasp. Both suprematists and neo-plasticists have a further end in view: their aim is to get behind or beyond appearances. Their simple forms, symbols chosen under the strong influence of Oriental theories, are more than geometrical fundamentals; they are also essences, or symbols of the essences that lie at the heart of reality behind the veil of appearance.

> We ought not to look past nature [Mondrian writes]; rather we should look through it; we ought to see more deeply, our vision should be abstract, universal. Then externality will become for us what it really is: the mirror of truth. [13]

> The abstract is inwardness brought to its clearest definition, or externality interiorized to the highest degree. [14]

Neo-plasticism appears to deal in straight lines and rectangular, unmodeled planes only to those who can see no fur-

ther, who are bound by old-fashioned "morphoplastic" habits; others are accessible to a "more interiorized beauty," and are susceptible to "the pure expression of free rhythm," because neo-plastic art, not constituted of forms, however abstract, but of "an equilibrium of pure relations" only goes past "the natural appearance [which] veils the expression of relations."

> Man is enabled by means of abstract-aesthetic contemplation to achieve conscious unity with the universal . . . the individual is pushed into the background, and the universal appears. . . . The new painting, which is breaking away from natural appearance . . . is characterized by a more clearly defined representation of the universal.[15]

Mondrian, influenced in his thinking by esoteric doctrines, reduced his color scheme to the three primaries, eliminated the curve, and concentrated on the equilibrium of the horizontal (feminine) and the vertical (masculine) to produce a "relational" art intended as the "clear realization of liberated and universal rhythm . . . It is the expression of tangible reality on a higher plane."[16]

The exact sources of Mondrian's doctrine, the extent of his dependence on Indian philosophy and the way in which he adapted it to his own purposes have still to be uncovered.[17] Nor are they of particular importance here. What is important is that his mysticism (like that of the suprematists) sought for universal fundamentals, found them in certain "simple" principles, and gave them visual expression by a process of elimination, purification, and reduction. The quest for an ultimate—and truthful—simplicity, more meaningful than any discoverable subtleties and distinctions, is analogous to the more romantic primitivism which invokes the example of the arts of primitive peoples.

We cannot enter here into a detailed analysis of the canvases done in accordance with these theories. Such criticism has been performed *in extenso* by various writers, who have pointed out the infinite variations and the extreme subtlety

of composition of a painter like Mondrian, who has achieved endless refinements in the use of primary colors combined with different arrangements of the rectangle. To a lesser degree this is also true of Doesburg, Ozenfant, and Malevich, all of whom, although (or because) they fall into the "error" of the cubists, create delicate and subtle works of art. In so far as such subtle results are achieved, the "simplist" qualities which we have been pointing out, and which should follow from the theories, are lost, and the resulting works require the extreme of delicate sensibility for their appreciation. Just as in the case of the *fauves,* the reduction of the means employed, which when done in and for itself is a primitivist tendency, calls forth an elaboration, division, and refinement of the sole means remaining to the artist, and thereby creates an opposite tendency. In so far, however, as this latter tendency preponderates and produces sensitive harmonies within their paintings (and it is usually just to this degree that we appreciate them as "pure" art), the artists were being false to both poles of their proposed program: For on the one hand this interior elaboration (even within, or rather precisely because of, the limits the artist imposed upon himself), increased the personal aspects of the work produced, limited its appeal to sensibilities in tune with those of an artist made acute by concentration upon a minute field, and excluded those who through more obvious references to a familiar world, might have come to some gross approximation of the artist's idea and intention. On the other hand, this increased personalization of the work contradicted the avowed aim of the artist to make use only of "objective" and "collective" means in order that he might be sure to transmit the idea carried by his creation. Thus his final intention, the creation of a common or collective style, based on sensations, which, because they are not conditioned by the external accidents of environment, will be present and comprehensible to everyone, is negated in the work of art as it actually comes into being. One might even say that this must by definition be so, since a work of

art, if it exists at all, is in itself a contradiction of the kind of universalization by reduction and exclusion desired by the formulae of these schools. If this program of abstraction were carried to its logical end, it would simply do away with the work of art.

The really successful elimination of all content would have much the same totally destructive result; and we are not, as a matter of fact, justified in assuming that these artists succeeded in what was their avowed aim. The preservation of a general but definite content is clearest in the case of the purists, who wish to make use of typical objects in order to appeal to a wide public:

> Purism would never admit a bottle of triangular form, because a triangular bottle, which would perhaps some day be executed on command, is only an exceptional object, a fantasy, as is also the idea which has conceived it.[18]

The purists, however, were engaged not so much in the representation of typical objects, as in showing, as subject matter, the common geometric qualities basic to all such objects. In pictures like Le Corbusier's *Still Life* (1920), or the *Glass and Bottles* (1926) and *Vases in an Interior* (1926) of Ozenfant, the bottles, glasses, and pipe disappear, even as typical units, in favor of incarnations of geometrical forms which are considered as their essence and as the essence of the spectator's world. But this geometry is by no means that of pure form, since it carries direct and indirect connotation of meaningful objects from the spectator's environment, and so in spite of itself has associative values.[19] The concentration on typical mechanical forms had begun in the first quasi-geometrical compositions of synthetic cubism, which purism sought to expand and to purify.[20] These paintings used objects, which, while still aesthetic (printed letters, books, *etc.*), have a more generalized content than the more personal objects of the preceding period of analytical cubism, and the purists continued on the road of generalization.

An attention to mechanical forms is evident also in the work of Léger, who by 1913 was showing an interest in this aspect of the modern environment. But Léger, in spite of his interest in the "complexity of modern machinery," chose to break up his machines as he had previously broken up his figures and landscapes and reduce them to their component geometric parts, thereby creating a more or less uniform pattern of such simple basic units instead of a representation of the complexity and intricacy of the finished and worked-out machine.[21] This is true even of his most differentiated compositions, those done from 1917 to 1921, whose patterns, though complex, suggest none of the articulation of parts that is a necessary characteristic of the machine in action. *The Factories* and *The Tugboat,* both of 1918, are cases in point; and it is to be noted that subjects like *The Acrobats* and *Le Cirque Medrano* are made up in the same way of similar geometrical forms whose use has hardly been changed by the radically different contents of the pictures. Instead of complexity, Léger, when he does not permit himself a nostalgic simplification, as in *The Mechanic* (1920) and *The Red Figure* (1926), creates a confusion of simple elements, thus showing where his main interest really lies. For him, as well as for the painters of purism, the forms employed are not simply plastic abstractions, but are really the direct representation of what are conceived as the simple, common elements of a new mechanical environment, whose intellectual abstraction from actual objects has been made, not in the painter's eye while he is working, but in his mind before he begins to set his ideas upon canvas.

In the case of the other two groups, the presence of this geometry as subject matter, with all the associations of subject matter, rather than as pure form, is demonstrated by their passage into other arts, notably architecture. Malevich's suprematist compositions, *Magnetic Attraction* (1914), *Sensation of Current* (1915), and others of this sort, if they are not representations, at least clearly imply the contemporary scientific world. But where these do not change into a

wish like Kandinsky's to convey a mystical oneness through a simplified, symbolic form (*e.g.,* *Sensation of World Space* (1916)), they refer to the modern mechanical environment only by means of the primitive constituent elements. That the transition to constructivism should have taken place so soon for many Russian artists, a transition to an art which, though purporting to use the same factors, did so with much more complication on the formal side and more direct associative reference on the side of subject matter, indicates (even allowing for the political pressures in the early twenties) that the suprematist emphasis is on basic, simplist factors, which, unless rigidly repressed, are naturally expanded and combined by the artist into more intricate and differentiated organic wholes. In a similar way, the incorporation of neo-plasticist designs as patterns for the decoration of the interiors of building—patterns which, by retaining their simple geometric character are felt to be an expression of the fundamental mathematical quality of the new architecture—shows that the squares and rectangles of neo-plasticist abstractions carry with them implications of content which belie their purely formal suppositions. Here too are geometrical representations, however generalized, representations of the simple, primitive elements of an all-important mechanical environment whose variation and complication are scrupulously avoided by suprematists and neo-plasticists and, to a lesser degree, by the purists.

The reasons for this avoidance of direct and unambiguous reference, involving as they do the position of the artist in his contemporary society, his attitude toward it, and his mutual relations with his public, we cannot analyze here. We wish merely to point out the similarities between this point of view, completely uninfluenced by primitive arts or by exotic yearning for primitive life, and that of those artists who were so influenced. Such similarities are of course only similarities; they are not congruities: Yet that movement of "interiorization and expansion" which we have noted among those whom we have grouped together as emotional primi-

tivists is to a certain extent paralleled among the "intellectuals." In both (Picasso and the *Brücke*) there is at first an impulse from foreign, primitive sources, noticeable in content as well as in form; this gradually lessens as the content becomes wider and vaguer and its associations more indigenous, transferring their primitivism from beyond the seas to personal psychology or, as here, to personal environment; while form, becoming further and further identified with the primitivism of content, is also expanded, until for both a limit is attained. That limit, in so far as it can be consciously conceived, we have again reached here, as we saw it was reached in the latest works of the *Blaue Reiter*.

NOTES

1. However, in a slightly later article (July, 1918), Apollinaire does say "when we will know the ateliers and the periods in which they were conceived, we will be better able to judge their beauty and compare them among themselves . . ." Guillaume Apollinaire, *Chroniques d'art*, ed. L.-C. Breunig (Paris: Gallimard, 1960), pp. 441–442.

2. A. Ozenfant and Ch.-E. Jeanneret, *La Peinture moderne* (Paris: Povolosky, 1920), p. 1; and "Le Purisme," *L'Esprit nouveau*, January, 1921, No. 4, p. 377.

3. *Ibid.*, p. 386.

4. *Loc. cit.* In this way purism will avoid an "art of fashion," and will tend toward "the objectivation of an entire world."

5. Théo van Doesburg, "Réponse à notre enquête 'Où va la peinture moderne,' " *Bulletin de l'effort moderne*, I (1924), No. 3, p. 7.

6. Théo van Doesburg, "Vers un style collectif," *Bulletin de l'effort moderne*, I (1924), No. 4, p. 16. All these writers take it for granted that a collective style is something desirable.

7. Piet Mondrian, "Où va la peinture moderne?," *Bulletin de l'effort moderne*, I (1924), No. 2, p. 6.

8. Doesburg,, "Vers un style collectif," p. 116; Ozenfant and Jeanneret, *La Peinture moderne*, p. 376.

9. Ozenfant and Jeanneret, *La Peinture moderne*, p. 378.

10. Kasimir Malevich, *The Non-Objective World* (Chicago: Theobald, 1959), p. 76.

11. *Ibid.*, p. 94.

12. *Ibid.*, p. 61.

13. Galerie Beyeler, *Piet Mondrian* (Basel, 1964), p. 28.

14. *Ibid.*, p. 44.

15. *Ibid.*, p. 26.

16. Piet Mondrian, "Pure Plastic Art," in *Piet Mondrian* (London: Whitechapel Art Gallery, 1955), pp. 16, 46–47.

17. The great influence of Oriental doctrine, both direct and indirect

(Theosophy), on Malevich, Mondrian, Kandinsky, and Klee is presently being studied by L. Sihari.

18. Ozenfant and Jeanneret, *La Peinture moderne*, p. 377.

19. This is more or less admitted by Ozenfant, *ibid.*, although with reluctance.

20. Alfred H. Barr, Jr., *Cubism and Abstract Art* (New York: The Museum of Modern Art, 1936), p. 163; and Ozenfant and Jeanneret, *La Peinture moderne, passim.*

21. Barr, *op. cit.*, p. 96.

@ @ @ @ @ @

# VI The Primitivism of the Subconscious

## The Modern Primitives

The discussion of the preceding chapter, concerning Picasso's appreciation of the primitivism of African sculpture, mentioned his simultaneous admiration for the work of Henri Rousseau. It was pointed out there that Rousseau's connection with the art of primitive peoples lay in the similar appeal which his painting made to the emotions of sophisticated artists, rather than in any objective formal qualities that it has in common with the art production of aboriginal tribes.[1] The problem of the modern primitives—Rousseau and the other "naïve" artists who have been associated with him—is introduced into our discussion from this point of view and with this fact in mind, and not because we wish to discuss the complicated question of the nature of

primitive art as such. The problem can be divided into two distinct, though necessarily related, aspects: The first is the question of what is meant by the primitivism, or the naïveté, of these artists, since such a description, unless we wish merely to indicate an identity with other characteristics already defined as primitive, is of qualities which are always relative, and has the implication of external standards which must condition its evaluation. The second is the question of the kind of appreciation given this so-called naïve art, and the extent to which it was relevant to the aim and intention of the "naïve" artists themselves on the one hand, and to the production of the "sophisticated" artists on the other. We must consider a double contrast: that of the aim of the artist and his achievement; and that of the achievement of the artist and its appreciation. Such contrasts between intention, result, and understanding are always present, even with a contemporary public, and no matter who the artist; but the very fact that these painters are distinguished from others as naïve indicates that in their case the distances between the poles have reached such magnitude that they are of paramount importance, and that far from wishing to destroy them, a conscious pleasure is taken in their existence.

The name of "Sunday painters" which was at one time given to the artists of this group—Rousseau, Vivin, Bombois, Bauchant, Séraphine, Léfèbre—is not accurate in its implications.[2] Most of them had, it is true, at one time or another to earn their livings by means other than painting. Nevertheless, painting for them was not a pastime or even a secondary activity. Rousseau long before he retired, Bombois and Bauchant before they were taken up by a group of collectors, considered art their real occupation and any other work a necessary evil, to be abandoned as soon as possible. This fact is not to be neglected, because it distinguishes these artists from those true Sunday painters whose designation they appropriated, of whom Gauguin, before he devoted himself entirely to his art, is the most notorious

example.[3] The stir and storm of disapproval caused by Gauguin's ceasing to "earn his living" indicate the light in which the Sunday painters regarded their own artistic activity: For these dilettante bourgeois, painting really was an avocation to be indulged when the serious business of life had been taken care of, an aesthetic performance with no practical significance, an unessential pastime. To turn artist, that is to turn "bohemian" as Gauguin had done, was not even imaginable. But for Rousseau and for his later colleagues, at least as long as they were "unspoiled," painting was a method of setting down not only their impressions, but also their ideas about the world; and, what is more important, a means of conveying these ideas to others. The seriousness and consequent meticulousness which sprang from such an attitude to art was responsible for much of that naïveté which was, as we will see, the principal cause of their popularity, and it was recognized by the *avant-garde* as akin to its own dedication.

On the purely technical side, it is quite justifiable to call these painters naïve if by that adjective we are simply pointing out a technical inadequacy to accomplish the task that they had consciously set themselves. It has been forgotten that the ideal of these artists was exactly that nineteenth-century academic traditionalism, strongly influenced by the recorded "truth" of the camera, which all the other artists and amateurs who finally came to an appreciation of their work were striving to avoid, but which they themselves simply never attained. And it is the striving for this academic, "photographic" goal—rather than any inner kinship with the primitive artists who stress realistic detail because of its magical properties and its religious uses—which results in the careful leaf-by-leaf rendering of Rousseau's forests, or the brick-by-brick depiction of Vivin's *Chamber of Deputies,* patterns bearing, it is true, a certain resemblance to the primitive treatment of ornamental surface.[4] Whatever limitations technique and vision may have imposed, we need only compare Rousseau's *Père Juniet's Cart* (1908) and the

photograph from which it was drawn to be convinced that in spite of the artist's involuntary "re-presentation" of nature, the transcription is as close as he has been able to make it.[5] The same may be said of his group portraits, in which, as in the provincial English conversation pieces of the eighteenth century or the portraits of the itinerant American "primitive," a uniformity of facial type is the result of a *faute de mieux* formula, and not of a desired stylization.[6] Rousseau longed for recognition so that he might establish himself in others' eyes as he saw himself: a solid, serious, official artist with a recognized standing in the community; not a revolutionary and bohemian like those who finally did accord him friendship.[7] In this, too, Rousseau was *retardataire;* his progressive contemporaries had already made a virtue of their enforced isolation. The extent to which Rousseau's art was based upon previous conventions, fused with a desire to transcribe an external "reality," is evident in pictures such as the *Environs of Paris* (ca. 1895), which resembles the pre-impressionism of the sixties, or the *Landscape with Cow* (ca. 1906), whose sketch shows that it combines impressionist and Barbizon attitudes while remaining unconscious of any of their sense of capturing a changing world.

The desire for realism, and its basis in the academic and sophisticated art of the nineteenth century that took Gérome and Bonnat for its models, is not invalidated either by the origin of Rousseau's subjects in sleeping or waking dreams, or, on the technical side, by his inability to translate those dreams on canvas to the full degree that he wished. That such dreams were possible to him is evidence of a pictorial imagination, which visualized compositions in much the same way as other artists, but with an extraordinary reality.[8] Much of the tropical atmosphere of his pictures is also due to his rendering: *Muse Inspiring the Poet* (1908) and *Portrait of Joseph Brummer* (1909) have the same overgrown, rubbery-foliage setting that gives an exotic air to the jungle scenes, yet the plants are obviously local and al-

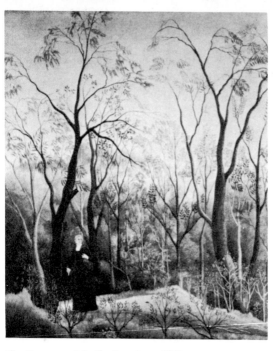

41   Rousseau / *In the Forest,* ca. 1886

42   Rousseau / *The Dream,* 1910

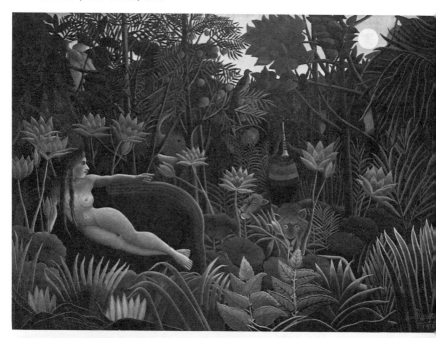

most domestic; while the walker in the similarly tropical *Promenade in the Forest* (1886–90) is dressed for a *faubourg* stroll.[9] This mixture shows that what is important even in those compositions whose intent is entirely exotic, is that though their elements may derive from a variety of sources—academic models, photographs, reading about exotic countries—they are transformed into actual events that he is recording as best he can. In spite of the large factor of imagination obvious to the spectator, for the artist these events are external to himself, existing in their own right unconditioned by his individual peculiarities of personality.[10] The ferocity of Rousseau's animals derives chiefly from the convention of concentric circles which he uses for their eyes; but they have an interior, positive existence which also pervades their jungle setting, an assertive vitality which, in a manner comparable to the conceptions of William Blake (a more skillful artist, but also working with a *retardataire* form), does not wait for the impression of the spectator, but makes itself actively felt.[11] This is also true of Rousseau's portraits and portrait groups. These are not interpretations of personality in a particular light, literal or figurative, as were the contemporary portraits, of the post-impressionists and early cubists (which in this respect were still within the impressionist tradition); rather, they take this personality for granted as an integral whole, and seek to record some actual event in which it has played a part. This is the sense of *The Marriage* (1904), *Past and Present,* and *The Muse Inspiring the Poet* (1908).[12] The artist has no doubt about the existence of these people, nor is he trying to bring out the facets of a complicated and changeable personality. The pictures are records, in the same sense that the ancestor portraits which lined the houses of the nineteenth-century bourgeoisie were records, transcriptions whose aesthetic, *i.e.,* whose purely decorative value, was, if considered at all, an entirely secondary factor in their appreciation.[13] They are, first of all, documents. The same interest may also be seen in those pictures, such as the *View of Brittany* (1907) or the

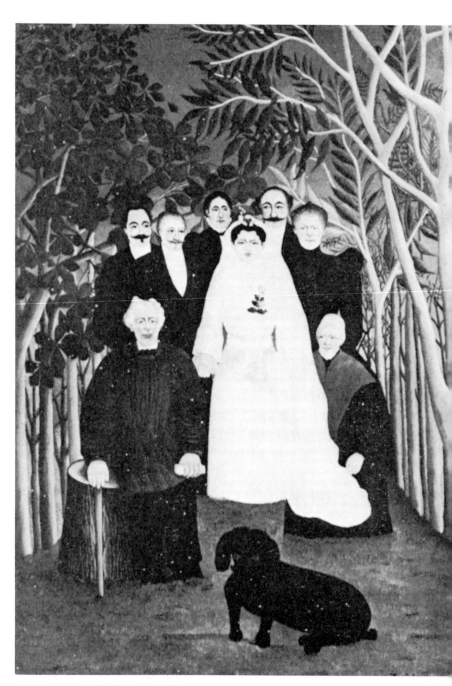

43    Rousseau / *The Marriage*, 1904

*Pasturage* (ca. 1906), whose perspective convention, sub-
ordination of figure to landscape which yet keeps an inti-
mate quality, and choice of subject mark them as stemming
from the school of Barbizon, a style which had by this time
become conventional enough for Rousseau to use.[14] And in a
similar way, as their vague boundary indicates, his "fantas-
tic" pictures were records of events in the imagination, so
that, as with the portraits, their first requirements were ac-
curacy and realism.

For these reasons there is only a partial justification for
calling the painting of Rousseau and his colleagues a folk
art.[15] Based upon a formal ideal which, although belated
and *retardataire* when used by them, had nevertheless been
developed by the advanced art of its time, upon an ideal
which had not yet penetrated as common knowledge to the
part of the population to which Rousseau belonged—and
for which in rare cases he painted, his painting is a folk art
only in the unself-consciousness of the artist. Though, as we
have just pointed out, Rousseau himself placed all his pic-
tures on the same level, only a few of them made sense to
the associates of his *quartier*. The portraits they could un-
derstand, the rest not. Rousseau's personal "childishness,"
which endeared him to the artists of Montmartre, only
made him seem queer and eccentric. Although without that
side of his personality he could not have been an artist at
all, this is in itself indicative of the fact that in so far as his
art is the result of this element, it is not a proper product of
the people.[16] The same separation is implied in the fact that
he could sell few of his pictures to his natural friends, the
people of his own quarter that he invited to his musical
evenings. It is perhaps going too far to say that true folk art
is always anonymous, but at least it is always part of, under-
stood by, and reabsorbed into the environment that has
produced it. With Rousseau this is eminently not the case;
nor is it true of such artists as Louis Vivin and Camille
Bombois who, admired by a sophisticated taste in the wake
of enthusiasm for Rousseau, had the same relation to their

own art as he did, or who, like Paul Léfèbre, intimidated by what they knew would be the attitude of those around them, tried to hide their artistic activity even from their admirers.[17] In the early pictures painted by Bombois before he became self-conscious, the striving for an imitation of a recognized art form—in this case, that of the early impressionists—influenced not only his method of composition, with its receding diagonals and figures gazing into space, but extended even to his choice of subjects, which have the contemplative, purely aesthetic character of early impressionism.[18]

The Beaux-Arts is evident in the naïve artists' use of classical and heroic themes.[19] Whatever "visionary" quality may lie in the inspiration of their painting, the same academic realism, coupled with a mechanical technique more adequate to the attainment of its goal, also characterizes the work of the Frenchwoman Séraphine and the German Adolf Dietrich. As with Rousseau, the visions are to be painted as others would paint reality; the artists themselves did not think in visionary terms. The essentially meaningful goal these artists set themselves distinguishes them from such a painter as Grandma Moses perhaps more than any superiority of talent. The tradition she, a naïve artist, wished to join was much closer to her own vision, but it was a folk tradition, already somewhat contaminated, and she herself was aesthetically self-conscious.

These considerations of the technical and social origins of "naïve" art do not, however, alter the estimates which have been current of the modern primitives. Rousseau has been called a "trained craftsman of delicate sensibility," and this we do not mean to deny.[20] But it is important to realize that the style he achieved was but a stopping place upon a road along which he would have traveled further if he could, and that the effect which he attains, seen from the point of view of the mechanics and psychology of its creation, is *because* of this intention, even if it is *in spite* of it from the point of view of the sophisticated observer. Having reached the limit of his ability, Rousseau was able, as a result of an innate

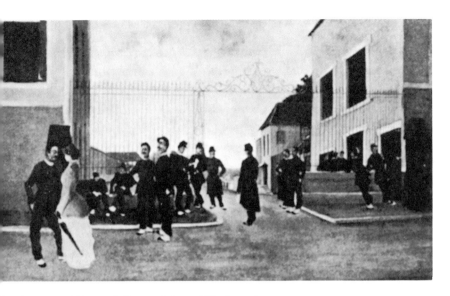

4  Anonymous Nineteenth Century Painter / *The Barracks*

5  Bombois / *The Allée, ca. 1925*

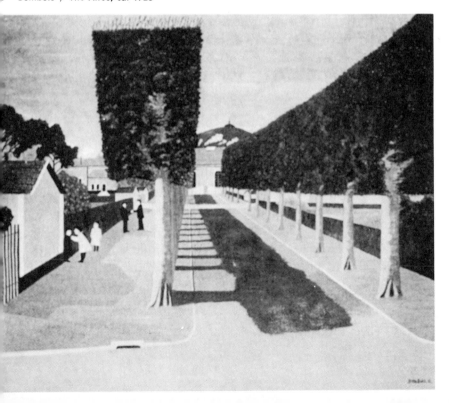

artistic sense and unremitting work, to perfect a means of rendering which, because of this very perfection, we now take to have completely suited his purpose. The example of other artists, such as André Bauchant and Bombois, who changed their styles as they approached the facility they desired, shows that Rousseau's style would have been transformed, and thus for the purposes of sophisticated appreciation would have been spoiled, had he been able to accomplish what he wished. That his manner should have been arrested just where it was is of course more than a mere mechanical accident. Though his art began in observation, it was an observation bound by severe conventions and limited by a timidity in the face of an unexpected purely aesthetic result.[21] He begins with an idea, and it is this which gives his works their force, but his style is intimately bound up with the decorative sense, the feeling for an evenly distributed pattern and for contrasts and balances of pure and brilliant color. These are the stylistic constants of his painting, tighter and more graphic at the beginning, broader and freer in the later work, whose particular quality is the mark of his genius. Nevertheless, some of his effects, such as the regular recurrence of a flat all-over pattern, as in *Landscape with Monkeys* (1910), or the continuous repetition of the same motif, as in *Garden Landscape* (1908?), may also be found in the work of other "primitives," and, wherever they occur, are due to the technical arresting of his realistic ambition. That with Rousseau the final result may be controlled by a sensibility superior to those of the other men should not blind us to their similarities since it is finally their style (whose explanation we are seeking) which justifies the grouping together of the "naïfs." The recurrence of such uniform patterns in all of the painters of this group, most obvious in the small linear units of Vivin and the repetitious waves of Dominique-Paul Peyronnet, would seem to indicate that they take pleasure in the rhythmic movements necessary for their production as well as in the final visual effect. But the elaboration of this repetition into a decora-

tive pattern without associative significance is controlled by the artist's wish to convey a real event and by his conceptual realization of the parts of an object which must be present in order that it may exist. The psychological extremes of these two tendencies are to be found, on the one hand, in the minute all-over pattern produced by some psychotic artists, in which the movement used to render some particular feature is expanded into a decorative pattern by a kind of manual stutter; and, on the other, in the "second-stage" drawing of children, in which conceptual inclusions are allowed to override everything else.[22]

On the psychological side, moreover, we do not mean to question the usual assumption that in comparison with their sophisticated contemporaries Rousseau and the other artists for whom he created a vogue were "primitive." Like the true folk artist, whether aboriginal or provincial, he had an unquestioning belief in the efficacy and the comprehensibility of his painting, as well as a faith in its general purpose. His "ideology" was perhaps readily intelligible, but the details of its iconography and its symbolism were personal, deriving from experiences apart from those of the generality of his fellow citizens. In spite of this he did not consider that he was expressing emotions or a vision peculiar to himself. Not thinking of himself as queer, as did his neighbors and his artistic friends, not imagining that he was in opposition either to an established way of living or to an established artistic tradition, under no compulsion to artistic innovation or originality and so having no doubts as to his own seriousness of purpose, he managed to have an unsplit, generalized vision and an unself-conscious ("naïve" "intuitive") acceptance of the importance of painting in his own life and in the life of the community. He quite rightly understood that the members of the Academy had attained this position, and so felt he belonged among them. It is this attitude that gives his paintings the "symbolic" quality usually attributed to them. Because his attitude to art was that of a previous period in that his subject matter is not in itself

aesthetic and in that he used his technology to express an experience not contained within its own manipulation, and because he assumed that everyone would be able to understand a language that he himself took for granted, Rousseau could accomplish what those who discovered him were attempting by other means: to render "classes" of experience. Rousseau's assumptions made his realism possible, and these included the spectator within a confident and meaningful world; but his realism becomes "magical" only through the connotations of a particular event, reached through an attitude of surface objectivity, not through the typifying or generalizing of the event itself. Those who later, in the interests of mysticism, equated a detailed surface realism with an abstraction and extraction of an inner essence, and pointed to Rousseau's work as the beginning of such a style, were confusing the results of his brush work with an aesthetic position which he would never have understood.[23]

It has already been pointed out that it was as much for these qualities of use and meaning as for any purely decorative formal arrangements which he created that Rousseau was adopted by Apollinaire and his friends at the same time that they were discovering African art. The element of unself-conscious vision is even more important in the appreciation of Vivin, Bombois, and the others, who are somewhat lesser natural artists. The admission of these men to any ranking would not have been possible among artists for whom brush manipulation and facility in the conventional copying of nature would be necessary conditions for any further artistic excellence. But neither, on the other hand, would it have been possible if it had been simply for *plastic fundamentals,* as they said, that Picasso and Apollinaire were seeking. The order and the monumentality of the aboriginal and the modern primitives have no common plastic term. They result, given a minimum of artistic sensibility on the part of the particular artist, from the use of an accepted formal tradition for ends which are only unconsciously purely aesthetic. It was the recognition of this common atti-

tude toward different plastic materials that caused the aboriginal artists and the modern primitives to be linked in admiration.

NOTES

1. See above, Chap. V, "Intellectual Primitivism." In the United States the qualities of "American primitive" painting of a previous century were recognized shortly after 1920, first by artists, then by the public. Recognition of contemporary primitives like John Kane waited until the next decade.

2. Wilhelm Uhde, "Henri Rousseau et les primitifs modernes," *L'amour de l'art*, XIV (1933), p. 189.

3. This distinction was first suggested to me by Dr. Meyer Schapiro. Also see Uhde, *loc. cit.*

4. Philippe Soupault, *Henri Rousseau, le douanier* (Paris: Editions des Quatres Chemins, 1927), p. 29.

5. Henri Certigny, *La Vérité sur Le Douanier Rousseau* (Paris: Plon, 1961), Photos p. 327; and James Johnson Sweeney, *Plastic Redirections in 20th Century Painting* (Chicago: University of Chicago Press, 1934), p. 16, and Plates IVa, IVb. The correct distinction made by Sweeney applies to the result; we are talking of the intent. *Cf.* Christian Zervos, *Rousseau* (Paris: Editions Cahiers d'Art, 1927), p. 18.

6. *Cf.* Sacheverell Sitwell, *Conversation Pieces* (London: B. T. Batsford, 1936), *passim.*

7. Note Rousseau's unremitting representations at the Salons to which he was admitted. His persistence was not unlike that of Cézanne before Cézanne's desire for recognition was embittered into the combined wish for solitude and revenge.

8. *Cf.* his remark: "One day when I was painting a fantastic subject I had to open the window because fear seized me." Uhde, *op. cit.*, p. 190.

9. He could paint correct "eastern" scenes when he wished; *cf. The Holy Family* and the *Tiger Hunt*, influenced by the Biblical realism of the middle of the century.

10. It is interesting to compare the relative exotic and documentary character of some of these landscapes with certain Roman "Egyptian" landscapes, in which the same large unit foliage, flat relief, and silhouette against a high horizon are used. *Cf. The Flamingos* and examples from the Villa Livia, Rome.

11. But Blake's religious mysticism is closer to primitive animism; also, though Blake did not make use of contemporary forms, he was not living in the midst of the most advanced art of his time.

12. In the group portraits of Henri Fantin-Latour, which also purport to be a simple record, it is the artistic personalities that count, both individually and in their interplay.

13. The comparison is of course closest with the works belonging to the lower bourgeoisie, in which exterior display, whether of forceful personality or of possessions, is not necessary.

14. *View of Brittany* is one of two paintings based on a landscape by Camille Bernier. *Cf.* Dora Vallier, *Henri Rousseau* (Cologne: Dumont-Schauberg, 1961), Plates 112, 114.

15. And not simply because it is of a higher quality than the work usually done by similar people; as *e.g.*, Uhde, *loc. cit.*

16. *Cf.* Zervos, *op. cit.*, p. 23: "Enfin l'œuvre de Rousseau n'est pas une œuvre populaire, issue d'une conscience collective."

17. Léfèbre's work was first discovered by Erich Wolters, from whom he hid its identity, claiming for a long time that it was the product of a brother's hand.

18. This show-off character is most evident in *Les Femmes.* Other pictures, such as the views of Chartres, show "post card" influence.

19. *Pericles Justifying the Use of the People's Money, The Battle of Thermopylae, The Proclamation of American Independence.*

20. Sweeney, *loc. cit.*

21. *Cf.* Vallier, *op. cit.*, p. 116.

22. *Cf.* Hans Prinzhorn, *Bildnerei der Geisteskranken* (Berlin: J. Springer, 1923); and H. Eng, *The Psychology of Children's Drawings* (New York: Harcourt, Brace, 1931).

23. Wassily Kandinsky, "Ueber die Formfrage," *Der Blaue Reiter,* ed. Franz Marc and Wassily Kandinsky (Munich: R. Piper, 1912), pp. 92–93. Other writers, such as Franz Roh, *Nach-Expressionismus* (Leipzig: Klinkhardt & Biermann, 1925), seem to have derived their ideas from him.

# The Child Cult

The discussion of the primitivism of the artists of the *Brücke* and *Blaue Reiter* groups noted a movement away from the exotic primitive and toward indigenous sources of primitive inspiration. Part of this tendency, which was also to be found among the *fauves,* was a new evaluation of children's art, in which educators and psychologists as well as artists were beginning to take an interest.[1] The members of the *Brücke* prized their own childhood drawings and emulated their use of broad, indefinite line. Kandinsky admired the art of the child for what he saw as its direct, intuitive expression of the interior essence of things. But none of the work so far examined has involved a pervasive influence of the child's method of representing his thoughts and his experiences; and it is first in the pictures of Paul Klee, associated with the *Blaue Reiter,* that we are given a chance to

examine paintings in which the art of the child is the predominant influence.[2] Other artists—Dufy, Chagall, Feininger, Itten, Masson, and especially Miró and Dubuffet, and even on occasion Picasso—have felt its attraction; but the work of Klee is the initial and fertile example of its hegemony, so that we may be permitted to use his paintings to fix its place within the history of primitivism.[3] As when we dealt with the modern primitives, our purpose here is not to determine whether, in any absolute sense, such art is truly primitive (it is obviously not truly childlike), but to try to discover just what its particular characteristics are and what their relations are to each other and to the assumedly primitive art from which they borrow.

Children's art is not the only primitive source from which Klee drew, nor do pictures with an obvious primitive affiliation by any means constitute the whole of his production. Klee studied masks in ethnographical as well as theatrical museums; in the banded stripings of *The Mask* (1925) we may see an influence from the large Congo specimens which use a similar decorative motif, although in alterations of black and white.[4] Some drawings (*e.g., Façade,* 1924) and paintings (*e.g., Coolness in a Garden of the Torrid Zone,* 1924) which establish an all-over repetitive linear pattern of small geometric shapes, indicate a knowledge of the tapa cloth designs of Oceania, particularly those of the Society Islands which are executed in an almost uniform color; others suggest the more open designs of the Lake Sentani area of New Guinea.[5] *Picture Album* (1937) borrows the stylized human images of Papuan Gulf ceremonial boards with their concentric linear patterns, and combines them with other Melanesian motifs. When translated into painting this connection with the primitive is less obvious, but in *Young Garden* (1927), for example, it is still discernible, although there is now the added comparison of a child's schematic representation.

In other pictures Klee makes use of forms which have their clear analogies in drawings of the mentally ill, and are

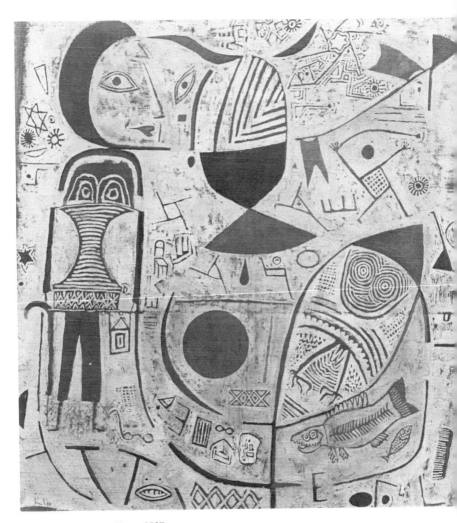

46    Klee / *Picture Album, 1937*

probably derived from this source: Characteristic are the extension of the human features, especially the eyes and the mouth, into ornamental linear motifs which are then, in neglect of the original intention, elaborated for their own decorative value; the use of a close all-over pattern made up either of dots or of a minute linear scheme which the eye cannot follow in detail and designed in such a way that the eye has equal and yet exact demands on its attention from the whole picture surface, thus creating a tremendous strain; and the repetition of the face in other parts of the body.[6] In *Costumed Puppets* (1922) the eyes, ears, and elbows expand into symmetrical scrolls, and in *Angelus Novus* (1920) hair, hands, and feet undergo a similar evolution. The etchings of 1904–05 (*The Comedian, e.g.*) employ the tight overall technique, so minute as to appear compulsive and give the impression of stripped flesh. *Scene from the Drama of a Riding Master* (1923) has the blurred, skewed aspect often found in some work of the insane.[7] Examples of distortions of the human form—which, while keeping the connection of the parts, pull and stretch them in all directions but without a unifying visual principle, as if they were seen through several distorting mirrors at once (a quality also common in the art of the insane)—are to be found in *Boy in a Fur* (1909) and again, combined with cubist influence, in *Fool* (1924) and *Fool in a Trance* (1929). *Introducing the Miracle* (1916) employs child-drawn figures in a setting inspired by the cubist use of planes and facets, but with the deliberate destruction of a unifying scale. These affinities occur only in a limited number of Klee's pictures, and within the context of many other elements of his fused, composite style. He has chosen them for certain controlled, symbolic ends, whereas in the works by which he has been inspired these same forms are compulsory and their makers consider them exact transcriptions of events.[8]

Klee's affiliation with children's art is of course much more pervasive than his affinity for the art of the mentally ill. Technically, he uses the circumferential, ill-controlled

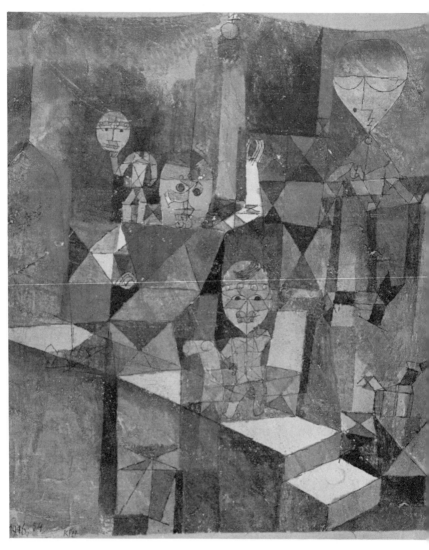

47   Klee / *Introducing the Miracle*, 1916

outline, without modeling, which children employ. Representationally, he quite deliberately limits himself to the stage of "intellectual realism." [9] This kind of representation is opposed to visual realism in that it is composed of the inclusion of those features of an object which are considered important and which are *known* to be part of it, regardless of whether they could all be visually present at the same time. This is a stage of artistic formulation through which all children apparently pass, until in response to some form of pressure from the established tradition they begin to turn to visual representation. It disregards "correct" optical proportions in favor of a hierarchy of size that reflects importance, whether among different figures or within the same figure (so that the head is always large), and, unlike the drawings of the mentally ill, carries through on this basis, so that there is no compulsive continuation in chance associative elements (chance that is, to the outsider), nor are there purely decorative schematizations.

Because Klee is making use of such "intellectual realism" on a selective basis and with conscious intent, viewing his result as an aesthetic object and not only as the representation of the conceptual idea of a scene, he necessarily never carries the process through completely: There is always some modification in the interests of design or composition —effects which are purely fortuitous (or at least unconscious) in the production of the child, and noticed, indeed, only by the adult observer. Nevertheless the influence of children's art is apparent in many of Klee's pictures, of which *Zoo* (1928), *She Roars, We Play* (1928), and *Female Dancer* (1940) are examples. These use a linear technique, akin to that of children's drawings in its description of the objects, although narrower and finer. But other works of Klee are closer to the following stage of child development, that of the beginning of visual representation. *Houses by the Sea* (1920) and *Weimar Suburb* (1925) are examples of children's cityscapes, with box houses and no perspective; *Portrait of Mrs. P. in the South* (1924) is as if drawn by a

48   Klee / *Arrival of the Circus*, 1926

child; *The Scholar* (1933) and *Child Consecrated to Suffering* (1935) are children's self-portraits. These influences are not always clear-cut: *Greeks and Barbarians* (1920) perhaps includes elements of early medieval manuscript depiction, particularly in the central figure, as well as the influence of childish forms.[10] Because of such mixtures, which we can still recognize, and compounds, which we can only infer, as well as the factor of choice and elimination, motif-by-motif comparisons with individual child pictures are not very fruitful; yet analogies can continually be pointed out, even though detailed similarities are rare.

To catalogue in this manner Klee's borrowings and adaptations from the primitive and from children's art defines neither his attitude toward the originals, nor his use of them, nor his reasons for both. A reflective artist, Klee was conscious of his sources, whether in contemporary art or elsewhere. In 1912, writing from Munich for a Swiss newspaper, he explained the importance of the *Blaue Reiter:*

> These are primitive beginnings in art, such as one usually finds in ethnographic collections, or at home in one's nursery. Do not laugh, reader! Children also have artistic ability and there is virtue in their having it! The more helpless they are, the more instructive are the examples they furnish us; and they must be preserved free from corruption at an early age. Parallel phenomena are provided by the works of the mentally diseased; neither childish behavior nor madness are insulting words here, as they commonly are. All this is to be taken seriously, more seriously than all the public galleries, when it comes to reforming today's art.[11]

The reformation that Klee had in mind was a recapturing of freshness and innocence, a wish not unlike that of the romantics, but going much further and containing mystical overtones. Already in 1902, at the beginning of his career, when he had not yet formed his personal style, he had noted: "I want to be as though new-born, knowing absolutely nothing about Europe, ignoring poets and fashions, to be almost primitive." [12] This state of innocence he con-

tinued to admire and, in his own way, to emulate. During his Bauhaus years he told Lothar Schreyer that he had no objection to having his pictures compared to "children's scribbles and smears. That's fine! The pictures my little Felix paints are better than mine, which all too often have trickled through the brain; unfortunately I can't prevent that completely because I tend to work them over too much." In the same conversation he called some of the illustrations in Prinzhorn's book on the art of the mentally ill "fine Klees," and expressed admiration for the "depth and power of expression" of certain of the pictures with religious subjects.[13]

Klee was, of course, not simply adopting a stylistic mannerism. Close as some aspects of his technique are to children's methods, he saw his own work as analogous, rather than imitative. On the one hand he is a conscious artist who, as he said in the same conversation, "never violates the limits of the pictorial concept, nor of pictorial composition," employing to his own ends many of the means developed by his contemporaries, the most pervasive being his adaptation of the modulated plane derived from cubism. On the other hand he feels an affinity with the insights of "children, madmen and savages" into an "in-between world" that "exists between the worlds our senses can perceive."[14]

Klee always sought such mystical understanding. In 1916, contrasting his own goals with those of the more "human and earthy" Franz Marc, he wrote: "I seek a remote place for myself only with God . . . I cannot be understood in purely earthly terms. For I can live as well with the dead as with the unborn. Somewhat nearer to the heart of all creation than usual. But still far from being near enough."[15]

It is this quality in children's art—the way it "merges with the universe"—that Klee values and that, from the beginning, he himself wishes to attain. Children achieve it effortlessly; he must strive for it consciously, endeavoring (while he remains in control of his medium) to allow its elements, which are the forces of the universe, to speak for themselves

through him and thus express the heart of the matter. This identification is what Klee has in mind in his two best-known succinct phrases: "Art does not render the visible, but renders visible," and "a line taking a walk with itself." Klee's purpose, then, is to achieve an emotional pantheism, so to atune himself to the universe that it will be expressed in the microcosm of his pictures. The way to do this is to achieve that relaxation of the will that allows children to see into the "worlds [which] have opened up, which not everybody can see into." And from it will come the essence of his own art: "My hand is entirely the tool of a distant will." [16]

Not for a moment, however, does Klee renounce control over his art. He is neither intuitively spontaneous in the manner of children nor "physically automatic" after the fashion desired by the surrealists (however much he may have influenced some of their work and their thinking). In 1909 he noted in his *Diaries:*

> . . . will and discipline are everything. Discipline as regards the work as a whole, will as regards its parts. If my works sometimes produce a primitive impression, this "primitiveness" is explained by my discipline, which consists in reducing everything to a few steps. It is no more than economy; that is, the ultimate professional awareness, which is to say, the opposite of real primitiveness. [17]

Although written some ten years before the maximum impact of children's art upon his painting of the twenties, at a time when he was still concerned with a complete professional competence, the statement remains true in his later work. It is characteristic of Klee, and indispensable to much of his effect, that he captures the feeling of the child's technique while remaining distant from it. He introduces childish drawing and perspective, whole and with sympathy, into an abstract pictorial and color organization of the most advanced sort, calling upon his awareness of all of the achievements of modern art. In the contrast there is a deliberate irony that is at the root of the humorous yet mournful note, that sense of the helpless that is struck by so many of these

small pictures and that lends them their larger implications.

The double aspect of this attitude becomes somewhat clearer upon examination of the *Pedagogical Sketchbook* (1925), written for his students at the Bauhaus. It is partly a classroom handbook aimed, in line with the Bauhaus philosophy, at forcing renewed attention to the material (as opposed to the conventional) properties of the medium. It is partly directed at a relaxation of the will, so that the "inner nature" of these properties may speak for themselves. And it is partly a miniature cosmology, pantheist in approach, which gathers meaning from the very seriousness of its simplicity. Klee's symbolic-mystic intention is much the same as Kandinsky's, and this book resembles Kandinsky's writings in its pantheist (or animist) method, wherein lines are in themselves "active" and "passive" (a division proper to the whole universe), the "father of the arrow is the thought," and earth, air, and water are made symbols of the states of the soul. But the symbols which Klee chooses to make up the letters of his graphic alphabet—since they borrow less from conventional geometric forms for which a universal harmony is found and depend more on Klee's own graphic invention and on certain deliberately arbitrary units, of which the arrow is most important—are both more intellectual and more personal and mystifying than those of Kandinsky. Where Kandinsky talks only of the qualities inherent in colors, lines, and geometric forms, giving them an existence of their own which the acute observer can catch and reflect, Klee unites them directly with human thought and human emotion: "Art plays an unconscious game with ultimate things, and achieves them nevertheless." [18] He talks of the combination of the conscious and the unconscious mind, and his biographers refer to the recapture of the world through childish intuition. His mysticism has in it something of Marc's desire to unite with the world on the level of animal and plant life, and in this Klee has been properly connected with the German Romanticists, who influenced him early in his career.

It has been remarked that the expression of such a mystic unity in plastic terms is impossible of achievement since its only complete formulation must be a complete lack of formulation.[19] We may nevertheless examine with what means Klee makes the attempt. It is significant that, although Klee borrows much from the child, contrary to childish practice he is careful to leave his figures indeterminate and his scenes unlocalized. His linear sketches, small in comparison to their frames, are surrounded by a field which is undifferentiated except for delicate color nuances and which defines no limited spatial setting. The figures themselves, put thus into a void or onto an unlimited plane, have no volume, and no spatial or psychological relation to one another. Klee makes of the child's inability to render perspective a deliberate and calculated abstraction "which shatters habitual values in vision."[20] Through the reduction of the rendering of the objects he makes their reference unspecifiable, and by floating them against an unspecified plane he gives to what would otherwise be purely private meanings an unlimited reference and importance. A deliberate tension is established between the particularity of detail and the generality of the symbolic object. This effect is moreover increased by the titles of the pictures, which, instead of giving us the expected explanation—that is, relating the separated objects of the canvas by indicating some common frame of reference—are repetitions of the composition's obvious parts, re-enumerating in print what has already been separately set down in paint. In this manner the significance of the scene is increased for the observer, since it is at once obvious and obliquely mysterious, flatly representational and abstract. Thus these small scenes, set down so seriously, take on an ironic humor and become microcosmic comments on a larger world.

It is not accidental that Klee should have made use of children's symbols and technique. They provide the common ground of immediacy and suggest that the result is not art but ideographic communication. Yet these symbols are

employed with the greatest skill and artistic understanding. The subtle gradations of color, the constantly changing and carefully calculated harmonies of his painting are those of a highly sophisticated vision and technique. Much of the effect of his pictures comes from the divorce of these harmonies from the apparently casual placing of the forms represented, increasing the apparent spontaneity of the creation. The naïve and the sophisticated are not fused; each retains its independence and heightens the effect of the other. This is perhaps what Klee meant when he once objected that "The legend of the childishness of my drawing must have originated from those linear compositions of mine in which I tried to combine a concrete image, say that of a man, with the pure representation of the linear element." That is to say, notation, or childish anecdote, with the purest abstraction. Of course the result is anything but childish or simple. The subtlety of the effects of color and form needs no stressing; it is also true of their suggestions, which require a self-conscious imagination. Perhaps more than any other, this kind of primitivizing through simplification of the separate elements of representation (but not of their plastic relations), needs an acute, educated, and extremely subtle refinement of sensibility for its appreciation.

Compared to Klee, Joan Miró's relation to children's art (and perhaps to the aboriginal as well) is at once closer and more distant. Unlike Klee, who though perhaps a mystic was a consciously analytic artist, it is generally agreed that Miró, enormously gifted, continues to have something childlike about him, both as a person and a painter. André Breton, allowing him a place apart in the movement, noted "a certain arresting of his personality at an infantile stage," which gave him a special relationship to the automatic dream images of surrealism.[21] He has been qualified as "the most daring, but also the most primitive of leading contemporary painters." And his friend Michel Leiris singles out the "child-like character of the marvellous in Miró, as in folk lore. Nothing sophisticated about him, as there is with so

many other surrealists." [22] Leiris also mentions the "nursery-rhymes aspect of Miró's art." Such characterizations are of course not criticisms, as they might well have been in an earlier period; nor are they merely neutral descriptions. Rather, they are appreciations of the valuable quality of continuing freshness and simplicity which Miro, unlike less fortunate artists, has preserved and which is one of the secrets and sources of his genius.

Miró probably first encountered aboriginal art in Picasso's Paris studio in 1919; later, as a member of the surrealist group in the twenties, he became more familiar with its many manifestations—Oceanic as well as African. [23] He admired it, but less for its formal structure than for the atmosphere it evokes. "Courage consists in remaining within one's ambience, close to nature, which takes no account of our disasters," he wrote in 1936. "Each grain of dust possesses a marvelous soul. But to understand this it is necessary to rediscover the religious and magic sense of things—that of primitive peoples." [24]

Nevertheless, there do seem to be a number of instances in Miró's work where he has directly adapted designs or motifs from primitive art. The two *Circus Horse* pictures of 1927, with the animals' big bodies and small heads seen in profile and as though in the distance isolated in space, and with the clear, flattened color separation of the body areas, may be related to somewhat similar depictions in the late prehistoric rock shelter paintings of eastern Spain and North Africa. But a reminiscence of the hobbyhorse that appears with other toys in paintings of the early twenties (*e.g., Still Life with Toy Horse*, 1920) may also be present. Later works—*Woman under the Moon* (1944) or *Red Disk in Pursuit of the Lark* (1952–53)—occasionally suggest the facial stylizations of New Guinea (Papuan Gulf boards or Sepik River house masks), but whether Miro's representations are derived from the primitive, or are merely generally similar in their round-patterned simplifications, it is difficult to say.

It was also almost certainly in Picasso's studio that Miró first saw the works of the Douanier Rousseau. He has acknowledged his admiration for Rousseau at this time (along with that for Van Gogh and Picasso), and some of Rousseau's directness of vision and desire for a complete cataloguing of the known objects in a scene appear to have found their way into the series of pictures that culminates in *The Farm* of 1921–22. Yet the element that seems closest to Rousseau, the penmanship-like feathery delineation of the silhouetted leaves against the sky, is already evident in the *Kitchen Garden with Donkey,* painted in 1918, before Miró came to Paris. These may therefore be more generally related to popular art as a whole, with which Miró was already familiar in Spain, (and to the strong linear renderings of the medieval frescoes of Catalonia) and which prepared him for an immediate understanding of Rousseau's kind of realism. The folk-art influence, if it is one, was in any case short-lived.

Miró's relation to children's art seems so much a part of his tone and his technique that it comes as some surprise to find that the methods of children's drawings, with their broad irregular outline, simplified figure notations, and arbitrary proportions and perspective, occur in a pure state in relatively few of his paintings and lithographs. Miró's references are to an earlier, less-articulated stage of children's art than Klee's, and suggest watercolor rather than drawing. A striking example is *The Caresses of Moonlight Met by a Beautiful Bird at Dawn* (1954). Here is the child's stick figure, with body and arms made of a single thick line that has spread at the edges and broadened further at the hands to form the lumps repeated in the braids defining the head and once again in the eyes. This figure, with the triangular body-skirt, is to be found often, with varying proportions, and attached to all different manner of heads—for example, in *Women and Birds in the Night* (1946). These broad-line stick figures appear again somewhat more fluidly, rendered in the series of 1948 lithographs called Album 13, where

their long necks, short bar-arms, and curved legs give them a certain resemblance to the grouped figures of neolithic rock-wall hunting scenes.

More often, Miró bases himself on an even earlier stage of childish representation, one in which no body is shown, and the head, seen full face as an irregularly defined oval or circle, rests directly upon straight legs ending in ball-like feet. Variations of this extremely simplified figure occur in *At the Bottom of the Shell* (1948), *Cry of the Gazelle at Daybreak*, a group of pictures simply called *Paintings* of 1950, and a number of other paintings of 1952 and 1953.

These relatively direct appropriations from the representational language of children's art are comparatively rare events in Miró's large and imaginatively free creations. If a great deal of his painting nevertheless gives the impression of "a thing at once elementary and precious," related to uninhibited childish notations, it has more to do with a general sense of the ideographic symbol (whether for plants, birds, stars, or figures) than with any precise similarity of iconographic representation. It is this sense, combined of free drawing and a personal sign language, that Leiris refers to when he describes the "graffito aspect of Miró's painting. Such painting is properly speaking 'graffito' because it has an equal share in the characteristics of drawing and of handwriting." [25] Unlike Klee, who transfers the method of children's drawing, almost unchanged, into new surroundings of space and color, Miró fuses his childish signs with all kinds of imaginative deformations. Some of these are personal, as for example the round, square, or triangular heads that shoot out from doll-like bodies on a long thin line, so that they exist both near and far in space. Others are related to surrealist symbols and bodily exaggerations, some first developed by Picasso. Childish bodies erupt into fierce heads with immense teeth or long noses that have erotic overtones; small figures have enlarged feet or prominent pudenda, and the large highly colored, carefully delineated eye appears almost everywhere, at once an

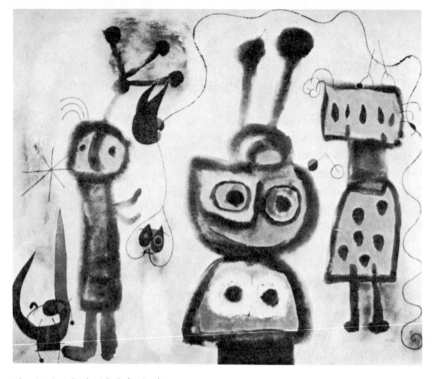

49 Miró / Bird with Calm Look,
His Wings in Flames, 1952

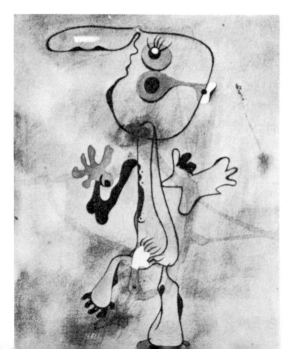

50 Miró / Personnage, 1935

abstraction and a female symbol. Thus, basing himself in part on childlike representation and in part on the imaginative freedom of the child seen through adult-distorting lenses of surrealist automatism and double-imagery, Miró has an ambiguous relation to children's art. He employs it, but drastically changes it, to create a world of his own fantasy, full of movement and gaiety, but also sardonic and grotesque, with some of the child's unhesitating cruelty. In Klee's world, too, apparently childlike means are made to convey oblique adult comments, but with romantic irony and a certain intellectual wit and detachment. In contrast, Miró's world, perhaps for the very reason of his own unforced simplicity (which has nothing to do with his artistic intelligence), is lusty, humorous and whole-hearted.

Graffiti and children's art also serve as exemplar and inspiration to Jean Dubuffet. But the scratched drawings and thick-bodied paintings which Dubuffet admires, and to which much of his work is an adult parallel, are not those on prehistoric cavern walls, but the familiar and abundant designs traced on the pavements and stone fences of Paris. Like Klee, but in a much more brutal, direct, and tangible way, Dubuffet, wishing to cast off the accepted tradition of the "acquired means," sought a road back "into the elementary and formative beginnings of art [to transcribe] a state of child-like innocence and amazement." [26] Dubuffet, like Klee, was interested in Prinzhorn's publication of the art of the insane, and he was attracted by untrained, amateur art of all kinds (whether children's, barbaric, folk or psychotic), and made a considerable collection of l'art brut. But his models are of an entirely different scale and power, and his own graffiti are reminders of the streets "where the crumbling plaster of the housefronts has become little more than a record of the passage of time, and the tattooing on the walls is the work of a lonely madman or of children with a vagabond instinct." [27]

Dubuffet has said that he wishes "to carry the human image . . . immediately into the range of effectiveness

without passing through esthetics." [28] In so doing he discards all the traditional means (perspective, proportion, and fine drawing) and traditional concepts of the artistic (conventional beauty and accepted subjects) in favor of the simplest frontal and profile views, crude bodies with enlarged heads drawn in the outline manner of a child, and the child's emphasis on the remembered message-carrying detail. Purely programmatically this is primitivism of a familiar kind; but there is also something more. Dubuffet builds up his materials, whether oils or synthetic substances, in a thick and ridged impasto and with a deliberate preservation of messiness and confusion that conveys something of the child's tactile pleasure in manipulating clay or mud. He creates an object which has a fetish-life of its own (apart from all reference and resemblance) and which elaborates the accidental to enhance its independent reality. At the opposite pole from Miró's gayly colored surfaces and Klee's colored atmospheric setting for his childlike line, Dubuffet employs color only as one attribute of substantial matter to help divide and distinguish its different areas. This is to say that, like the dadaists, Dubuffet extends his "anti-cultural" position, which is a kind of primitivism, from attitude and technique into material. But where the dadaists, who after all adopted the vision and structure of contemporary cubism, inevitably transform their "unartistic" materials into art, Dubuffet's aim is to leave them as close to their raw state as possible.

Dubuffet's purpose is, of course, not the simple re-creation of a children's art—this is never the intention of primitivist procedures. He has said of his pictures of 1942–44 that they were painted in "a style, that for lack of a better word, I call 'theatrical.' . . . I think I might say that these paintings aim at showing human emotion, man's particular ways (innocent like the ways of children when they draw) of transcribing the sights spread out before his eyes, and the complete harmony of man's nature, his life, and his condition with these sights, but also the painter's very positive inter-

51   Dubuffet / *View of Paris—Life of Pleasure, 1944*

52   Dubuffet / *Touring Club, 1946*

vention . . ." [29] Certainly a great many of Dubuffet's paintings appear savage and aggressive, and such a series as the *Corps de Dame* (1950) seems to point more toward a bitter or a mocking nihilism than toward his own stated goal: "my art is an attempt to bring all disparaged values into the limelight." [30]

Yet Dubuffet assures us that his art is neither critical nor humorous: "I don't worry about [objects] being ugly or beautiful; furthermore these terms are meaningless for me . . . I have liked to carry the human image onto a plane of seriousness where the futile embellishments of esthetics no longer have any place, onto a plane of high ceremony, of solemn official celebration, by helping myself with what Joseph Conrad calls: 'a mixture of familiarity and terror' . . . My position is exclusively that of celebration, and whoever has thought to detect in it intentions of humor or satire, of bitterness or invective, has misunderstood it." [31]

If Dubuffet has "reinvented the conventions of ignorance" it is because he hopes through them to rediscover and record some underlying truths which aesthetic skills and traditional vision have obscured. He wishes to describe objects as he believes most people see them, not in the isolation that conscious attention produces, but within a surrounding matrix that blurs and confuses their configurations, and yet constitutes their everyday reality: "My persistent curiosity about children's drawings, and those of anyone who has never learned to draw, is due to my hope of finding in them a method of reinstating objects derived . . . from a whole compass of unconscious glances, of finding those involuntary traces inscribed in the memory of every *ordinary* human being, and the affective reactions that link each individual to the things that surround him and happen to catch his eye." [32]

Although Dubuffet's pictures are in many ways closer to those of children than are the paintings of either Klee or Miró, they are still far removed—in technique, in representation, and above all in the choices, the emphases, and the

exaggerations of his subject matter. In this sense Dubuffet's art has a very deliberate, adult iconography. The comparison with the two older artists is revealing. Compared to Klee's mystic pantheism, Dubuffet's is a material continuum; compared to Miró's open, transparent spaces, Dubuffet's figures live in opaque, literally earthy surroundings from which they are often hardly distinguishable. Compared to Klee's wit and Miró's humor, Dubuffet's mood is one of aggressive immediacy, a positive pleasure in the ordinary (the vulgar), from which there is to be no distance, no escape, since one comes against a solid, impenetrable wall of figures or a single figure, and of paint itself. Dubuffet's art is somehow an art of the city, even in his landscapes. He paints crowds, but beyond this all his pictures are crowded. Dubuffet's first relation is to the graffiti of city walls, and his primitivizing style, which took its characteristic tone of confined violence during the gray, huddled, and bodily dirty years of the war in Paris, "celebrates" a generalized mass reduction.

A century ago, in the *Peintre de la vie moderne*, Baudelaire wrote his famous definition of genius as *l'enfance retrouvée*:

> Genius is nothing more nor less than *childhood recovered at will*—a childhood now equipped for self-expression with manhood's capacities and a power of analysis which enables it to order the mass of raw material which it has involuntarily accumulated.[33]

In some ways Klee, Miró and Dubuffet, their work inspired by the art of children, are examples of what Baudelaire had in mind. As he suggests, they wish to escape from the jaded and the conventional, from the *idée reçue* and the repetition of the familiar, and to recover the freshness of sensation and feeling which belongs to youth. But they have gone far beyond his intention. In his *Journal* for 1849, Delacroix writes: "Perhaps very great men (and I believe it completely), are those who, at an age when intelligence has

all its powers, have kept a part of that impetuosity of their impressions which is characteristic of youth," and as Margaret Gilman has pointed out, it may well have been he who suggested to Baudelaire the relation of childhood to genius.[34] What they both sought was the youthful ability to perceive acutely and to feel with enthusiasm. But the methods by which this experience was to be expressed were the methods of maturity, the skills employed (as Delacroix's own practice shows) were to call upon the accumulated knowledge and cunning of the past, and the feelings themselves, however elementary their basis, were not only profound, but developed and subtle.

Both the painter and the poet of the nineteenth century would have been shocked to find artists who are inspired by the actual forms of children's art and who adapt at least some part of its techniques (or lack of technique) into their own work, as these modern artists have. Of course the paintings of Klee, Miro and Dubuffet do not really resemble those of children. They are nevertheless reminiscent of them, and quite deliberately so. It is the conscious incorporation of this reminiscence, and its evocation with a particular accent (witty, gay, or brutal) to comment upon man's adult condition, that distinguish the twentieth century.

NOTES

1. See above, Chap. I, Part 2; as well as for a coincidental change in interest on the part of German ethnologists.

2. Klee knew the *Blaue Reiter* artists in Munich in 1911, at which time he also learned of Matisse's painting.

3. Dufy and Chagall have been discussed above; though related to children's work only in an indirect, humorous manner, Dufy's painting would be impossible without an appreciation of it. Itten and Lascaux are "false primitives"; Masson uses children's subjects on occasion; for Picasso, *cf.* his *La Catalane* (1911), which uses a humorous adaptation of child technique.

4. *Cf.* the dance masks of the Basonge, with their horizontal stripings.

5. These designs are usually made by a system of block printing, and rarely done by hand.

6. *Cf.* Hans Prinzhorn, *Bildnerei der Geisteskranken* (Berlin: Springer, 1923), pp. 65, 85, 246. The drawings of the mentally ill are far from being uniform, even within the same malady, and are in most cases quite conventional. Prinzhorn's illustrations represent an oriented selection.

7. For comparisons of the *Comedian*, Prinzhorn, *op. cit.*, p. 60, and Plate II; for the *Scene*, p. 100, and Plate III. The etchings also show some influence of the revival of German sixteenth-century work which we have mentioned in connection with the phenomena of German primitivism; see above, Chap. IV.

8. Feininger also places childishly composed forms in a space derived from the cubist treatment of planes. His infant ships, however, are diminished and simplified to increase the vastness and the romance of the surrounding sea.

9. G.-H. Luquet, *The Art and Religion of Fossil Man* (Paris: Masson, 1930), pp. 72–73.

10. *Cf.* Klee's admiration for Byzantine art on his trip to Italy in 1901, René Crevel, *Klee* (Paris: Editions N.R.F., 1930), p. 5.

11. *The Diaries of Paul Klee, 1898–1918*, Felix Klee, ed. (Berkeley: University of California Press, 1964), p. 266.

12. New York, The Museum of Modern Art, *Paul Klee* (New York, 1945), p. 8.

13. Felix Klee, *Paul Klee* (New York: Braziller, 1962), pp. 182–184.

14. *Ibid.*, p. 183.

15. Klee, *Diaries*, p. 344.

16. Will Grohmann, *Paul Klee* (New York: Abrams, 1954), p. 214.

17. Klee, *Diaries*, p. 237.

18. Paul Klee, *Pedagogical Sketchbook* (New York: Praeger, 1953).

19. Jerome Klein, "The Line of Introversion," *The New Freeman*, I (1930), pp. 88–89.

20. *Loc. cit.*

21. André Breton, *Génèse et perspective artistique du surrealisme*, 1941, reprinted in *Le Surrealisme et la peinture* (New York: Brentano, 1945), p. 94.

22. Michel Leiris, *The Prints of Joan Miró* (New York: Curt Valentin, 1947), p. 2.

23. James Thrall Soby, *Joan Miró* (New York: The Museum of Modern Art, 1959), p. 24.

24. Georges Duthuit, "Où allez-vous Miró," *Cahiers d'art*, VIII–X, 1936, p. 262; quoted in Soby, *op. cit.*, p. 28.

25. Leiris, *loc. cit.*

26. Peter Selz, *The Work of Jean Dubuffet* (New York: The Museum of Modern Art, 1962), p. 11.

27. Daniel Cordier, *The Drawings of Jean Dubuffet* (New York: Braziller, 1960), Plate 10.

28. Peter Selz, *New Images of Man* (New York: The Museum of Modern Art, 1959), p. 60.

29. Quoted in Selz, *The Work of Jean Dubuffet*, p. 137.

30. Quoted in Selz, *ibid.*, p. 19.

31. Quoted in Selz, *New Images of Man*, p. 60.

32. Quoted in Selz, *The Work of Jean Dubuffet*, p. 81.

33. Charles Baudelaire, *The Painter of Modern Life and Other Essays*, trans. and ed. by Jonathan Mayne (London: Phaidon, 1964), p. 8.

34. Margaret Gilman, *Baudelaire the Critic* (New York: Columbia University Press, 1943), pp. 149–150.

## Dada and Surrealism

In tracing the idea of primitivism in its various manifestations, and in indicating the relatonship of modern painting to primitive art, we have constantly attempted to separate the professed program of the different artists and schools from the manner in which that program was actually carried out in their pictures. Any discussion of the primitivism of the surrealists makes this distinction more than ever necessary, because their attitude toward the subconscious—in other words, toward indigenous and personal primitive elements—is by definition such that its results cannot coincide with its intention. It is not possible here to enter into a detailed analysis either of the surrealists' attitude toward psychoanalytic theories which so strongly shaped the desire and the form of their expression of the submerged ninetenths of the iceberg of the human mind, or of many of the individual pictures which have resulted from it. Whatever may be, in any particular case, the degree of assimilation of these theories, it must be clear that as soon as (and perhaps before) surrealism abandoned the definition of itself as "pure psychic automatism" which characterized its *temps héroique* from 1919 to 1923 and adopted a position of the conscious use of the processes of the unconscious, its results were necessarily at variance with the psychological theories from which it pretended to get its validity.[1]

Dali asserted that he had no notion of the meaning of certain of his pictures when he painted them and was not able to explain them when they were finished (*i.e.*, they were automatic). This position is contradicted by his literary activity concerning them, by the compositions them-

selves and the titles he gave to them, and by the "paranoiac-critical" method. But to accept it on his own terms is to accord a kind of self-analysis and control of his own subconscious which is entirely suspect, and which, were it feasible, would in itself do away with the freely associative and unhampered expression of that portion of the mind whose value according to the surrealist doctrine lies precisely in its uncontrollability.[2] As soon as the double character of what Dali calls a "paranoiac" image is recognized as such, and strictly speaking this can be done either by the artist or the spectator only in his capacity as investigator, its value as direct expression of the subconscious is immediately compromised; while a subconscious recognition (accepting for a moment its possibility) can come only from the extremely limited number of people whose "delusions" parallel those of the artist.[3]

Three aspects of the surrealists' view of their method and art may be called primitivist: In the first place they looked upon themselves as continuing a tradition of anti-rational exteriorizing of the subconscious that went back to the alchemists and included Rabelais, the Marquis de Sade, Gérard de Nerval, Lewis Carroll, Baudelaire and Rimbaud. This tradition they saw as having "wished to give back to civilized man the force of his primitive instincts," either directly, as with Sade, or by disguising itself in exotic or historical fantasy in order to delve into emotions which for social and wrongly moral reasons had more recently been overlaid with a surface of manners, but which nevertheless are basic in the makeup of every human being.[4] The connection of the horror and fantasy of these authors with the sexual bases of human conduct, rarely consciously recognized by them, is a link which the surrealists themselves establish and emphasize. The tradition is largely literary, although André Breton at one time tried to extend it back into the history of art, including Uccello, Blake, the pre-Raphaelites, Moreau, Redon and Seurat among the ances-

tors. Its outstanding pictorial example is the use made by Dali of the (to us) generally morbid atmosphere and the technique of Arnold Böcklin.[5]

In the second place the surrealists, although recognizing some valuable ancestors, saw themselves as beginners, as pioneer explorers in the realm of the subconscious, a field which they were the first to investigate systematically by artistic means. It is nevertheless not quite clear whether they considered their investigations works of art or not—"painting, literature, what are they to us," says Breton—because following dada they wished to break down the artificial delimitations that tradition had set around "art." But in any case they were convinced that later discoveries within that "future continent" on whose shores they had landed would eventually give their work a crude and primitive aspect.[6] This crudity, however, would only add to the impact and the importance of their productions:

> But all question of emotion-for-emotion's-sake apart, let us not forget that in this epoch it is reality itself that is in question. How can anyone expect us to be satisfied with the passing disquiet that such and such a work of art brings us? There is no work of art that can hold its own before our essential *primitivism* in this respect.[7]

And lastly, and for our purposes this is the most important, the surrealists considered that they were working with the essentials of human nature as finally revealed by psychology. Taking a position similar to attitudes already discussed, they assumed that such a preoccupation in itself gave their work importance. They valued an exclusive concentration on the imagination just because by this method it was rendered no longer imaginative, that is unreal, but became the sole reality, good in itself, which it was the task of their work to reveal.[8] More than this, however (and in line with the theories of other movements), they considered that by this very concentration their work was necessarily intelligible to a larger audience than was the case with those traditional types of art that had to depend upon conscious, ra-

tional formulations. They felt that because they were dealing with emotional elements common to everyone and powerful in each individual, their work, instead of uselessly "embroidering" upon unimportant emotional nuances, was bound to be not merely of interest but also immediately comprehensible to all.[9] Indeed, in a carry-over of the "intuitive" epoch of surrealism, when their art tried to free itself of the external controls of traditional conception and technique in what was a turning inward of the reaction against accepted "art" forms which dada had expressed by the use of "ready made" nonartistic objects or materials, the surrealists claimed that surrealist objects may be produced by anyone, or (which is the same) simply found, or discovered. Since the essence of their kind of art was, as they saw it, the revelation of a reality through the freest possible activity of an irrational subconscious, anyone who achieved this state was an "artist," and any object (fabricated or discovered) through which this state was symbolized was a work of art— and of non-art.

As has just been suggested, the primitivist tendency already inherent in dada lay in dada's destructive conviction that no acquired technique is necessary for the creation of works of art. Behind its pranks, both artistic and social, was the notion that it is the internal factor which alone counts in either realm, whereas the world has put its faith solely in the external.[10] Though this made the dadaists sympathetic to the work of children and of madmen as direct expressions of inner feeling, their own productions are of a highly allusive character: Rather than ignoring the art they wish to destroy, they refer to it through startling juxtaposition of form or content, and in consquence their creations are of an extreme sophistication and have a minimum of directness and simplicity.[11]

To ask whether or not the surrealist result, as it is embodied in the paintings of such men as Salvador Dali, Yves Tanguy, René Magritte, and Max Ernst, is primitive in its effect is to be (even more strikingly than concerning other

schools of modern art), entirely irrelevant. We may never-
theless note a complication of form and subject matter
which makes their work anything but easily digestible—al-
ways excepting that supposedly intuitive comprehension
about which there can be no argument, but of which there is
also little possibility. By deliberately composing their sub-
jects out of Freudian iconographic symbols, and so lifting
them into consciousness, they both alter their meaning and
restrict their understanding. Dali's double images, Ernst's
scenes of torture and levitation, Tanguy's dream perspec-
tives, and the pervasive suggestion of sexual organs have all
become rational glosses on a known text. In the process they
have lost the irrational subterranean communicative power
for which they were appropriated. As has been pointed out
in the case of abstract art, the lifting into consciousness and
the concentration upon things whose effect was formerly
subconscious, instead of increasing the effect merely moves it
from the direct emotional plane to the allusive and the lit-
erary.[12] What was previously the work's underlying motiva-
tion now becomes its subject. Since in surrealist painting
this change carries with it a whole body of complicated the-
ory while abstract art is concerned only with geometrical
form, the effect is that much more completely destroyed.
Thus if the viewer takes them seriously, Dali's watches and
flies affect the beholder conversant with Freud simply as
psychiatric history; if not, they become curios of technique
and recondite literary reference.[13] In either case, the ob-
server's conscious attention is occupied in reconstituting
the iconography of the picture, establishing a connection
between parts whose relationship, on the surrealists' own
assumptions, can be emotionally effective only at a subcon-
scious level. The necessarily detailed manner of examina-
tion which thus results is moreover aggravated by the sur-
realists' method of exact depiction of individual objects,
using various established technical methods of the past to
lend reality to the unreal by an overminute rendering of
detail. They thereby add the pleasure of recognition to the

shock of unexpected juxtaposition, but never, as in a true metaphor (whether conscious or subconscious), really combine the two. Thus the "surrealist" level, at which "real" and "unreal" fuse and lose their meaning, is never reached. Further, the inclusion of actual erotic objects within the picture, or at least their representation in such a fashion that they are not sufficiently removed from the originals to be called symbols for the conscious and surely not for the censored subconscious mind, means not only that the supposedly scientific basis of the iconography has been upset by the confusion of two levels of the mind, but, once more, that there can be no question of an intuitive grasp of the picture's meaning: The kind of recognition to which the spectator is forced always belongs to the realm of reason and never attains that region beyond (and before) reason whose grasp is surrealism's professed goal.[14]

Coupled with the minute handling of detail is the placing of small objects in vast flat expanses, the use of a distant horizon and much sky, the extension of space parallel to the picture plans, and the exaggeration of perspective so that the eye sees into immense distances. While recognizing in these methods an attempt to reproduce the unlimited dream spaces of the mind, one may point out that they derive from painters who were consciously engaged in the representation of the exotic, whether with Oriental and tropical overtones, as in the case of Meissonier (from whom Dali's smaller pictures stem), or, as in the pictures of Böcklin, with romantic-classical and archaizing suggestions.[15] The surrealists, however, in spite of the accuracy of their detail, further diminish the already vague localizations of these painters and further emphasize the almost infinitive distance of the source of illumination. By these means they increase the overtones of symbolic importance, adding suggestions of meanings which are never specifically indicated and whose possibly great significance, never given within the picture itself, is—as already noted with Klee—emphasized by the deliberate obliqueness of the titles which are given to it.

It is not possible, then, to discover in the more narrowly surrealist paintings any primitivist result, either of form or of direct psychological content; indeed, they make deliberate use of all the external oversophistication and "decadent" complication of manners and meanings which they profess to deplore and to be intent upon destroying. In that intention, and in its avowed method, however, we may discover certain primitivist tendencies connected with others which we have discussed. The surrealists were interested in what they considered the pre-rationalist aspects of primitive art and its more "fantastic" inventions, and so were more drawn to Melanesia and the Northwest Coast than to Africa. The connection between children's art and the intuitive phase of surrealism has been mentioned above, as well as the dadaist and early surrealist emphasis on the primitive inner sources of inspiration which parallels Kandinsky's appreciation of children's art and his wish to emulate it. The connection is most evident in Miro, who was able to adopt the surrealist attitude without its apparatus. In the sexual and "paranoiac" subject matter of later surrealism we see an attempt to find important and generally compelling themes of which to treat, themes which will capture the attention of the individual and still be comprehensible to a large public. As we have already remarked, this is not in itself a primitivist aim; what makes it so is that it is carried out by what is supposed to be a return to primitive and basic psychological factors and by an omission of the new and intricate, but nevertheless common, objects and external situations.[16] They thus arrive at an exclusive emphasis on the internal motivation of their art which, lacking any interplay with external factors, must obtain its ostensible justification by driving deeper and deeper into the pervasive foundations of the mind.[17] The assumption that this process will automatically increase the vitality of their art, and by this same token its audience, is one that, with variations, we have noted before. It is indicative of the primitivist orientation and tendency which runs through a great deal of modern painting.

NOTES

1. See the definition given by André Breton in the *Manifeste du sur-réalisme* in 1924, and quoted by him in *What is Surrealism?*, trans. by David Gascoyne (London: Faber and Faber, 1936), p. 59:

> SURREALISM, n. Pure psychic automatism, by which it is intended to express, verbally, in writing, or by other means, the real process of thought. Thought's dictation, in the absence of all control exercised by the reason and outside all aesthetic or moral preoccupations.

The second epoch Breton calls the "reasoning" one. *Ibid.*, p. 50.

2. Salvador Dali, *Conquest of the Irrational* (New York: Julien Levy, 1935), *passim*. Despite definitions, it is difficult to ascertain just what (in practice) the "paranoiac-critical" control of the mind consists; any demand for consistency is hopelessly pedestrian and un-surrealist.

3. The double "paranoiac" interpretation of events is almost always associated with the combined delusions of persecution and grandeur. In giving the second interpretation of their images an exclusively sexual character they are perhaps themselves guilty of a neurotic obsession.

4. Paul Eluard, "Poetic Evidence," in *Surrealism*, ed. Herbert Read (London: Faber and Faber, 1936), p. 177. Also Breton, *op. cit.*, p. 77.

5. André Breton, *Le surréalisme et la peinture* (Paris: Gallimard, 1928), p. 42.

6. Breton, *What is Surrealism?*, p. 17.

7. *Ibid.*, p. 13.

8. *Ibid.*, p. 64: "The admirable thing about the fantastic is that it is no longer fantastic: there is only the real."

9. Breton, *ibid.*, p. 13. This is Dali's reason for establishing his "critical" method in order to get rid of difficult Freudian interpretations which have a "vast margin of enigma, especially to the great public." Dali, *op. cit.*, p. 14.

10. Arthur Cravan's hanging of an empty picture-frame in the Luxembourg Museum in 1914 is the classic dada gesture (carried out before the creation of dada) against the accepted notion of art. *Cf.* Georges Hugnet, "L'esprit dada dans la peinture," *Cahiers d'art*, IX (1934), p. 109. The surrealists continued to carry on the rather outworn fight against "The very narrow conception of imitation which art has been given as its aim." Breton, *What is Surrealism?*, p. 13.

11. *E.g.*, *Fatagaga* of Arp and Ernst, Ernst's *La Femme 100 têtes*, Duchamp's signature of "R. Mutt" to his *Fontaine* (1917), and his decorations of Leonardo's paintings, and finally Kurt Schwitter's *Merzbilder*. This was a necessary concomitant of dada's destructive character.

12. See above, Chap. V.

13. *E.g.*, *Illuminated Pleasures* (1929), *The Persistence of Memory* (1931), *Atmospheric Skull Sodomizing a Grand Piano* (1934). Dali's "critical" method does not destroy this aspect.

14. *E.g.*, *The Enigma of William Tell* (1934), *The Invisible, Fine, and Average Harp* (1933), *Average Atmospherocephalic Bureaucrat in the Act of Milking a Cranial Harp* (1933).

15. *E.g.*, Dali's *Apparition on the Beach at Rosas* (1934) and his *Mediumistic-Paranoiac Instantaneousness* (1934) for Meissonier coloring and

lighting; the first picture, as well as his *Surrealist Object Indicating Instantaneous Memory* have suggestions of Böcklin. Tanguy's pictures also have these characteristics.

16. André Masson's works of the twenties contain elements of animal-primitivism and also show the influence of infantile and psychiatric line drawings, as in *Battle of the Fishes* (1927) and *Animals Devouring Themselves* (1928).

17. The surrealist attitude toward untrammeled expression of the subconscious was taken over in the late forties by the New York group of abstract expressionists. Earlier, they had been influenced by American Indian painting.

@ @ @ @ @ @ @

# VII Primitivism
# in Modern Sculpture

In the creative arts of Africa and Oceania, sculpture is predominant. It is, to be sure, a sculpture very different in technique and in formal tradition from that of the west. The distinctions among the arts familiar to traditional European aesthetics are unknown to it, so that it is notably less "pure" than such theories would demand. Primitive sculpture quite naturally employs color to enhance, or even simply to produce, any desired plastic effect, just as it can add modeled clay to a carved core of wood: Artificial questions as to the propriety of mixing media never occur to either artist or audience. Painted surfaces play an especially large role in Melanesian sculpture (some of it flat, as in the Papuan Gulf region; some of it intricately three-dimensional

and spatial, as in New Ireland), but the African sculptor does not hesitate to brighten and variegate both masks and figures when it will increase their power and their drama. Despite this fusion, these objects physically remain sculpture, and aesthetically they must solve the problems of sculpture.

Moreover, sculpture's predominating role among the primitive arts was, for the modern western artist, heightened by the conditions of their importation. The rock paintings of East Africa or Australia, the wall decorations of the houses of West Africa or the painted gables of men's houses of New Guinea, these and similar works were seen only rarely in Europe, while masks and figures abounded in museum cases and dealers' shops. Body-painting, so integral a part of primitive man's ritual environment, necessarily remained unseen and ignored.

Given this historical setting, it would appear natural that primitive art, consisting largely of primitive sculpture, should have had a direct, formal influence on modern sculpture, more significant and more extensive than its influence on painting. If this in fact is not the case, there are a number of reasons. Until recently at least, painting rather than sculpture has been in the forefront of stylistic change, so that painters were the first to become conscious of how certain aspects of aboriginal art met their needs, and of how to absorb, transform, and adapt them to their own uses. The history of cubism is the outstanding instance, but the priority of painting applies as well to surrealism, since Ernst and Miro were painters long before they were sculptors for whom the primitive example permitted and suggested certain freedoms and fantastic combinations. Perhaps more important was that the formal inventions of the primitive sculptor weighed too directly on the modern sculptor, precisely because he was a sculptor. Lacking the transposing distance of a different medium which compelled the painter to rework his admiration and to concentrate more on emotional result than upon compositional method, the sculptor was faced

with possibilities of directly incorporating motifs, stylizations, and plastic rhythms into his own work. Although momentarily tempting as an experiment, derivative solutions of this kind were of course unsatisfactory. He was thus left with the liberating impression of the enormous variety of primitive sculpture's formal images, of its freedom from the inhibitions of Western naturalism, and of its resulting power and vitality. But the sculptor had to be more wary than the painter of the forms themselves: Unless he kept his distance, his relation was too close for comfort.

The seeming paradox has already been examined in the work of Gauguin. It is above all in his sculpture that individual decorative and representational motives are taken over and re-employed almost without alteration—the Marquesan tiki, Easter Island hieroglyphs, Indian seated deities.[1] And yet these direct incorporations, limited in number, have less of the primitivizing spirit than his paintings, where, by being transposed and necessarily altered, they are blended into a more personally expressive style.[2] Less specifically evident in the paintings than in the sculpture, the primitive is nevertheless—and perhaps just for this reason—more pervasively and even more fundamentally present, because its initial stimulus has been thoroughly reshaped in Gauguin's own imagination.

It has been suggested that the only sculptor among the Nabis—who as a group in the nineties were strongly influenced by Gauguin's ideas of a decorative, non-naturalistic art—was also familiar with "Maori" sculpture.[3] What one knows of George Lacombe's production, which seems to have been small, hardly bears this out. His handling of symbolist-induced subjects, like those in the wood panels of *The Bed,* suggests rather that he was attracted by the simplifications of provincial carvers whose style showed a mixture of late medieval and Renaissance traditions. Other members of the Nabis, like Gauguin himself, were also drawn to the folk manners and customs of Brittany, and similarly found virtue in their simplicities.

Matisse encountered African sculpture as early as 1904 or 1905, and, as has already been noted, soon formed a considerable collection. Its influence on his painting, and on that of the other *fauve* artists, while real, was, as we have seen, indirect and romantic, having more to do with the correlation of the primitive with directness and immediacy than with any formal borrowings. Almost the same is true of Matisse's sculpture. Barr has discussed the very few works that may have been influenced by West African sculpture: *Torso with a Head* (1906), "so sharp-breasted and sharp buttocked"; *Two Negresses* (1908), which seems to have something of the proportions of the "thickset figures of the Ivory Coast"; *Jeannette III* (1910/11), which may be related to certain Cameroon masks; and perhaps *La Serpentine* (1909) in the angular character of its modeling.[4] These instances are after all very few within a large output, and even here, as Barr says, "Negro influence on Matisse's sculpture, if any, is generalized and very well assimilated." In these figures its effect appears to have been only to turn Matisse toward a more marked punctuation and staccato emphasis of his own naturally smoother modeling and sense of arabesque.

Given the importance of African sculpture in the preparation of cubism during Picasso's "Negro" period, one would assume that it was a significant influence on cubist sculpture. It appears in the three roughly cut tree-trunk-like figures carved by Picasso in 1907. Neither their cramped posture nor their broad facial features suggest any particular stylistic source, but altogether they reveal a clearly primitivizing intention. After this, however, the role of African sculpture is minor and peripheral, most evident in the most decorative works of the group's artists.[5] Thus the oval silhouette of Pablo Gargallo's copper *Mask* (1914/15) is probably related to the contours of the wooden masks of the Ivory Coast (Baulé or Guro); and its laminated stripping and the employment of the copper itself may have been suggested by the similar handling of this material in the Bakota *bieri*

figures from the Gabun. The figure-eight mouth of another of Gargallo's masks (1915–16) perhaps derives from the same stylization found in the Basonge figures of the Congo. But these resemblances are superficial, since the masks themselves retain the sentimental feeling common to much of Gargallo's work. Not only was his aim to produce "anti-sculptural sculpture," an intention very much opposed to the three-dimensional African vision, but the deliberate lack of intensity he cultivated in his work was altogether unlike the seriousness fundamental to the ritual or magic function of nearly all primitive art.

The stylizations common to Baulé masks may also have influenced two metal masks of about 1929 by Julio Gonzales. Both reduce the nose to a single sharp line, but the larger of the two, following a device often found in early cubist painting, treats one side of the face as if it were in deep shadow, blurring the eye socket and running it into the recessed cheek. The other mask more faithfully follows the African pattern of pointed chin and flat plane of an inverted triangle between the tip of the nose and the straight line of the cut-out eyes, but the usual tiny mouth has been entirely omitted. Unlike African masks, Gonzales' two masks remain almost two-dimensional. A mask done in 1924 by Antoine Pevsner, however, employs constructivist techniques developed from cubism to achieve and even intensify the three-dimensional effect attained by the Negro artist. Here the prototype is a Dan mask, clearly indicated by the open, birdlike lips with teeth showing, the strongly overhanging forehead and the slit eyes and nose projecting from continuous curve of the recessed cheeks and eye sockets. The African artists' ability to suggest volume by outlining a void, so influential in early cubist painting, has here been developed by Pevsner through the use of translucent plastic. Space thus replaces mass, in accordance with the constructivist credo, but the interplay of positive and negative has certainly been prompted by the congenial, formal achievement of the Ivory Coast carver.

As has been suggested, the works mentioned here are hardly central to the cubist tradition. Laurens and Lipchitz, the sculptors most closely allied with the cubist movement, were certainly aware of primitive, and especially African, art but it is hardly evident in their works, although Lipchitz was an ardent collector from 1912 on.[6] Laurens, in fact, seems to have been entirely unaffected by primitive art, and both his early reliefs and his sculptures in the round attack problems first posed by cubist painting. With the possible exception of *Bather* (1915), whose long torso and squat legs bent to balance the curve of the head were probably suggested by the proportions of African figures, the same is true of Lipchitz cubist sculpture from 1912 through 1930. Both artists were concerned with giving actual tangible substance to the cubist painters' vision of simultaneous multiple views. They were undoubtedly impressed with the natural three-dimensionality of African sculpture and with its rhythmic interplay of solid and related void. But in its frontality and mass, though often composed of *cubic* shapes, it was anything but cubist, and was indeed fundamentally anti-cubist in conception. The African sculptor, whether his forms were rectangular, elliptical, or round in outline, and whether he cut back little or much into the cylinder of fresh wood with which he began, was content to show one aspect of his figure at a time. He achieved his "instinctive" three-dimensional effect by a calculated simplification and separation of parts that allowed the eye to grasp each one as a unified, coherent mass. The cubist sculptor, on the other hand, wished to "make his figure turn" by simultaneously showing or suggesting frontal and orthogonal planes, by flattening diagonals, and by swinging other hidden surfaces into view.[7] His play with the opposition, or the ambiguity, of the tactile and the optical impression, the three and the two-dimensional, would be inconceivable to the primitive artist whose figure, whether religious or magic, embodied an independent self-sufficient existence. There is here such a difference in the basic impulse from which the work springs that the result-

ing creations are necessarily fundamentally opposed. Even the substitution of a concave for a convex form (which rests upon the interplay of optical and tactile), which the cubist sculptor extends to the figure as a whole, is in Negro art largely confined to the mask, or to the facial planes of the head, and is not used in the shaping of limbs or torso.

It has been suggested that the principle of pierced or transparent sculpture, which first appeared in cubist relief constructions in 1913 and almost immediately thereafter in sculpture as well, derives from the projecting cylinders employed in certain Poro society masks of Wobé people of the Upper Ivory Coast.[8] These cylinders, which come forward horizontally from the vertical plane of the face, do more than replace the eye; they also stand for the continuation of the eye in the concentrated intensity of its gaze, fixed upon the spectator at a distance. The transformation of such a powerful positive shape into its opposite—a negative volume—involved the entire reversal of the intention of the primitive artist. It therefore is not surprising that Picasso's reliefs (or Lipchitz' *Man with a Guitar* of 1916, if it has the same origin) should bear very little resemblance to its presumed source.[9]

During these same proto-cubist and cubist years, African sculpture exercised a more profound and lasting influence on modern sculpture through an artist who, while not himself "belonging" to cubism, evolved his own characteristic style in constant contact with and appreciation of the cubist revolution: This was Brancusi.

Brancusi was certainly very much aware of African sculpture by 1909, when he formed a close friendship with Modigliani, and he may well have known of it a year or two earlier. In 1912 he protested to Epstein against its influence, and may even have destroyed a work which he thought betrayed certain African traits.[10] Nevertheless, it undoubtedly played a role in his formation. That role did not consist in the adaptation of specific forms of Negro sculpture, and (unlike Modigliani's) his work is never related to any par-

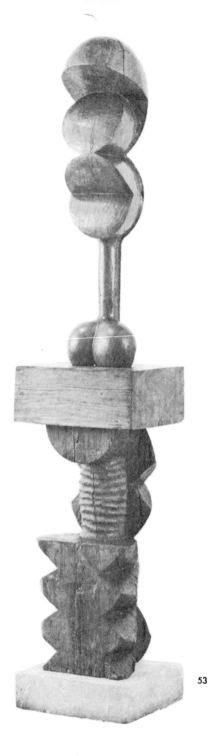

53   Brancusi / *Adam and Eve*, 1921

ticular tribal style. It is rather that his wooden sculpture displays a sense of the upright three-dimensional, combined with a freedom of attack upon its contours, that is allied to the African approach. Brancusi's forms are even more simplified and generalized, more geometric and abstracted. Yet the strongly indented rhythms of *Adam and Eve* (1917 and 1921) or of *Chimera* (1918) would be impossible without the African stimulus. The single large ovoid of the *Chieftan* (1925) and the repeated ovoids of *Socrates* (1923), both broken by the bold gash into the closed volume of the head, are also related to African staccato handling of solid and void.

Yet it is understandable that Brancusi was unhappy with a work that resembled Negro sculpture; he has transmuted the Negro influence into something entirely modern. The primitive artist, however he may simplify for reasons of form or iconography, always represents, although his figure may well have more than one reference, depicting, *e.g.,* both a real and a mythical ancestor. In contrast, Brancusi suggests. He differs radically from the primitive artist in two ways: He allows himself to be captured by the structure and relation of some geometric forms for their own sake (witness his cubist interplay of curves and straight edges); and he pushes other forms over the borderline from specific depiction into a more generalized symbolism (he is of the generation of the symbolists). But these two directions never split apart; they are kept in balance, as the parts of a single work seem to shift back and forth between pure abstraction and iconographic program, while containing them both within a varying emphasis. In the enigmatic quality thus achieved Brancusi, in his own personal way, attains that sense of presence (of intensity and meaningfulness) which attracts many modern sculptors to the primitive, and for which, without being in any way derivative, they seek their own equivalents.

There is another element in Brancusi's sculpture which, while differing markedly from the primitive, is yet primitiv-

ist in feeling: This is his respect for the material itself, his wish to conserve an awareness of its original state within the awareness of the work of art it has become. In his preface to Brancusi's first one-man shown at the Brummer Gallery (1926), Paul Morand wrote:

> Let us visit [Brancusi's] studio. Studio? This stone quarry? . . . Nothing here but great blocks of building stone, beams, trunks of trees, boulders and rocks, and here and there a highlight of polished bronze. One of these primitive forms detaches itself from the rest, and advances towards us, massively.[11]

A sense of respect for the medium, a feeling that its inherent qualities of grain or crystalline structure, its limits of stress and strain must not be violated, is shared by many modern sculptors. This attitude, summed up in the phrase "truth to materials," which at first seems an entirely ethical condition, has its own primitivist aspects, especially in its extreme projection of the pathetic fallacy. (Any kind of successful manipulation of the material is aesthetically justified—provided it is successful, physically and visually.) But Brancusi goes further. In his wood sculptures and in some of the earlier ones in rough stone (*Ancient Figure* [1908] and *Girl's Head* [1907–18], for example), he deliberately emphasizes the untouched condition of both the shape and surface of his material (a condition often more apparent than real), and contrasts it with the refinement and sensibility of its composition. He thus appears to assemble pieces of wood, found by chance, which accident and age have reduced to an elemental condition, material that seems to have its own life, resistant to the artist's aesthetic will and never entirely brought into submission. By means of this tension Brancusi puts a conscious emphasis on what for earlier sculptors had simply been an unavoidable condition of their work's physical existence, and in so doing, gives a positive value to the primordial. His work anticipates the romanticism of materials that appears again in the "found sculpture" of the surreal-

ists and the "junk sculpture" of the fifties. The one stresses natural castoffs, the other industrial; they are alike in insisting that fundamental materials should not be hidden by the artist as creative artisan, and must indeed be prominently displayed. Brancusi's few sculptures in wood distill the essence of this primitivism of materials.

This ideal is very different from the kind of simplicity which Brancusi achieves in his stone and bronze works. There the simple, instead of being found conserved in all its original roughness, is achieved through constant refinement, and it is to these works that Brancusi's own statement applies: "Simplicity is not an end in art, but one arrives at simplicity in spite of oneself in approaching the real sense of things." [12] It is the difference between the aboriginal and the classic, and the legend of Brancusi's own personality includes something of them both. That he himself in his later years undoubtedly cultivated the legend, suggests that his primitive qualities have been exaggerated. He came from Rumanian peasant stock; in his later years (although not in the twenties) he lived simply and frugally outside the socially artistic world of Paris. He said, as have other modern artists before and since, "When we are no longer children we are already dead." [13] He was also a sophisticated, reflective, analytic, and, in the best sense, a patient and calculating artist.

Modigliani's first contact with African sculpture is usually fixed in 1909, the year in which he did his own first carvings in stone. But Modigliani had been in Paris since 1906, and before 1909 he knew and greatly admired Picasso, so that it is likely that he was aware of Negro art somewhat before this time.[14] His earlier sculptures in wood (dating probably from 1907 and 1908), have disappeared, and it is in the stone heads done between 1909 and 1914 that his assimilation of certain features of Ivory Coast masks and figures is most evident. From 1909 to 1911 Modigliani lived on the Left Bank near Brancusi, who was also interested in African art, and devoted himself entirely to sculpture, to the exclu-

sion of painting. Some time in 1914 he gave up sculpture and worked only at painting until his death in 1920.

The chronology of Modigliani's sculptures has not been established.[15] It is therefore not possible to determine if the various stylistic influences that appear in them follow any sequence. It is evident enough that in a number of his heads he is following the example of the Baulé style (and especially its masks) in the elongated oval of the head with narrow chin, the almond eyes, the sharply defined drawn-out rectilinear volume of the nose that, like the tiny lozenge-shaped mouth, hardly interrupts the smoothly rounded curve of cheeks and chin. The neck cylinder is African too, but its regional source is less easy to locate.

These characteristics are more prominent and more isolated in some heads than in others, but even where they are most easily recognizable they do not occur alone. Archaic Greek art certainly plays a role in the treatment of the hair, and perhaps even more in a handling of the stone surface which, though smooth, remains unpolished—very different from the high patinations of African wood. In other heads there is the pinched smile of the Greek *Koré,* or the fuller, more sensuous expression and fleshier modeling of Khmer sculpture. And in one or two instances, the rough carved capitals of the Middle Ages have served as a precedent to which Brancusi perhaps drew his attention.

To recognize Modigliani's enthusiasms (he is said, about 1909, to have talked endlessly of Negro art) is not to deny him his own genius.[16] That he singled out the Baulé example to fuse with other archaic styles shows that he was being guided by a strong sense of personal creation. Baulé sculpture is the most refined and linear, the most aesthetic and the least daemonic of African work; it could be easily integrated with the other styles Modigliani assimilated, and with the graceful, sentimental direction of his own art, best seen in the paintings that follow the sculpture.[17] His primitive inspiration transformed him no less than it did his contempo-

54  Modigliani / *Head of a Woman,*
ca. 1911

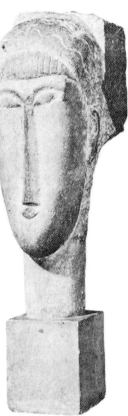

raries. But for Modigliani, almost alone among modern artists, the primitive connoted neither force nor mystery (despite the inward Oriental smile of some of his heads). Its enchantment seems to have held no suggestion of the elemental, and to have been more seductive than strong. Modigliani is thus exceptional in recalling the attitude of an earlier time. The simplified charm he discovers in the primitive is closer to the linear grace which the archaizing neoclassicist extracted from the tradition of Greece and Rome, than to the sense of aboriginal power of both composition and expression that the twentieth-century artist has usually drawn from the primitive.

Jacob Epstein began to buy African sculpture while he was in Paris during the latter half of 1912, engaged on the then-much-criticized figure for the tomb of Oscar Wilde. He was a passionate and determined collector for the rest of his life, concentrating on Africa, but also acquiring numbers of fine Maori and Marquesan carvings and a scattering from other areas. His group of Fang *bieri* heads and figures was exceptional, and included works considered among the finest of African sculptures.[18]

In his *Autobiography* Epstein notes that he had first discovered the "mass of primitive sculpture, none too well assembled" at the Trocadéro, some ten years earlier (about 1902), at a time when he was also attracted by "works that were not at all famous then, but have since come into their own—early Greek work, Cycladic sculpture, the bust known as the *Lady of Elche* and the limestone bust of Akhenaton.[19] His interest was revived later in London, about 1910, by the "vast and wonderful collections" from Africa and Polynesia in the British Museum, which he studied in some detail. These early discoveries were made on his own; but when he went to Paris again in June, 1912, he met Picasso, Brancusi and Modigliani, all of them admirers of African art and, in very different ways, under its influence. His collecting began in that enthusiastic atmosphere, and in his own sculpture the direct evidence of his

interest in the primitive is largely confined to the years 1910–14.

The influences discernible are not from Africa alone. *The Sun God,* begun in 1910 but not finished until 1931, shows appreciable ancient characteristics in its squarely cut stone figure, elongated and flatly projecting from an otherwise uninterrupted wall, but it is difficult to say whether they recall Egypt or the ancient Near East. There is no doubt, however, about the sources of the *Tomb of Oscar Wilde* (1912): Its narrow upright rectangle topped by an emerging face flanked by low relief on the side planes clearly stems from the winged bull of Assyria. Epstein is using these precedents as a means of freedom from naturalistic proportion and as a method of arriving at the architectonic and the symbolic. His purpose, similar to that of other artists in their adaptation of the archaic or the primitive, is to reinforce his meaning by adding both formal weight and iconographic overtones of power and mystery.

During these same years, African sculpture (and not surprisingly, Fang especially) also played a large role. Its influence is already to be found in *Sunflower* (1910), with its long neck, oval face, single curved line of nose and eyebrow, and small, withdrawn mouth. If in deference to the subject the petal-like surrounding mass is more jagged than in the *bieri* heads, it nevertheless frames the face in much the same way. The original version of *Maternity* (1910–11; it was reworked at a much later date) showed a somewhat prettier face than *Sunflower.* The shallow concave heart-shape that composed the sunken eyes, broad nose, and low mouth were even more clearly Fang in their derivation, although the sensuous corpulence of the rest of the figure was related to Indian precedents and certainly had nothing to do with Africa.

The vortex group with which Epstein was associated on his return to London in 1913, largely under the influence of cubist and futurist tendencies given a special inflection by Wyndham Lewis, was generally interested in traditions that

would reinforce its desire for strength and even brutality. Vorticist artists admired what they felt to be the anti-intellectual, expressionist qualities of the exotic arts. Henri Gaudier-Brzeska, the young French sculptor in England at this time, wrote:

> The modern sculptor is a man who works with instinct as his inspiring force . . . His work is emotional. That this sculpture has no relation to classic Greek, but that it is continuing the tradition of the barbaric people of the earth (for whom we have sympathy and admiration), I hope to have made clear.[20]

A few works of Gaudier's own too brief career bear the stamp of such an orientation. His *Seated Figure* (1914) is treated with an over-all simplification in which emphasis is given to the unitary mass of the broadly cut head and face at the deliberate expense of refinement. The head of *The Imp* (ca. 1914) is handled in the same way, while the oval curves of the short bent legs whose heaviness pulls down the figure's whole mass is probably influenced by African proportions. But it is in Gaudier's portrait of Ezra Pound that the conventions of a particular primitive style are most closely followed. This head, which was made to rest directly on the ground without a base, like the great stone heads of Easter Island, also closely resembles them in its elongated cheeks and deep-set eyes with overhanging brows.[21] One of these heads stood in the portico of the British Museum, by the side of the front entrance, and it is probably there that Gaudier found the model he adapted to his purpose.

*The Rock Drill* (1913), Epstein's most vorticist production, shows no primitive affinities, unless it is in the animal-mask suggestion of the covered face; but the two versions of the *Venus* (done in the same year, 1913) again use certain African forms. The contours of the blunt faces, even though featureless, are once more reminiscent of Fang sculpture, as is the exaggerated length of the necks, while the heavy legs, so flexed that the figure seems half-kneeling, are, as in Gau-

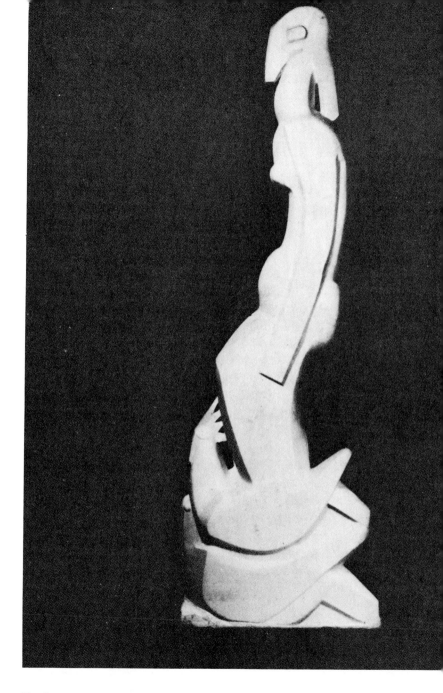

56    Epstein / Venus, 1913

dier's *Imp,* derived from African practice. African wood sculpture, from the Sudan to the Congo, quite generally employs this disproportionate emphasis on legs and feet, and other modern sculptors have been attracted by it because it unifies and solidifies the figure's total mass.

Epstein has denied any over-all affinity of his own sculpture with the primitive:

> I have, because of my appreciation of and my enthusiasm for African work [he writes in his *Autobiography*], been accused—as if it were a crime—of being largely influenced by it. *That is not so.* My sculpture (apart from a short period in 1912–13 when cubism was in the air and abstraction an interesting experiment) has remained in the European tradition of my early training.[22]

This statement is quite generally correct, and the bulk of Epstein's work, his many portraits and figure studies, is of an unexceptionable and often very sensitive naturalism. Even after 1914, however, when Epstein has a religious or symbolic figure to do, he seems to turn toward the primitive, as in *Genesis* (1930), *Woman Possessed* (1932), *Primeval God* (1933), *Ecce Homo* (1934), and *Adam* (1938). The stylistic traditions invoked are not always quite clear (although *Genesis* again recalls the Fang, and *Ecce Homo* perhaps Easter Island), and may indeed be mixed within any one work. The reason they are called upon seems evident: They lend added significance and seriousness, and create an awe and wonder of which the "European tradition" is no longer capable. As Anthony Blunt wrote in connection with *Ecce Homo,* Epstein's initial interest in primitive art may have been formal and visual: "But this more or less technical interest in savage art seems to have led Mr. Epstein to feel further that these artists also offered a new way of making statements about the supernatural . . . He has vivified European religious art by an infusion of dark blood, itself not pure, but drawn from the African, the Aztec and many other races."[23] Like so many other artists, Epstein found in

the exotic arts a means of giving to his own work a broader and a deeper meaning than his own immediate tradition afforded. At least this is what he sought, and it explains the size, the emphasis, the deliberate coarseness and brutal energy of these primitivizing works.

In an article written in 1941, when because of the war the British Museum collections were closed and inaccessible, Henry Moore acknowledged all that he had earlier learned from the examples of primitive art—African, Oceanic, and Mexican—crowded into the cases of the Museum's ethnological department. These arts, first of all, showed him the basic necessity of "Truth to material . . . one of the first principles of art so clearly seen in primitive work. . . . The artist shows an instinctive understanding of his material, its right use and possibilities." [24] The African sculptor understood the open forms possible to the fibrous consistency of wood, so that he "was able to free arms from the body, to have space between the legs, and to give his figures long necks when he wished." Mexican sculpture, in contrast, had its own truth to material in "its stoniness . . . its tremendous power without loss of sensitiveness, its astonishing variety and fertility of form invention, and its approach to a full three-dimensional conception of form." The awareness of material, both its possibilities and its limits, and the need to make these felt in the work itself that Moore perceived as the pervasive fundamental virtues of primitive sculpture, setting it off from more sophisticated traditions, he adopted as his own, endeavoring to treat each material in the manner appropriate to it.

Primitive sculpture also impressed upon Moore another basic principle:

> . . . It eventually became clear to me that the realistic idea of physical beauty in art which sprang from fifth-century Greece, was only a digression from the main world tradition of sculpture, whilst our own equally European Romanesque and Early Gothic are in the main line. [25]

In both respects, then, Moore like other artists, is suggesting that the primitive embodies certain fundamental characteristics which, far from being restricting because they are elementary, must be observed in order to achieve true freedom of expression. If there is a certain morality, as well as an aesthetic, in the maxim "truth to material" we have already noted that much primitivism has overtones of this kind, and far from wishing to hide, rather insists on their inescapable connection.

Moore thus avows his interest in primitive sculpture in a more objective way than most other artists; it is less a discovery and a revelation than an accepted part of his education as a sculptor. It is therefore perhaps natural that its formal influence on his own work, although general and profound by his own testimony, is specifically evident in only a few of his sculptures, and these are among his early works. African inspiration can be seen in the heavy, squared-off bent legs and buttocks, the enlarged feet, and the general proportions of *Standing Woman* (1923); they are related to the "heavy bent legs" by which African sculpture, rising upward like the tree it comes from, still "is rooted in the earth." [28] Two small stone figures of this time, *Mother and Child* (1922) and *Maternity* (1924), have a deliberately rough and unrefined quality of expression and of surface that is exceptional in Moore, who does not usually try to borrow strength in this way. These characteristics, as well as the poses, suggests the influence of the Vortex artists—Gaudier and the early Epstein.

Moore's admiration for Mexican sculpture also appears in a number of his smaller works. Two little carved faces (*Mask, Verde di Prato,* 1924, and *Greenstone Mask,* 1930) are evidently related to the early Guerrero style; an alabaster *Head* (1923) shows some of the rectangular characteristics of Teotihuacan stone masks; a very small concrete *Mask* (1927) is perhaps under Veracruz influence; and there are several heads that put the round-face open-mouthed blank-eyed expression of the Aztec Xipe Totec into a semi-

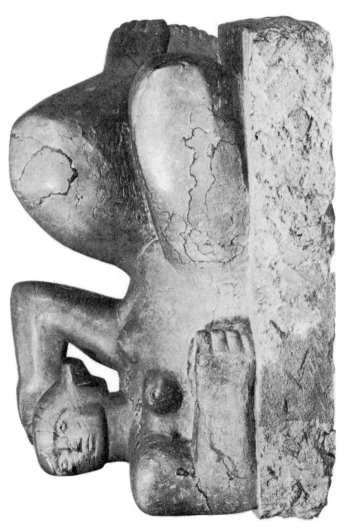

cubist handling of broken planes. But the most striking
instance of Mexican influence is the *Reclining Woman*
(1929).[27] This first monumental treatment of one of
Moore's favorite themes is unabashedly similar to the fa-
mous Chacmool. Moore has adopted that figure's square
lines and its modeling reduced to frontal and orthogonal
planes, in order to approach "a full three-dimensional con-
ception of form." Its later versions are varied by the infu-
sion of other concerns, both spatial (as they derive from con-
temporary painting) and psychological; here Moore has
limited himself to the single plastic problem posed by the
figure of the Mexican god. The *Reclining Woman* is typical
of Moore's relation to the primitive.[28] He is of course aware
of its power and symbolic presence, but he has not tried to
carry over this element of its primitiveness into his own
work; he goes to it almost entirely for its formal lessons.

Consciousness of the primitive entered the general stream
of modern sculpture through Brancusi. Since then modern
sculptors have admired primitive sculpture, and many have
themselves collected it. Yet as the comparative brevity of the
above reviews shows, the direct formal adaptations have
been few, and, except perhaps for Brancusi himself, very
little modern sculpture even recalls the general proportions
and rhythms of any specific primitive tribal style. But the
example of the primitive did reinforce a tendency already
strongly present in the whole modern tradition: the empha-
sis on creative invention independent of the precedents
found in nature, the insistence that the work of art, instead
of imitating the natural environment, is a new and added
element. Because so much of primitive sculpture has a reli-
gious and/or magical function, much of it is largely free of
the constraints of naturalism. Concerned as he is with the
non-visible, the primitive artist is free to embody it in the most
effective possible form, however this may vary from the
ordinary and the expected, and thus to create the "pres-
ence" that holds even the alien observer. Despite all the
differences of his own situation, this power of concentrated

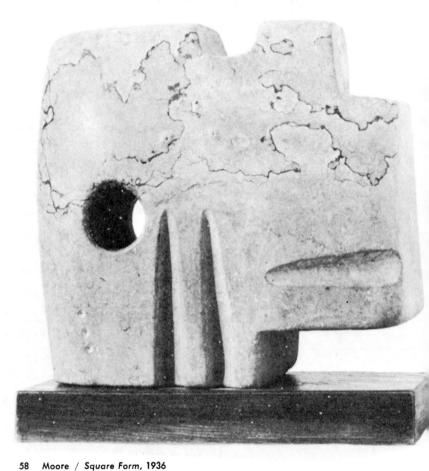

58   Moore / *Square Form, 1936*

imaginative materialization has captured the attention of the modern sculptor. He finds in it precedents for the spiritual uses of his own aesthetic freedom.[29] In so far as this is true—but only in so far—are there any true parallels, either formal or psychological, between primitive and modern sculpture.

NOTES

1. See above, Chap. III.

2. Maillol was referring to this difference when he remarked: "Gauguin made a mistake when he imitated Negro sculpture. He should have done his sculpture in the same way as his painting, by drawing from nature, while instead he made women with large heads and little legs." (Judith Cladel, *Aristide Maillol* (Paris: Grasset, 1937), p. 130. Maillol goes on to object to the influence of Negro art in France, although acknowledging "its strange inventiveness of form . . . and its inventiveness and extraordinary sense of decoration . . ."

3. This is suggested very generally in Agnes Humbert, *Les Nabis et leur époque* (Geneva: Pierre Cailler, 1954), p. 76.

4. The proportions found in *Two Negresses* are also present in Picasso's *Two Nudes* (1906) and Braque's *Nude* (1908).

5. Picasso's thin and elongated bronze figures of 1931 are related to early Mediterranean sculpture. But here, as so often elsewhere, Picasso is experimenting with forms suggested by the art of the past; that in this instance these happen to be "primitive" forms is of no special significance.

6. Alexander Archipenko visited the Trocadéro "a thousand times" following his first arrival in Paris in 1908. *Cf.* Yvon Taillandier, "Conversation avec Archipenko," *XX Siècle*, New Ser., XXV, No. 22 (Christmas, 1963), Supplément.

7. These principles are especially in evidence in the stone figures that both Laurens and Lipchitz executed in the early twenties.

8. This connection was first established by Kahnweiler, who places great emphasis on a single Wobé mask owned by Picasso at that time. D.H. Kahnweiler, "Negro Art and Cubism," *Horizon*, December, 1948, pp. 412–420. See above, Chap. V.

9. Lipchitz has claimed this work as the first pierced sculpture of the modern movement, since he considers that Archipenko's hollowed-out figures, which start as early as 1912 with *Walking Woman*, have an entirely different character.

10. Jacob Epstein, *An Autobiography* (New York: Dutton, 1955), pp. 49, 191.

11. *Brancusi*, preface by Paul Morand (New York: The Brummer Gallery, 1926), p. 3.

12. Carola Giedion-Welcker, *Brancusi* (New York: Braziller, 1960), p. 220.

13. *Ibid.*, p. 219.

14. Jeanne Modigliani, *Modigliani: Man and Myth* (New York: Orion Press, 1958), p. 54.

15. *Ibid., passim;* and Alfred Werner, *Modigliani the Sculptor* (New York: Arts, Inc., 1962), p. xxx.

16. Modigliani, *op. cit.,* p. 54.

17. Enzo Carli, *Modigliani* (Rome, 1952), pp. 16–17.

18. Epstein, *op. cit.,* pp. 188–190. His collection was exhibited after his death by the Arts Council of Great Britain, in London, 1960.

19. Epstein, *op. cit.,* p. 12.

20. Ezra Pound, *Gaudier-Brzeska* (London: Jones Lane, 1916), p. 35.

21. Wilhelm Valentiner, *The Origins of Modern Sculpture* (New York: Wittenborn, 1946), p. 72.

22. Epstein, *op. cit.,* p. 190.

23. In *The Spectator*, March 15, 1935, cited in Epstein, *op. cit.,* p. 150.

24. Henry Moore, "On Primitive Art," *The Listener*, XXV, No. 641 (April 24, 1941), pp. 598–599, cited in *Henry Moore* (New York: Curt Valentin, 1949), pp. xliii–xliv.

25. *Ibid.*, p. xliv.

26. *Ibid.*, p. xliii.

27. Mexican influence may also be found in Giacometti's *Head* (1934/35), half of whose face shows only the skull. Earlier the compact shapes, rough surfaces, and animal forms of Aztec sculpture exerted a strong attraction for John Flannagan.

28. For a Jungian discussion of this relationship, *cf.* Erich Neumann, *The Archetypal World of Henry Moore* (New York: Pantheon, 1959; Bollingen Series LXVIII).

29. The parellel made by Herbert Read ("Tribal Art and Modern Man," *The Tenth Muse* [London: Routledge and Kegan Paul, 1957], pp. 304–310) between primitive and modern sculpture based on a presumed correspondence between primitive "religions of fear, terror, propitiation and retribution" and the "existentialist anguish or uneasiness" of modern man does not seem at all tenable. Existentialist anxiety may or may not parallel the concerns of primitive religions. But Read's distinction between the naturalism of paleolithic art, based on life-enhancing attitudes, and the abstractions of African art, based on attitudes of fear, a contrast which goes back to Worringer, can hardly be maintained. African ritual, like presumably the prehistoric, is much concerned with fertility. And the tribal styles of Africa, stemming from philosophies essentially similar to each other, exhibit a whole range from naturalism to extreme stylizations of many different kinds.

@ @ @ @ @ @ @ @

# VIII  A Definition of Primitivism

"these approximate terms have a value. . . ."

In attempting a definition of the artistic attitude whose course we have been following, we do not mean to set down an exclusive description. It would be possible to collect the final residue after filtering out all those manifestations which are not common or typical, or which may be found accompanying other attitudes in art besides the primitivist, no matter how important or characteristic they may be for certain phases of primitivism, and this meager residue could then be reduced to an epigram. Such an attempt, though it might arrive at a paradigm which would serve as a base in the search for exceptions, would hardly find any other useful purpose. It will have been obvious throughout that the

unity of this study lay more in the various attitudes and intentions which were being described than in the formal, or even the psychological similarity of the works of art created in accordance with these attitudes. And it will have become clear that, in detail at least, the attitudes and intentions also—conditioned by their immediate cultural and artistic situation as well as by the larger factors common to them all—varied among themselves. The purpose of this final chapter is therefore to summarize the different phenomena while preserving their individuality; to rewind in comparative haste the connecting thread we have been unraveling so slowly.

But if this thread is not in the art nor in its theoretical program, where can it be? We think it is possible to say (without being guilty of any more primitivism of analysis than comes from an adaptation to our subject), that it lies in a *common assumption* that pervades the works and their apologetics. This is the assumption that externals, whether those of a social or cultural group, of individual psychology, or of the physical world, are intricate and complicated and *as such not desirable*. It is the assumption that any reaching under the surface, if only it is carried far enough and proceeds according to the proper method, will reveal something "simple" and basic which, because of its very fundamentality and simplicity, will be more emotionally compelling than the superficial variations of the surface; and finally that the qualities of simplicity and basicness are things to be valued in and for themselves: In other words, it is the assumption that the further one goes back —historically, psychologically, or aesthetically—the simpler things become; and that because they are simpler they are more profound, more important, and more valuable. Certainly we have seen that the nature of this "simplicity"— even in the rare cases in which it is found—varies with the nature of the seekers. But (since it is primitivism and not the primitive we have been studying), its axiomatic existence and desirability remain.

Primitivism presupposes the primitive, and at the core of an artistic primitivism we may expect to find a nucleus of "primitive" works of art. In the case of each of the divisions we have made—the romantic, the emotional, and the intellectual or formal, there were works of art considered primitive by the modern artists, and appreciated and influential because of that. Without going into the question of what the *really primitive* is, the paleolithic or the neolithic, the African or the Eskimo, we may note that in accordance with the primitivist assumption just described, these supposedly primitive arts are not united by any common qualities of form and composition. This is evident from their variety: For Gauguin they were the Egyptian, the Indian, and the Polynesian alike; for the *fauves* the "curious" phases of African sculpture and the *images d'Epinal;* for the *Brücke* and the *Blaue Reiter* the sculpture of the exotic peoples generally, the drawings of children, and their own provincial folk art; while for Picasso primitive meant Ivory Coast sculpture and the painting of Henri Rousseau. This is to say that for the modern artist the primitiveness of these different arts lay in the common quality of simplicity attributed to them. More psychological than formal, it was a quality read into the objects rather than objectively observed and so it was bound to vary with the orientation of each group. The possibility of finding such simplicity in any form of aboriginal art, no matter how formally complicated it might be, was of course facilitated by an assumption inherited from the nineteenth century, still continuing though often avowedly rejected. This was the correlation automatically made between the assumed simplicity of the physical and social organization of a people and the simplicity (in both the senses of unvariegated and whole-hearted) of the import of their works of art. In the case of child and folk art it was based upon an appreciation of psychological beginnings. Far from being the cause of any "primitive" qualities that may be found in modern art, primitive art only served as a kind of stimulating focus, a catalytic which, though not itself used or bor-

rowed from, still helped the artists to formulate their own aims because they could attribute to it the qualities they themselves sought to attain. For these reasons the very limited direct formal influence of primitive art is not to be wondered at; the causal action is indeed rather the reverse. Even the use of aboriginal art as an example to be quoted against the necessity of copying from nature and of following academic rules could easily have been dispensed with, since this process and protest in its modern form had begun before the discovery of primitive art in 1904. Consequently its continued reiteration as an example in favor of a return to "fundamentals" is only evidence of a more widespread primitivist drive.

For these reasons also the variety of arts valued as "primitive" is not surprising. It is not the first time in the history of modern art that a return to, and an emulation of, the primitive has been talked about, and in terms of a return to fundamentals. These earlier movements—notably those of the *Barbus,* the Nazarenes, and the pre-Raphaelites—grew out of the historical consciousness of the nineteenth century, which at first (and as it affected them) had a religious tinge, but which later (and in the form which influenced ethnological investigation and artistic primitivism) supplanted this with a scientific, evolutionist aspect. The search for beginnings was thus transformed from cultural to physical-emotional interests, and can properly be described as a search for "lower" instead of "higher" origins. Those artistic movements of the nineteenth century differed from these of the twentieth in two important respects: First, they had a longing for a style once attained but later lost, a style that belonged to their own tradition, to their rightful heritage, interrupted and become degenerate. The earlier style was valued on the basis of its "abstract" qualities because it included more of the elements of a good art than any style which had come after it; however "pure" it might be in its ignorance of later overelaborated techniques, it was only *relatively simple.* It was, to be sure, a more limited style

than the intervening baroque and rococo, and in emulating it one traveled a certain distance back toward beginnings— but only just so far. "Italian primitive" was therefore a very relative term, with overtones of early Christianity. Its implication of a restraint dedicated to telling the truth is very different from primitivism's distrust of all analytic control. Secondly, on the emotional side, simpler early styles were considered to have a certain lyric quality, to embody the best of human sentiment and feeling within an easy harmony undisturbed by the intensity of unruly basic emotions. During the nineteenth century the evaluation of "primitive" art still had something of the idea of a falling from grace of later styles. A previously attained perfection was destroyed by the welling up from beneath of things which should be kept suppressed: a combination of a cultural primitivism with the "decline theory" of chronological primitivism. The periods valued by the nineteenth century were high points in the past and were not thought of as folk arts in which medium and technical method did not count. Even in the imitative communal attempts of the Nazarenes or the pre-Raphaelites, the personality of the artist was at best obliterated only within the specialized artistic group. The arts valued by the twentieth century are exotic arts in which it is imagined that technique has been kept properly subordinate by the intensity of the emotion expressed, or indigenous arts (those of the folk, children, and madmen) where, ideally, the medium would be obliterated in favor of a direct conveying of emotion. The contrast is forcibly brought out by the tremendous difference between attitudes of Paul Klee and Philipp Otto Runge toward the child: In spite of similarities of verbal program and even identity of literary influences, the latter is all sweetness and hope, the former all ironic despair. Klee may today seem gentle in comparison with later expressions, such as those of Dubuffet, partly inspired by him; compared to Runge his humor masks cruelty and anxiety. The fact that the primitives of the twentieth century are not part of the artist's own tradition is

in itself of value because it frees the individual and so makes his desired return to a single underlying intensity that much easier. The "sweetness and light" characteristic of the nineteenth century conception of what is called the primitive have now disappeared in favor of a real love of the savage, although this ferocity is often (as was the earlier notion of gentleness) only the product of a civilized imagination.

As the artists could select and appreciate different aspects of primitive art, so the primitivist elements which they chose to emphasize in their own work were varied. If we group the artists whom we have called "romantic" primitivists with those designated as "emotional," then the primitivism we have examined falls into two large divisions: one whose main emphasis is on internal psychological factors— on the basic elements of human experience; and one which sought out the fundamental factors of external form—the bases of human perception and of nature.

Within the first group fall the artists who concentrated on the fundamental emotions and passions, on the crucial situations of life, using such events as the subject matter of their pictures. This in itself would not make them primitivists; it is rather their desire to present these subjects immediately, with as little "psychic distance" as possible, to reduce the picture to a single, simple dominating scene which will not be analyzed as a variegated formal composition, but will absorb the spectator, or be absorbed by him in a direct and undifferentiated fashion. To this end they use technical means which, in their broadness and coarseness, are supposed to be primitive. The scene presented may be either brutalized or idyllized; in either case it is meant to be simple and dominating. This is as much the aim of the *fauves,* whose art is intended to be restful through its discarding of intellectual and formal complication, as it is that of the *Brücke,* who wish to overcome superficial differentiation by more forceful and stirring methods, or that of the *Blaue Reiter* artists who tend to sink complication in an identifi-

cation with simpler, untroubled beings, whether animal or human. In the art of Gauguin the externality of the goal, proper to the romanticism behind him, is still present. But he has already exchanged the desire for a unity achieved on a higher level which characterizes the romanticism of Delacroix, or for the golden-age harmonious idyll belonging to early German romanticism (which has much in common with archaism), for a combination of the two which results in an intensity (often erotic) which tries to, but never succeeds in dominating the emotional tone of his pictures: Grace still properly belonged to Gauguin's conception of the primitive, and to the pictures which were its result, but only in spite of himself. It is of some importance that the legend of Gauguin (like the legend of Van Gogh) should try to sink the sweetness of his pictures in the "savagery" of his life. Not that the sweetness is not appreciated, but that even now the public thinks it more proper to be wild than to be gentle.

The work of Gauguin also continues another quality which had already begun in the *Jugendstil* of which he is in some measure a part, that of the symbolism of the individual work of art. This symbolism is reached by the omission of such detail, in both formal and iconographic senses, as would particularize the situation presented in terms of the characters involved, and so would make it external, peculiar, and not susceptible of emotional identification by the spectator. Neither Gauguin's Bretons nor his Tahitians are individuals, nor are his landscapes particular spots in the countryside; they are symbols of the simple man and his home. The scenes depicted by both the *fauves* and the *Brücke* have that strange enveloping "jungle" quality that results from a combination of close-up rendering with a formal and psychological generalization. They have an immediate equatorial quality which differs sharply from the external tropicalizing scenes of the previous French romanticists, scenes which preserve that "otherwhereness," the exterior goal to be pursued—here partly geographical—which

is one of the characteristics of their art. The primitivizing picture is not a symbol in the sense of being the condensation of a developed intellectual conception—this requires minute, deliberately worked out characterization—but it attempts to expand its representation by a reduction of the inner relations of the situation to their simplest, and by a broadening of their means of rendering so that detailed examination is not required. The result is that while there is little definite reference outside the canvas, the emotional field within is both broad and simple. We need not emphasize how much this differs from aboriginal art, where the accurate rendering of detail, in order that the external reference also shall be accurate and thus effective, always controls the rendering of an emotional state, or its personification.

Both these characteristics—the immediate presentation of themes for direct absorption and the vague symbolic quality obtained by generalization—are carried over into the representation of nature, and from there lead, by a process of further iconographic rather than formal expansion, into abstract painting. In either case the result is a kind of symbolic animism, an attribution of independent life and activity to the forms of the canvas themselves, which are conceived both as paralleling human moods and as representing in miniature the moods of a whole living universe. For this development the works of Kandinsky and Klee are the outstanding examples.

This sort of thinking bears a certain relationship to primitive ideas of an animized world, but it is even closer to the survivals of these ideas in later mysticisms, with which it has stronger resemblances and from whose medieval, Indian, and early-nineteenth-century manifestations it was directly influenced. In common with such mysticism it has definite anti-intellectual and simplest leanings which are strengthened by its knowledge and preference for children's art and aboriginal art, and which from a philosophic point of view we are perhaps justified in calling primitivist in themselves.

Moreover, there is a continuing preference for a mystical sinking in the basic and fundamental rather than a union with the total climaxing unity of the world which at least makes for a "primitivizing mysticism"; and though Kandinsky has called this a necessary passing phase, the confusion between emotional primitivism and emotional pantheism has not yet been resolved entirely in favor of the latter.

The general development of primitivism within the work of those we have classified as having intellectual primitivist tendencies moves in the same direction as that which has just been outlined. Though their relationship to primitive art is never of that purely analytical formal character which they attribute to it, they have nevertheless, notably in the case of Picasso, an appreciation of its interior structure and compositional arrangement with which the emotional primitivists, more interested in the symbolic power it conveyed to them, were never concerned to analyze. We have described the intellectuals as concentrating on the fundamental formal elements of human perception and of nature. The intention is to present these stripped of any limiting connection with an individual scene or object, in order that, by such omission, a class of perception instead of a single perception is realized, spectator and artist thus arriving at a direct appreciation of the factors upon which all true art has been built, but from which the superstructure has now for the first time been cleared away to bring them into a full and obvious light. The ultimate logical result of this aim is however not attained immediately, the process of expansion taking some time. At first the "class" is limited to certain similar enduring formal aspects of types of objects; and though the choice of these has an apparent objective justification in a basic geometry which the painter tries to bring out, their particular relationship within the picture as well as the type of object which is chosen is peculiar to the individual artist, in conformity with the impressionist tradition from which the early development of cubism stemmed; and so the appeal of any picture is limited by its dependence

upon the momentary realization of his sensibility. For this reason there is at times an apparently opposed development into particularization and intricacy which in certain instances retains the upper hand, as for example in the work of Georges Braque. And for the same reasons cubism was in a sense—in the light of the cubists' own declared ideals—a retrogression from the work of Cézanne and above all of Seurat, men whose manner of interpretation was intrinsically less limited. Nevertheless a gradual triple tendency of generalization is perceptible, the three aspects of which are of course not always carried out independently of one another:

The first of these is a continual extension and expansion of the type of object represented, its vaguer and vaguer iconographic definition, until all its qualities as object and even as type of object are lost, its formal and representational aspects are merged into one, and it is impossible to tell (but not because of any unclarity of technique) what is geometry and what is subject matter. At the same time there is an expansion and simplification of the form of the picture: details are eliminated and the scale becomes larger. This line of evolution begins with the work of Juan Gris and continues through that of the purists, Ozenfant and Jeanneret, to its culmination in the artists of the *Effort Moderne*.

The second tendency deals more directly with the fundamental forms and formal relationships which interest the artist, these being made the subject matter of his canvases. These forms are continually redefined and expanded until they include all those aspects, and eliminate all others, which are believed to be at the base of perception and to constitute the formal foundations of the world. Although the epistemological question is never clearly faced, the assumption seems to be that these exist independently, the artist's task being to embody them with as little personal distortion as possible, rather than to project ideas which would otherwise not come into existence. In any case the

problem, as it is shown in the works of Mondrian and Does-
burg, is to exhibit them with as little superficial and extra-
neous matter as possible, presenting them simply and di-
rectly, with the characteristic assumption that they will then
be comprehensible to all. But combined with the concentra-
tion on fundamental geometry as such is the idea that the
forms thus reached are also at the base of a new technique
and of a new aesthetic growing out of this technique—so
that the forms are symbolic of a new content as well as
being merely abstract fundamentals. Therefore at its limits
this tendency meets the first, the former making its form its
subject matter, the latter identifying its subject matter with
its form.

The third process of generalization, and one which is in
part shared by the later stages of emotional primitivism, is
the reduction of the conscious factors of the artist's experi-
ence, factors which are considered to be necessarily peculiar
to the individual artist, in favor of the substitution of sub-
conscious factors which, because they are subconscious and
therefore uncontrollable, will be common to many besides
the artist himself. Thus by sinking back to a lower level of
experience for its inspiration, art tries to become the ex-
pression of the basic qualities of the human mind—qualities
which are primitive both in the sense of being pervasive and
of possessing the power of occasionally overwhelming the
more refined levels of the mind. What is particularly primi-
tivist is that this should now be thought desirable. By the
nature of their inspiration, form and subject matter merge
into one, since the former possesses, or is made to possess, a
symbolic meaning; but this union is stronger in those pic-
tures which are under the influence of children's art and
abstract art (Klee and Miró) than in those surrealist works
which manipulate realistically depicted (but not necessarily
real) objects according to an only too deliberate and pro-
grammatic "subconscious" iconography.

To sum up, it can perhaps be said that primitivism tends
to expand the metaphor of art—by which is meant a well-

defined object-form with a definite, precise, and limited if intricate reference—until either by formal simplification or symbolic iconographic generalization, or both, it becomes a symbol of universal reference, and that this process is possible only on the basis of the primitivist assumption which has been stated above. There is here an obvious difference from "primitive" art, that is, the art of the aboriginal peoples, in which either the symbol and its reference are identical (as in the case of the true "fetish") or in which the reference, although imminent and powerful and perhaps not altogether clear in its formulation, is nevertheless limited, and in which the symbol, in order to be effective, must always be located, accurate and recognizable, although it may also be multiple or ambivalent. It is, moreover, instructive as to the combined difficulty and persistence of the primitivist impulse, that its expansion should never have been carried through by any one artist; in each case it has been taken up where others have desisted.

It will perhaps be clarifying to distinguish primitivism from the two artistic tendencies of the nineteenth century to which it bears certain resemblances (and which are related to each other). In giving these descriptions we do not mean to give absolute formulas, nor to imply that even within modern painting is it possible to find perfect, unadulterated instances of their exemplification; but since *primitivism* in part stems from *archaism* and *romanticism,* and in any case is of the same order, these concepts will perhaps serve as points of reference for the clearer distinction of the characteristics of primitivism. (While it may well be argued that in a broad historical context, archaism is one facet of romanticism, they are sufficiently distinct—both in spirit and in the forms of distant art to which they go for inspiration—to allow them to be discussed separately.) Both archaism and romanticism are attempts to infuse new life into art by breaking away from the current and accepted formulas; and both, though in different ways, try to renew the *essentials* of art, as does primitivism. Archaism (as it is found in the

Nazarene and pre-Raphaelite movements) is also similar to primitivism in that it goes back to an earlier art for its inspiration, but, since it considers the epoch it has picked, which technically it realizes and appreciates as a beginning one, as the highest point which art in *its expression* has reached, it sticks formally closer to this art than does primitivism. Moreover the works which it admires and copies are considered to be in its own cultural tradition, a style whose freshness lies in its suggestion of a later, too-full-blown flowering, and whose charm lies in its restraint when compared to this now well-known later period. In the same way the content which is conveyed by this form has only an intellectualized, or an arbitrary meaning; intellectualized because it belongs to a taught tradition, arbitrary because it no longer has an immediate emotional meaning and is significant only in fitting into a preconceived, artificially limited ideal. As part of the appeal of this ideal lies in its familiarty, so in conformity with it archaism strives for a clear-cut formal restatement of its own art which it tries to renew by means of an elimination of later features, retaining only those elements of style characteristic of an earlier art. But because of its knowledge of later developments (to which indirect reference is not only inevitable but necessary for the archaistic ideal), it cannot help giving to these early elements an extreme precision and a calculated refinement which results in a coldness and formalism not found in the work imitated, and in a substitution of knowing restraint for a sincere naïveté.

Romanticism, on the other hand (as it is best exemplified in the work of Delacroix), in contrast to archaism and in common with primitivism, has an anti-intellectual attitude and a desire for an intensity of emotion. It characteristically takes its inspiration from works belonging to cultures (or directly from cultures which it considers as *other* than itself) of an historical, geographical or literary distance productive of an emotional distance, and which provide anecdotal subject matter or new formal experiences susceptible of intense emotional concentration and assimilation. In

order to fulfill this latter condition it is necessary that the subject matter be not entirely foreign, so that it may be possible to interpret it in terms of the exaggeration of features of ordinary life, and that their violence and intensity may be appreciated in comparison with this norm, seen as so dull that it compels the imagination to flee elsewhere. The emotions which romanticism thus manages to achieve, it values for their intensity and their momentary exclusiveness, for their ability to absorb and engulf the whole personality for the time being. But in contrast to primitivism it is finally interested in the refinement and differentiation of many emotions, each of which is complicated within itself and each of which brings all the possibilities of personality into play, and thus in attaining the eventual development of a varied and self-conscious personality. The pursuit of romanticism's "flying goal" is therefore the opposite of primitivist in its effect, and it values exotic arts and exotic cultures in so far as, by the addition of new experiences which would not otherwise be realized, they contribute to the achievement of this ideal. For these reasons, which are similar to those of primitivism only in that they also prohibit the accurate seeing of exotic people, romanticism can do but little accurate borrowing from the arts of exotic cultures, and characteristically distorts them to fit its own notions; and whenever an approximately correct use of these arts occurs we may recognize the infiltration of archaistic ideas.

These are of course, even for the specialized area to which we have limited them, ideal descriptions. In most actual instances combinations occur, and we may have archaist-romanticism or primitivist-archaism. The latter, for example, would be the case with the earliest work of Ingres, in which there are certain truly primitivist elements which we may suppose more fully realized by the *Barbus,* whose desire to lose themselves in emotion was greater, but for whom also the archaistic ideals of clarity and grace are already paramount. On the other hand an archaistic romanticism is

evident in the works of the Nazarenes and the pre-Raphael-
ites, where a mixture of the desire to purify one's sentiments
and to increase the total volume of one's emotions occurs. It
is prevalent also among the medievalists of the early nine-
teenth century, who treated in a romantic fashion, as if it
were exotic, an art which they claimed to value because it
was their rightfully indigenous heritage and their own
proper tradition. In the same way, as our analysis of him
showed, there are in the work of Gauguin mixtures of the
archaist, the romantic, and the primitivist attitudes; while
the mystical conceptions of Kandinsky and Klee and their
ideas about the East and its arts are influenced by and still
have certain affinities with the attitudes of an earlier roman-
ticism. Nevertheless primitivism, in the particular and es-
sential emphasis which it gives to phenomena also touched
upon by archaism and romanticism, is distinguishable from
them, and is a peculiar attribute of the art of the twentieth
century.

It will also have been obvious from its history that primi-
tivism is not static, either in the arts from which it takes its
inspiration and with which it chooses to find kinship, or in
its own pictorial results. Is it, however, possible to find any
positive and continuous direction in the changes that have
been observed? One tendency at least is clear: The primitiv-
ism of the twentieth century which began with Gauguin and
received its greatest impetus in the simultaneous discovery
of primitive sculpture in Germany and France, was at first
incited and influenced by the lives of primitive peoples (or
rather by its various ideas concerning them) and by their
works of art. While the emphasis on the subject matter se-
lected or the formal qualities imitated varied with the
school and artist, still the influence of one or the other is
direct and perceptible. Gradually, however, a double change
took place: The "primitive" works of art which provided
inspiration began to be less exotic and removed and to
come closer to home; children's art and folk art were at first
mixed with the African and the Oceanic and similarities

were found between them; and then, with the addition of subconscious art considered under its primitive aspects, they entirely replaced the aboriginal productions. Secondly, the primitivist tendency created works which were now (even in the view of their authors) only theoretically related to the art of primitive peoples, but which sought to primitivize through the use of indigenous materials. This is to say that there is a double, if interrelated, process of endemization, a process which is itself the natural result of two tendencies in modern art which provided the setting for the possibility of primitivism, namely, the tendencies of interiorization and expansion.

This brings us finally to the causes of the whole primitivist movement, a problem which we have thus far deliberately avoided since our purpose was to present the manifestations themselves in all their variety. But it may be well in closing to mention some of the contributing conditions of primitivism, in order to emphasize the fact which its very presentation must have shown, that primitivism is not an immanent artistic movement, self-born and self-borne, but that it grows from the general social and cultural setting of modern art and that it pervades, even where it does not dominate, a great deal of recent painting.

The growth of the ethnological museums and of the knowledge of the primitive arts, which were the condition for the gradually revised estimates of their character and quality, went hand in hand with the expansion of colonial empires. It was within their context that exploration and documentation took place, as well as the stamping out of traditional religious practices and the forcible or agreeable removal of many cult objects. All these activities (although not the religiously motivated destruction of works of art), by increasing the number of pieces available to European eyes, by permitting familiarity and comparison, took primitive art out of the class of the curio. The conquest of a Benin or the colonization of a Cameroon and the consequent furnishing of the museums and of private collections

did more than bring the art of these people to Europe: The collections were themselves part of a historical and comparative spirit long prevalent in the arts, a point of view which tended to isolate the individual object from its cultural setting in the same way as the contemporary artist was cut off from his own surroundings. Thus by bringing primitive art into the museum it could be assimilated to this spirit and studied as a historical manifestation, without any disturbing thoughts as to the very near reasons for its already being so remote. The assumption—common even at the beginning of the century and still largely accepted today—that the "better" pieces of primitive art must be the older ones, has perhaps another cause than the happy merging of theories of "decline primitivism" (ultimately religious in origin) from the artistic and the anthropological fields: It was comforting to suppose that the decline of the backward peoples had begun even before the white man assumed the burden of interfering with their cultures. At the very least, primitive art, like primitive society, should be static; the idea that it may be developing or evolving (or that the peoples themselves may be changing) does not fit in with the notion of a simple, immemorial primitiveness.

These considerations in part explain why the art of Mexico and Central America, examples of which were to be found in European museums long before anything from Africa and Oceania, should not even have been included within the general concept of primitive art. This omission had little to do with the actual difference in cultural level, which in many instances was little lower than in the Americas (*e.g.,* the Bakuba empire of the Congo, or the New Zealand Maori), and with which in any case only specialists were acquainted. It was perhaps partly due to the relative formal complication of the American arts, although even here there was often no great distinction. It may be explained chiefly, we think, by the fact that the Inca and Aztec societies had long been destroyed and their lands occupied. They were thus no longer living symbols of primitive sim-

plicity subject to aesthetic idealization and imperial conquest. (A local hierarchy did of course insist on the inherent primitive qualities of the peon.) As a result, America was not included in that myth of simplicity which provided the unconscious background of the European artists' acceptance of the primitiveness of the natives, without which they could not have discovered the stimulus they were seeking from these arts.

The particular instance of the omission of America from their roster also confirms the fact that the interest in the primitive arts was something more than merely a last resort. While it is true that the nineteenth century had examined and made use of many historic periods and exotic styles, it would in any case be rash to conclude that the intrinsic possibilities of influence they contained had been exhausted. But we have here an objective check on the conclusion drawn from our analysis that the interest in the primitive arts was really (however mistakenly) a concern with the primitive and not just one more romantic exoticism. And it may be pertinent to remark that the last foreign style influence which preceded and mingled with the primitive was that of the Japanese print, the simplest and most popular of all Asiatic forms of expression.

The first book on children's art, published in Italian in 1887, was translated into German in 1906, two years after the "discovery" of the primitive. The scholarly interest in the art of the child, which took on a sudden growth at this time in Germany and England, was the direct result of an expansion of the educational system toward the inclusion of the poorer classes and the consequent changes in curriculum. This was especially true of Germany, which, due to its former backwardness, necessarily made its reforms more rapidly. These changes focused attention on pre-adolescent artistic expression, which was found to be much more a transcription of the child's thoughts about the world than of his visual perception of it. The idea that the child should "express himself" by setting down this "intellectual realism"

true only to his own inner and personal logic, and that his learning of the traditional artistic language should be deferred as long as possible—although it today derives much of its educational strength from artists who have developed their own adult styles in this fashion—was then due only in extremely minor part to a similar feeling on the part of the artists. Its use in the school studio came rather from the application of general educational theory, evolved in other fields, to the province of art; and it indicates that the artist's affinity with childish expression in what Ellen Key predicted would be the "century of the child" was more than a superficial borrowing, that they were linked by a similar concern with the expression of primitive fundamentals of personality.

But this double emphasis on inner expression reacted in a peculiar way on its own appreciation. With traditional technical standards destroyed, with no rule by which to tell a child's work from a masterpiece, there were two solutions: One was to proclaim any truly "free" expression art, and in so far as this was uncritically resorted to—children's exhibitions as art rather than as education, early surrealist practice and later surrealist theory, etc.—the primitivist tendency won through. But to those artists and writers disturbed by this tendency, a critical process by its nature indefinable and intuitional was forced to become more and more esoteric, so that the appreciation of an art supposedly accessible to everyone tended at first to be restricted to the initiate, and the artist found himself communicating, not with a universal, but only with a sophisticated audience. We have noticed this anti-primitive result of primitivism at several places in our analysis of the pictures themselves: This is a social extension of what seems to be the inevitable defeat of one of the primitivist goals.

The measure of success that may be granted to the primitivist aims of the surrealists has already been discussed. Here we simply wish to note that they considered it possible to make use of investigations and hypotheses which, while any-

thing but primitivist in their correct application, could nevertheless be distorted toward a kind of sensational primitivism. This has to do with more than the mere use of sexual subject matter: One has only to call to mind the themes used by the eighteenth century in France to realize that the manifestly announced and pictorially suggested savagery of the surrealists is not the necessary concomitant of sexual subjects. How far the extreme sophistication that accompanies proclaimed violence is in itself documentation of certain psychoanalytic theories is a different question. (Freud himself declined to comment on surrealist art.) However, the parallel between the extreme individualism and subjectivity of the axioms on which the structures of both the psychiatrists and the modern artist are built is especially noteworthy, and their similar emphasis on the purely emotional side of man's mind. Given the initial necessity (resulting from problems concerning the isolated individual—contrast the eighteenth century with its highly social art) to produce something from one's inner consciousness alone, a primitivism is perhaps an inevitable result.

This necessity was of course not of the artist's own choosing, and even though he has been forced to make a virtue of it, his protesting too much shows that he did not accept it as natural. The separation of the artist from his public had already begun in the nineteenth century, when patronage lay largely with a new middle-class group whose taste tended, because of a lack of assurance in artistic matters, to be of a *retardataire* sort. The contest between artist and official, respectable patronage became so legendary that until recently the twentieth century accepted it as having always existed. But, although it had its roots further back, it only arose in an acute form when, apart from a few painters producing ordered portraits, the artists (like others in their society) were forced to produce for a free market, which in this case did not keep up with them. Until the end of the century, however, they applied their sensibility to what was

apparently their first refuge from a hostile society, namely, the natural scene, or to those elements of city and suburban life which could be viewed in the same aesthetic light. Just what should have exhausted this field for the twentieth-century European artist (with certain derivative exceptions) it is hard to say. But it is significant that the first evidences of modern primitivism, as we have found them to exist in the artists of the *art nouveau* in the nineties, should precisely have been attempts to seize nature at its lowest levels—the use of oranamental forms adapted from the lowest ranges of animal and plant life. Thus this exhaustion was in a way felt by the artists themselves before they abandoned the field entirely, and the simultaneous spread of a primitivist feeling throughout Europe at this period is a remarkable fact.

At the same time that the artist was forced back upon himself by this social situation, the historical consciousness of the nineteenth century brought home to him the existence of a tremendous variety of styles and the extreme relativity of any one plastic vision. Without a controlling public demand he tended to renounce whatever was close to him and to find his affinities in remote periods of greatness—a historical, but not yet an aesthetic primitivism. Besides this, even as far back as the impressionists there was a conscious concern with psychological and physiological fundamentals —which was something new. But increasingly the artist's immediate (and articulate) public was his fellow artist, so that there was a constant premium upon technical skill, innovation, and wit as judged by an overacute audience. Thus the artist was in a situation which, while it emphasized technical proficiency and its origins, at the same time called sharp attention to the uselessness of technique as a final goal. This combination of influences may explain that peculiar indirect simplification of style—a simplification based upon a knowledge of, and an allusion to, more obviously intricate and elaborate styles, an ellipsis whose references are recalled by their very omission—characteristic of so much of pictorial

primitivism, and also to be found in modern literary primitivism: On the one hand the artist discounted technical and manual cleverness but was unable to avoid it as a means of making his personality felt. On the other hand, lacking a common social and plastic language, he sought a way of intensifying his own personal emotion, of broadening its objective and its subjective base, in order to give it reason for existence. The methods—historical and geographical, subjective and objective—by which he tried to achieve that end fitted into a trend toward an art of an absolute character arrived at by an expansion of the primitivist means.

The original question as to how far modern art is "really primitive" would now be rather superfluous: It must be clear that, in spite of considerable inspiration from the aboriginal arts, and some direct borrowings, primitivism as it is embodied in modern painting and sculpture has little similarity—though it has a definite and essential relation—with the chronologically, the culturally, or the aesthetically primitive in the arts. But since primitivism itself and the effort to achieve the absolute character previously noted are both products of the same situation in modern art, its primitivist features may be considered not merely accidents, but of its essential nature.

# IX  Judgments of Primitive Art, 1905–1965

Before the discussion by others proceeds to the role and function of the artist in the many and various non-Western societies, I wish to examine the history of European and American judgments of the so-called primitive arts. This history is intended to serve as an introduction to the papers that follow by furnishing an awareness of the past and present background against which these discussions take place.[1] It should help to explain the aesthetic context and the sequence of partly subjective attitudes that have led to present efforts at more objective analysis of primitive art.

First of all, what of the adjective "primitive" itself, incorporated into the name of the Museum of Primitive Art, with which I am connected? Some anthropologists have considered it unfortunate, or incorrect, and have tried to find a

more accurate substitute. With that search I am not concerned here; even though words are conventional counters and "primitive" has entered into current usage with a no-more-than-normally ambiguous meaning, I do not believe that fabricated replacements are especially useful, nor indeed likely to prevail. Much more important than any ideal denotation of the word "primitive" are the effective connotations it has come to have when coupled with the word "art." There is the realization that for more than fifty years, first among modern artists and then among those connected with and influenced by them (writers, critics, collectors, and public), the word "primitive" has been not merely a description, but a term of praise. The phrase is "primitive-art" or "primitive-arts," inseparably joined. It has nothing to do with lack of skill or with either technical or aesthetic crudity, but refers to a wide variety of styles and sources, connected by a vitality, intensity, and formal inventiveness which have appealed to the modern artist and have had a considerable, even though largely indirect, effect upon him. This aesthetic context and all its associations have, after all, shaped our responses to the primitive arts, as much, if not more, than any ethnological studies, and we should therefore be aware of its nature and its history.

The importance of such an awareness is borne out by the fact that the Wellcome Collection, now at the University of California, Los Angeles, will be studied in the future under double auspices, ethnological and artistic. Its first public showing thus provides an excellent occasion to tie together some of the attitudes toward the primitive arts which we in the West have had, and, more particularly, at least to suggest a resolution of the profound misunderstandings and the assorted antagonisms that have divided anthropologists from artists and from art historians in their discussions about the primitive arts.

My reasons for wishing to attempt such a reconciliation are first of all personal ones. Since my own training was in the history of art (through examining problems in the meaning and direction of modern art, I first became interested in the primitive arts), I have some sympathy for the

point of view of the artist and what he has contributed to our understanding; this is an attitude not always shared by my colleagues who come from other disciplines. For illustration I go back to a time just after the opening of the Museum of Primitive Art in New York in 1957 and to a discussion with a distinguished archaeologist concerning a lecture series we were then trying to arrange. He suggested that there were two points of view that the museum might present to its public. That of the scientists, which he and his friends shared, was the inductive approach which, working from the evidence out to the theories, arrived, of course, at the correct theories. The other, taken by the artist, the art lover, and the art historian (he put them together in a single quick phrase), was the deductive approach which, starting with agreeable theories, selectively gathered evidence in support of entirely subjective points of view.

I am, unfortunately, not an artist; but neither, I believe, am I an art lover in the pejorative sense that the archaeologist intended. As an art historian, however, I am conscious that my initial attitudes and approaches toward works of art, what I stress or overlook or what I like or dislike, especially in unfamiliar works, are very much conditioned by what artists have taught me to see. Without accepting the artists' insights uncritically, I realize that I must be aware of them, for they are the measure of my aesthetic conditioning, just as I must be familiar with the scientific sources of my views in the information provided by the archaeologist and the anthropologist. Being conscious of both attitudes, I should like to be able to resolve the problem posed by these two divergent (and supposedly antagonistic) points of view.

My reasons for attempting this reconciliation are also theoretical. It has been said, the phrase is Fagg's, that in 1905 Picasso and his friends "took over." He meant that when the modern artist found or "discovered" the primitive arts, the objective investigation of those arts, which had already begun on a scientific basis, was interrupted and arrested. From that date on, for several decades, the primitive arts were perforce viewed through the eyes of artists,

with all the subjectivity, mistaken emphasis, and romantic speculation that this implied. A sequence of artistic generations—expressionist, cubist, abstract, and surrealist—imposed their views on the informed and the uninformed public alike, at the expense of the objective anthropologist, while he, in turn, seemed to have lost his former interest in material culture and the arts and devoted himself largely to other aspects of primitive society. It is understandable that the anthropologist may deplore such a sequence of events, because in his view it inhibited the correct understanding and appreciation of the primitive arts. But precisely as an anthropologist he must consider that if for a period in our own society the artist did in fact take over, that if for a time in our own culture these subjective judgments replaced more objective research and evaluation, such a development could hardly have been the result of historical accident alone. There must have been some reason why for several decades a subjective, culture-bound, primarily aesthetic attitude toward the primitive arts was dominant. Perhaps it could not have been otherwise. I should like to address myself to this question.

The profound effect that primitive art exerted upon modern art is known and recognized. Although this influence is part of the evidence of the essential significance of the period of subjective understanding, I do not wish to examine it here. I would for the moment prefer to give some attention to the other side of what has been a reciprocal relationship. Granted the primitive arts have influenced the modern artist for the last fifty or sixty years—and so through him have affected our artistic understanding—it is also through the eyes of the modern artist that we have learned to see and appreciate certain qualities of the primitive arts. The artist has thus been both student and teacher, and we can evaluate our attitudes today only if we acknowledge the part he has played in their formation, and what, quite literally, we now see when we look at an African or an Oceanic sculpture.

The artist's role as teacher and as student began with his so-called discovery of the primitive arts. I am suggesting

that the years since then (more than a half century, if we employ 1905 as the symbolic, if not the exact, date of that discovery) have been not only a contributory prelude, but perhaps also an inevitable prelude, to a just understanding of the primitive arts. This subjective stage had in fact to precede and to play itself out before a more objective one became possible.

A similar evolution and change have taken place more than once. Each time the West has become conscious of new non-Western art, or even of an earlier forgotten period in its own artistic history, there has been a time during which it has been seen through the eyes of the artist rather than through the eyes of the analytic historian. (I am, of course, referring not to new knowledge of individual works but to the impact made by the consciousness that there exists an unfamiliar kind of artistic imagination.) Generally it has been the acute sensibility of the artist which has made the initial discovery. After the artist has absorbed from the unfamiliar style those elements that are useful to him, transforming and adapting them to his own purposes, and the new art, now become familiar, is no longer a source of inspiration, then a more objective point of view has taken over, and external unbiased analysis has begun. Surely, in a large sense this was true for the first contact of the Renaissance with the ancient world, made by its artists, by its poets, and by its poet-philosophers in a highly selective, unhistorical, and biased fashion, ignoring all those historical distinctions between Greece and Rome, Republic and Empire, all the accurate cultural correlations and changes that later scholarship was to work out. This process repeated itself in the late eighteenth century when (despite Winckelmann) the neo-classic artist made personal contact again with the classical styles (using and abusing scholarship), and found in them something more than the Renaissance had found. Just as, somewhat earlier in the century, rococo painters had created an imaginative Chinoiserie that would have been the despair of any scholar who hoped to find in its adaptations a correct understanding of any single period of oriental art or iconography, but nevertheless revealing

it to Western eyes. Similarly the churches of the Gothic revival, and even the restorations of medieval buildings carried out by revivalists, are hardly the places to look for historical precision. It was not until Gothicism was played out as an inspiration to a lingering romanticism that the Middle Ages could be seen in perspective. During the years since 1905 the sequence of artistic discovery, enthusiasm, inspiration, and gradual fading has once more been repeated, this time in relation to the primitive arts. We are therefore today at a point where the anthropologist and the art historian can come together and look at these arts with some objectivity. But to do this they must also be conscious of, examine, and evaluate all those ways of "seeing" that the artists have been teaching them throughout the indispensable interim period.

How this has come about can best be understood by examining in sequence a series of primitive works of art, each of them traditional, each of them altogether typical of the style and culture from which it comes, but each also, from the point of view of Western aesthetic consciousness, representing a new stage in a process of expanding awareness. It is a development bound up with the evolution of Western art but revealing at last the enormous variety of non-Western forms, separating them out in turn from a mass of styles until then lumped together, so that each one, becoming visible, can be examined on its own independent terms. (Again I am not talking of particular works, or even of tribal styles, but of ways of seeing.) Admittedly, this has been a process that has concentrated on form and on the reading of the expressive qualities of form and has neglected context, function, and iconography. It is not the less important for such emphasis, which has served to correct the tendency of anthropologists toward overly intellectual analysis.

At the end of the nineteenth century, during what may be called the prehistory of our subject—it anticipates the so-called discovery of primitive art by some fifteen years—the name of Gauguin occupies a prominent place. The romantic tragedy of his life in the South Seas is part of a different (even if related) subject which there is no need to

evoke here. More pertinent, because it affected his vision of his surroundings, is the indication in his paintings that he shared two conflicting traditions concerning primitive peoples: the idyllic and the malevolent. The first is the partly biblical, partly classical tradition of Rousseau, Bernardin de Saint-Pierre, Chateaubriand, and other subsequent writers who imagined that primitive peoples were inherently good and that like all people they were later corrupted by civilization. The second tradition supposed that violence and brutishness manifest themselves initially in the primitive mentality, and that those characteristics are only partly tamed by later civilization. Such a picture as the "Day of the God" (1894) combines the two conflicting attitudes, the people indolent and idyllic, the dominating figure of the deity in the background suggesting dangerous, occult forces.

Even more directly related to our history is the question of how Gauguin saw the primitive art with which he came into contact and which of its elements he was able to absorb. The praise of Maori art which is scattered through his writing comes as no surprise; in this, as in his own creation, he was ahead of the taste of his time. What is surprising is to find that his vision was not so exceptional, after all, but was instead somewhat similar to that of the contemporary anthropologists who were studying South Seas art. Painter and sculptor though he was, and it is above all in his sculpture that he borrows directly from Marquesan art, it is the flat, decorative elements that he is able to absorb into his own work, not the handling of mass and space in three dimensions for which the primitive arts later became famous. He takes a Marquesan Tiki figure (in the original a freestanding form of considerable bulk even when executed on a small scale in ivory or wood), draws it out flat, and makes a design or a frieze of it (ill. 59). Or he adapts the various parts of a Marquesan club top, with its subtly balanced, flaring, concave surface and the projecting heads placed at the eyes of the Tiki mask and transforms them into a surface decoration, a contrast of filled and empty areas so cut into the skin of a wood cylinder that it can later be transferred to black and white as a woodcut. In other words, Gauguin is seeing

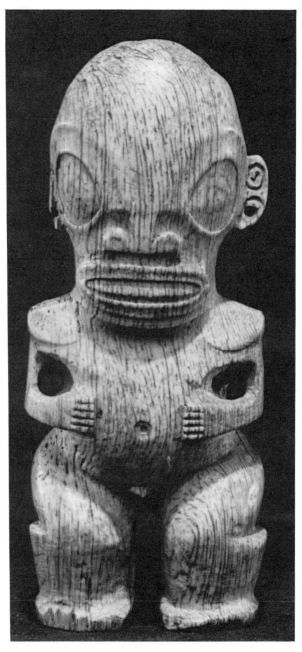

59  Polynesia, Marquesas Islands  /  *Figure*

in terms of schematic patterns, just as did A. C. Haddon and H. Balfour when they traced the evolution of decorative motifs (ill. 60). These men had, of course, their own scientific interest in the progressive transformation or "degeneration" of naturalistic forms; Gauguin, on the contrary, found "mystery" in the same stylized shapes. Although both their concerns and their methods of thinking were in opposition, they saw in remarkably similar fashion. They shared a preoccupation with design and a willingness to break down the design into its component parts. It is a first step in the modern realization of the wide variety of expressions to be found in the primitive arts. As the century progresses it will be replaced by other kinds of awareness seeking out other facets of expression.

Gauguin's emphasis on the qualities of the "mysterious" to be found in primitive art belongs to the antiscientific aesthetics of the end of the century, mystery being the term symbolists use for the reality beneath appearance which it is the purpose of art to evoke. A decade later, at the beginning of the twentieth century, the power of those hidden forces was even more strongly felt, and also more personalized. The German artists of the Brücke group were uninterested in refinements of surface. They regarded pattern, like naturalism, as the mark of an enervating decadence. They saw in primitive art the expression of an immediate and irrepressible vitality; they found in it that direct transcription of emotion they sought in their own work. As a result, they were able to view African and Melanesian sculpture in a new light, undisturbed by conventional prejudices concerning likeness, skill, control, and finish. They were the first to understand that if a mask or figure has a demonic or magical intention, such qualities are at best irrelevant, and that rough, broad handling, so-called crudity of carving, and clash of colors can be expressively effective. In consequence, such characteristics, far from being the unwanted by-products of a more "civilized" aesthetic aim, desired but still unattainable, had best be grasped as essential parts of the artist's controlled intention. The *Brücke* painters found these qualities in the roughhewn, brightly colored

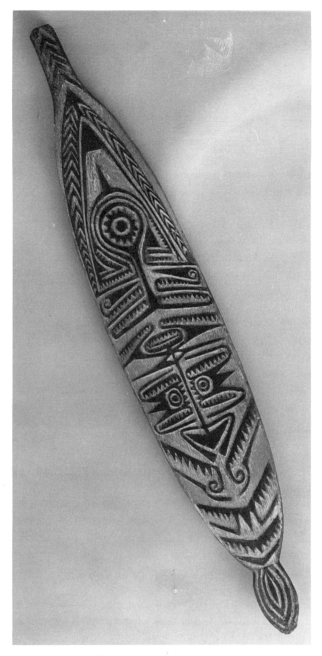

60  New Guinea, Elema / *Decorative Tablet from Ceremonial House*

figure sculpture of the Cameroun (available to them in the Berlin and Dresden museums) and, thus freed from the evolutionary conventions of the time, were able to appreciate not only its vigorous qualities of expression, but also the way in which such qualities were tied to the free, rhythmic handling of mass, color, and design. Undoubtedly the vision of these artists was one-sided but at least they were not subjecting Cameroun art to the canons of some other sculptural style, whether African or European. Moreover, they sensed that much African art expressed, not aspects of the visible world, but rather the invisible forces behind that world, and that this explained its strength. Their intuitive understanding was, of course, related to the aims of their own art; it in no way diminishes their pioneering role in the acceptance of this sort of expressive power as proper to the arts.

I have already mentioned Picasso's "discovery" of primitive art and the symbolic year of 1905. There is no need for us to go into the exactness of that date, or into questions of priority and credit, or of who told whom about just what masks and figures. These are problems for the detailed history of modern art, and the continuing debate about them is an indication of the important role primitive and especially African art played in that history. It is more pertinent for us to reexamine briefly the nature of the discovery.

In point of pure chronology, Vlaminck, Derain, and Matisse all preceded Picasso in their recognition and appreciation of African sculpture, even if by only several months. Yet there is little, if any, evidence of the formal influence of this sculpture on their own art. From this fact alone we might reasonably conclude that it was hardly only its compositional structure that attracted them. Such a conclusion is borne out by the written records we have; it seems clear that what they, too, admired was a certain expressive energy, communicated, to be sure, by plastic means, which they felt no need to analyze too carefully.

Picasso, on the contrary, was strongly affected by the appearance of some styles of African masks and sculpture.

It seems to me, however, that underlying this influence—in fact, making it possible—was an emotional attraction that affected him as it did his colleagues. It is not generally the way the story has been told. In describing Picasso's relation to African art, stress has usually been placed upon the purely formal derivations: the adoption of lozenge shapes for eyes and facial contours, the use of surface striations as a means of differentiating areas, the simplification of outline, the reduction of rounded modeling to flat, faceted planes, and, most of all, the rhythmic interrelation of solid mass and hollow interval. There is no doubt that these African solutions of abstract problems of structure and composition played an important role in Picasso's attraction to Dan masks and to Bakota figures (ill. 61). One has only to compare the studies done in connection with *Les Demoiselles d'Avignon* of 1906–07 to see how direct this formal influence was. But what made possible the acceptance of the stylizations and formal rearrangements he found in African art was his willingness to perceive and accept their inherent power. We can see this by the way in which Picasso alters the African forms he uses in order to achieve the force, the rhythm, and the intensity that he has found there. It is clear that he cannot free himself entirely from a naturalistic derivation and that he therefore still maintains a relation to muscular tension and to physical movement. But it is clear that he has understood that the African artist creates his intensity by even more stylized means. Picasso has taken the work as it was intended—not as the representation of what is around us every day in the physical world, but as the presentation of some power beyond or behind that world (ill. 62). In the vocabulary of a more recent artistic language, he has sensed that the African artist creates a presence, an imagined form—an imagined form, however, which has the power of its own intense existence. Picasso's own works done in 1907 and 1908 under Negro influence never match this achievement, never have that impersonal presence, but they retain an assertiveness, an individualistic bravado entirely foreign to African art. It is this, as much as their simplifications, which contributes the most to their "savagery." In-

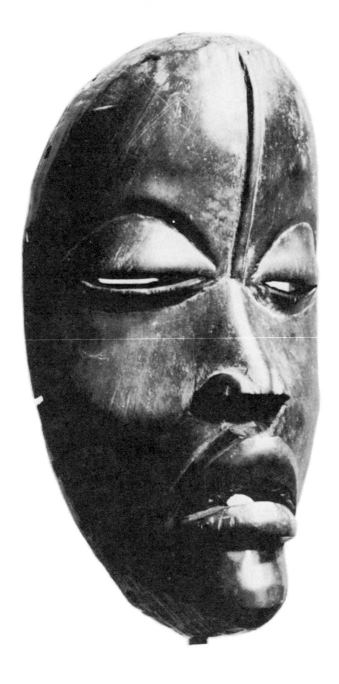

61  Liberia, Dan / *Mask*

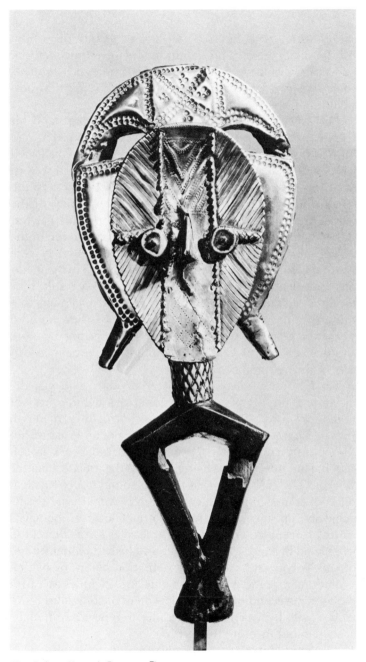

62   Gabon, Kota / *Funerary Figure*

sofar as this is true, Picasso's view was a romantic distortion. All the same, he saw and taught others to see qualities that had not previously been grasped; his frame of reference, subjective as it was, opened up new insights and new possibilities on the road to a larger understanding.

The aspects of primitive art stressed by Picasso and his friends in Paris and by the *Brücke* artists in Dresden had little to do with skill and technique. They were concerned with qualities of formal expressive imagination and so with what was created rather than how it was accomplished (ill. 63). In fact, if we are to judge from what we know of the works they collected at the time, it would appear that traditional qualities of craftsmanship would have gotten in the way of their grasp of the more intangible qualities they were the first to see. Hardly giving conscious thought to the methods by which the primitive artist arrived at his result, they thought of him as an intuitive artisan and imagined that those qualities of structure and incisiveness they admired were in large measure obtained only by neglecting the more accepted aspects of beauty, including those usually associated with the traditional *objet d'art.*

Yet for some time we art historians have said just the opposite about the primitive arts; namely, that they are not really "primitive," that the artist is in control of his material, that he knows exactly what he wants to do, and that within the cultural context that gives him his framework (a traditional but nevertheless living context) the artist is a master worker. The realization that this was so did not come all at once, of course, nor did it come entirely from the aesthetic-subjective lineage we are tracing here. The anthropological study of primitive art goes back at least as far as Boas (and in isolated instances beyond that) and his influential studies of the Northwest Coast. Boas' definition of art, or of that evolutionary point at which art emerges, includes as a fundamental precondition the achievement of consciously controlled skills by which a society is able to repeat traditionally accepted and meaningful forms.

The artist and the aesthetically oriented public also made a large contribution toward an awareness of the more con-

63   Liberia, Ngere / *Mask*

ventionally accepted artistic aspects of the primitive (ill. 64). During the second and third decades of this century, notably in Paris, there were those who began to appreciate precisely those characteristics the "discoverers" of the first decade had chosen to ignore. In the postwar period the emphasis was on gentler rhythms and more subtle stylizations, on smooth surfaces and fine patina, on subdued rather than violent expressions (or at least on expressions that could be so interpreted), and on a greater naturalism. The technology and skill of the primitive artist were approached in terms of a variety of objects that, whatever their provenance and their style, lent themselves to the taste of the European collector of antiques, a taste accustomed to finely grained surfaces and polish and to forms that were composed more in graded harmonies than in sudden contrasts. For a period the primitive arts were praised in these terms. It is no accident that for some years the styles that were the most appreciated were those of the Baule, of the gentler, polished type of Dan mask, and of the Fang (ill. 65). They were all accessible as *objets d'art,* as antiquities, on these terms. They fitted with distinction into eclectic surroundings with a reserve that did not demand interpretation. One might say that they were treated as secular arts, which, indeed, the Baule works in large part actually were. Such an attitude was, once again, very partial; it ignored some works and denatured others. But it permitted the detailed and sympathetic examination of the workmanship of primitive art and an understanding of the skill, the subtlety, and the careful judgment that went into its making. More important, this viewpoint implied the acceptance of their creators as artists, that is, as men who were not simply the unconscious medium of a group expression, but reflective individuals of varying talents and, sometimes, of genius.

Here again an artist was a precursor. Only a few years after Picasso extracted force and directness of expression as the essence of African art, Modigliani carved his famous series of sculptured heads based in part upon African prototypes but executed in an altogether different spirit. By concentrating on the decorative elements of technique and

64   Ivory Coast, Baule, Yaoure subtribe  /  *Mask*

65   Ivory Coast, Baule  /  *Standing Male and Female Figures*

material and on a brooding, mystical expression, he fused African and Asiatic sources with the traditions of his native Italy to create works that suggest a generalized and sophisticated exoticism, gently and undemandingly. This is the very opposite of the earlier, more forceful vision of the primitive, and it well characterizes the more aesthetic, cabinet quality of the collectors' taste of the following years when certain kinds of masks and figures became part of a well-arranged modern decor. Yet, biased as it was, and distant from the psychological sources and social uses of most primitive art, this very eclectic appreciation, by assimilating the techniques of the primitive artist into those of artists everywhere, added one more facet of understanding.

During these same years, while the craftsmanship of primitive art was being accepted and at length taken for granted, intuitive comprehension of its meaning was also being widened. A comparison of the work of two sculptors will perhaps make its basis clear. Epstein's *Venus* has been influenced by the proportions of African figures. Although the work refers to no specifically stylistic source, it is evident that its masklike head overhanging the long neck, its thickened, bent legs, and its summary treatment of arm and hand are reminiscent of Africa. The same can be said of Brancusi's much more simplified "Caryatid." He, too, has realized that in African sculpture the upper portion, particularly the usually large head of the figure, is balanced by the curve of shortened, heavy legs to achieve a vertical composition both stable and powerful (ill. 66). But there the similarity ends. Epstein has transposed a subject of Western mythology into formal rhythms that suggest African art; he has perhaps widened its meaning, but that meaning remains specific, and exotically literary.

Brancusi has also started with a classical reference interpreted through relations of form having their sources in African figure sculpture. He has, however, left his subject general, and by making it into a caryatid with nothing to support, he has allowed it to retain its reference and has stressed a vitality that springs from its own inner tensions. In contrast to Epstein whose work remains discursive, Bran-

66   Gabon, Fang  /  *Funerary Figure*

cusi has created a symbolic object that is at once allusive and self-sufficient.

One of the elements of primitive art given importance in recent analyses is the lack of specific, discrete, that is to say, discursive, reference. It is an awareness that has found its place on the labels in the exhibition of the objects in the Wellcome Collection. We have come to realize that it is not possible to say whether a given figure is, for example, a figuration of a human ancestor or of a divine ancestor or a god of some sort. Such a determination is impossible not because of lack of knowledge, but because the sculpture in question may be all of these things at once. This way of putting it is a concession to our own traditional way of thinking, which, so to speak, separates things, whereas the African figure has, instead, gathered them together. These overlapping meanings inherent in the African sculpture exist simultaneously and thereby give the sculpture its total significance. Brancusi seems to have had an intuitive grasp of this collecting of meanings, some of which can be described because they antedate the figure or the mask and are, indeed, the reason for its creation, whereas other meanings cannot be traced because they come into being with the fact of its creation. Brancusi transposed this understanding to his own work which for this reason appears to have affinities with the primitive, although, significantly, we are never able to pin down any precise formal derivation. Brancusi is a crucial figure in the history of modern sculpture. He transmitted his vision to other artists and caused the modern public, of which we are a part, to be receptive to his way of seeing. An essential characteristic of primitive art, not conceivable from the point of view of the nineteenth-century figure sculpture (a character essential even if not always present in every work), became accepted, without having been given a scientific formulation. This acceptance prepared us for the understanding we have today.

If the decade of the twenties began to acknowledge primitive craftsmanship and control, the thirties corrected what was in danger of becoming a purely aesthetic or decorative point of view. And here again the attitude of a modern art

movement made a significant contribution. We are presently willing to admit to the category of "art" a wide range of works that lack the conventional disciplines of technique, from sculptural forms that are almost entirely unelaborated and without detail to objects that are conglomerations of various materials (ill. 67). Certainly this sympathetic leniency is due in some measure to our increased knowledge of the traditions of craftsmanship, which determine even such apparently haphazard fabrications, and of the functional role they play. We realize that a Ngere mask with bells, a Senufo *kafigueledio* with its stick figure inside its sacrificial coating and costume, an enormously encumbered Mundugumor flute stopper are in both senses as much works of art as objects more conventionally conceived and executed (ill. 68). But neither must we neglect the historical fact that, just as earlier artists had "discovered" certain kinds of clearly composed primitive art, artists of the thirties, with or because of another kind of bias, saw the power of such disparate and untidy objects. The Dakar-Djibouti Expedition of 1931, which first brought back the strangely simple works of the Dogon, so different in workmanship from the previously admired Baule and Dan, was, after all, carried out under joint auspices and included men who were much interested in a particular kind of contemporary art, namely surrealism (ill. 69). The surrealists, M. Griaule, M. Leiris, and others were more concerned with art's unconscious "magic" than with its conscious forms; in certain works of primitive art, they found support for their ideas. Seeking out these, so to speak, new and unorthodox kinds of primitive objects and pointing out with enthusiasm qualities until then overlooked, they brought them into our field of vision. It seems to us today that the 1931 expedition collected surprisingly few objects; this is partly because we are heirs to an attitude they first conceived, because we so freely admit that there are works of art that employ means unfamiliar to our own limited experience (deliberate simplicity or great elaboration, denuded form or extraordinary mixtures of materials) and which use them successfully to attack the imagination. The surrealists, who in the forties also collected

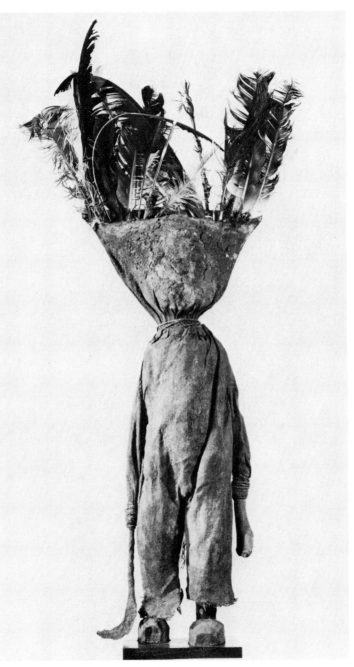

67   Ivory Coast, Senufo  /  *Fetish Figure*

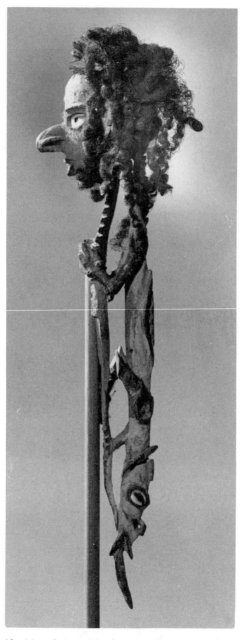

68   New Guinea, Mundugumor  /  *Ornament for Sacred Flute*

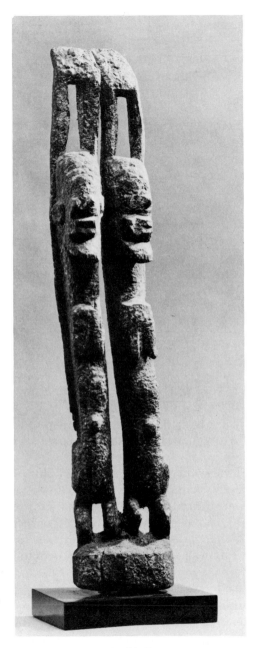

69   Mali, Dogon / *Double Figure*

Eskimo art, helped us to attend to such works and to realize that it does not matter so much whether or not they are "beautiful" as that they are effective (ill. 70). Thus the range of what was visible in primitive art was further broadened.

We have been reviewing a series of partial "discoveries" of the primitive arts, each one subjective, and all related to the creative needs and problems of modern artists. This relationship was the condition for the discovery; its possibilities and limitations, stemming as they did from the same kind of intuitive insight, could not be separated. In the course of reviewing these changing viewpoints, I have used as illustrations few works of modern art, concentrating instead on the types of primitive art from which they drew their inspiration. Even fewer among those modern works bear any kind of direct formal relationship to the primitive. This is, of course, not accidental and indicates only that modern artists sought and found in primitive art some more fundamental qualities which they turned to their own account.

I suggested at the start that this subjective stage, immensely fruitful and perhaps inevitable, is now completed, has, in fact, been completed for some time, and that for the modern artist, the primitive, although still respected and admired, has now become part of the neutral history of art. It is the artists themselves who first documented this new attitude for us, not by the neglect of the primitive, but by showing a new, increasingly objective point of view. Two very different examples will serve as illustration.

Paul Klee's "Picture Album" makes use of certain primitive motifs. His exact model, even the particular stylistic source (if there was only one), is difficult to determine, although the oval, lined shape would seem to indicate the Gulf of Papua region of New Guinea. One can hardly carry such determinations further, and the attempt is in any case rarely useful. What is more important is to recognize that Klee is choosing certain design motifs, extracting them from the context of the object, and then reusing them. His degree of accuracy hardly matters. What counts is his ability to isolate these forms because it indicates a distance and an

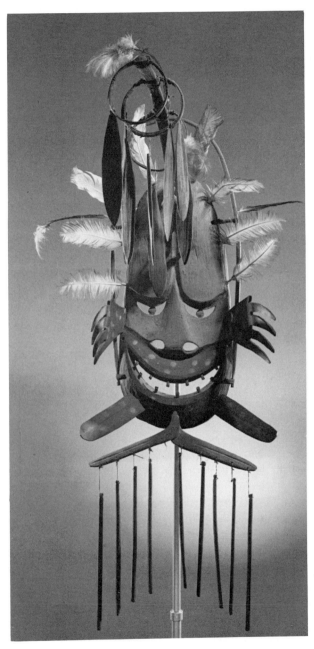

70  Alaska, Eskimo / *Mask*

objectivity on his part. Klee employs only the separate elements; he ignores the totality, and in this and in his willingness to recombine them in his own design, he suggests the attitude of Gauguin; neither is really affected by the inherent expressiveness of his model. A distance, then—and being by Paul Klee, an ironic distance—has been established, a step toward the detachment of our own contemporary vision.

Henry Moore is far from ironic. He has described in some detail how he spent many hours in the British Museum looking at its collections of primitive art, much more interested in the sculpture of Africa and pre-Columbian Mexico than in his own Western tradition. He felt strongly that these works were both more plastic, because their creators had an innate sense for three-dimensional composition, and more vital, because they were directly expressive of the forces of natural and human growth. Yet, when we come to Moore's work, what do we find? On the one hand there are some half-dozen works that derive from individual examples of primitive sculpture in a very closely reasoned, analytic fashion, and on the other there is the great bulk of his sculpture altogether without this influence, having its sources quite clearly and directly in modern Western art of the immediately preceding generation. All in all, this suggests that, as much as Moore admires the primitives, he is not very close to them and views them with analytic detachment as examples of the universal principles of true sculpture, works upon which he can draw but which have none of the attractive, almost magical power they had possessed for the older artists.

The so-called discovery of primitive art by the artist (and, because of his intervention, by the art-loving public) was, as we have seen, not a sudden and single event. It has been a drawn-out, evolving process, with different emphases at different times, finally revealing a whole gamut of styles and qualities. It has involved little direct derivation of specific forms at any time, and when such derivative art occurs it indicates that a more fundamental influence has begun to wane. I have tried to point out that in the history of this

relationship the usual stress should perhaps be reversed. It is less important that the artist has made use of primitive art than that he has made it amenable to our experience. By his series of enthusiasms, by his sequence of partial views, he has in the long run helped us to become aware of its variety of methods, of materials, and of intended effects, to realize that all are valid (even if sometimes strange) and that each demands, so far as possible, a response in its own terms. In the course of half a century, the artist has embraced the whole of primitive art. He has done even more. He has intuitively understood, and made many people understand, that art is not technique and aesthetic alone (a mere illustration of function). Someone has said, "art begins where function ends"; this is a false separation. The art is part of the function, not simply its later illustration, and the function is part of the art, not simply its precondition. The aesthetic is not an overlay but an integral part of primitive culture. First understood through immediate visual confrontation, and with considerable subjective bias, this knowledge can now be put to objective use. Although the artist's role is completed, it has played an essential part in our comprehension of primitive art today.

NOTES

1. This essay originally appeared in *Tradition and Creativity in Tribal Art,* edited by Daniel Biebuyck (© 1969 The Regents of the University of California. Used by permission). At that time Robert Goldwater was Chairman of the Administrative Committee of the Museum of Primitive Art in New York, a collection which has since become a part of the Metropolitan Museum.

# X   Art History and Anthropology: Some Comparisons of Methodology

These observations are set down by one initially trained in the methods of the history of Western art rather than in the disciplines of anthropology.[1] Having first approached the study of the primitive arts through an investigation of the interest they held for the artists of our own society in the twentieth century, I was less concerned with their position in their own societies than in the influence they had had upon others, that is, in the analysis of a modern accultur-ative process based on the "artistic artefacts" of certain prim-itive cultures. This inevitably led to an interest in the works themselves, and primitive art being at that time outside the purview of academic art history, I attempted to apply some of the same methods to its classification and understanding.

Since then I have dealt with museum collections. Never having done field work, my contact with primitive art is through objects no longer in use and my knowledge of primitive societies is only indirect. Therefore these few informal considerations on comparative methodology cannot have an entirely comprehensive or systematic character; they must be limited to the ways in which the framework of the investigation, collating, analysis, and judgment of more conventional art history and the study of primitive art seem to have evolved.

The information needed for an understanding of primitive art and the methods of acquiring it have been discussed by those who have worked in the field. In the long run the kind of information required for the understanding of the role of the arts in any society is of the same sort (whatever aspect of artist or audience one is concerned with), and art historian and anthropologist must in the end base their conclusions upon similar evidence. In no instance is the information ever complete, and in every instance it must attempt to transcribe into the incompatible medium of words experiences that, whatever their individual or social radiation of meaning, begin as directly visual. Fundamentally then, the study of art in any society should be carried out in essentially similar ways. Nevertheless, since the mutual awareness of their respective disciplines and methods by art historians and anthropologists is comparatively recent, and their conscious collaboration even more so, and since for the reasons of their own histories, and quite apart from the differences imposed by the material, the emphases of the two disciplines have been very different, it may be useful to compare some of the modes of thought they have employed to order and to understand the information available.

It is generally assumed that the chief distinction in the subjects of the anthropologist concerned with art and of the art historian is to be found in the relative distance of the societies they study: the latter examines art in cultures that are part of his own tradition, while the former must deal with arts that function in cultures so different from his own

that he may even be forced to inquire whether art as he knows it exists at all. Even the most sociologically minded art historian, by definition, takes the existence of the arts for granted, while the anthropologist, partly by definition, but also partly because of the traditional accidents of his discipline, raises the question of the origin and nature of their existence. Add to these differences of information and of attitude the circumstance that the historian has written documents to compare with the visual evidence, while the anthropologist at best has only oral information and tradition, and the methodological gap would seem enormous. Nevertheless, at the risk of suppressing details that must vary even within each discipline, I would suggest that they have evolved in very similar ways.

It is obvious that the past is not the present and that the historian, although dealing with a more familiar tradition, must reconstitute, or attempt to reconstitute, a situation that is never complete, and some of whose elements are unknown to him. On the basis of the evidence, he makes certain factual suppositions. And since cultural attitudes change rapidly, even the recent past can be foreign to his natural modes of understanding his own present, especially in the interpretation of visual material. But such circumstances are only relative, and are hardly enough to force a similarity with the difficult problems inherent in the understanding of the arts of non-literate cultures—even granting that the historian's written sources often shed little or no light upon the direct impact and comprehension that the arts of another period had in their own time.

And yet despite these undoubted divergences, it may be enlightening to notice some of the methods art history has employed in dealing with periods in the Western past and to recognize how they have evolved, because that methodological development seems at least in part to have been repeated in a series of approaches to primitive art.

The parallel is especially striking if one examines the historiography of medieval art. As others (notably Firth and Fagg) have noted, the Middle Ages offer a propitious comparison for the treatment of primitive art on several counts:

medieval, and especially Romanesque and pre-Romanesque art is a comparatively recent field of investigation; the overwhelming preponderance of the art was "functionally determined," being either religious or ceremonial in use and intention; and most of the representational works of art, whether painting or sculpture, like most works of primitive art, offer varying degrees of non-naturalistic stylization which by our own traditional standards are at the very least more "expressive" or "imaginative" than "beautiful." Here, as in the primitive arts, it was the apparently purely technical causes of an evolving or declining naturalism that were first investigated, largely in the narrow terms of the development or loss of skills alone, with the assumption (stated or assumed) that where skills were adequate naturalism would ensue, since it was the normal artistic goal. Thus the look of early medieval art was explained by the loss of Roman techniques and there was great interest in the minute tracing of the changes in Romanesque and Gothic figure sculpture as an unbroken, linear, and so-to-speak teleological development. Problems of iconography were treated separately, as if the religious subject-matter was an abstraction unrelated to its particular embodiment, so that one could change without the other. As a consequence of this separation, the more difficult, but still crucial questions of the origins and implications of expressive form were only tackled later (as with the use of Riegl's concepts for the early Middle Ages, or the significance of the cult of the Virgin in the development of the Gothic style), just as they are only now beginning to be broached as problems central to the understanding of the arts in primitive society.

It is not surprising that in the handling of the problems of style the methods employed in organizing the material have progressed in a strikingly similar sequence. First of all in terms of representation interest understandably proceeded from the more to the less familiar, the most highly stylized forms were considered only in their supposed developmental relationship to more naturalistic ones—coming before or after. Parallel with this attitude, and somehow separate from it, the earliest concerns were also, in

both disciplines, with the description and limitation of local styles. A bewildering mass of undifferentiated material had to be set in some graspable order, and this was achieved by the establishment of static focal points. It was necessary to localize and describe individual schools of early medieval manuscript illumination, the masons' ateliers at Notre-Dame and Chartres, or the Florentine and Venetian styles of the fourteenth century. In the same way it has been necessary first of all to distinguish Bakuba from Baluba and Bena Lulua, or Ibo from Ijo and Ibibio, and it is presently important to distinguish the various local tribal and village styles in the Cameroons or along the Sepik. At this stage of information and understanding the separate character of the local style seems most significant. Since the job at hand is descriptive recognition, it is qualities of type that are emphasized in order to give a cohesive and discrete character to each local style. Differences are underscored, and all works tend to be divided up as exclusive productions of recognized centres whose character is known, and such schematic allocations inevitably tend to play down works ("hybrid," or, more lately "non-nuclear") whose atypical character make them more difficult to place. What is more, the descriptions and the consequent allocations at first tend to be made almost entirely on the basis of what can be described as external characteristics. There are such details as the shape of an ear-lobe, the outline of an eye, the incisions that stand for the human hair, or the striations in the surface of an antelope horn—generally elements of a certain minimal stylization about which objective agreement among outside observers seem most easily reached.

Art historians named this method after the nineteenth-century historian Morelli, who was the first to employ it in systematic detail. The Morellian approach, which in the interest of accurate observation divides the work into small and separate parts, necessarily tends to isolate individual details from their contexts, and to concentrate almost entirely on elements of representation and the degree of their stylization. It tends to ignore those aspects of the work's total impact—rhythm, interrelationship and sequence, and

overall formal concepts—that are more fundamental to ex-
pressive meaning. It is a method that is useful in height-
ening the focus of attention by fragmentation, and that in
its desire to define style through circumscribed detail para-
doxically concentrates on small elements of skill and accu-
racy which are, precisely, those that can be borrowed the
most easily. But in striving for analytic clarity it tends to
overlook the larger, more basically structural factors that
give a work its synthetic character, factors that are inimitable
because they have to do with attitudes as well as skills and
are ultimately dependent on its social setting. The limita-
tions of the Morellian method have long been recognized
by art historians, and notice taken of those other qualities,
more difficult to convey through verbal definition, which
must nevertheless be accounted for. The description of
primitive art has for some time now been at the Morellian
stage. Franz Olbrechts employed the Morellian details as
exclusive indicators of stylistic definition in his book on Congo
art, where his purpose was precisely to arrive at a stylistic
breakdown by making exclusive distinctions.[2] This was a
pioneering work in the treatment of primitive art, but to
an art historian it came as a surprise to find Olbrechts in
1946 explaining his methodology as new and inclusive. It
is a method that almost certainly will be incorporated into
more penetrating approaches to stylistic differentiation.

It is perhaps also legitimate to follow the implications of
the methodological parallel somewhat further. As has been
mentioned, the first step seems always to be the establish-
ment of strict style areas, and in recent years great strides
have been made along these lines in both Africa and the
Pacific. There is no doubt that this compartmentalization is
at least in part a reflection of the character of the material
itself (that is, that "nuclear" styles do exist and do have some
sort of paradigmatic influence), and that this is perhaps
more especially true for primitive art, based as it is upon
relatively small social agglomerations. But if one may judge
by the art historical precedent there is a tendency at this
stage of classification, due not to the evidence but to the
manner of its formulation, to overemphasize the highly in-

dividual character of separate styles and to tie them too tightly to particular localities. Material, social, and religious contexts (that is, techniques and function), closed and static in nature, are found to explain why such a style must belong to such a place. But once ease has been established in the definition and repartition of the available material, familiarity permits a relaxation of vision, probably truer and more internal to the art, and it begins to be possible to see variations of type and intermediaries of style. At this point the existence of peripheral contacts must be acknowledged, and the so-called transitional style (which has as much or as little validity whether it is defined geographically or temporally) is seen to have widespread existence. This at least has been the progression in the art historical analysis of those regional styles in which personalities are largely unknown. The evolution of our stylistic recognition of primitive art is likely to be similar, and it thus seems fair to suggest that with the necessary differences (and these will of course vary from area to area as well) the discussion will move away from the traditional insistence on strict tribal or village attribution, and that in the future purity of style types will have a good deal less categorizing importance.

The question of influences from outside the cultural circle of the style then arises, and the nature of the propitious circumstances in which they become effective. "La forme voyage seule," Denise Paulme has written, concerning the spread of Dan mask forms. Despite extreme functionalist objections this may indeed be the case in certain instances, but why do they occur? (There is no need here to raise the more basic problem of classic diffusionism and motive hunting; it is only the more localized contacts that are under discussion.) Here it would seem proper to invoke the role familiarly applied by anthropologists in other areas, but perhaps too little considered in the problems of artistic contacts: influence is rarely imposed; it more generally occurs in response to need or desire. In artistic matters what looks like push is actually pull (although the unwanted push may of course be taking place at another more material level of force or domination) and is effective only in so far as useful

absorption is possible. Such assimilation may be formal or iconographical, or a mixture of the two, and if one is willing to grant that form is in itself expressive (and not just skill or decoration—see below) then the two can hardly be separated, and only a division of emphasis need be made between formal and functional alteration.

Some reflection upon the concepts developed in Western art history may also be useful in developing a terminology for dealing with all those problems usually lumped together under the heading of aesthetics. In fact the term itself raises problems. It usually points to those aspects of art that are left after function, ritual or otherwise, iconography and meaning—if these can indeed be distinguished—are separated out. It is sometimes made to include skill, or the self-consciousness (on the part of the artists), or the admiration (on the part of the audience) for skill, but only in so far as that skill is employed for the purposes of arrangement and design and not in so far as it is devoted to the accurate making of traditional forms. Thus aesthetics as used in most discussions of primitive art may be said to apply to what in the discussions of our own art would be called its "abstract" aspects, that is, those having to do with the pleasing distribution of formal elements. In a way that one suspects has a good deal to do with our own subjective (and historically very recent) bias, an awareness of this kind seems to be one of the central concerns of most of those who have dealt with the role of art in primitive societies.

Primitive art is of course generally described as functional, and the ways in which it participates in the practical, ceremonial, and ritual concerns of its society are stressed. Indeed this "functional" role is often emphasized to the point of making it a defining factor which sets apart the primitive from the arts in other societies. But such an emphasis, far from denying the assumption of an isolated "aesthetics" which determines the presence or absence of "art," seems rather to confirm it. It is true that one of the first questions that attracts investigators is whether what is called "art for art's sake" is present as a separate interest for either artist or public. Since this phrase has by now come to mean

the narcissistic preoccupation with "art" divorced from all the other concerns of society and the individual's role within that society (hardly its original meaning) the answer in almost all instances is predictably in the negative. This is hardly surprising; what is surprising is that the problem seems to have such attraction, since (quite apart from modern Western society—and even here its existence as it is now defined may be argued) it is certainly the rare exception among historic cultures—if indeed it can be said to exist at all.

Nevertheless the view of "art" that initially compelled the question remains: namely, that there is something called the aesthetic faculty, or the aesthetic reaction, which responds to works of art that are in every respect functional, as if a certain aspect of them were divorced from function. The question, as it is put, suggests that this is the case, and that the functional work of art is constituted by the joining of two separate and diverse attitudes—the one in the broadest sense utilitarian, the other free-floating and self-satisfying—which generally exist independently but have been brought together for this particular occasion. This is often expressed by some such phrases as "an undecorated log would do just as well for the ritual purpose at hand, but . . . ," or, "although there is no need for anything but a simple covering to hide the wearer so that the mask may have the full power it possesses or symbolizes, nevertheless . . . ," suggesting that any "aesthetic" character the figure or the mask possesses is an entirely separable element. This tends to reduce the particular formal character of the functioning object to the level of decoration, which can be added or omitted at will without in any way affecting the nature or the mode of its function, that is, its representational, symbolic, or magical role. (Although the treasures of the medieval cathedrals are evidence enough that even decoration alone, and the skill, the effort, the marshaling of resources that its presence implies, affect the power and efficacy of a ceremonial or religious object.)

Here once again the parallel of art historical thinking may be invoked. Of course the evolution of that thinking, itself influenced by an increasing consciousness of non-

Western art, has already been partially followed, or paralleled in the analysis of primitive art. Today no one would think of invoking the simple standard of "beauty" for the goal intended by the primitive artist, although a century ago this was frequently done, and his success or failure (which was thought of as collective rather than individual) measured by it. There are two basic reasons for the abandonment of such a standard.

One reason will immediately be clear. "Beauty" is a measure developed by a culture external to primitive societies and therefore not applicable to any such society. Even granting that the recognition of feeling it describes may be found outside the classical tradition, it will not be aroused by objects of corresponding appearance. So to invoke it is an elementary ethnocentric error, obvious today, although not always so in the past. The same applies to the closely related standard of naturalism, which is immediately recognized as applicable to only a few tribal cultures and even to these with changes (Ife is the outstanding example), and altogether inapplicable to most.

But more is involved here than a simple acknowledgment that different cultures employ varying measures of an unvarying aesthetic response. What is in effect recognized is that beauty and naturalism are not generalized concepts which can be either overlaid or omitted at will from previously imagined functional objects, changing their "aesthetic" aspect but not their function. The presence or absence of these qualities, in part determined by role, but also affecting that role by the impact they have, is an essential and primary aspect of these objects—as basic as their material substance or their iconographical character. Thus such qualities are not only reflections of function, but are themselves functional. (I am referring to qualities found generally in the art of a given culture, or during a time-span within that culture, and not to the relative success of individual objects.) We acknowledge this when we recognize that where we see a naturalism altered (as in the middle period of the art of Benin, and also perhaps in the Lower Niger bronze industry) or an expressionism softened (as in later

Maori works), the broader character of the culture is also changing. This suggests that the search for a primitive aesthetics, which implies qualities of pure arrangement and design and the satisfaction of self-contained order, will at the very best be inconclusive in its results.

The faulty implications buried in the use of the word "aesthetic" have been noted before by others.[3] Although the noun "beauty," with its Hellenic connotations, is now generally avoided, Vandenhoute notes that its adjectival form is common in the descriptions and definitions of primitive arts of quite diverse character. He observes further that "aesthetic" is employed as a synonym for "beautiful," and the aesthetic experience taken to be the awareness of forms and arrangements considered to be beautiful. As long as it is so restricted, he says, "it will be difficult or even impossible to justify the use of the word 'aesthetic' in an ethnological study. . . ."

This point would apply to studies of the arts well outside the range of ethnology, and in making it Vandenhoute is actually invoking the evolution of art historical concepts. "Aesthetic experience," he writes, "includes a quantity of other aspects, e.g. the experience of ugliness, of horror, of the hateful, of surprise, of the comic, the tragic, the religious . . . ," and here he is calling on the history of the "science of aesthetics," whose two-hundred year evolution has in large part been an attempt to keep pace, not only with an expanding range of contemporary art, but an increasing knowledge of the arts of all societies—and not the least the primitive. Ever since the eighteenth-century recognition of the sublime as both different from beauty and a proper goal for the arts, the study of historical art has increasingly been compelled to acknowledge the diversity of different types of art, and even more the incommensurate qualities of different periods of art. If this is true for the various periods of an historical tradition, how much more true for contrasting cultures. But once the term "aesthetic" has been broadened in this fashion and given such diversity of reference, one must question whether it retains much of its usefulness.

Its employment may in fact still be misleading in its implications. For even if it is now allowed that "aesthetic" refers to a wide range of artistic intentions (thought out or not) on the part of the maker of an object, and a corresponding spectrum of responses on the part of his audience, it still seems to refer to the secondary characteristics of a "functional work of art," aesthetic aspects that are not only different, but less essential to it than its functional role. But is this in fact the case, can the separation of these two facets of art be justified as anything more than a temporary analytic device?

Here the precedent of art historical method is of less assistance. Robert Redfield remarks with some irony:

> It is so often said that the art of a people expresses that people that I hesitate to deny it. . . . Among both art historians and anthropologists there have been those who have seen art styles as expression in concrete form of the thought and feeling that pervades and characterizes a whole culture. . . . But I should not expect to derive much valid understanding of a primitive world view from the art style of that people.[4]

Redfield's scepticism may be justified; even the social historian of art, who often reasons deductively from society to art, rarely reasons inductively from art to society. But one must note that his description still puts aesthetics in a secondary role: the world view first, art later as its illustration.

But it is also possible that the arts must be seen in a different relation to society, not as illustrations, but as primary documents. A religious sculpture may indeed seem to follow up and exemplify ideas and attitudes already in force. But it must not be forgotten that it also has behind it other earlier sculptures from which it largely takes its particular character. This character, or style, not only conveys a message, but more than this in itself embodies a message or a meaning and one that is essentially untranslatable. (Philosophers such as Suzanne Langer have belatedly come to acknowledge "symbolic form"; artists have always known that in this direct and elementary sense the medium is the message.) As George Kubler has written, "Anthropological con-

clusions about a culture do not automatically account for the art of that culture."[5] Art is thus its own model at least as much as it is a demonstration (in both the literal and the figurative senses) of ideas first elaborated elsewhere. A work, or a series of works, exists in this way not only for its creator, but also for its audience, whose vision it forms, so that its initial reality precedes and embodies ideas and feelings at least as much as it illustrates them. If this is so, then art is a primary document in a culture, and as such cannot be explained out of the other elements of that culture any more than they can be explained by it.

NOTES

1. This essay originally appeared in *Primitive Art and Society*, edited by Anthony Forge (© The Wenner-Gren Foundation for Anthropological Research, Inc.; published by Oxford University Press, 1973).

2. F. Olbrechts, *Plastik van Congo* (Antwerp, 1946).

3. See the discussion in M. W. Smith, ed., *The Artist in Tribal Society* (London, 1961), and more especially in P. S. Vandenhoute, Comment on *Methods of Studying Ethnological Art,* by H. Hasselberger, *Current Anthropology,* vol. 2, 1961, p. 374.

4. R. Redfield, "Art and Icon" in *Aspects of Primitive Art* (New York, 1959).

5. G. Kubler, "Rival Approaches to American Antiquity" in *Three Regions of Primitive Art* (New York, 1961).

# Appendix

## Summary Chronology of Ethnographical Museums and Exhibitions

XVIII C   Some of Cook's South Sea objects enter Montague House, later to form part of the British Museum collections.

1799   Salem, Massachusetts, East India Marine Society founded; Oceanic collections acquired during the first quarter of the nineteenth century.

1800   At about this date Vienna acquires some of Cook's objects for the Hofmuseum.

1823   The British Museum acquires Aztec sculpture.

1837   Leiden, the Royal Japanese Museum founded with Von Siebold's ethnographic collections.

1841   Copenhagen, the Danish national museum adds department of ethnography.

1850   An ethnographical collection already exists in Hamburg.

1851   Oxford, Pitt-Rivers Museum founded; attached to the University in 1883.

1855     Paris, the project of an ethnographical museum begins to take shape, in connection with the Universal Exposition of 1855.

1856     Berlin forms an "ethnographical section" in connection with the museum of antiquities.

1857     Oslo, ethnographical museum, University of Oslo, founded.

1864     Leiden, Japanese museum becomes Rijksmuseum voor Volkenkunde.

1865     The Christy collection presented to the British Museum.

1866     Harvard Peabody Museum founded; building 1877.

1866     Yale Peabody Museum founded; building 1876.

1867     Museum of antiquities, St. Germain-en-Laye is founded.

1868     Adolf Bastian founds the Berlin Königliche Museum für Völkerkunde, and becomes professor at the university.

1869     Leipzig group headed by Hermann Obst buys the Gustav Klemm (Dresden) ethnographical collection.

1869     New York, the American Museum of Natural History founded; opens in 1874.

1872     Stockholm, founding of the Nordiska Museet.

1874     The Leipzig ethnographical museum is opened.

1875     Hofrat Meyer, in Dresden, founds the anthropological-ethnographical museum of the State of Saxony.

1875     Founding of the Museo preistorico ed etnografico in Rome, through Professor Luigi Pigorini's activity.

1876     Adolf Bastian made director of the Berlin museums.

1877     The Hamburg museum becomes the Museum für Völkerkunde.

1878     E.-T. Hamy founds the Trocadéro, Paris. Made possible through the impulse given by the universal exposition.

1881     The Cambridge University Museum of Archaeology and Ethnology is founded.

1883     The Christy Collection is moved into the British Museum.

1883     Amsterdam, Colonial Exposition.

1885     By this date there are local ethnological museums in Florence, Venice, Milan, and Turin.

1885     The Leipzig museum buys the Godefroy (Hamburg) Oceanic Collection.

1887     London Colonial Exposition. All objects of material culture from various regions exhibited in confusion.

1888     Zurich, University ethnographic collection begun.

1889     Paris Exposition Universelle. Many Oceanic objects,

though few of artistic value, shown; while from West
Africa only a few Ashanti things.

1891 Göteborg, ethnographical museum founded.

1892 Leipzig museum, special African exhibition.

1893 Basel, ethnographic museum is founded.

1893 Chicago, the Field Museum of Natural History founded.

1894 Antwerp international exposition.

1895 Brooklyn, Museum of Arts and Sciences founded.

1896 Leipzig museum opens new building with sections for the
South Seas, Asia, Africa and America.

1897 Tervuren exposition of the Congo. (Part of the universal
exposition.) Formed the basis for the Tervuren museum
(Musée du Congo Belge).

1898 The *Annales* of the Tervuren museum start.

1899 The Wilhelm Joest Collection (principally Asiatic objects)
given to the City of Cologne by the Rautenstrauchs.

1899 Philadelphia, the University Museum founded.

1902 Stockholm, state ethnographical museum founded as a
department of the Swedish museum of natural history.

1904 André Level begins collecting African sculpture.

1905 Vlaminck, Matisse, Picasso and Derain begin to collect
African sculpture at about this date.

1905 Musulman Exposition, Algiers.

1906 Cologne ethnographical museum (Rautenstrauch-Joest)
opened.

1907 Leipzig museum opens its prehistoric section.

1907–
1909 Tervuren museum aids the Torday-Joyce Congo Exposi-
tion, which brings back much "art."

1908 Tervuren museum's new building is opened.

1908 Frankfurt-am-Main opens its ethnological museum (be-
gun in 1902).

1908 Léonce Rosenberg, Paris, begins collecting African sculp-
ture.

1909 New York, African sculpture shown at Alfred Stieglitz'
291 Fifth Avenue gallery.

1910 The Trocadéro opens its Oceanic Hall.

1910 Tervuren museum is reorganized.

1910 Munich exhibition of Mohammedan art.

1912 Essen, Folkwang Museum exhibits African sculptures as
works of art.

1914 Formation of the Société des Amis du Trocadéro.

1914–
1918   German scholars work at the Tervuren museum.

1915   *Negerplastik,* by Carl Einstein; the first book devoted exclusively to African sculpture. (Second edition, 1920).

1916   *African Negro Art and Its Influence on Modern Art,* by Marius de Zayas, published in New York.

1917   *Sculptures Nègres,* by Paul Guillaume and Guillaume Apollinaire—the first book in French on African art.

1919   *Première Exposition d'art Nègre et d'art Océanien,* Paris, at the Devambez Gallery, with a catalog by Clouzot and Level.

1920   Roger Fry, Clive Bell, André Salmon write in praise of Negro art.

1921   Leipzig museum, exhibition of Negro sculpture.

1922   Leipzig museum, *Ahnenkult* exhibition.

1922   Marseille, Exposition Coloniale. Exhibition of Dahomean art.

1923   Paris, Pavillon de Marsan, *Exposition de l'art indigène des colonies françaises d'Afrique et d'Océanie.*

1923   Brooklyn Museum, exhibition of Primitive Negro Sculpture organized by Stewart Culin.

1925   Paris, Exhibition of Negro art, Galerie le Portique. Catalogue by Carl Einstein.

1926   Munich museum reorganized on a *kunstwissenschaftlich-ästhetisch* basis.

1928   Reorganization of the Trocadéro; greater artistic appeal.

1930   Vienna museum reorganized according to a cultural documentary method.

1930   Exhibition at the Galérie Pigalle, Paris.

1930   Antwerp, International Colonial Exposition.

1931   Paris, Exposition Coloniale. Musée des Colonies founded.

1933   London, Lefèvre Galleries, exhibition of Primitive African Sculpture.

1935   New York, the Museum of Modern Art, exhibition of African Negro Art.

1935   Paris, the Musée des Colonies reopens as the Musée de la France d'Outremer.

1937   The Trocadéro reorganized as the Musée de l'Homme.

1937   Antwerp, exhibition of the arts of the Belgian Congo.

1946   New York, the Museum of Modern Art, exhibition of the Arts of the South Seas.

1948    San Francisco, de Young Museum, exhibition of African Negro Sculpture.

1949    London, Royal Anthropological Institute, exhibition of African art.

1951    London, the Festival of Britain, exhibition of Traditional Art from the Colonies.

1952    Zurich, the Rietberg museum (Baron von der Heydt collection) founded.

1953    London, the British Museum, exhibition of the Webster Plass Collection of African Art.

1954    New York, the Museum of Primitive Art (Nelson A. Rockefeller Collection) founded; original name the Museum of Indigenous Art. Opened in 1957.

1954    New York, the Brooklyn Museum, exhibition of Masterpieces of African Art.

1956    Philadelphia, the University Museum, exhibition of African Tribal Sculpture.

1960    Paris, the Musée des Colonies (de la France d'Outremer) reorganized on an aesthetic basis as the Musée des Arts Africains et Océaniens.

# The Publications of Robert Goldwater (1907–1973)

Compiled by Phyllis Tuchman

The passing of Robert Goldwater is a sad loss to the world of art, and particularly to all who personally knew and admired this great critic and scholar.

His pioneering research and writing on the role of primitive art in the development in modern art was at once widely recognized as a landmark. Undertaken when both these forms of art were still relatively unfamiliar, it broadened the general appreciation of both fields. His work at the Museum of Primitive Art, as one of its organizers in the early stages, and later for many years as its director, continued this important effort.

More recently, he was deeply engaged with the planning of the Michael C. Rockefeller Wing, which will be part of The Metropolitan Museum of Art and form the permanent

home of the Museum of Primitive Art's collection. All of us who shared his concerns are fortunate to have known him as colleague, guide, and friend. He is deeply missed.

NELSON A. ROCKEFELLER[1]

## 1932
Review: Hans Weigert, *Die Stilstufen der deutschen Plastik von 1250 bis 1350,* in *Art Bulletin,* 14 (1932), no. 2, pp. 186–189.

## 1934
Review: John Dewey, *Art as Experience,* in "Professor Dewey on Art," *The Nation,* 138 (1934), no. 3598, pp. 710–711.

## 1935
Contributor: *African Negro Art: A Corpus of Photographs by Walker Evans,* exhibition catalogue, Museum of Modern Art (New York, 1935).
"An Approach to African Sculpture," *Parnassus,* 7 (1935), no. 4, pp. 25–27.

## 1936
*America · Oceania · Africa,* exhibition catalogue, Pierre Matisse Gallery (New York, 1936).

## 1937
"The Art of Africa," *The Brooklyn Museum Quarterly,* 24 (1937), no. 1, pp. 4–19.
"A Unique Gauguin," *Magazine of Art,* 30 (1937), no. 1, pp. 24–26, 54–55.
"Prehistoric Rock Pictures," *Magazine of Art,* 30 (1937), no. 6, pp. 380–382.

Contributor: *Harper's Encyclopedia of Art* (New York–London, 1937). (Unsigned entries: "Negro art—Africa," pp. 252–253; "Oceanic art," p. 256.)

## 1938
*Primitivism in Modern Painting* (New York–London, 1938).
"Cézanne in America: The Master's Paintings in American Collections," *Art News,* 36 (1938), no. 26, pp. 134–160.
"Masters of Popular Paintings," *Magazine of Art,* 31 (1938), no. 6, pp. 356–357.

## 1939
"Gros, Géricault, Delacroix," *Art in America,* 27 (1939), no. 1, pp. 37–39.
"Seventeen Masterpieces of Dutch Painting," *Art in America,* 27 (1939), no. 2, pp. 90–91.

## 1940
"Picasso: Forty Years of His Art," *Art in America,* 28 (1940), no. 1, pp. 43–44.
"Artists Painted by Themselves: Self-Portraits from Baroque to Impressionism," *Art News,* 38 (1940), no. 26, pp. 6–14.
"David and Ingrès," *Art in America,* 28 (1940), no. 2, pp. 83–84.

1940 (*continued*)

Review: Lionello Venturi, *Les Archives de l'Impressionisme,* in *Art Bulletin,* 22 (1940), no. 2, pp. 111–113.

1941

"Some Aspects of the Development of Seurat's Style," *Art Bulletin,* 23 (1941), no. 2, pp. 117–130. Reprinted in Norma Broude, ed., *Seurat in Perspective* (Englewood Cliffs, N.J., Prentice Hall, 1978), pp. 84–92.

Review: Nikolaus Pevsner, *Academies of Art, Past and Present,* in *Art Bulletin,* 23 (1941), no. 2, pp. 184–185.

1942

"Renoir," *Art in America,* 30 (1942), no. 1, pp. 63–64.

"Modern Art in the College Curriculum," *College Art Journal,* 1 (1942), no. 4, pp. 90–93.

" 'L'Affiche Moderne,' A Revival of Poster Art After 1880," *Gazette des Beaux-Arts,* 22 (1942), no. 910, pp. 173–182.

1943

"The Teaching of Art in the Colleges of the United States," *College Art Journal,* 2 (1943), no. 4, Part II—supplement, pp. 3–31.

Review: John B. Flannagan, *Letters,* in *Art Bulletin,* 25 (1943), no. 3, pp. 287–288.

1944

"Derain: Revaluation in Retrospect," *Art News,* 42 (1944), no. 17, pp. 19, 25.

1945

Editor: *Artists on Art, from the XIV to the XX Century* (with Marco Treves) (New York, 1945). Reprinted New York, Pantheon, 1972.

"Art and Nature in the 19th Century," *Magazine of Art,* 38 (1945), no. 3, pp. 104–111.

"Abraham Rattner: An American Internationalist at Home," *Art in America,* 33 (1945), no. 2, pp. 84–93.

Review: *Camille Pissarro, Letters to His Son Lucien,* Lucien Pissarro and John Rewald, eds.; John Rewald, *Georges Seurat;* Hans Graber, *Paul Cézanne nach eigenen und fremden Zeugnissen;* Erle Loran, *Cézanne's Composition: Analysis of His Form with Diagrams and Photographs of His Motifs,* in *Art Bulletin,* 27 (1945), no. 2, pp. 158–161.

1946

Review: Guillaume Apollinaire, *The Cubist Painters;* Piet Mondrian, *Plastic Art and Pure Plastic Art;* Laszlo Moholy-Nagy, *The New Vision,* and *Abstract of an Artist;* Hilaire Hiler, Henry Miller, and William Saroyan, *Why Abstract?* in "Moving Towards the Absolute," *Kenyon Review,* 8 (1946), no. 1, pp. 164–167.

1946 (*continued*)

"Puvis de Chavannes: Some Reasons for a Reputation," *Art Bulletin,* 28 (1946), no. 1, pp. 33–43. Reprinted in James S. Ackerman, et al., eds., *The Garland Library of the History of Art* (New York, Garland, 1976), pp. 73–83.

"The Genesis of a Picture: Theme and Form in Modern Painting," *Critique,* 1 (1946), no. 1, pp. 5–12.

"Symbolist Art and Theater: Vuillard, Bonnard, Maurice Denis," *Magazine of Art,* 39 (1946), no. 8, pp. 366–370.

Review: Erle Loran, *Cézanne's Composition: The Arts, Number One,* Desmond Shawe-Taylor, ed.; *The Drawings of Henry Moore,* in "Art Notes," *Partisan Review,* 13 (1946), no. 5, pp. 599–600.

1947

*Rufino Tamayo* (New York, 1947).

"Art Letter," *Kenyon Review,* 9 (1947), no. 1, pp. 110–112.

"Dubuffet's Diablerie," *View,* 7 (1947), no. 3, pp. 47, 49.

"Note on Marsden Hartley's 'Evening Storm, Schoodick, Maine,' " *Kenyon Review,* 9 (1947), no. 2, pp. 165–166.

"Gauguin's 'Yellow Christ,' " *Gallery Notes* [Buffalo Fine Arts Academy, Albright Art Gallery], 11 (1947), no. 3, pp. 3–13.

Review: *Renoir Drawings,* John Rewald, ed.; Germain Seligman, *The Drawings of Georges Seurat,* in *Art in America,* 35 (1947), no. 3, pp. 238–239.

"Art Chronicle: A Season of Art," *Partisan Review,* 14 (1947), no. 4, pp. 414–418.

"Symbolism in Painting," *Art News,* 46 (1947), no. 7, pp. 14–17, 44–45.

"A French Nineteenth-Century Painting: Manet's 'Picnic,' " *Art in America,* 35 (1947), no. 4, pp. 324–328.

1948

Editorial: "Boston Backtrack," *Magazine of Art,* 41 (1948), no. 4, p. 122.

1949

"Modern Art in Your Life" (with René d'Harnoncourt), exhibition catalogue, *Museum of Modern Art Bulletin,* 17 (1949), no. 1, pp. 1–48.

Review: Simon L. Millner, *Ernst Josephson,* in *Magazine of Art,* 42 (1949), no. 1, p. 30.

Editorial: "Miniver Cheevy and the Dignity of Man," *Magazine of Art,* 42 (1949), no. 2, pp. 57, 72.

"A Symposium: The State of American Art," *Magazine of Art,* 42 (1949), no. 3, p. 83.

1950

Editorial: "Richmond Revisited," *Magazine of Art,* 43 (1950), no. 6, pp. 230–231.

"A Symposium: Government and Art," *Magazine of Art,* 43 (1950), no. 7, p. 243.

1951

"Letter from Paris," *Magazine of Art*, 44 (1951), no. 5, pp. 184–185, 193.

Editorial: "The Lost Independents," *Magazine of Art*, 44 (1951), no. 8, p. 302.

Participant: "The Western Round Table of Modern Art," Douglas MacAgy, ed., in *Modern Artists in America* (New York, 1951), pp. 24–37.

1952

Translator: Walter Friedlaender, *From David to Delacroix* (Cambridge, Mass., 1952).

Editorial: "American Art Abroad," *Magazine of Art*, 45 (1952), no. 1, p. 2.

Editorial: "Partial Criticism," *Magazine of Art*, 45 (1952), no. 2, p. 50.

Editorial: "Minding the Artist," *Magazine of Art*, 45 (1952), no. 3, p. 98.

Editorial: "The Barnes Suit," *Magazine of Art*, 45 (1952), no. 4, p. 146.

Editorial: "Regionalism—Nationalism—Internationalism," *Magazine of Art*, 45 (1952), no. 5, p. 194.

Review: *The Dada Painters and Poets: An Anthology*, Robert Motherwell, ed., in *Art Bulletin*, 34 (1952), no. 3, pp. 249–251.

Editorial: "The Monument and the Landmark," *Magazine of Art*, 45 (1952), no. 6, p. 242.

Editorial: "Artist and Critic," *Magazine of Art*, 45 (1952), no. 7, p. 290.

Editorial: "Words and Pictures," *Magazine of Art*, 45 (1952), no. 8, p. 338.

1953

*Vincent Van Gogh* (New York, 1953).

*Modern Art in Your Life* (with René d'Harnoncourt), 2nd and 3rd revised eds. (New York, 1953).

"Arthur Dove," *Perspectives USA*, no. 2, Winter 1953, pp. 78–88.

Editorial: "Art and/or Culture," *Magazine of Art*, 46 (1953), no. 1, p. 2.

Editorial: "The Academy of Nature," *Magazine of Art*, 46 (1953), no. 3, p. 98.

Editorial: "Valedictory" (with James Thrall Soby), *Magazine of Art*, 46 (1953), no. 5, p. 194.

"These Promising Younger Europeans," *Art News*, 52 (1953), no. 8, pp. 14–16, 53–54.

1954

"Vuillard's Intimate Art," *The Art Digest*, 28 (1954), no. 9, pp. 7–8.

Review: John I. H. Baur, *American Painting in the 19th Century: Main Trends and Movements*, in "Lincoln's Art," *Saturday Review*, 37 (1954), no. 14, pp. 58–59.

Review: Henry R. Hope, *The Sculpture of Jacques Lipchitz*, in "Modern Stonecutter," *Saturday Review*, 37 (1954), no. 32, pp. 34–35.

1954 (*continued*)

"The Arensberg Collection for Philadelphia," *Burlington Magazine*, 96 (1954), no. 620, pp. 350–353.

"Individuality and Style," *Design Quarterly*, no. 30 (1954), pp. 3–8.

1955

Review: I. Groth-Kimball and F. Feuchtwanger, *The Art of Ancient Mexico;* Friedrich Hewicker and Herbert Tischner, *Oceanic Art;* Eckart von Sydow, *Afrikanische Plastik;* Werner Schmalenbach, *African Art;* Miguel Covarrubias, *The Eagle, the Jaguar and the Serpent,* in "The not-so-primitive," *Art News*, 53 (1955), no. 9, pp. 30–31, 65–66.

Introduction to *Fifty Paintings, 1905–1913; The Fiftieth Anniversary Exhibition,* exhibition catalogue, Fine Arts Academy, Albright Art Gallery (Buffalo, 1955), pp. 7–16. Also published as "1905–1913: The Crucial Years of Modernism," *The Art Digest*, 29 (1955), no. 17, pp. 11–13, 31; no. 18, pp. 18–20, 30.

Review: Georges Bataille, *Lascaux, or the Birth of Art,* in "Prehistory in Image," *Saturday Review*, 38 (1955), no. 35, pp. 15–16.

1956

"Sculpture Today in New York," *Cimaise*, 4 (1956), no. 2, pp. 10, 43–44 (in French, pp. 24–28).

"David Hare," *Art in America*, 44 (1956/1957), no. 4, pp. 18–20, 61. Republished in *Three American Sculptors* (New York, 1959).

1957

*Paul Gauguin* (New York, 1957).

"Primitives beautés," *L'Oeil*, no. 27, 1957, pp. 14–19.

Introduction to *Selected Works from the Collection, 1,* exhibition catalogue, Museum of Primitive Art (New York, 1957).

Introduction to *Selected Works from the Collection, 2,* exhibition catalogue, Museum of Primitive Art (New York, 1957).

"The Museum of Primitive Art in New York," *Graphis*, 13 (1957), no. 74, pp. 528–537, 557 (in English, German, and French).

1958

"Renoir at Wildenstein," *Art in America*, 46 (1958), no. 1, pp. 60–61.

Introduction to *African Sculpture Lent by New York Collectors,* exhibition catalogue, Museum of Primitive Art (New York, 1958).

Introduction to *Herbert Ferber: First Retrospective Exhibition,* exhibition catalogue, Bennington College (Bennington, Vt., 1958).

1959

*Jacques Lipchitz* (New York, 1959).

Introduction to *Sculpture from*

1959 (*continued*)

*Three African Tribes: Senufo, Baga, Dogon,* exhibition catalogue, Museum of Primitive Art (New York, 1959).

Foreword to *The Art of Lake Sentani,* exhibition catalogue, Museum of Primitive Art (New York, 1959), p. 5.

Review: John Canaday, *Mainstreams of Modern Art,* in "After Jacques-Louis David, what?" *Art News,* 58 (1959), no. 8, pp. 42, 63–64.

Foreword to *Aspects of Primitive Art (Lecture Series Number One)* (New York, 1959), pp. 8–9.

"Cahier, or Everyone Knew What Everyone Else Meant," in *It is* (Autumn, 1959), p. 35.

1960

*Bambara Sculpture from the Western Sudan* (New York, 1960).

"Reflections on the New York School," *Quadrum,* no. 8, 1960, pp. 17–36.

Foreword to *The Lipchitz Collection,* exhibition catalogue, Museum of Primitive Art (New York, 1960), p. 5.

Foreword to *The Raymond Wielgus Collection,* exhibition catalogue, Museum of Primitive Art (New York, 1960), p. 5.

1961

"Reflections on the Rothko Exhibition," *Arts,* 35 (1961), no. 6, pp. 42–45.

"Reflections on the Rothko Exhibition," *Mark Rothko,* exhibition catalogue, Whitechapel Art Gallery (London, 1961). (Under the auspices of the International Council, Museum of Modern Art.)

Review: Clement Greenberg, *Art and Culture,* in "Art and Criticism," *Partisan Review,* 28 (1961), nos. 5–6, pp. 688–694.

"Reuben Nakian," *Quadrum,* no. 11, 1961, pp. 95–102.

Introduction to *Traditional Art of the African Nations in the Museum of Primitive Art* (New York, 1961).

Foreword to *Three Regions of Primitive Art (Lecture Series Number Two)* (New York, 1961), pp. 8–9.

1962

*The Great Bieri* (New York, 1962).

Contributor: *Dictionary of Modern Sculpture,* Robert Maillard, gen. ed. (New York, 1962).

"Art Chronicle: A Surfeit of the New," *Partisan Review,* 29 (1962), no. 1, pp. 116–121.

"Reflections on the Rothko Exhibition," *Mark Rothko,* exhibition catalogue, Kunsthalle, Basel (Basel, 1962). (In English and German; under the auspices of the International Council, Museum of Modern Art.)

Review: Harold Rosenberg, *Arshile Gorky: The Man, the Time, the Idea,* in "The Genius of the Moujik," *Saturday Review,* 45 (1962), no. 20, p. 38.

"Art Chronicle: Masters of the New," *Partisan Review,* 29

1962 (*continued*)
(1962), no. 3, pp. 416–420.

Foreword to *The John and Dominique de Menil Collection*, exhibition catalogue, Museum of Primitive Art (New York, 1962).

1963

"Symbolic Form: Symbolic Content," in *Problems of the 19th & 20th Centuries* (Studies in Western Art, IV) (Princeton, 1963), pp. 111–121.

"Governor Nelson A. Rockefeller, New York: Primitive Art and the Twentieth Century," in *Great Private Collections*, Douglas Cooper, ed. (New York, 1963), pp. 270–281.

*Sculpture from Africa in the Museum of Primitive Art*, exhibition catalogue, Museum of Primitive Art (New York, 1963).

Review: Man Ray, *Self-Portrait*, in "An Exciting Ride in the Van," *Saturday Review*, 46 (1963), no. 33, p. 19.

1964

*Senufo Sculpture from West Africa* (New York, 1964).

Contributor: *African Folktales and Sculpture*, Paul Radin, ed., 2nd ed. (New York, 1964).

Review: Christopher Gray, *Sculpture and Ceramics of Paul Gauguin*, in *New York Review of Books*, 2 (1964), no. 2, p. 9.

Review: Albert Elsen, *Rodin*, in *New York Review of Books*, 2 (1964), no. 7, p. 11.

Review: Sam Hunter and Hans Hofmann, *Hans Hofmann*, in *New York Review of Books*, 3 (1964), no. 5, pp. 17–18.

1965

"Bonnard," *The Lugano Review*, 1 (1965), no. 1, pp. 129–137.

"Truth to What?" *Arts Yearbook 8: Contemporary Sculpture*, 1965, pp. 64–73.

1966

"The Glory that Was France," *Art News*, 65 (1966), no. 1, pp. 40–42, 84–86.

1967

*Primitivism in Modern Art*, revised ed. (New York, 1967). Japanese translation (Tokyo, Iwasaki Bijutsu-Sha, 1968). French translation by Denise Paulme-Shaeffner (Paris, Presses Universitaires de France, 1986).

Foreword to *The Asmat of New Guinea: The Journal of Michael Clark Rockefeller*, Adrian A. Gerbrands, ed. (New York, 1967), pp. 5–7.

Introduction to *Franz Kline: 1910–1962*, exhibition catalogue, Marlborough-Gerson Gallery (New York, 1967), pp. 5–8. Also published as "Franz Kline: Darkness Visible," *Art News*, 66 (1967), no. 1, pp. 38–43, 77.

"Problems of Criticism, I: Varieties of Critical Experience," *Artforum*, 6 (1967), no. 1, pp. 40–41.

1967 (*continued*)

"Letters," *Artforum*, 6 (1967), no. 4, p. 4.

*Space and Dream*, exhibition catalogue, Knoedler Gallery (New York, 1967).

"L'Expérience occidentale de l'art nègre," in *Fonction et signification de l'art nègre dans la vie du peuple et pour le peuple* (Colloque/Festival Mondial des Arts Nègre, 1er, Dakar) (Paris, 1967), pp. 347–361.

1968

"From . . . by . . . and for . . . Ralph C. Altman," *African arts/ arts d'Afrique*, 1 (1968), no. 2, pp. 36–39, 78–79.

1969

"Judgments of Primitive Art, 1905–1965," in *Tradition and Creativity in Tribal Art*, Daniel P. Biebuyck, ed. (Berkeley–Los Angeles, 1969), pp. 24–41.

"Art of Oceania, Africa, and the Americas," *The Metropolitan Museum of Art Bulletin*, 27 (1969), n.s., no. 9, pp. 397–410.

Introduction, and section on "Africa" (with Tamara Northern), for *Art of Oceania, Africa, and the Americas from the Museum of Primitive Art*, exhibition catalogue, The Metropolitan Museum of Art (New York, 1969).

Review: Rene S. Wassing, *African Art, Its Background and Traditions;* Michel Leiris and Jacqueline Delange, *African Art,* in "Black is Beautiful," *New York Review of Books*, 13 (1969), no. 11, pp. 36–40.

1970

*What is Modern Sculpture?* (New York, 1970).

1971

"Rothko's Black Paintings," *Art in America*, 59 (1971), no. 2, pp. 58–63.

1972

"The Sculpture of Matisse," *Art in America*, 60 (1972), no. 2, pp. 40–45.

1973

"Art History and Anthropology: Some Comparisons of Methodology," in *Primitive Art and Society*, Anthony Forge, ed. (London–New York, 1973), pp. 1–10.

*Bernard Karpel, Librarian of the Museum of Modern Art, New York, and the Library staff at the Museum of Primitive Art, New York, graciously aided in the preparation of this bibliography.*

NOTES

1. This bibliography was first published in the *Metropolitan Museum Journal*, volume 8, 1973 (© The Metropolitan Museum of Art, 1974).

# Index